Mi Fu

PETER CHARLES STURMAN

Mi Fu

Style and the

Art of Calligraphy

in Northern

Song China

Yale University Press • New Haven and London

Designed by Sonia Scanlon
Formatted in Fournier type by Elsa Ann Danenberg
Chinese setting by Birdtrack Press
Printed in the United States of America by Edwards
Brothers, Inc., Ann Arbor, Michigan

Library of Congress Cataloging-in-Publication Data
Sturman, Peter Charles
 Mi Fu : style and the art of calligraphy in
northern Song China / Peter Charles Sturman.
 p. cm.
 Includes bibliographical references and index.
 ISBN 0-300-06569-8 (alk. paper)
 1. Mi, Fu, 1051–1107—Criticism and interpreta-
tion. 2. Calligraphy, Chinese—Sung-Yüan
dynasties, 960–1368. I. Title.
NK3634.M5S78 1997
745.6' 19951' 092—dc20
96-9556
 CIP

A catalogue record for this book is available from the
British Library.

The paper in this book meets the guidelines for
permanence and durability of the Committee on
Production Guidelines for Book Longevity of the
Council on Library Resources.

10 9 8 7 6 5 4 3 2 1

For Adrianne and George Sturman

"For old age comes creeping and soon will be upon me,
And I fear I shall not leave behind an enduring name"

—Qu Yuan, "Li sao," from David Hawkes, *Ch'u Tẓ'u: Songs of the South*

Contents

Acknowledgments

A friend recently asked how one could possibly say anything new about someone as famous and well-studied in China as the calligrapher Mi Fu. After working on the art of the Mi family now for well over a decade, I can appreciate this question. Mi Fu has been a subject of serious study for more than eight centuries, beginning with his son, Mi Youren, who helped the imperial court of the Southern Song collect and arrange his father's scattered calligraphy. Yue Ke, Zhu Yunming, Zhang Chou, Weng Fanggang . . . these are names unknown to most Western readers, but they are prominent cultural figures in China and some of the dedicated scholars from centuries earlier who directed their attention to Mi Fu. Little at all could be said of Mi Fu without the foundation established by these people, and it is to them that I and all others who comment on Mi Fu's art first owe appreciation.

In more recent times there are many indeed whose work has made this book on Mi Fu possible, including Nakata Yūjirō, Wai-kam Ho, Lothar Ledderose, Wen Fong, Sun Zubai, Xu Bangda, Zheng Jinfa, and Gao Huiyang. I owe a particular debt to Cao Baolin, whose work provides the most significant advance in the *kaozheng* tradition of ascertaining facts about Mi Fu's life and calligraphy since Weng Fanggang in the eighteenth century. Our opinions may differ about the dating of some of Mi Fu's writings, but this in no way diminishes the great obligation I owe Cao Baolin's studies for the checks and corrections they brought to this manuscript. I have also benefited greatly from the work of Jonathan Chaves and Ronald Egan, whose studies of the literature and calligraphy of the Northern Song provided welcome perspectives on Northern Song culture as well as materials that proved valuable for my understanding of Mi Fu and his art.

Richard Barnhart read an early version of this manuscript and made important suggestions. Wu Hung, Haun Saussy, and Zhang Longxi kindly offered their thoughts on the Introduction. Hui-shu Lee helped with the reading of troublesome poems and letters. My deepest appreciation is reserved for Richard Edwards, who evaluated the manuscript for Yale University Press and provided an important guide for its rewriting. I am also grateful to Laura Jones Dooley and her expert editing of the text.

Special assistance in obtaining photographs and permissions was provided by Ho Ch'uan-hsin of the National Palace Museum and by my friends at Nigensha Publishing Company in Tokyo, Mr. Takashima, Mr. Arai, and Mr. Morishima. I also thank Thomas Prutisto of Hong Kong for his help with the photography

and Steven Brown of Artworks, University of California at Santa Barbara, for his time and guidance concerning the computer-generated illustrations. I am grateful to the National Palace Museum in Taipei, the Tokyo National Museum, the Osaka Municipal Museum of Art, the British Museum, the Art Museum of Princeton University, the Metropolitan Museum of Art, the Museum of Fine Arts in Boston, and the Arthur M. Sackler Foundation for allowing me to reproduce works of art from their collections. Funding for portions of the research for this book was generously provided by the Asian Cultural Council and the Interdisciplinary Humanities Center and College of Letters and Sciences of the University of California at Santa Barbara.

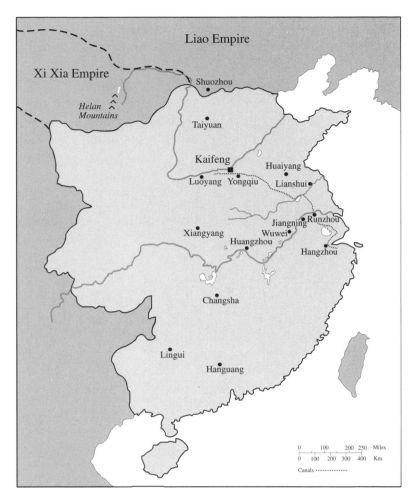

Map 1. Northern Song China.

Rare Views from the Studio of Oceans and Mountains—Style and the Chinese Artist

In the city of Zhenjiang, on the south bank of the Yangtze River in southern Jiangsu Province, rises the promontory called Beigushan (North-fortifying Mountain). Its height is a modest 190 feet, but Beigushan offers a broad view of the city below and the wide expanse of China's mightiest river. Visitors usually enter by Zhenjiao Road, follow a pleasant tree-lined path, pause by what remains of the eleventh-century Iron Pagoda, and then continue to the venerable Ganlu (Sweet Dew) Temple. Little remains of the temple's past glory, but those conscientious enough to read the labels provided by its present keepers can perhaps imagine grand halls decorated with mural paintings by the famous sixth- and eighth-century painters Zhang Sengyou and Wu Daozi and the presence of China's most revered poets and luminaries, who, like themselves, climbed Beigushan to appreciate the spectacular view.

One who often made the climb to survey the grand vista was the scholar-official Mi Fu (1052–1107/8), a man skilled equally in the arts of calligraphy and eccentricity during one of the richest periods of cultural accomplishment in China. Zhenjiang, or Runzhou, as it was generally known in the Northern Song period (960–1127), was Mi Fu's adopted home, and he built a studio just in the shadow of the terraces and towers of the Ganlu Temple under the western slope of Beigushan (map 2). According to a famous anecdote recounted by a contemporary witness, Mi Fu acquired the land in a trade with a cultured collector who received not cash but an inkstone in the form of a mountain with thirty-six peaks that had formerly been owned by Li Yu (937–78), ruler of the Southern Tang kingdom of the Five Dynasties period.[1] On a dedicatory plaque Mi Fu wrote the characters *tian kai haiyue,* "Heaven unfolds oceans and mountains," and named his study Haiyuean, the Studio of Oceans and Mountains, in honor of this view. A painting by Mi Fu's son, Mi Youren (1074–1151), preserves an idea of the old family studio, as well as the view that it overlooked after it was rebuilt on a hill east of the city (fig. 1).[2] Visitors who enter Beigushan through a recently built park entrance at the southwest foot of the hill and pass by the so-called Sword-testing Rock of third-

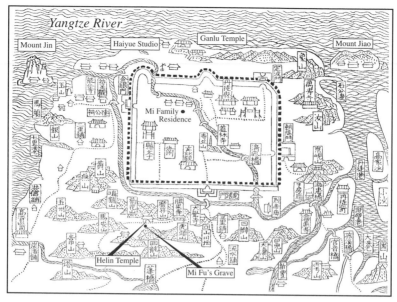

Map 2. *Runzhou (Zhenjiang, Jiangsu Province), adapted from a map in* Dantu xianzhi *(1521).*

century fame before continuing up to the temple unknowingly pass near the old site of Mi Fu's studio. The grounds of a boat factory now encompass where it stood. According to Lu Jiugao, retired director of the Zhenjiang Museum, a three-room hall commemorated Mi Fu's old studio on this site until 1960, when it fell victim to China's modernization.

More intrepid visitors to Zhenjiang with a particular interest in Mi Fu might wander south across the railroad tracks, just past the fertilizer, cement, and porcelain factories, to the beginning of the city's rural suburbs and the old site of the Helin (Crane Forest) Temple, next to the hill called Huangheshan (Yellow Crane Mountain). I made this trek on my first visit to Zhenjiang in 1984, following my map of the city here in search of what was marked as Mi Fu's grave. Unfortunately, Zhenjiang's cartographers had failed to account for the needs of local farmers, who in recent years had dismantled the gateway that marked Mi Fu's grave and had used its stones to repair homes and bridges. Since then Mi Fu's grave has been reconstructed on the northwest slope of Huangheshan, the gateway rebuilt with three of the recovered pillars and graced with the calligraphy of the contemporary scholar Qi Gong. It matters little that a dwelling hides the true gravesite a hundred or so yards away; pilgrims now have a place to pay their respects.

In premodern China such respects were paid with a reverence and participa-

tory spirit quite distant from contemporary habits. Laudable as the city of Zhenjiang's efforts are in reconstructing Mi Fu's grave, a mere perusal of local gazetteers of recent centuries points up how much memorabilia once existed on these sites and how much has been lost. At the Helin Temple, now barely recognizable with families living within, were eulogistic descriptions of Mi Fu alluding to his frequent visits and Chan Buddhist studies. Mi Fu's original grave inscription was here, written by his friend Cai Zhao, as was a small self-portrait of Mi Fu engraved in stone with an inscription by Mi Fu's son, Mi Youren, not to mention fragments of Mi Fu's writings, similarly transferred to stone. In addition to Mi Fu's grave were those of his parents and a residence purportedly built by Mi Fu. Someone later erected a small shrine to honor Mi Fu's "temple-protecting spirit," nourished, one suspects, more by temple anecdotes and legends than by food offerings.[3]

At Beigushan there had been much more. Beginning in the thirteenth century with Yue Ke (b. 1183), one of Mi Fu's greatest admirers, the grounds of Mi Fu's old studio were repaired numerous times, old buildings rebuilt, new ones established, and records written commemorating each act. Yue Ke founded the Inkstone Garden and made his residence here as he gathered Mi Fu's scattered calligraphy and substantially added to the task of reconstructing Mi Fu's lost collected writings.[4] Important regional officials rebuilt Mi Fu's studio during the Xuande (1426–35) and Wanli (1573–1615) reigns of the Ming dynasty. A library was established on the site in 1763. And of course there were numerous engraved stones and wood plaques presenting the calligraphy of Mi Fu and those who came to pay their respects. Even the Qing dynasty emperor Kangxi (r. 1662–1722), traveling through China during one of his inspection tours, acknowledged Mi Fu's memory with a sample of his imperial hand: "The left-over traces of Bao-Jin [Mi Fu]."[5]

Outside Zhenjiang there was more. In Xiangyang, Hubei Province, a shrine for Mi Fu is established on the old family property.[6] Visitors to the provinces of Guangzhou, Guangxi, and Hunan made note of Mi Fu's former journeys to these places as a young official, often leaving words and appreciations next to Mi Fu's own.[7] Memories of Mi Fu lingered in Lianshui, in northern Jiangsu Province, where in 1725 his Washing Ink Pond was commemorated by a district magistrate some 625 years after Mi Fu lived there under circumstances he probably would have preferred uncommemorated.[8] According to a contemporary map of China, a shrine for Mi Fu still exists in Wuwei, Anhui Province, where Mi Fu served toward the end of his life and, according to an oft-repeated story, addressed a strangely shaped rock as elder brother.[9]

Those familiar with China and the mindful eye with which it regards its past may not be surprised by the degree to which Mi Fu's memory has been pre-

served, but it should provoke wonder about what Mi Fu did to deserve such a lasting name. The locus classicus for the standards that confer immortality in China is found in the *Zuo zhuan* commentary to *The Spring and Autumn Annals*, where the question is asked what the ancients meant by the saying, "They died but suffered no decay." Shusun Bao, courtier of Lu, responds with a description of the *san buxiu*, or "three non-decays": the establishment of virtue (*de*), successful service (*gong*), and wise speech (*yan*). "When these examples are not forgotten with length of time, this is what is meant by the saying—'They do not decay.'"[10] Precisely how one establishes an example of virtue is left unclear, but this, in any case, is not for what Mi Fu is remembered. Nor is his memory cherished for great acts in his service to the state, nor for wise, edifying words. Rather, if de virtue and its concrete expression in successful service and wise words are considered representative of an individual's worth, then what has preserved Mi Fu's name for a thousand years and more is the outer style to virtue's inner content. Mi Fu's fame is entirely reliant on his abilities in calligraphy, painting, and the connoisseurship of these arts—secondary pursuits at best in traditional China and endeavors never supposed to provide a vehicle to immortality.

Mi Fu's story is interesting in part because he actively pursued an immortal name, but what makes it especially interesting is his eventual awareness that this goal might be attained not by the historically sanctioned *san buxiu* but by this disreputable path of skill in art. Not one to hide from a contradiction, Mi Fu boldly taunted conventional wisdom with a troubling revelation in the preface to *Hua shi* (*A History of Painting*). The subject at hand is a painting of two cranes by the Tang courtier Xue Ji (649–713) and a verse written by the famous poet Du Fu (712–70):

> In a poem concerning Xue the junior preceptor, Du Fu writes,
> What a pity! Merit and fame pass on by,
> While one sees calligraphy and painting transmitted to the future.

> Fu, that old Confucian, was anxious with regard to merit and fame. Could it be he was unaware of this thing called fate? I suppose this was just his longing amid the lonely desolation of his life. Alas! The achievements of the Five Kings soon become subjects for the smiles of young women. But the junior preceptor's brush was refined and his ink subtle. Copies and rubbings of his work further its wide dissemination. If the stone cracks, it can be recut. If the silk splits, it can be repaired. And if one speaks of his actions in life, how many can be enumerated? This being so, men of talent and discerning scholars consider precious ornaments, auspicious brocades, and the tens of richly woven garments as important treasures. Looking back at the splendor of the Five Kings,

it's all so much chaff and dust. How can they be worth discussing?!
Even a child knows perfectly well that their achievements are still far
from those of the junior preceptor.[11]

Mi Fu's irony in this passage was largely lost on the Qing dynasty editors of
the imperial library, who remarked that elevating Xue Ji's painting over the
achievements of the Five Kings of the Tang dynasty was sheer lunacy and an
example confirming Mi Fu's reputation for being mad. "Though [this comment]
exists, one need not discuss it," they write.[12] But it deserves discussion, for al-
though Mi Fu's statement is certainly a prime demonstration of eccentricity, to
dismiss it as such is to overlook an issue both pressing for this talented artist and
fundamental to much of Chinese art.

That issue concerns style and the early recognition in China of its value as
the conveyor of those qualities that constitute a subject's content or center. Sub-
ject, here, is spoken of less in the sense of what is depicted in a painting or poem
than in the sense of the human agent that produces it. One knows this subject
from the manner in which it is given presence. Thus, ancient philosophers wrote,
one determines the moral tenor of a king's court from the sounds of its music.
One evaluates a person's quality by the poetry he or she writes, by the calligra-
phy he or she inscribes. The Qing imperial editors are offended by Mi Fu's out-
rageous declaration that something as grossly material and superficially pleasing
as a painting of cranes may have more value than the high-minded achievements
of Tang dynasty noblemen, yet Mi Fu is simply pursuing a conclusion founded
on this premise that the traces of one's art can convey the essential qualities of an
individual, and occasionally with greater longevity than successful public ser-
vice. Never mind the Tang dynasty poet Du Fu. Anxious in his *own* life with
regard to merit and fame, and aware that his only hope for achieving a piece of
immortality might well be his skill in art, Mi Fu clings to the notion that virtue
can be known through style. In the preface to his *History of Painting* Mi Fu car-
ries this to an absurd extreme, pronouncing the unpronounceable: art was the
fourth non-decay.

This is a book about style. More accurately, it is about aspects of art and ex-
pression in China whose descriptive terms are commonly translated into English
as style. The distinction is important because the notion of style in traditional
China differs significantly enough from what one finds in the West as to alter the
role and responsibility of what Leonard Meyer calls the style-analyst.[13] It is use-
ful to begin with some of these points of differentiation in order to establish the
parameters of discussion, and the first point of note is that what we are differen-
tiating from remains remarkably amorphous. Ever since Meyer Schapiro's im-
portant article on style appeared in 1953, art historians, literary critics, linguists,

and musicologists alike have been aware of the multitude of uses of style in the English language, decried its imprecision, and in some cases worked toward a reductive definition. Yet style seems to take its cue from Heisenberg's uncertainty principle and the frustration it postulates for empirical observation. As Berel Lang remarks, "The more closely we approach the center of distinctively human phenomena—the organ of vision or understanding itself—the less clearly we can resolve the elements of that center as objects."[14]

In "Style as Instrument, Style as Person," Lang posits two different models for style, one described gramatically as "adverbial," the other as "verbial" or "transitive." The adverbial model of style presumes separation between some *thing* and its mode of expression (exemplified by the familiar phrase "Subject is what is said, style is how"). Accorded independent status, style can be likened to an instrument, thus matching the word's etymological origins in the Latin *stilus* (stylus)—the tool that gives form to writing. Style-as-instrument is modal and classifiable. As such, it provides a means for "handling" works of art and indeed is so used in the general practice of art history, where styles are employed to clarify authorship, dating, relationships, and influences. Styles describe the topography of art in spatial, temporal, even social terms. But style, as Lang observes, is ultimately a product of human minds and hands. He argues for the concept of style as "a mode of personification and an end in itself."[15] This is his transitive model, so labeled for its assertion of *no* separation between the "what" and the "how." Instead, there is a "transitivity of manner," an articulation of the work as process in which there exists a reciprocal causality between form and content. Style does not play the outside to content's center; rather, it is part of an organic process whose ultimate source is the human agent. Lang writes: "In discriminating the features of style, what the viewer does corresponds to the process of recognizing persons, and thus the particular style, what he discerns, is both a person and the field of agency or vision of that person which acts on the viewer as he discerns the style."[16]

I single out Berel Lang's argument because the idea of style as person largely matches the concept of style in traditional China. This becomes apparent in a review of the Chinese vocabulary for style, some of which would have fit neatly in the section of Lang's article that is titled "The Physiognomy of Style." The most common terms are two-character compounds centered on the graph *feng*, or "wind," such as *fengge* (category of wind), *fengdu* (measure of wind), and *fengdiao* (tone of wind). The function of wind in this context, however, can be clarified only through its original pairing with *gu*, "bone." An oft-cited passage from Liu Xie's (early sixth-century) *Wenxin diaolong* (*The Literary Mind and the Carving of Dragons*) describes feng as the source of transformation: the affec-

tive, suasive airs that instruct and inform all who encounter them. Generating feng's potent currents is the stable structure of gu, bone, upon which words depend for order and unity.[17] Strictly speaking, Liu Xie's bone in this context is a figurative reference to qualities of writing rather than of person, but the natural extension back to the anatomy of the writer is implied by feng's power to convey one person's thoughts and emotions to another.

For Chinese calligraphy, body metaphors abound, as John Hay has well demonstrated in an important essay.[18] "Flesh," "bone," "sinew," "blood," and "veins" are all part of the critical vocabulary evaluating the health of one's writing. Again, the immediate context is the physical representation of the written characters, but it was one shy step to see in the deportment of one's calligraphy the emotional, psychological, even corporal traits of the person behind the brush. It is thus not surprising that in certain contexts related to calligraphy, the Chinese term for body, *ti*, is also translated as "style." Such terms as "Yan ti" and "Liu ti" (the styles of the Tang dynasty calligraphers Yan Zhenqing and Liu Gongquan) are usually applied to someone's later use of these canonical models and can be considered a reflection of the powerful winds that emanated from these two writers.

Style reduced to the narrow sphere of an artist's inclinations becomes inextricable from the concept of expression, and one might argue that this sense of an individual's inner quality is better served by such terms as *tone* or *voice*. These terms also convey something of the amorphous nature of expression, the difficulty of describing, let alone analyzing and measuring, style at this most personal level. But it is precisely here where the Chinese model of style establishes a different set of ground rules for the art historian. A priori recognition of feng's suasive power and its ties to the somatic structure of its source encourages an artist's self-consciousness of style. Chinese critical writings on the arts make it clear that this was far from a welcome consequence. The ideal model was one of unadulterated expression, with the responsibility of communication falling squarely on the shoulders of the audience, *zhiyinzhe*, "one who understands the sounds" (a reference to the ideal listener of one's expressive music).[19] For most, however, knowing (or hoping) that there would be someone out there with ears inclined could not but affect the way their sounds are produced. Plainly put, recognizing that others would look at one's poem or calligraphy as an extension of the person encourages the writer to manipulate its appearance, to design style, and what is consciously designed is an important step removed from the uncertainty associated with that vague center Berel Lang refers to as the organ of vision or understanding itself.

An artist's consciousness of style removes it from the realm of intangibles.

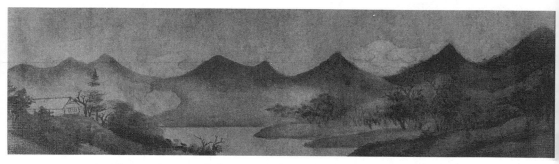

1a. Mi Youren (1074–1151), "Rare Views of Xiao-Xiang." Datable to ca. 1137, Southern Song period. Handscroll, ink on paper, 19.8 × 289.5 cm. The Palace Museum, Beijing. Second section, from the right. See the following page for the beginning of this scroll. From Zhongguo lidai huihua, 3:2–3.

Style becomes the product of human intentions and as such can be described, mapped, and analyzed as clearly as any other conscious decision. By recognizing the status of style as a reflection of that center the Chinese call *de* (virtue) and manipulating it, ironically, the artist moves style back from the inside out. This has clear methodological implications for the art historian, who is left to uncover the intentions of style: a process less of interpretation than of historical analysis. But it should be made clear that these implications do not apply equally to all forms of art and all artists at all times in China. In general, it was the scholar-official class, the educated elite commonly known as the literati, that was most self-conscious with regard to personal style. Occupying one of the highest rungs of society, the literati were constantly judging and being judged in matters of morality, policy, administration, and, down the line, art. All were seen as manifestations of the individual's inner quality or virtue. For those who paid particular attention to the last of this list, whether it be for poetry, calligraphy, or painting, style became an important element of performance aimed at convincing others of intrinsic worth.

Few paid as much attention to matters of art than Mi Fu, and it is doubtful than any were as self-conscious. His inclination to use art as a showcase of personal virtue was passed on to his son Mi Youren, whose painting of the Studio of Oceans and Mountains illustrates (fig. 1). The title of the painting, "Rare Views of Xiao-Xiang," is misleading because in Mi Youren's usage Xiao-Xiang stands not for the literal landscape crossed by the two rivers of these names, seven hundred miles south of Runzhou in Hunan Province, but generically for surpassing scenery of rivers and mist. Similarly, although Mi Youren's long accompanying

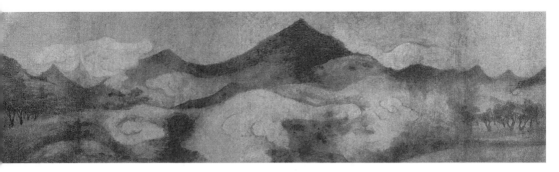

inscription clarifies the subject as the family studio at Runzhou, it would be inadvisable to assume the image to be a literal depiction. Mi Youren painted it for a colleague named Zhongmou while in Nanjing, forty miles away, and at a time (1137) when little remained in Runzhou worth describing (the city had been reduced to rubble in heavy fighting between the Song and Jurchen armies some seven years earlier). The painting, rather, is symbolic. Zhongmou, and any other twelfth-century viewer, would have immediately associated the famous Studio of Oceans and Mountains with its celebrated owner, Mi Fu. (It was common practice in China to identify closely with one's studio—hence one of Mi Fu's sobriquets: Mi Haiyue.) Mi Youren makes certain of the identification by beginning his inscription with a celebratory poem written for Mi Fu and his studio by a well-known scholar of the day. The painting memorializes Mi Fu's legacy, and in this regard Mi Youren was not unlike the many others who later helped to preserve Mi Fu's memory.

But Mi Youren's painting is much more than a documentary record of the family studio. In fact, the focus of the painting is not the studio itself but the long stretch of landscape that leads to it. Unfurling the scroll from right to left the viewer first passes through an extended progression of strange curling clouds before arriving at the hills that surround the studio placed at the very end of the painting. Mi Youren writes, "Now this scroll depicts the view of mountains from the studio. In general, the rare aspects of the mountains' and clouds' ten thousand layers of transformations are in the clearing and obscuring amid early dawn rains. But few people of the world know this. In my lifetime I have become familiar with the rare views of Xiao-Xiang, and every time I climb a mountain or

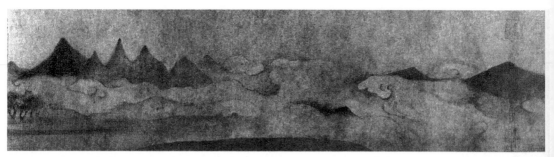

1b. "Rare Views of Xiao-Xiang." First section, from the right.

face the waters of excellent scenery I immediately sketch out its true flavor. . . .
How could this be something intended merely to please others?"

Mi Youren proudly faces the well-known challenge posed a generation ear-
lier by Su Shi (1037–1101) for "superior men of outstanding talent" to paint sub-
jects of "inconstant form but constant principle," such as clouds and mist, which
are ever-changing but always in accordance with their basic nature or principle.[20]
He does so by taking advantage of the temporal quality inherent in the handscroll
format by which one travels laterally through time and space. There is a twist,
however, to Mi Youren's approach. As the journey commences (moving from
right to left) there is only the confusion of strange floating clouds, to which no
logic or principle is readily apparent. The reason is that the clouds are moving in
a contrary direction, from left to right. This becomes clear only after one en-
counters, at the end of the scroll, Mi Fu's studio and Mi Youren's inscription,
which clearly states that the view should be seen from this vantage. Our initial
confusion is to be expected ("few people of the world know this"). In fact, it is
purposely manipulated by Mi Youren to establish the singularity of the view. If
he had placed the studio at the beginning of the scroll, the view, in a sense, would
be public, readily shared by anyone who opens the painting. By placing the fam-
ily studio at the end of the scroll Mi Youren differentiates our view from his (and
his father's) and lets us know that we must ultimately reverse course to glimpse
the landscape's "rare views." The true subject of Mi Youren's painting is neither
the studio nor the landscape but a view, a private view, a personal act of seeing,
or, as Berel Lang writes, vision and the presence of a person.

The "center" to which Lang alludes, "the organ of vision or understanding
itself," whose elements are so difficult to resolve the more closely we approach,
is well symbolized by the clouds of Mi Youren's painting. Their presentation is
intended to suggest the mysteries of nature and, through the agent of Mi Youren's
inherited vision, a sense of family virtue, but not in so detailed a manner as to

remove that essential quality of the unknown. The logic in the clouds' left-to-right movement as they languidly uncoil and emerge from a hill slope is no more than is necessary to convey the sense that principle is present. Mi Youren preserves their mystery, just as he intends to preserve the exclusiveness of the family vision he inherits from his father. Virtue, ultimately, remains undefined; its depth and profundity can only be suggested.

Mi Youren's painting is highly unusual. The issue of personal virtue is often alluded to, but rarely in Chinese art, even among the literati, is it so directly confronted as to become the very subject of a painting. As the following chapters will detail, however, Mi Youren was simply perpetuating a particular family tradition. Mi Fu's medium of choice was not painting but calligraphy, and he honed his skill in the art of writing to a point of subtle, expressive nuance rarely if ever matched in the history of China. Calligraphy had long been accorded such expressive capabilities. From its beginnings as the vehicle for oracles in the Shang dynasty to its development as a high art a thousand years later, calligraphy was considered to be revelational. It is a direct line from that point where the ink-charged brush meets the paper through the fingers, hand, and wrist to the eye and brain. As anyone who has tried their hand at wielding the calligrapher's tool would know, whatever skill or ineptitude exists is readily apparent in the graphic record left by the deceptively simple brush. The sensitivity of the brush is such that a well-schooled viewer feels as if the calligraphy offers an immediate image of the writer. "Writing is a picture of the heart," goes a saying often quoted in the Song dynasty.[21]

Berel Lang's argument for the transitive model of style, articulating the work as process, is particularly well-suited to Chinese calligraphy. Calligraphy is unidirectional and hence linear in temporal as well as in graphic form; there can be no going back, no doctoring of the brush's initial movements. The traces of ink left on the paper or silk leave a clear record of the process of writing. Traditional

critics demonstrate how this aspect of calligraphy was valued by emphasizing naturalness (*ziran*, literally "self-so-ness"), the absence of mediating thoughts that may put a kink or two in that line from inner center to written surface. However, a gap exists between theory and practice that is important to recognize. Although the nature of calligraphy promotes the notion of automatism, to regard calligraphy as a purely natural art denies its potential role as the displayer of human intentions. Self-consciousness of style commonly results in the formation of twists in the line and, ironically, perhaps never more so than with the calligrapher who is most self-conscious about naturalness. Mi Fu exemplifies the contradiction. The conflicting interplay between this ideal and the persistent thought he invested in his writing forms a central theme of this book.

For the self-conscious artist intent on forging a personal style, the goal was to generate a wind of lasting force, and as reflected by the shrines and encomia that still pepper the Chinese landscape with his memory, not to mention the many later calligraphers who imitated his style, in this Mi Fu was immensely successful. A last Chinese term for style summarizes the issues outlined in this introduction—actually a phrase: *zicheng yijia*, literally "to become (found) a school on one's own," but in common practice, "to establish one's own style."[22] The key character here is *jia*, which in its original context referred to a school of thought or philosophy. However, as the humble etymological origins of the graph for *jia* suggest (a pig under a roof), the character has more familiar connotations. *Jia* also means home, residence, family, and its pertinence in the context of the Mi family is well demonstrated, literally, by Mi Youren's painting of the Studio of Oceans and Mountains. The transmission of a school of teaching, or a style, was largely conceived according to the ancient model of the perpetuation of a clan and clan rules. *Zicheng yijia* is an expression that encapsulates the originality of a personal style and its permanence, the extension of one's anatomical architecture to the structure of home, family, and later admirers. This book maps the passage of one such style in its first generation. An epilogue suggests some reasons why, metaphorically speaking, Mi Fu's Studio of Oceans and Mountains has proved to be one of the most enduring edifices in the history of Chinese art.

Notes on Calligraphy

The popularity of calligraphy in East Asia is directly related to the relative ease with which it can be appreciated. The sole requirement is an ability to read and write Chinese characters. Unfortunately, this is beyond the means of most people outside China, Japan, and Korea, and for this reason a brief introduction to some of the rules and characteristics governing the Chinese art of writing may assist the uninitiated reader. Precisely because of the accessibility of calligraphy in

traditional China, a vast corpus of terms and instructions has developed over time. The following notes are restricted to the most simplified explanations of the most basic vocabulary.[23]

In the fully evolved standard form of writing, Chinese characters, or graphs, are essentially of fixed form, composed of an established number of brushstrokes. There is a predetermined order to the writing of the individual strokes in a given character and a predetermined direction for the writing of each stroke. These rules are integral to calligraphy's expressive dimension, for they allow the later viewer to retrace visually the process of writing. Stroke by stroke, character by character, column by column (from right to left), one "reviews" the original performance of writing. The more informed the viewer, the more familiar with how the brush is handled through his or her own experience with writing, the more vivid the sensation of the brush's original movements and pacing. As an art, calligraphy is uniquely participable.

SCRIPTS

The early history of Chinese writing is characterized by the evolution of a number of scripts, of which five basic forms predominated and continued to be practiced through the later centuries. Although Mi Fu's calligraphy is almost entirely composed of a single script—the semicursive *xing shu*—the others play important roles in his understanding of calligraphy as a theorist, historian, and even practitioner. They are introduced here not in the customary order of chronological evolution but in accordance with their prominence in the Song dynasty.

> *Kai shu*—The "standard" or "regular" script, the last of the major scripts to evolve into mature form but, once established, the most commonly employed for any kind of official or public function, including printing. Characters are squarely composed, and individual strokes are clear and crisp. Also called *zhen* or *zheng*, this is the script with which one begins to learn how to write (see fig. 4 for an example).

> *Xing shu*—The "semicursive" or (literally) "running" script, an informal, more quickly paced form of writing in which standard script characters are slightly simplified and brushstrokes within a single character are often linked. More a mode than a distinctive script, semicursive writing is the most casual form of Chinese calligraphy and that most favored in the Song dynasty for its expressive potential (see fig. 5).

> *Cao shu*—The "cursive" or (literally) "draft" script (often mistranslated as "grass" writing), the most quickly paced, abbreviated mode of

calligraphy. Cursive calligraphy began as a rough, expedient form of writing but later was often used as an overtly artistic performance medium. Cao shu subdivides into three basic forms that evolved in progression: *zhangcao* (draft cursive), *jincao* (modern cursive or, simply, cursive), and *kuangcao* (wild cursive). Draft cursive, the earliest, retains elements of the clerical script (see *li shu*, below) and is characterized by flared endings to certain strokes and few if any links between characters. Modern cursive emphasizes fluidity and speed, with more abbreviations and linkages. So labeled in recognition of its distinction from the earlier form of cursive writing, the emergence of jin cao in the latter half of the Han dynasty coincided with a heightened appreciation of the aesthetic and expressive potential of calligraphy (see fig. 49). Wild cursive, as the name implies, is a particularly uninhibited, exhibitionistic form of cursive writing. Its roots are ascribed to some of the more energetic early practitioners of jin cao, though it does not really emerge as a distinct mode of writing until the middle of the eighth century (see fig. 50). Cursive calligraphy is certainly the least constrained of all the scripts. Nevertheless, even in wild cursive the movements of the brush and the abbreviation of characters remain largely governed by rules and conventions.

Zhuan shu—"Seal script," a general rubric for the types of writing used in the Shang and Zhou dynasties and seen today in the inscriptions cast in ancient ritual bronze vessels. For later generations, zhuan shu was commonly employed as an ornamental script for the titles of stone stelae (*bei*) and for seals. Also known in the past as *zhou shu*, early seal script writing is characterized by a strong pictorial element, characters of variable size and complexity, and strokes of even modulation. In its later historical development, known as *xiao zhuan* (lesser seal script), the characters become more uniform in size and orderly in appearance.

Li shu—"Clerical script," the immediate predecessor to *kai shu* that evolved in stages during the Qin and Han dynasties out of the lesser seal script in a movement toward simplification of the Chinese writing system. The late form of the clerical script, also known as *bafen*, is characterized by flexed and modulated strokes, including a broadly flaring type called the "breaking wave," that reflect a growing interest in the expressive potential of the brush in the latter half of the Han dynasty. Like seal script, clerical script calligraphy was used largely as a decorative form of writing in later periods.

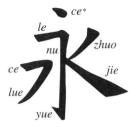

2. *The character* yong *(eternal).*

STROKES

In standard script the number of individual strokes that compose a Chinese character can range from one to more than forty, and in calligraphy the types of brushstrokes can number into the dozens depending on the degree of nuance differentiated in the movements of the brush. As distinct and basic formal units, however, the brushstrokes of Chinese calligraphy are much more limited. One text datable to the seventh century counts seven basic strokes, but the most common formulation numbers eight, which happily correspond to the component elements of the auspicious character *yong,* "eternal" (fig. 2). Unfortunately, in common parlance a different set of terms is used to describe some of the basic strokes. These include the following:

heng—the horizontal stroke, written from left to right (the *le* stroke of fig. 2);

shu—the perpendicular stroke, written from top to bottom (*nu*);

pie—the downward sweeping stroke, from right to left (*lue*);

na—the downward sweeping stroke, from left to right (*jie*); and

dian—the dot (*ce**).

There are other basic strokes, not to mention variations of each one (one author, for example, describes twenty-one dian dots alone, which he calls "only the most common"), but for the simple goal of facilitating the description of individual characters in the following chapters these five should suffice. Other important terms related to the practice of calligraphy are *feibai* (flying white) and *cangfeng* and *loufeng* (hidden and exposed brushtips). *Feibai* is the effect produced by an unsaturated or quickly moving brush whose stroke reveals the white

of the paper or silk underneath. Hidden and exposed brushtips refer to two basic approaches to handling the brush: with the tip centered in the stroke (hence hidden) or with the tip slightly aslant or "exposed" and thus allowed to demarcate a stroke's contour (especially beginnings and endings).

AESTHETIC CRITERIA

The appreciation of calligraphy has many aspects, from the discrimination of a writer's particular skill at handling the brush to the intangible pleasure that stems from the sense of an individual's presence or personality. At the fundamental level, however, a calligrapher's success depends on an ability to engender a sense of life and energy in the writing. This begins with the individual brushstroke, the expressive character of which can vary tremendously. One basic principle that should be noted is whereas the hidden brushtip technique conveys a sense of quiet strength when skillfully employed, the exposed tip releases energy. At the next level brushstrokes interact to create perceptions of continuity, discontinuity, movement, stasis, balance, confrontation . . . perceptions that continue and expand at the level of characters and even columns. An important term that broadly defines these various levels of movement and energy is *shi,* which can be roughly translated as "configural force" or "momentum."

Shi is the manifestation of both potential and kinetic energy. The dian dot, for example, is described in one text as "like a stone falling from a high peak, bouncing and crashing, about to shatter."[24] Such metaphors abound in the early literature, likening the dynamics apparent in calligraphy to everything from bears battling on a mountain cliff to billowing summer clouds. The same sense of dynamic energy underlies the comparison of calligraphy to a living organism, replete with skeletal frame, blood, sinew, and flesh. One eleventh-century calligrapher even apportions body parts to individual strokes: dian dots are eyes, the horizontal heng is the shoulders, the vertical shu is the body's frame, the pie and na strokes are arms and legs.[25] It was a relatively short step to read from these physiological characteristics moods, emotions, and personality traits. Mi Fu and other late Northern Song calligraphers were particularly adept at coining clever metaphorical descriptions to characterize both earlier calligraphers and contemporaries. This becomes an enjoyable and potentially wicked game.

REPLICATION

As a fine art in China, calligraphy was and remains eminently collectible, and like all collectibles in China, calligraphy was forged. Calligraphy, however, was also a practical skill, a fact that led to a more honorable tradition of replication. Texts for public proclamation commissioned by the government, temples, and citizens alike were often written by famous calligraphers, usually in the kai standard script,

and then carefully transferred by engraving to large memorial stones called *bei*. Rubbings made from these stelae provided an inexpensive means of disseminating both the content of the text and the calligrapher's art, albeit in negative and somewhat removed from the original owing to the difficulties of reproducing brushwork with a chisel (see fig. 4). If valuable enough, other forms of calligraphy not originally intended for stelae, such as personal letters, poems, and notes, often referred to as *tie* and customarily written in the more casual xing and cao scripts, were also carved in stone. Sets of these occasional writings, sometimes gathered with more formal writings, were called *fatie*, or "compendia of model writings" (see fig. 45). They could be commissioned by both the court and wealthy individuals with (or with access to) important collections of calligraphy. Fatie provided the most important means for transmitting the art of earlier calligraphers, though it was a process limited by both the shortcomings of the technology and, occasionally, injudicious editing.

Early calligraphy was also copied by hand, a process that ranged from the laborious but highly accurate *shuanggou* (double-outline) technique (see fig. 3), in which outlines of strokes were carefully traced before the interiors were filled, to *lin*, a freehand copy. Because the process of learning calligraphy entailed ceaseless freehand copying, the border between honest copying and the making of forgeries was easily blurred. This blurring of boundaries is a curious theme in the story of Mi Fu's calligraphy and a source of great fascination to succeeding generations.

"Ideas" and Northern Song Calligraphy

Looking back on the rich legacy of calligraphy that preceded him, the Ming dynasty theorist Dong Qichang (1555–1636) recognized three epochs fundamental to the formation of the canon and succinctly characterized each one: Jin calligraphy is governed by *yun* (resonance), Tang calligraphy by *fa* (methods), and Song calligraphy by *yi* (ideas).[1] The fact that this pithy formulation has been endlessly repeated to the present day suggests that what Dong Qichang meant is self-evident from extant calligraphy, the complexity and ambiguity of these three aesthetic terms notwithstanding.

"Jin calligraphy" itself is an amorphous label. In its broadest application it may refer to the writing of the Three Kingdoms period (220-80), Jin dynasty (265–420), and successive southern dynasties (Liu) Song (420–79), Qi (479–502), Liang (502–57), and Chen (557–89) that followed the great empire of Han (206 B.C.–A.D. 220). In practice, however, it refers almost exclusively to the tradition exemplified by Wang Xizhi (307?–65?) and his son Wang Xianzhi (344–88), known as the Two Wangs, that developed in the lush landscape of the Yangtze River basin during the latter half of the Jin (317–420). Wang Xizhi's calligraphy in particular was considered representative of the artistically graceful writing adopted for casual notes and letters by the aristocrats of his day. Three centuries later the early Tang dynasty emperor Taizong (r. 626–49) labeled Wang Xizhi peerless, collected his calligraphy, and promoted its style at the court. When Dong Qichang speaks of Jin calligraphy, he refers to the remnants of this once powerful tradition that trickled down through the later dynasties.

A detail of a Tang dynasty tracing copy of one such casual Wang Xizhi note, seen and appreciated by Dong Qichang, may help illustrate *yun* (fig. 3). The calligrapher's brush moved smoothly to create strokes of graceful, even pliancy, with the brushtip mostly centered. The harmony and ease that radiates from each character is achieved through a subtle balancing of forms and forces, with generous spaces created between the traces

3. Wang Xizhi (307?–65?), "Xingrang tie." Tracing copy of the Tang dynasty. Letter mounted as a handscroll, ink on yinghuang paper, 24.4 × 8.9 cm. The Art Museum, Princeton University. Anonymous loan. Photo by Bruce M. White.

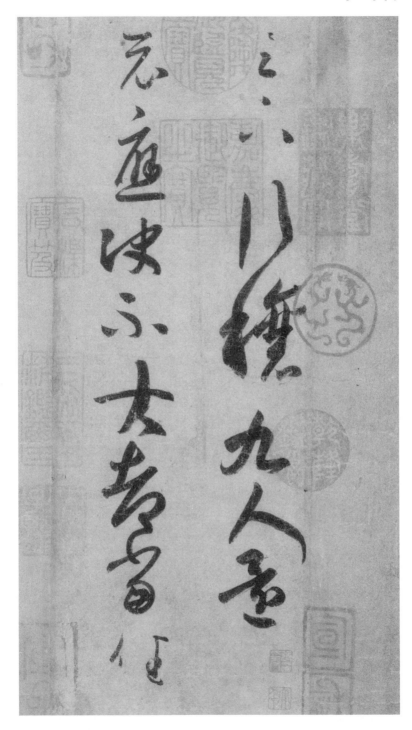

陳大道無名上德不

德玄功潛運幾深莫

測鑿井而飲耕田而

食靡謝天功安知帝

of ink. Yun is the quiet, self-contained energy that seemingly resonates about the writing like an electrical field. It suggests forces basic to the natural world, and it calls to mind, for those familiar with the period, the spirit of élan (*fengliu*) and naturalness embodied by the men of Jin.

Fa methods, in contrast, suggest regimen and discipline imposed from above by a higher authority—moral, political, or otherwise. In its association with Tang one thinks in particular of the beginning of the dynasty, the formation of the great structure that would rule China for three hundred years, and the codification of apparati that would assure its longevity. Tang Taizong's elevation of Wang Xizhi's writing to the status of canonical model and promotion of its practice at the court, thus creating a unified standard, is one such example. The methods of Tang are exemplified by the writing of Ouyang Xun (557–641), one of Taizong's high ministers and, according to traditional commentators, a careful student of the Wang Xizhi tradition (fig. 4; see fig. 23).[2] Each stroke of his standard script writing is a model of precision, and each character a model of calculation. The spontaneity of Jin transforms into an image of wrought perfection. Ouyang Xun's calligraphy, whether in the kai or xing script, bespeaks the elegance of court: grace tempered by control and propriety.

And what of Song yi? *Yi* means intent, will, reason, the cognitive processes that distinguish the individual along with his or her personal idiosyncrasies. It is not that qualities of individuality are absent in earlier calligraphy, just as fa methods (Dong Qichang writes elsewhere) are certainly not limited to the Tang, but never are "ideas" more strongly sensed and the individual more directly celebrated than in the writing of the Song calligraphers active in the second half of the eleventh century. A brief glance at one of the most famous of all Song dynasty writings, Su Shi's "Cold Food Festival Poems Written at Huangzhou" of circa 1082 (figs. 5, 6), reveals that "ideas" manifest themselves largely at the expense of the elegance and perfection represented by Wang Xizhi's and Ouyang Xun's calligraphy. The characters are mostly squat, their strokes occasionally compressed into inchoate pools of ink. Song dynasty calligraphy represents a revolutionary departure from the tradition that preceded it. Long accepted standards of beauty and practice are suddenly replaced by something much more personal and human.

When Dong Qichang wrote of "Song ideas," foremost in his mind were the famous calligraphers of the late Northern Song: Su Shi (1037–1101), Huang Tingjian (1045–1105), and Mi Fu (1052–1107/8). But these three simply provide

4. Ouyang Xun (557–641), "Inscription on the Sweet Spring at Jiucheng Palace." Dated 632, Tang dynasty. Detail of a Song dynasty rubbing. From Tō Oyō Jun, Kyūseikyū Reisen mei, 33.

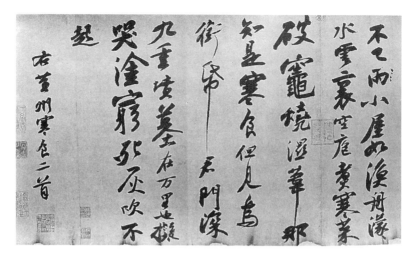

5. Su Shi (1037–1101), "The Cold Food Festival Poems Written at Huangzhou." Ca. 1082, Northern Song period. Handscroll, from the right, ink on paper, 33.5 × 118 cm. Collection of the National Palace Museum, Taipei, Taiwan, Republic of China.

the most prominent reflections of the dynamic changes that were taking place in their time. We need to look at the factors that led to the development of this distinctive quality of Northern Song calligraphy and to raise some of the issues that actively engaged such masters as Su, Huang, and Mi. We will then be in a position to see how the ideas that governed Mi Fu's writing differed from those of his more conventional contemporaries.

The Received Tradition

Facing a painting by the eighth-century master Wu Daozi, Su Shi was moved to reflection: "Those who are knowledgeable create things," he wrote, "and those who are capable narrate." He continues with an extraordinary comment: from the time of great antiquity until the Tang dynasty, all was preparation for what would prove to be the culmination of human achievement. In poetry there was Du Fu (712–70), in the writing of prose, Han Yu (768–824). Mastery of the art of calligraphy was achieved by Yan Zhenqing (709–85), and that of painting by Wu Daozi. With these four masters, he writes, "all that could be done was done."[3]

Su Shi's world was separated by the last of these masters by more than two hundred years, and what had occurred in the intervening period helps to explain the unbridgeable gap Su Shi perceived between their dynasty and his. The central authority of Tang disintegrated over the course of the ninth century, re-

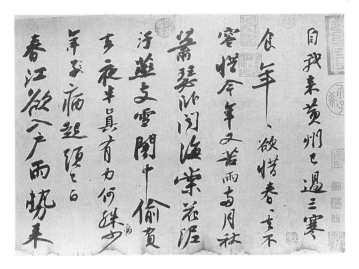

placed by regional powers vying through warfare for territory and power. After the dynasty collapsed in A.D. 907, there followed half a century of continued fighting, short-lived kingdoms, and general instability known as the Five Dynasties period (907–60). In its early years the Song dynasty resurrected many of the patterns and traditions that had served as a model for dynastic unity back in the early Tang, notably the sponsorship of vast compilations of earlier literature and knowledge. However, other changes had taken place that widened the rift and made true continuity impossible. The new and vastly important technology of printing disseminated knowledge more readily and encouraged the rise of a new elite from ranks other than the old aristocratic families and from regions other than the north. Success in the civil service exams was weighed more heavily in measuring qualifications for office. Su Shi himself exemplified the new man of culture, coming from a family of Sichuan townspeople that had achieved prominence only with the generation of his father, Su Xun (1009–66). Looking back, the achievements of Tang seemed to belong to an entirely different world, one in which Su Shi could partake only as a narrator of past glories.

Mirroring the disintegration of Tang order that led through the Five Dynasties period to Song, at least in the minds of eleventh-century critics, was a pitiful decline in the art of calligraphy. So often was this lament raised that it rings like gospel through the later centuries. And yet, a careful look reveals subtle modi-

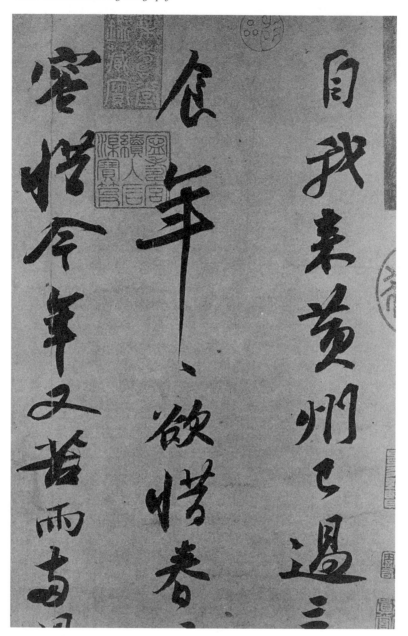

6. *Detail of "The Cold Food Festival Poems Written at Huangzhou."*

fications in this charge as it first took shape over the course of the eleventh century, modifications that are important indicators of the truly dynamic changes beginning to occur at midcentury.

The first consistent voice belongs to Ouyang Xiu (1007–72), Su Shi's mentor and a particularly interested and discerning critic of calligraphy.[4] The main theme of Ouyang's inscriptions is that the practice of calligraphy had faded along with the Tang and had yet to be revived. "The practice of calligraphy was never stronger than during the Tang, and never weaker than today," he laments in one inscription dated 1064.[5] As Ronald Egan points out, one likely factor in Ouyang's Xiu's perspective was the widespread belief that calligraphy was dutifully practiced during the Tang because it served as a criterion for judging examination candidates. Another factor was Tang's relative proximity to, and continuity of, the rich tradition of writing that stemmed from the fourth century, which in concrete terms meant the availability of superior models. Both practice and models were wiped out by the disasters of the previous century. This made the occasional encounter with a fine piece of writing from the Five Dynasties period or early Song an opportunity to speak of its uncommonness, as Ouyang Xiu did, for example, in 1063 for a text written by Guo Zhongshu (d. 977) in small-character kai script:

> People today only know of [Guo's] lesser seal script, unaware that his standard writing is especially fine. One never sees his *kai* characters engraved in stone. This is the only one and thus all the more to be cherished. With the wars of the Five Dynasties, schools and academies declined. This is what is called the time of the disintegration of the gentleman's *dao* [way]. Yet there were still those like Zhongshu. The [Song] dynasty has been established now for one hundred years, and the realm is at peace. Studies flourish once again. Only calligraphy remains in a state of decay, to the point where it is practically cut off from the past.[6]

Ouyang Xiu's attitude is practical and analytical. Calligraphy is a skill, one that needs to be taught, nurtured, and practiced. When schools decline, models disappear, and practice stops the results are predictably bad. Moreover, because calligraphy is a skill dependent on such concrete phenomena, excellence is something that can be readily determined. When Ouyang Xiu praises the calligraphy of even relatively unknown figures from the Tang dynasty essentially he is commenting on the higher standard of brushmanship that he believed existed in the earlier era. In his own day, Ouyang Xiu counts only "about three" who understand something about the art and chase after the traces of former writers.[7] There

is, however, another side to Ouyang Xiu's critique. Skill in calligraphy is a minimum requirement. Beyond competence there must be something personal that distinguishes one's writing, and that, in Ouyang Xiu's mind, was indelibly linked to the individual's moral worth.

> All men of the past were capable calligraphers, but only the writing of those who were sagacious would reach far. People today fail to realize this. They concentrate solely on their calligraphy, ignorant of the fact that countless were the skilled calligraphers of yesteryear whose writings nonetheless were lost and discarded. Even if Lord Yan [Zhenqing's] calligraphy were not fine, it would still be treasured by later generations. Yang Ningshi used frank words to remonstrate with his father; his integrity is apparent in adversity. Li Jianzhong was pure, scrupulous, gentle, and refined. Those who appreciate his calligraphy do so together with appreciation of his character.[8]

Elsewhere Ouyang Xiu writes that the methods employed by the Tang dynasty calligraphers were the same yet the writing of the famous masters came out differently. The reason why was diligence of practice and a disinterest in forging beautiful, pleasing forms.[9] Ouyang Xiu's championing of the individual comes out most clearly in his warning against "slave calligraphy" (*nushu*), the result of going no further than the copying of one's models.[10]

The tradition to which Ouyang Xiu was responding needs further delineation before we can proceed with the eleventh-century critique. Its first component is Jin calligraphy, long honored but of decidedly waning influence at this relatively late stage of its transmission. Examples of Wang Xizhi's, Wang Xianzhi's, and other pre-Tang writers' calligraphy had become exceedingly rare, and what did exist was complicated by questions of authenticity. A rough idea of the tradition was broadly known, but through rubbings of stelae, such as the late-seventh-century compilation of Wang Xizhi characters "Preface to the Sacred Teachings" (fig. 7), and compendia of model writings rather than genuine works. An important source for Jin calligraphy was *Model Writings from the Chunhua Pavilion (Chunhuage fatie)* of 992, a compendium of fatie in ten fascicles sponsored by Song Taizong (r. 976–97) that showcased the calligraphy of the Two Wangs.[11] The Chunhua Pavilion compendium was one of the high-profile projects designed to legitimize Song rulership at the beginning of the dynasty on the model of Tang Taizong's reign. In the 350 years separating the

7. "*Preface to the Sacred Teachings.*" Stele erected in 672, Tang dynasty. Text by Tang Taizong (r. 627–49). Characters by Wang Xizhi (307?–65?), compiled by Huairen in 648. Detail of a rubbing. From Da Tang sancang shengjiao xu.

獎半珠間道遷十有七

載備通擇典利物爲心以貞

觀十九年二月六日奉

物於弘福寺翻譯聖教

要文凡六百五十七部引大

beginnings of these two dynasties, however, much of what had defined the Jin tradition had disappeared or been dispersed. This became increasingly obvious through the eleventh century, as both this compendium and its chief editor, Wang Zhu, fell into disrepute. Su Shi claimed that roughly half of its contents were outright fakes or misattributions. Mi Fu echoed this appraisal in a colophon dated 1088, pointing out that among the grosser errors are an attribution of the "Thousand Character Essay" to Emperor Zhangdi of the Han (r. 75–88) (the essay was composed by Zhou Xingsi, who lived almost five hundred years later), inclusions of calligraphy by the Tang cursive master Zhang Xu under Wang Xianzhi's name, and that of some "vulgar" follower of the sixth-century monk Zhiyong taken to be Wang Xizhi.[12] In spite of Song Taizong's early efforts, in the first half of the eleventh century the Jin tradition remained distant and of limited relevance.

In contrast, the presence of Tang dynasty writing was strong. Of the calligraphers active early in the Tang, Ouyang Xun was the most directly influential on writers of the eleventh century because of the prevalence of his calligraphy, both handwritten specimens and stelae engravings.[13] His importance, however, and that of such other renowned early Tang calligraphers as Yu Shinan (558–638) and Chu Suiliang (596–658), is more significantly measured by the role these calligraphers played in establishing a lasting dynastic style. From an eleventh-century perspective their achievements represented a synthesis largely founded on the Jin tradition, and one that was the foundation for Tang excellence. Confirming the link between Jin and Tang were the various and many copies produced at Tang Taizong's court of that most famous of all works of calligraphy, Wang Xizhi's "Preface to the Poems Composed at the Orchid Pavilion," including freehand versions by these three writers (fig. 8).[14] Copies of the "Orchid Pavilion Preface" provided a significant model in the eleventh century (the original, according to legend, was buried with Tang Taizong on his orders), though these copies may well have reflected more the Tang interpretation of the Wang Xizhi style than that of the fourth-century master himself.

Much of Tang calligraphy gave the impression of unity and strength, and as such it easily shouldered the mantle of orthodoxy—the received tradition. When Ouyang Xiu speaks in one inscription of "eighteen or nineteen" skilled calligraphers of the Tang, he refers to the finest practitioners of an art with firmly entrenched methods that provided the tradition with continuity.[15] Had he specified, Ouyang Xiu's list would have included Li Yong (678–747), an extremely prolific calligrapher whose writing, like that of Ouyang Xun, provided an important model in the Northern Song because of its accessibility through rubbings (fig. 9). Li Yong's calligraphy, with its trim brushstrokes, evenly proportioned char-

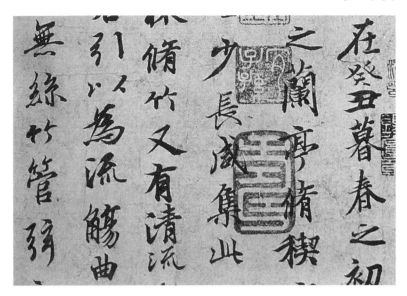

8. *"Preface to the Poems Composed at the Orchid Pavilion." "Shenlong" version copy, sometimes attributed to Feng Chengsu. Tang dynasty. The original preface by Wang Xizhi was dated 353. Detail of a handscroll, ink on paper, 24.5 × 69.9 cm. The Palace Museum, Beijing. From* Lanting moji huibian.

acters, and overall attractiveness reveals a practiced familiarity with the Wang Xizhi tradition and the "Orchid Pavilion Preface" (compare with figs. 7 and 8), which had reached a peak of popularity in the first half of the eighth century.[16] The athletic flair that it also displays probably would have been attributed by Ouyang Xiu to Li Yong's individual character.

Two Tang calligraphers who were particularly important for Northern Song writers were Yan Zhenqing and Liu Gongquan (778–865) (fig. 10; see fig. 60). Again, prominence was owed largely to the accessibility of their calligraphy, particularly through stelae.[17] Muscular, bony (especially in Liu's case), and somewhat difficult to reconcile with the relaxed elegance of the received tradition, this style of writing was not universally appreciated. For example, Li Yu (937–78), the last ruler of the Five Dynasties period kingdom of Southern Tang, found Yan Zhenqing's calligraphy offensively direct, "like an uncouth farmer facing forward with arms folded and legs spread apart."[18] For Ouyang Xiu, however, this confrontational style well accorded with the heroic image Yan Zhenqing cast as a high minister of unquestioned loyalty and courage, a stalwart defender of the court and a martyr who died at the hands of a would-be usurper.[19] Ouyang

9. Li Yong (678–741), "Li Sixun Stele." Dated 739, Tang dynasty. Detail of a rubbing. From Tō Ri Yō, Ri Shikun hi, 9.

10. Yan Zhenqing (709–85), "Record of the Yan Family Ancestral Shrine." Dated 780, Tang dynasty. Detail of a rubbing. From Yan Zhenqing, 5:241.

Xiu insists on the presence of "methods" in Yan's writing, thus connecting him to the general excellence of Tang calligraphy.[20] Su Shi goes a step further by perceiving in Yan Zhenqing's innovations the final synthesis of the received tradition.

In the evolving critique of earlier calligraphy, Yan Zhenqing marks the point of a subtle but important departure, from Ouyang Xiu to Su Shi and the next generation. That departure centers on a change of emphasis from methods to individual expression, and it begins to appear in comments on the calligraphers active in the late Tang, Five Dynasties period, and early Northern Song. Ouyang Xiu perhaps plants the seeds for this new emphasis by championing individual style and moral quality as indispensable accompaniments to methods and skill in calligraphy, with Yan Zhenqing playing the exemplar's role. Yet Ouyang still retains a traditional respect for the methods of the received tradition as they were transmitted to later generations. From his perspective they simply were not transmitted effectively enough. Thus, he takes care to note those whose calligraphy stood out from the general morass of lower standards during the Five Dynasties period, individuals such as Wang Wenbing, Li E, Guo Zhongshu, Yang Ningshi (873–954), Luo Shaowei, and Qian Shu (929–88).[21] In contrast, one perceives a sense of historical inevitability in the comments of some who followed Ouyang Xiu—an irrevocable decline that takes place in the late ninth and tenth centuries that the reinvigoration of methods alone would not change. Of this particular group singled out by Ouyang Xiu, and for that matter of all Five Dynasties period calligraphers, only Yang Ningshi's name earns consistent and lasting respect. Here is the beginning of Su Shi's general assessment:

> After the deaths of Yan [Zhenqing] and Liu [Gongquan], the methods
> of the brush declined to the point of being severed with the past. Add to
> this the despairing chaos that accompanied the end of the Tang dynasty,
> the withering and obliteration of human talent, and [what might have
> existed of] the beauty of letters and élan during the ensuing Five
> Dynasties period was completely swept away. Only the brush traces of
> Lord Yang Ningshi were stalwart and outstanding, carrying with them
> the remnants of the Two Wangs, Yan and Liu. He can truly be called a
> hero of calligraphy, one who was not buried by his own times.[22]

Praise for Yang Ningshi is almost unanimous among later eleventh-century critics, and it is interesting to consider why. Yang's adult life precisely corresponded with the final years of the Tang and the Five Dynasties period. He attained his *jinshi* degree during the reign of Zhaozong (888–904), the next-to-last emperor of the Tang, and then served successively under each of the short-lived

northern regimes that together comprise the Five Dynasties. Easily traded loyalties such as these attracted moral disapprobation in the case of Yang's contemporary, Feng Dao (882–946),[23] but later appreciators of Yang Ningshi's calligraphy preferred to overlook such infelicities and see the man as somehow removed from the unpleasantries of his times. Yang was viewed as an untrammeled sort whose primary joy resided in covering the walls of Luoyang temples with his calligraphy. The few examples of his writing on paper or silk that survived into the later stages of the Northern Song reinforced this image. A portion of one that has made it to modern times shows how uninhibited and casual Yang Ningshi could be (fig. 11). The calligraphy in this letter addressed to a monk has the feeling of the wild cursive script, with the brush inattentive to detail, the characters varying markedly in size, and the columns intruding upon one another. Little survives by which we can judge Yang Ningshi, and what does survive is each in a different script form, making his image rather amorphous.[24] Nonetheless, Yang Ningshi and his calligraphy clearly were admired by later critics precisely because they gave the appearance of being spontaneous and somewhat independent of the received tradition.

The calligraphy of Li Jianzhong (945–1013) provides the essential contrast (fig. 12). An early Northern Song official who spent considerable time in Luoyang, Li Jianzhong is reputed to have greatly admired Yang Ningshi's calligraphy. Yet, in distinct contrast, Li's letter reveals a full dose of the methods of Tang. Full-bodied and attractive, his writing replaces the idiosyncrasies of Yang's brush with the grace and ease typical of such eighth-century calligraphers as Li Yong (compare with fig. 9). Huang Tingjian described Li Jianzhong's writing as "plump but without excess flesh, like a beautiful woman of the time," and this seductive quality coupled with solid technique is undoubtedly what led to Li's popularity in the early years of the Northern Song and to many writers' choice of Li to be the model for their calligraphy.[25] Respect for Li Jianzhong's skill is still apparent in the comment by Ouyang Xiu mentioned earlier. Su Shi's evaluation, however, is remarkably harsh. After speaking highly of Yan Zhenqing, Liu Gongquan, and Yang Ningshi, Su Shi writes, "At the beginning of our dynasty Li Jianzhong had a reputation for being an able calligrapher, but the character of his calligraphy is mean and turbid, continuing the wasted and lowly spirit that had been perpetuated since the late Tang. [Of his generation], I have yet to see any who stood out and pursued the company of those earlier men."[26]

It is notable that Su Shi speaks of character rather than skill, the presence of which in Li Jianzhong's calligraphy was not disputed. Consequently, it is important to recognize the subjective nature of Su Shi's judgment. Li Jianzhong was a fine calligrapher, as were others of his generation, and occasional comments in

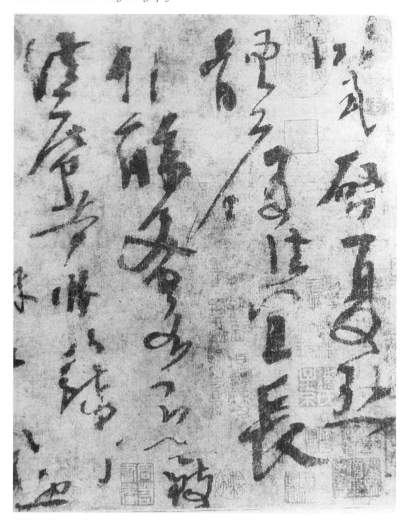

11. Yang Ningshi (873–975), "Summer Heat." Five Dynasties period. Detail of a handscroll, ink on paper, 23.8 × 33 cm. The Palace Museum, Beijing. From Gugong bowuyuan cang lidai fashu xuanji, *vol. 1.*

late Northern Song writings on calligraphy admit as much. He was also, however, an unfailingly orthodox calligrapher writing in a time when, from Su Shi's point of view, old methods appeared symptomatic of degeneration and historical decline. Su Shi's comment essentially declares a rejection of the received tradition, and with a resoluteness that marks a profound shift away from Ouyang Xiu and the previous generation. The degree to which fundamental attitudes

have changed can be measured by a remark made by Su Shi's younger friend Huang Tingjian, in which even such early Tang exemplars of the tradition as Ouyang Xun, Yu Shinan, and Chu Suiliang are rejected because they were "too restrained by methods."[27]

Calligraphy was considered a noble but minor art, and because of its relative unimportance in the grander scheme of things even those who genuinely appreciated it, like Ouyang Xiu and Su Shi, were not necessarily driven to systematize their thoughts and comments. Today we can only look for general trends and do our best to interpret the more pronounced opinions in accordance with what is known of the critics and what can be seen of those they critique. With regard to earlier calligraphy, and the received tradition in particular, a strong and telling parallel with a reform campaign in literature championed by Ouyang Xiu known as the *guwen* (ancient prose) movement demands notice. At the same time, although attitudes expressed by Ouyang Xiu and others concerning prose and poetry are useful and often relevant to understanding changes taking place in the sister art of calligraphy, differences in the traditions and practice of these arts should caution against attempts to press the parallels too specifically.[28]

The ancient prose movement arose in reaction to the highly ornate and difficult form of parallel prose employed in the civil service examinations of the early Northern Song. The fundamental complaint was that such showy, allusion-filled writing emphasized outward technical style at the expense of content, the latter playing little role in the examiners' judgments of the candidates' essays. An earlier opposition movement to this kind of writing took place in the mid-Tang, led by Han Yu, who sought to replace parallel prose with a more direct form of composition roughly associated with the Classics of antiquity. Han Yu's charge was picked up again early in the Song by the scholars Liu Kai (947–1000) and Wang Yucheng (954–1001), and again by Ouyang Xiu, who finally managed to have the guwen style implemented as standard in the civil service exams of 1057. The degree to which Han Yu's prose style had become the model of admiration in the second half of the eleventh century is reflected in Su Shi's inclusion of Han with the elite company of Du Fu, Yan Zhenqing, and Wu Daozi as the Tang masters who brought all matters of capability to an end.

The leading practitioner of early Northern Song parallel prose was Yang Yi (974–1020), a talented writer whose flair for literary intricacies extended to poetry.[29] Yang Yi is specifically regarded as the leader of what is known as the Xikun style of poetry, named after a compilation of poems edited by Yang that included his own work and that of sixteen contemporaries at the start of the eleventh century. Like its counterpart in prose, the Xikun style of poetry is preciously clever,

12. *Li Jianzhong (945–1013), "Consultation." Northern Song period. Detail of an album leaf, ink on paper, 31.2 × 44.4 cm. Collection of the National Palace Museum, Taipei, Taiwan, Republic of China.*

packed with allusions, and, to its detractors, void of substance. For the reform-minded active in the middle years of the eleventh century, the Xikun style represented a continuation of the general degeneration of poetry that took place in the late Tang and Five Dynasties period. This perception was guided in part by the fact that the primary model of the Xikun poets was the late Tang master of densely allusive poetry Li Shangyin (813–58) as opposed to (in Ouyang Xiu's words) the "heroic and expansive" High Tang poets Li Bo (699–762) and Du Fu of a century earlier.

It is with this retrospective view of trends in poetry leading into the eleventh century that we find a striking similarity with the evaluation of what had taken place in calligraphy. After the eighth century there is a general decline occasionally interrupted by the emergence of some exceptional talent (notably Han Yu and his circle of literary figures active early in the ninth century). As it was in his critique of calligraphy, Ouyang Xiu considered that the fundamental problem lay not with the particular methods used—in one inscription he defends Yang Yi and the Xikun school's use of allusions[30]—but rather how well they are used. As

13. Li Zonge (964–1012), "Poem." Northern Song period. Detail of an album leaf, ink on paper, 34.8 × 31.1 cm. Collection of the National Palace Museum, Taipei, Taiwan, Republic of China.

Jonathan Chaves notes, the brunt of Ouyang Xiu's complaint lay not with the chief Xikun poets but rather with the many emulators, in whose hands the style degenerated into empty mannerisms.[31] Ouyang Xiu again exhibits a certain respect for the previous generation and the received tradition, though not for those who followed them. In contrast there was the hardline position of Ouyang's contemporary Shi Jie (1005–45), in whose radical defense of guwen values Yang Yi and the Xikun poets are attacked for creating a great aberration, "carving up the Classics and fragmenting the Sage's meaning."[32]

Because of the close parallels in these critiques of poetry and calligraphy of the immediate past, Shi Jie's strident and relatively detailed criticism of the Xikun poets may suggest what were considered the specific faults of the early Northern Song practitioners of the received tradition of calligraphy. He bemoans Yang

Yi's poetry for "carrying prettiness to the ultimate degree and striking all possible postures," "being excessive in artfulness and extravagant in loveliness, superficially beautiful and full of silken elegance"[33]—descriptions that strike a chord of harmony with Huang Tingjian's characterization of Li Jianzhong's calligraphy being like a beautiful woman. Yang Yi's own calligraphy, unfortunately, does not survive,[34] but a single handwritten specimen is extant by another of the major Xikun poets, Li Zonge (964–1012) (fig. 13). As this tie is a poem typical of the Xikun style, the calligraphy provides an interesting pictorial counterpart to this oft-assailed form of early Northern Song poetry.

Shi Jie's characterization of Xikun poetry as extravagantly lovely might lead one to expect its counterpart in calligraphy to emulate the graceful airs of the Two Wangs tradition, but if Li Zonge's writing is any indication, this is not necessarily the case. His brushstrokes are often exceedingly heavy and his characters rotundly proportioned so that the writing establishes a bold and assertive presence largely antithetical to the qualities associated with Jin. Moreover, with its squat and awkward forms, Li Zonge's calligraphy seems rather removed from the seductive grace of his older contemporary, Li Jianzhong (see fig. 12). Yet, a careful comparison reveals that the two are closer than may first appear. The roots of Li Zonge's portliness lie in the lush forms of the orthodox Tang tradition. It is simply more eccentric than Li Jianzhong's calligraphy, with such quirky mannerisms as the occasional bending of vertical *shu* strokes and the peculiar construction of certain characters. The thirteenth-century critic Dong Shi writes, "At the beginning of the Song, Li Jianzhong's calligraphy was considered peerless, but the movements of his brush and the compositions of his characters tended toward plumpness. When we come to Li Zonge, though famous as a calligrapher, his writing did not escape being heavy and turbid."[35] Dong Shi then suggests that Ouyang Xiu specifically had Li Zonge in mind when Ouyang wrote the following: "People today like fat characters. [But] they are just like thick-skinned *mantou* [round loaves of bread]: though they may not taste bad, all one has to do is look at its appearance to know that it is something vulgar. The methods of calligraphy have been cut off now for fifty years."[36]

It was less the Wang Xizhi tradition that provided calligraphy's counterpart to the ills represented by the Xikun style of poetry than the dominant tradition inherited from the Tang. Its overt prettiness, as represented by Li Jianzhong, was offensive to some, but the primary problem was the tradition's distance from its original roots and a consequent preoccupation with outward appearances and mannerisms. For those who followed calligraphers like Li Jianzhong and Li Zonge in the decades leading to midcentury the problem became even more acute, as standards changed as quickly as the next most popular style, and that, as we see in

the following comment by Mi Fu, largely depended on whoever had assumed the mantle of cultural leader:

> At the beginning of our dynasty all the lords and ministers, following
> the predilections of the emperor [Song Taizong], studied Zhong You
> [151-230] and Wang Xizhi. Then Li Zonge dominated the literary scene
> for quite some time, and consequently scholars began to study his style
> of calligraphy, which was fat, squat, and awkward. All cast in with his
> likes, using his style of calligraphy for the writing of examination
> papers. From this time on the only interest was in whatever calligraphy
> was popular at the moment. Lord Song Shou [991-1040] became vice
> grand councillor and the court all studied his style, calling it the "court
> style." Lord Han Qi [1008–75] liked Yan Zhenqing's writing, and all,
> scholars and commoners alike, studied Yan. Once Cai Xiang [1012–67]
> was enfeoffed the scholars all studied him, and when Wang Anshi
> [1021–86] was made minister everybody then studied his style. From this
> point on no one spoke of the methods of antiquity.[37]

Mi Fu's comment suggests that the fundamental problem facing calligraphers in the second half of the eleventh century was the need to rediscover the earlier roots of their art. With the absence of readily available, sanctioned models, however, this was not easily achieved. It was one thing to recognize the faults of the received tradition; it was another to remedy them. Calligraphy after midcentury might be characterized as the groping for a response, and as we shall see, the results were as interesting as they were unpredictable.

Trends and Issues in the Second Half of the Eleventh Century

Perceptions of a fundamental rupture with the immediate past result in a highly fluid situation for calligraphy. This is exemplified by an ambiguity toward "methods." Because methods were indelibly associated with the process of learning calligraphy, and hence with the lingering habits of the received tradition, there was a natural inclination to deemphasize their importance. Ouyang Xiu's warning against slavish imitation and the value he placed on individual moral worth may have encouraged the urge to place other concerns first. And yet, methods remained the foundation of the art. Indeed, Ouyang Xiu held that the general absence of methods accounted for calligraphy's problems in the Song dynasty. Even Huang Tingjian, already quoted as being against the restraints of methods, had the good Confucian's trust in learning, practice, and discipline. In the same inscription that he expresses disapproval of the early Tang calligraphers' addiction to control, Huang notes that Yang Ningshi, though able to partake of the

14. *Huang Tingjian (1045–1105), "Colophon to an Essay Transcribed for Zhang Datong."*
Dated 1100, Northern Song period. Detail of a handscroll, ink on paper, 34.1 × 552.9 cm.
The Art Museum, Princeton University. Gift of John B. Elliott.

splendors of Wang Xizhi and Yan Zhenqing, nonetheless was a little lacking when it came to rules (*guiju*).[38] Apparently a desirable balance was to be found somewhere between too many methods and too few rules.

If nothing else, Huang Tingjian's comment reflects the uncertainties that surrounded calligraphy in these years. The need for structure was well recognized, but there was uncertainty concerning where it should come from and how it might be implemented if not inherited from one's forbears. With the received tradition discredited, there was a general movement to excavate new models or to reexamine old models in their original forms. This endeavor, however, had the potential to become remarkably personal and subjective. Again we turn to Huang Tingjian for an illustration (fig. 14). As scholars have long noted, an important model for Huang's gaunt, eccentric style was the vague and mysterious "Eulogy for a Dead Crane" (fig. 15), an inscription engraved in a cliff face that had broken off and fallen into the water by the island of Jiaoshan at Runzhou and could be visited only in fall and winter, when the waters were low.[39] Local tradition ascribed "Eulogy for a Dead Crane" to Wang Xizhi. More sober assessments, including those of Ouyang Xiu and Cai Xiang (1012–67), recognized a fundamental discrepancy between this unusual writing and everything known of the Two Wangs tradition ("It doesn't even come close," writes Cai).[40] Yet against all reason Huang

15. *"Eulogy for a Dead Crane," sometimes attributed to Tao Hongjing (452–536). Sixth century. Detail of a rubbing from a cliff inscription at Jiaoshan, Zhenjiang, Jiangsu Province. From* Zhongguo meishu quanji, *"Shufa zhuanke bian," 2:144.*

Tingjian persisted in believing in Wang Xizhi's authorship. Wang Xizhi's name was synonymous with excellence and orthodoxy, precisely the qualities Huang Tingjian wished to associate with this calligraphy that so appealed to him. Another factor was a rough resemblance between "Eulogy for a Dead Crane" and Yan Zhenqing's calligraphy, which Huang Tingjian also admired. The eulogy, in Huang's mind, thus provided a concrete link between Wang Xizhi and Yan Zhenqing, resulting in a new, personally agreeable model that represented both tradition and moral righteousness. This became Huang Tingjian's structure. Paradoxically, the results it helped spawn are among the most idiosyncratic in the entire history of Chinese calligraphy.

A deliberate attempt to leapfrog over the received tradition to earlier models first becomes noticeable in Ouyang Xiu's generation and the calligrapher Cai Xiang. A scholar from the southern province of Fujian, Cai Xiang was a strong supporter of Fan Zhongyan (989–1052), the reform movement of the 1030s and 1040s (in which Ouyang Xiu played a major role), and guwen values in general. Ouyang Xiu considered Cai Xiang to "walk alone" as the best calligrapher of the day, and the two comrades often discussed calligraphy.[41] It is thus not surprising to discover that Cai's writing largely accords with Ouyang's comments.

Two things are immediately striking about Cai Xiang's calligraphy: its professional polish and its range. Later critics take note of Cai's exemplary methods, the care and precision with which he handles the brush. They also note how each brushstroke in Cai Xiang's writing has a source in some earlier calligrapher. Comments on calligraphy by Cai Xiang himself suggest that he was a keen student of the art. From the ancient seal scripts to the wild cursive writers of the Tang, Cai Xiang was familiar with all of the major movements and historical figures, and these he dutifully copied for his and his descendants' edification.[42] When Ouyang

Xiu speaks of Cai Xiang as an exception to the general decline of standards in calligraphy in the eleventh century, it is because of Cai's workmanlike efforts to resurrect the discipline associated with the Tang calligraphers.

A letter of 1064 addressed to Tang Xun (1005–64), on the subject of inkstones, prominently displays a major source of Cai's study: Yan Zhenqing (fig. 16). Yan Zhenqing's calligraphy was especially popular among mid-eleventh-century guwen adherents because his bold and direct style of writing provided the closest pictorial counterpart to Han Yu's call for a return to the power of unadorned antiquity. Moreover, his stature as a man of uncompromising integrity particularly appealed to Fan Zhongyan, Ouyang Xiu, and others intent on governmental reform. By imitating Yan's strongly articulated style, Cai Xiang elicits these qualities of propriety and forthrightness—perhaps a little queerly, considering that the letter concerns the frivolous matter of acquiring inkstones and other knickknacks for one's studio (Tang Xun was an aficionado of inkstones). At the same time, the rougher edges of Yan's style are tempered by a pleasing delicacy and harmony added by Cai Xiang.[43] Other examples of Cai Xiang's calligraphy present a credible Tang-style interpretation of the orthodox Wang Xizhi cursive tradition; some suggest the influence of other Tang calligraphers, such as Liu Gongquan. Importantly, however, Cai Xiang's mixing of styles, though noticeable, is always harmoniously synthesized.

A clue to understanding Cai Xiang as a calligrapher might be found in a comment by another prominent member of Ouyang Xiu's circle, the poet Mei Yaochen (1002–60). Commenting on the poetry of his time, Mei likened Ouyang Xiu to Han Yu and other literary members of Ouyang's circle to poets known and admired by Han Yu: Shi Yannian (994–1041) to Lu Tong (d. 835), Su Shunqin (1008–48) to Zhang Ji (ca. 765–830) and Mei himself to Meng Jiao (751–841).[44] The subject is not calligraphy, and Cai Xiang is not even present, but this sense of identification with the last great flowering of Tang culture that Mei Yaochen reveals may be relevant. It reflects a desire to turn back the clock, to erase two centuries of cultural decay and pick up again where the mission of Tang had left off. Cai Xiang's calligraphy exhibits the same goal, synthesizing the best of what had come before him and always aspiring to the classical ideal that the best of Tang calligraphy represented.

In the traditional assessment of Song dynasty calligraphy, Cai Xiang's name is appended to those of Su Shi, Huang Tingjian, and Mi Fu to form the four great masters of the period. Some have found it strange that Cai, the most senior of the four, is placed last, but this probably reflects the fact that Cai Xiang's calligraphy has long been recognized as fundamentally different from that of the younger generation and not representative of the trends for which Northern Song

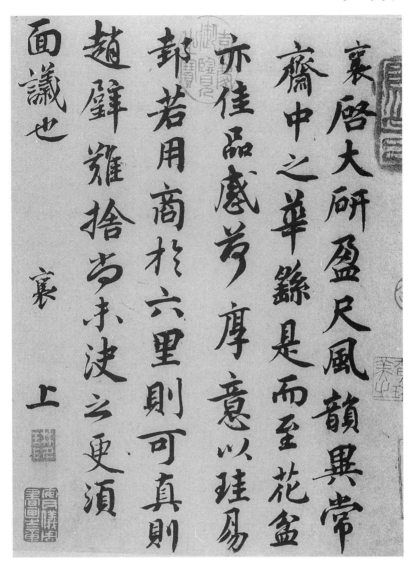

16. *Cai Xiang (1012–67), "The Large Inkstone." Dated 1064, Northern Song period. Detail of an album leaf, ink on paper, 25.6 × 25 cm. Collection of the National Palace Museum, Taipei, Taiwan, Republic of China.*

calligraphy is celebrated.[45] The Yuan dynasty calligrapher and connoisseur Yu Ji (1272–1348) said it directly: "In general, Song dynasty calligraphy up to Cai Junmo [Cai Xiang] still has the ideas of previous generations. After Slope [Su Shi] and Valley [Huang Tingjian] appeared, the prevailing trend was to follow

these two, and the methods of Jin and Wei were lost."[46] Yu Ji's recognition of an important break after Cai Xiang is correct, but his comment on Su's and Huang's influence is slightly misleading. An almost immediate negligence of Cai Xiang's calligraphy takes place in the second half of the eleventh century, but it cannot be directly attributed to Su Shi or Huang Tingjian. On the contrary, Su Shi is remarkably sympathetic toward Cai Xiang, defending his ability as a calligrapher against those who belittled him and consistently repeating Ouyang Xiu's high evaluation of him as the dynasty's best.[47]

The charge against Cai Xiang was weakness, and it arose in reaction to the delicacy of touch that colors all of his calligraphy, even his rendition of Yan Zhenqing. Mi Fu described it with a metaphor: "Cai Xiang is like a young woman of comely appearance and manner; she walks with slow, deliberate steps, adorning herself with celebrated flowers."[48] Su Shi challenged the charge of weakness by praising the solid fundamentals of Cai's calligraphy. If one wishes to speak of weak calligraphy, he retorts, then look to the writing of the Southern Tang emperor Li Yu, which avails itself of the outward appearance of strength but inside is lacking. Like a building, Su Shi would seem to suggest, strength is to be measured by structure and foundation, not by the decor of the facade.

Underlying the debate on Cai Xiang is a pronounced change of direction in the priorities of calligraphy. Su Shi's defense notwithstanding, Cai's technical mastery of the orthodox tradition and the senior generation's concern in general for proper methods must have seemed passé. Though none would have denied their importance, they were now considered secondary to establishing an individual manner. Cai Xiang's calligraphy was considered effeminate, perhaps indistinctive, and it quickly faded as the next generation came of age. Yet his efforts were not inconsequential to what followed. By being the first to examine and learn from specific earlier masters, Cai Xiang established an important pattern. Wang Anshi, Mi Fu reports, secretly studied Yang Ningshi (fig. 17).[49] His younger contemporary Li Peng combined the beauty of Wang Xizhi with the "breath and bone" of Yan Zhenqing, the strangeness of Liu Gongquan, and the "tone" of Yang Ningshi.[50] These names and a few others appear commonly as the recognized models for the generation that followed Ouyang Xiu, and yet their application differs markedly from what is seen in Cai Xiang's calligraphy. It is noteworthy that Wang Anshi's calligraphy is described chiefly as singular and individualistic, "like that of a person of the Jin or [Liu] Song."[51] It took the trained eye of a connoisseur like Mi Fu to recognize Yang Ningshi's influence. Plainly stated, the methods of earlier calligraphers are visible in Cai Xiang's writing because they were intrinsic to the goal of attaining a classical ideal that transcended the individual; they are less visible in the writing of Wang Anshi and

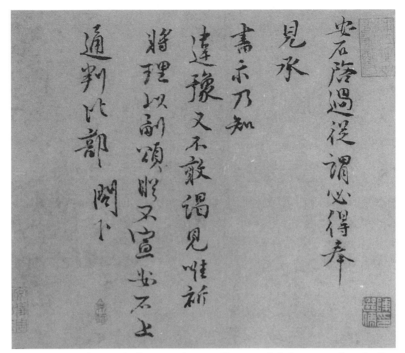

17. *Wang Anshi (1021–86), "Letter to the Controller General of the Bureau of Review." Northern Song period. Detail of an album leaf, ink on paper, 26 × 32.1 cm. Collection of the National Palace Museum, Taipei, Taiwan, Republic of China.*

others who followed because their function was now to aid the writer in finding an individual voice.

Perhaps the finest example reflective of the new trends after Cai Xiang is Su Shi's "Cold Food Festival Poems Written at Huangzhou" of circa 1082 (see figs. 5, 6). This piece of writing has long been celebrated as Su Shi's greatest for its combination of spontaneity and invention. From the misshapen character zi (since) that begins at the upper right to its finish there unfolds a ceaseless display of shifting rhythms, manners, and tones as Su Shi explores with abandon his inspiration at each moment. At times the results are idiosyncratic and disjointed, but the gain is an absolutely singular piece of writing full of creativity. It is thus surprising to read in Huang Tingjian's trailing colophon that Su Shi here combined the "brush ideas" of Yan Zhenqing, Yang Ningshi, and Li Jianzhong. Comparisons with Yan's, Yang's, and Li's writing might yield a resemblance or two, but certainly whatever Su Shi gained from these three earlier masters is well hidden beneath the writing's assertion of self.

Even more surprising than Huang Tingjian's claim of the influence of earlier calligraphers in "Cold Food Festival Poems" is that one of these is Li Jianzhong, the early Northern Song calligrapher Su Shi branded as vulgar and whose reputation he claimed was unearned. In similar fashion, Huang Tingjian frequently draws parallels between the plump and relaxed manner of Su Shi's customary writing with that of the Tang calligrapher Xu Hao (703–82), whose fleshy style was not dissimilar to that of Li Jianzhong, yet Su Shi specifically denies any resemblance.[52] It is impossible to dismiss Huang's observations as inaccurate—he and Su Shi were good friends and often discussed calligraphy. Rather, Huang's observations suggest an important point concerning the development of an individual style. The habits of writing can become so ingrained during the early process of learning that they later prove difficult to discard. Su Shi said it himself in a metaphor he offered to Cai Xiang: "Learning calligraphy is like trying to row a boat against a strong current. One can exhaust one's strength to the utmost, but the boat never leaves its old place."[53] According to Huang Tingjian, for Su Shi the "old place" was Wang Xizhi's "Orchid Pavilion Preface," which Su had studied as a youth.[54] Considering, however, what people knew of the "Orchid Pavilion Preface," especially in the hinterlands of Sichuan, where Su Shi came of age, it is likely that what Su Shi saw and practiced was the received tradition as interpreted by Tang calligraphers like Xu Hao before passing through Li Jianzhong to the generation of Su Shi's elders. For that matter, Li Jianzhong's calligraphy may have provided a childhood model for Su Shi, though he never acknowledges this.

Whether or not Su Shi ever studied the calligraphy of Li Jianzhong and Xu Hao is less important than the fact that, despite commonly perceived resemblances, and despite Su Shi's pronounced distaste, he never tried to alter his style of writing. Presumably, he could have. Huang Tingjian describes how he once went through two bags of Su Shi's private collection of writings and saw some that were close in style to the calligraphy of Chu Suiliang and Liu Gongquan, Tang calligraphers known for a more wiry style of writing. "And these," Huang says, "were absolutely superior to his commonly practiced Xu Hao style."[55] But Su Shi never forced himself away from who he was. The boat never got very far from its old place.

Ironically, this paradox of feeling compelled to reject that from which one can never easily escape may have had a liberating effect on Su Shi's calligraphy. The stronger the bonds to one's models, the harder it was to avoid Ouyang Xiu's label of "slave writing," and there is no question that the strength of those bonds was determined as much by public values as by an individual's predilections. In the Tang dynasty there had been a mandated model, but in the middle of the

eleventh century there was nothing comparable—only choices. When the rhythms of a dynasty's patterns are as clearly articulated as they were in the Tang, those who march to their own drummers risk the label of heterodox. In the latter half of the Northern Song there was no such restraint. Su Shi may not have been able (or willing) to eliminate lingering influences from the likes of Li Jianzhong and Xu Hao, but given the prevailing attitude he also need not pay them any attention. He could give full rein to the temptation to express his individuality, absolved from the unspoken responsibilities of remaining loyal, in a more literal fashion, to his models. He could, in other words, focus on who he was simply by trusting the brush to leave its own faithful record. And this, according to a poem of circa 1070, is precisely what Su Shi did: "My calligraphy is purely created, at root without rules / Dots and strokes simply trust my hand, I do not bother to seek [some result]."[56] In a well-known self-account of his approach to literary composition, Su Shi likens his writing to a bubbling spring, flowing freely and effortlessly over the terrain. "All that can be known is that it will move constantly when it should move and will unfailingly halt when it cannot but halt."[57] The metaphor should also undoubtedly be applied to his calligraphy.

As Su Shi suggests, calligraphy was supposed to be a natural art, but not all were so willing to trust the hand or to accept the mirror's direct reflection. Many, as Mi Fu described, simply followed the latest trends, yet others, keenly aware that writing was increasingly being viewed as the mark of the individual, made conscious efforts to paddle the boat harder, to mold or recast their styles. New combinations of models were explored, and new ideas flourished. It is in this rare atmosphere of individualism that Mi Fu came of age, and as the following self-admission reveals, he was ever one to fret over the appearance of his calligraphy: "When I was ten years old I wrote stele calligraphy. I also studied the epistle writing of Zhou Yue and Su Zimei and thereby founded my own personal style. But when people looked at it they said that the brush methods of Li Yong were within. Hearing this, I despised my calligraphy."[58]

Mi Fu began with stele calligraphy, by which he refers to the kai or standard script writing disseminated through ink rubbings taken from engraved memorial stone tablets. Elsewhere we learn that his early models were Yan Zhenqing and Liu Gongquan.[59] All who learn calligraphy begin by tackling the fundamentals of brush control and character composition with the standard script (Song writers in particular stress the importance of "learning to walk" with the kai before running with the xing and cao), and for this Yan's and Liu's carefully composed characters provided excellent and plentiful models. Mi Fu's first foray into the forest of letters was thus nothing more than standard practice circa 1060. Similarly, there was nothing unusual in Mi Fu's attempts to model his informal writ-

ing after the styles of Zhou Yue and Su Shunqin (style name Zimei, 1008–48), men of letters active in the preceding generation and famous for their writing in the semicursive and cursive scripts. Zhou Yue's reputation did not last, but during the Tiansheng and Qingli reigns (1021–31, 1041–48) "emulators had thronged in admiration."[60] Su Shunqin's writing was even more highly prized. A man of imposing appearance and bold personality whose professional ambitions were thwarted in the world of officialdom, Su wrote unbridled verses described by his friend Ouyang Xiu as pieces of gold and jade. "He excelled at cursive calligraphy, wielding the brush each time he was flush with wine. People competed in circling his writings, which became even more highly treasured after his demotion and death."[61] Mi Fu was presumably a young man in his teens when he proudly indicated that his own style of writing had emerged, born from the dashing forms of Zhou Yue and Su Shunqin.

But why Mi Fu's distress on hearing that his calligraphy resembled that of the High Tang calligrapher Li Yong (see fig. 9)? Li Yong had always been a highly admired writer. According to Ouyang Xiu, he was in an elite group of peerless calligraphers and a master of the methods of the brush.[62] In fact, when one of Ouyang Xiu's sons told Su Shi that his calligraphy was very similar to Li Yong's, Su Shi acknowledged the observation with no displeasure.[63] Perhaps it was simply that, through this accidental resemblance, Mi Fu's calligraphy was less personal than he had thought, but the question of individuality does not fully account for Mi Fu's virulent reaction. Rather, something in this suggested alliance profoundly bothered Mi Fu, and this is why his comment is so interesting.

Mi Fu's narrative soon suggests a reason for his unhappiness: "Consequently, I studied Shen Chuanshi; I loved his lack of vulgarity." Shen Chuanshi (769–827), a quiet, scholarly official as noted for his historical researches as for his subtly buoyant and unpretentious calligraphy in the kai and xing scripts, provides an interesting contrast with Li Yong. Li Yong, talented, brash, and of questionable morals, was frequently in trouble with the court. This alone would not have barred the Tang writer from Mi Fu's admiration, but Li Yong's open willingness to barter his literary compositions and calligraphy for considerable amounts of gold and silk from grandees and religious institutions apparently did. "Like a common fellow of newfound wealth whose actions are defiant and manners quite uncouth," Mi Fu characterized Li Yong's calligraphy.[64] In contrast, it is said of Shen Chuanshi that "he never used his calligraphy to ingratiate himself with men of influence, yet his colleagues were all men of the first rank."[65] Mi Fu's praise for the absence of vulgarity in Shen Chuanshi's writing, directly following his backhanded dismissal of Li Yong, suggests that his search for a personal style of calligraphy was guided in part by moral concerns. We sense Mi

Fu's belief in the concept that the writing reflects the writer, and we note his urgency in finding a remedy once alerted to the fact that his calligraphy resembled that of a man who unabashedly used his skills for mercenary gains. Such self-consciousness is the primary generator of ideas in Mi Fu's calligraphy.

Mi Fu's beginnings, with Yan Zhenqing, Liu Gongquan, Zhou Yue, and Su Shunqin, were absolutely commonplace for a young man learning to write in the 1060s—a combination of guwen values from Ouyang Xiu's circle with some lingering influence from calligraphers popular early in the dynasty. But unlike Su Shi, Mi Fu was unwilling to accept the inherited tradition. And unlike most of his contemporaries, who in the absence of paramount models were ever mindful of the latest popular style, Mi Fu developed definite ideas about what constituted good calligraphy, ideas that he flourished with refreshing conviction. It is true that Mi Fu's opinions reflect a highly independent, even eccentric, personality, but they were anything but haphazardly formed; they emerged only after years of careful looking. Ouyang Xiu, in his warning against slave writing, comments on the necessity of having a broad perspective of calligraphy: only after seeing a lot can one differentiate the genuine from the fake.[66] Mi Fu seems to have taken Ouyang Xiu's words to heart, as viewing calligraphy and differentiating the genuine from the fake became the single greatest preoccupation of his life. This approach of "traveling a thousand miles, reading ten thousand books," as Dong Qichang would later phrase it, became the means by which Mi Fu sought to establish *his* style: "In my early years I was unable to establish a personal style. People said my writing was a compendium of ancient characters, for I chose the strengths of the various early masters, combined and synthesized them. As I grew old I finally established my own style, and when people now look at my calligraphy they have no idea from what sources it developed."[67]

Proper Confucian values underlie Mi Fu's approach to the study of calligraphy, and in theory his approach was fine. In practice, however, there was a problem. There were certain biases against the graphic arts that prevented their practice and study from being taken too seriously. This was especially true for painting, but calligraphy, too, could be the object of criticism if pursued so vigorously that it impaired one's judgment. Ouyang Xiu criticized contemporaries who were so enamored with the graceful free-form epistle style writing of such Jin calligraphers as Wang Xianzhi that they used it inappropriately for writing important state documents. "Some even abandon all other activities and, injuring their vital energy and exhausting their strength, practice calligraphy as their sole undertaking in life, persisting at it until the end of their days. How absurd it is!"[68] Compare this with Mi Fu's admission of his obsession with calligraphy: "I have no desire for wealth or noble rank. My only love is for those letters from the brushes

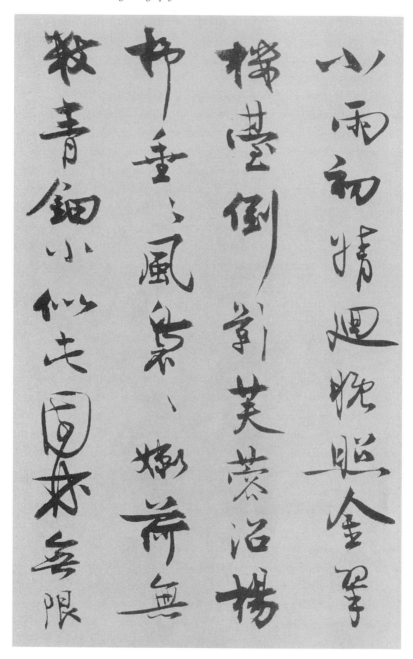

18. Wang Shen, "Poem Written on the Lake at Yingchang and Song to the Tune Dielian hua." Datable to 1086, Northern Song period. Detail of a handscroll, ink on paper, 31.3 × 271.9 cm. The Palace Museum, Beijing. From Gugong bowuyuan cang lidai fashu xuanji, vol. 3.

of the men of antiquity. Every time I clean the inkstone and spread out a scroll, I am oblivious even to the roar of thunder by my side, and the taste of food is forgotten. . . . I suspect that after I die I will become a book-eating silverfish who enters into scrolls of prized calligraphy, with gold-lettered title inscriptions and jade rollers, roaming about but without causing harm."[69]

Mi Fu could not have been the intended recipient of Ouyang Xiu's criticism— he was only twelve when Ouyang wrote it in 1064—but he would be targeted for the same faults a generation later by Ouyang Xiu's foremost follower, Su Shi. Su Shi's admonition against excessive attachment to the charms of painting and calligraphy are most clearly expressed in a prose piece written not for Mi Fu but for another incorrigible art lover, Wang Shen, who was one of Mi Fu's collector friends in the capital. Such aesthetic pursuits are healthy in moderation, Su Shi explains with the concern of one who has learned from personal experience, but are like an illness when they absorb to the point of obsession. He laughs at himself as a young man who "looked lightly upon riches and nobility yet treasured calligraphy, scorned death yet prized paintings." "Now," Su Shi writes, coining one of the more memorable metaphors in the history of Chinese art, "these things are like the mist and clouds that pass by my eyes."[70]

This was the era of celebration of the personal style in Chinese calligraphy. As an avocation, calligraphy offered a rare opportunity for the individual to explore the patterns of one's own voice relatively unencumbered by the usual expectations. The singular character of each writer's journey is borne out in their own descriptions: Su Shi, for example, is said to have likened Huang Tingjian's elongated brushstrokes to snakes dangling from tree branches (see fig. 14). Huang Tingjian returned the compliment by suggesting a resemblance between Su's crouching characters and frogs pressed under rocks (see fig. 5).[71] In a lesser-known but equally delightful comparison, Huang Tingjian suggests in Wang Shen's singular style of semicursive calligraphy the images of strange demonic creatures that he once saw in a piece of embroidery from a foreign land—some without hands and feet, some with too many (fig. 18).[72] In the absence of such an embroidery, we borrow the unusual creatures of the famous silk manuscript of Chu to illustrate Huang's description (fig. 19). "This kind of strangeness is not what is normally studied in calligraphy," Huang continues, "but Wang Shen certainly has developed his own style."

"Developed his own style" (zicheng yijia)—there is no mistaking the tone of grudging approval in Huang Tingjian's comment, and there is no mistaking the fact that this is precisely what Wang Shen had set out to do. This was an opportunity for artistic freedom and self-expression that came all too rarely to the scholar-gentry class. Commonly thrust into visible public roles, the literati were en-

19. *Details from the Chu Silk Manuscript and Wang Shen's "Poem and Song." Figures from the Chu Silk Manuscript are drawn from a photograph. The Arthur M. Sackler Collections. Photograph courtesy of the Arthur M. Sackler Foundation.*

wrapped by a complex web of restraints spun by the rules of Confucian orthodoxy and propriety. The ability of such notable public figures as Su Shi, Huang Tingjian, and others to develop intensely personal, unorthodox styles of calligraphy is testimony to the extraordinary circumstances of the second half of the eleventh century.

Later admirers have commonly grouped Su Shi, Huang Tingjian, and Mi Fu as the triumvirate representing individualism in Song calligraphy. The nature of Mi Fu's individualism, however, must be distinguished from that of his friends. In certain respects he was precisely their inverse. Whereas his colleagues dared not transgress the accepted rules of public behavior, Mi Fu wore his eccentricities on the outside—saluting strangely shaped rocks, donning the clothing of some three hundred years earlier, and never being far from a basin of water so that he could compulsively wash his hands. Yet, the sense of propriety that may too often have been missing in Mi Fu's public demeanor was the governing force in his calligraphy. Mi Fu chose to fight the immediate legacy left the eleventh century by the late Tang and Five Dynasties period calligraphers, and in this he brought a seriousness and a sense of purpose to his practice and study of the arts that in its excess was considered entirely misplaced, as the comments of Ouyang

Xiu and Su Shi demonstrate. More than any of his purported strange habits and escapades, it was the intensity of Mi Fu's involvement with the arts that established his eccentricity.

In the late eleventh century it was presumed that the style would follow from the substance of the man. Su Shi wrote of his good friend, the bamboo painter Wen Tong (1019–79), "[Wen] Yuke's prose is the dregs of his virtue, and his poetry is the hair's tip of his prose. But what his poetry does not exhaust overflows into his calligraphy. His calligraphy transforms and becomes his painting; both are the remnants of his poetry. Those who appreciate his poetry and prose are already few. Are there any who appreciate his virtue as they do his painting? What a shame!"[73] Mi Fu would not have disagreed, but because of his single-minded devotion to calligraphy, and the lifelong preoccupation with style that accompanied his study and practice, Mi Fu would often find that his own substance, or virtue, was being defined rather than represented by the appearance of his writing. This inversion of "roots and branches" (*benmo*), or what is primary and what is not, became the central paradox in Mi Fu's life.

The Style of a Connoisseur

Mi Fu declares that his personal style of writing did not emerge until late, but if a measure of stylistic signature is the consistent replication of recognizable patterns—those habits of brush movement and composition that prove individual and long-lasting—then the basic elements of Mi Fu's style are apparent well before the last years of his relatively short life. To trace how those elements became established, one must follow Mi Fu's development as a calligrapher from the late 1070s to the autumn of 1088, a moment marked by the survival of two important scrolls of Mi Fu's poetry. Mi Fu's models and his interpretation of their salient characteristics are central to our understanding of this early phase of his calligraphy, but equally important are the broader intentions that underlie his choices. As the title of this chapter suggests, a fundamental aspect of Mi Fu's early development is his self-identity as the ultimate student of his art. These ambitions may have been driven by a reaction not only to the legacy of calligraphy left by the immediate past but also to a personal legacy Mi Fu would have preferred to forget.

In the calligraphy text *Shushi huiyao* of 1376, Tao Zongyi includes the following comment about Su Shi's father, Su Xun (1009–66): "The gentleman was a skilled calligrapher, lacking something in discipline [*lü*] but with an excess of tone [*qiyun*]. The people of Shu [Sichuan] had never been good calligraphers, [but] during the Yuanyou reign [1086–94] Su Shi's calligraphy and painting began to earn wide acclaim. Although Shi's stream issued forth from Jin and Tang, in fact, he had dipped his goblet in Xun's spring."[1] Extant calligraphy by Su Xun is rare, but what exists shows a relaxed and practiced hand trained in the conservative models passed down from the Tang, and thus a logical point of departure for Su Shi's writing (fig. 20). The development from one generation to the next can be described as self-sustaining and organic—a family affair, with the calligraphy of Su Xun's other son, Su Che (1039–1112), paralleling to a remarkable degree that of his slightly older brother. And in the next generation Su Shi's two sons, Su Mai (b. 1059) and Su Guo (1072–1123), and Su Che's son Su Chi (d. 1155), confirm the family style by modeling their hands after their famous fathers (fig. 21).[2]

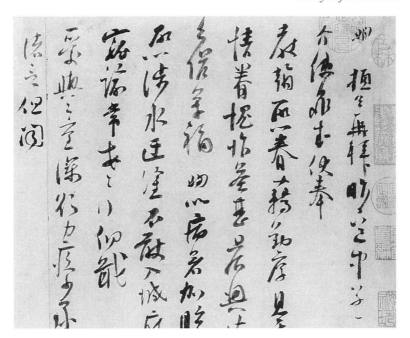

20. *Su Xun (1009–66), "Letter to the Supervisor and Vice Director." Northern Song period. Detail of an album leaf, ink on paper, 31.5 × 23.5 cm. Collection of the National Palace Museum, Taipei, Taiwan, Republic of China.*

The Su clan provides a model example of how a family style takes shape around an eminent figure. It begins in relative innocence, Su Xun's writing insignificantly settled in the prevailing patterns of his time. With the prominence of the second generation, however, the style accordingly grows in individual stature and then ossifies, as the third generation, fettered by the constraints of filial duty and the expectations of peers, self-consciously perpetuates the family image established by a famous father. Su Guo is a paramount example: known affectionately as Little Slope to his father's Big Slope (Su Shi's sobriquet was Dongpo, Layman of East Slope), Su Guo's calligraphy faithfully echoes Su Shi's. Depending on the depth of an artist's skill and prominence, the family style might then be sustained in perpetuity by later admirers.

This model largely applies to the Mi family as well, but with an important difference. There was, in a sense, no first generation, no family heritage for Mi Fu to stand on in his rise to prominence. By all accounts the family style begins with Mi Fu, and judging from his own comments and actions it begins from scratch. No one speaks of what Mi Fu inherited from *his* family, and for good

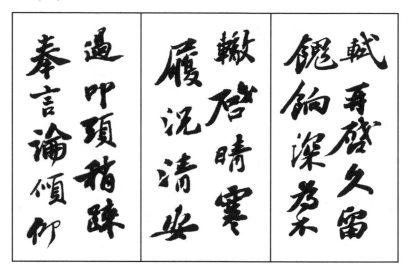

21. *Details from letters by, right, Su Shi (1037–1101), center, Su Che (1039–1112), and left, Su Guo (1072–1123). Collection of the National Palace Museum, Taipei, Taiwan, Republic of China.*

reason. According to at least one Song dynasty source, the Mi clan descended from the non-Chinese Hu people, a generic term that refers to Turkic tribes north of China's borders. More recent studies have demonstrated that the surname Mi was adopted by people who migrated east toward China from the country of Mi, or ancient Sogdiana, the land between the Amu Darya and Syr Darya Rivers now known as Uzbekistan.[3] The most important evidence of Mi Fu's family origins, however, is provided by the record of a now lost family genealogy assembled by Mi Xian, a third generation descendant of Mi Fu.[4] The first of the family line described is Mi Xin (ca. 927–ca. 993), who preceded Mi Fu by five generations. A ferocious warrior in the service of Taizu (r. 951–54) and Shizong (r. 954–59) of the Five Dynasties period kingdom of Later Zhou, Mi Xin was made general under the founder of the Song dynasty, Song Taizu (r. 960–76), and earned considerable merit first as a trusted commandant of the Palace Guard and later as a military figure in the field under the second emperor Song Taizong (r. 976–97). Mi Xin's contributions to the founding of the dynasty led directly to the clan's establishment on Chinese soil.[5]

According to his biography in the official history of the Song dynasty, Mi Xin was a member of the Xi people, a warrior tribe descended from the Xianbei (Eastern Turks) who resided mostly in the area near modern-day Chengde in Hebei Province and were known as skilled hunters of wild pigs.[6] Mi Xin's immediate family may have been centered further west around Shuozhou (Shuoxian,

Shaanxi Province). In either case, most of his kin lived in territory controlled by the Khitans north of Song borders. The story is told how Mi Xin's brother Mi Quan risked his life to cross over and "return" to Song. Mi Quan then waited expectantly in the Song frontier town of Daizhou while trying to arrange for the rest of the family to come across from Shuozhou, but they were thwarted by vigilant Khitan border troops. Mi Xin cried out, "I have heard that loyalty to one's ruler and faithfulness to one's family cannot coexist. Having decided to sacrifice my body for my country, how now can I attend to my relatives?" "He faced north and wept bitterly. Thereafter, his son and nephews were forbidden to speak of the incident."[7]

Two points in Mi Xin's biography are noteworthy. The first is the conflict that emerges between family background and Mi Xin's hard-won ties to the new dynasty. Under the surface of the short account of Mi Quan's failed attempt to bring the family across the border is a more fundamental dilemma in which Mi Xin feels he must choose between his native heritage and a future identified with the civilization of China. The finality of his choice is apparent in the command he passes on to the next generation. The second point concerns the immediate consequences of that choice. Whatever Mi Xin's intentions for the clan, he was an utter failure at displaying the civil virtues of *wen* that would come to define the Song dynasty. Because he was illiterate, he was unable to discharge his duties as prefect of Cangzhou (Hebei Province) in 989. The younger official He Chengju (946–1006) was appointed Mi Xin's assistant and essentially took over the affairs of the office while Mi Xin indulged his personal whims with little concern for the law. Mi Xin and his troops committed a number of indiscretions, including beating innocent civilians, illegally appropriating private property, and desecrating tombs. When a sick, elderly family servant was flogged to death, the court could no longer ignore Mi Xin's transgressions. He was found guilty and imprisoned, where he died.[8]

Given the martial nature of the Xi people, the court may not have been surprised by Mi Xin's barbarous ways. They did not, in any case, detract from Song Taizong's appreciation for Mi Xin's past deeds. He was awarded a posthumous title, and his son, Mi Jifeng, received the ceremonial position of audience usher at the palace. For generations the Mi family vocation remained firmly associated with the military. Mi Fu's father, Mi Zuo, for example, became general of the Left Guard. Nevertheless, by Mi Zuo's time the Mi clan was doubtless thoroughly sinified, their ancestral ways having receded into the past. Mi Zuo himself is said to have possessed the interests of a man of letters; he was fond of studying and of consorting with scholars. His wife was surnamed Yan. By this time Taiyuan, in Shaanxi Province, was considered the ancestral home of the Mi clan.[9]

According to the grave inscription written for Mi Fu by his close friend Cai

Zhao (1079 *jinshi*, or recipient of the "presented scholar" degree), the Mi family
in more recent generations had moved to Xiangyang, in Hubei Province.
Xiangyang lies in the heartland of China, well south of Taiyuan, in what was the
ancient kingdom of Chu during the second half of the Zhou dynasty. This fact
would later figure prominently in Mi Fu's attempts to forge what he considered
to be a presentable ancestral genealogy. Precisely when Mi Fu lived in
Xiangyang—if, indeed, he ever did—is difficult to determine, though the fam-
ily certainly had ties to the region.[10] A tradition of considerable age recounts that
Mi Fu first modeled his calligraphy after a stele in Xiangyang titled "Record of
the New Learning of Xiangzhou," written in A.D. 789 by Luo Rang. Luo Rang
has little reputation as a calligrapher, but if Mi Fu spent some part of his child-
hood here it is certainly possible that this stone influenced his early develop-
ment.[11]

Mi Fu was born in the last lunar month of the *xinmao* year of the Huangyou
reign of Emperor Renzong, which corresponds to the beginning of the year 1052.[12]
Cai Zhao alludes to some kind of relationship between Mi Fu's mother and Ma-
dame Cao (1032–93), wife of the royal prince Zhao Shu (1032–67), which led Mi
Zuo and his family to be invited to live in the Zhaos' official residence. This
would likely have been the mansion of Zhao Shu's father, Zhao Yunrang (995–
1059), where Zhao Shu and his wife lived after their marriage. Other sources
explain that Mi Fu's mother was a nursemaid for Madame Cao. It is unclear which
of the Zhao family children might have come under her care and when precisely
this took place, but the consequence was that Mi Fu grew up among Song dy-
nasty aristocrats. In 1063, Zhao Shu became Emperor Yingzong, thus bringing
great honor and privilege to the house of Zhao Yunrang. Two years later Ma-
dame Cao was instated as Empress Gao. Mi Fu's fortunes were in many ways tied
to this woman's power and prestige.[13]

As a child, Mi Fu thus found himself in the company of such young scions of
the imperial family as Zhao Zhongyuan (1054–1123), a grandson of Zhao
Yunrang, and Zhao Lingrang (better known by his style name Danian). These
two young men later became avid members of the elite group of art collectors
with whom Mi Fu was involved throughout his life. The core of this circle must
have formed in these early years in the Zhao family complex; the privileged envi-
ronment would certainly have fostered the practice and appreciation of the arts.
Another likely childhood friend and member of this circle was Wang Shen, one
of the most important painters of the late Northern Song. Wang Shen's family
background was somewhat similar to that of Mi Fu. His ancestor was Wang
Quanbin, another important general who contributed to the founding of the Song
dynasty, and Wang Shen, like Mi Fu, was raised near the royal family. Wang

Shen's close ties to the palace were cemented when he married Zhao Shu's and Madame Cao's second daughter, the princess of Wei (1051–80).[14] The role Mi Fu's mother played as a nursemaid for Madame Cao—possibly nursing the very child Wang Shen later married—easily explains Mi Fu's and Wang Shen's later familiar relationship.

Mi Fu was the sole son in a family of only two children.[15] According to his grave inscription, he was a bright and precocious child, able to read and commit to memory one hundred poems a day by age six. Such hyperbole is commonplace in the posthumous accounts of people of extraordinary talent, but other descriptions by Cai Zhao of Mi Fu as a youth are of genuine interest:

> He was extremely knowledgeable and well-read, but he worked at
> getting the general idea of a work and disliked following the studies that
> prepared one for the examinations. His opinions in discussions were all
> according to his own ideas. His theories and ideas were outstanding and
> sharp, so that scholars could not overturn them. He applied himself to
> literature, but never used the phrases of earlier writers. Traversing the
> unusual and treading the precipitous, for him the essential was for his
> own personality to shine forth.[16]

A picture emerges of an opinionated young man raised in privilege who follows his father's interest in letters but lacks the patience and discipline necessary for success in the examinations. Through his mother's fortuitous relationship with the empress, Mi Fu was assigned the post of collator in the Department of the Palace Library. He could not have held the post for long, however, because he was "promoted" in 1070 to be sheriff of Hanguang, in present-day Yingde Prefecture, Guangdong Province, or, as far as the eleventh century was concerned, somewhere beyond the known borders of civilization. Mi Fu later demonstrated a knack for insulting people of influence, and perhaps this explains his sudden departure for the bottom of China.

So began an odyssey that would last almost twenty years before Mi Fu would finally settle his family at Runzhou, on the banks of the Yangtze River in Jiangsu Province, and call it home. In this respect, Mi Fu literally did travel ten thousand miles in his quest for knowledge and experience, but it was knowledge and experience that seems to have been single-mindedly devoted to calligraphy. A distinct pattern of Mi Fu's life first becomes noticeable during this period of service in the deep south, as illustrated by the following account. By mid-1074, Mi Fu had been transferred from Hanguang west to Lingui, or present-day Guilin (Guangxi Province), a region of China best known today for its remarkable mountains. Here he befriended the local prefect, Guan Ji.[17] Guan owned a tracing copy of

writing by the famous early Tang calligrapher Yu Shinan (558–638) that had been discovered in a container hidden in a temple rafter. Guan must have enjoyed sharing this treasure, and whatever others he may have carried with him to this corner of China, with the discerning Mi Fu. This friendship, one of dozens Mi Fu established in coming years, proved beneficial to Mi Fu's involvement with calligraphy. Five years later Guan Ji remembered his friend Mi Fu, now in Changsha (Hunan Province), and sent him rubbings of a famous group of writings by the Tang calligrapher Zhang Xu. Mi writes that he first saw rubbings of the calligraphy as a youth and, while conversing with Guan Ji in Lingui, discovered that the stones were with the Guan clan in Qiantang (Hangzhou, Zhejiang Province) and the original ink works with the family of Lu Daxing. Three years later Mi had occasion to visit Guan Ji's elder brother, Guan Jingren (1059 jinshi), in Qiantang and see one of the originals, brought by the son of Mr. Lu, who happened to be Guan's pupil. The story does not end here. Four of the original five pieces of writing had been cut off by the important official Shen Gou (1028–67), who earlier had borrowed the scroll. Mi found Shen Gou's brother, Shen Su, who told him that the calligraphy was now with his nephew Shen Yansi. In the end, Mi Fu managed to see and acquire the four missing works.[18]

In 1075, Mi Fu petitioned the court and received permission to transfer to a low-ranking administrative post in Changsha, thus ending his tenure as sheriff of Lingui. The reason appears to have been the birth of Mi Fu's first child, Mi Youren. Twelve children would follow: four more sons and eight daughters, though most would be destined for short lives, including all of Mi Youren's brothers.[19] The Changsha clerkship was minor, but there were obvious benefits to being in a large metropolis. Lacking the customary credentials for office, Mi Fu relied almost entirely on personal recommendations from people he was able to impress firsthand. Whatever his talents as an administrator, it must have been his knowledge and skill in the arts that opened doors. All officials considered themselves cultured, and not a few owned old paintings and calligraphy. Some were genuine, most not, but in any case they were the essential trappings of status. When the matter at hand concerned antiquities, Mi Fu's growing reputation as a connoisseur raised him to a level equal with the highest ranking literati. Located in the heart of the Xiang River Valley, Changsha was the great hub of economic activity in the deep south, and its long history had left rich strata of cultural remains. Mi Fu's entrance into the city, at the age of twenty-three, marks a giant step from the wilderness of Guilin's mountains back into the civilized world.

During Mi Fu's six years in Changsha every important work of calligraphy in the area probably received his scrutiny. He formed long-lasting friendships with collectors like Wei Tai, a fellow native of Xiangyang, and Xie Jingwen (1049

jinshi), the city prefect. Most important were the numerous temples in the area, rich repositories of old calligraphy with their many stone stelae, plaques, and occasional handwritten treasures. In later writings Mi Fu mentions numerous items he saw in Changsha, but the calligrapher whose name appears most frequently is Ouyang Xun of the early Tang. Ouyang Xun was a native of Changsha, which explains the prevalence of his calligraphy in the area. It also explains Ouyang Xun's distinct influence on the earliest extant writing in handwritten form by Mi Fu, which dates to this period (fig. 22).[20] The missive is a minor adulatory verse Mi Fu presented to a superior embarking for a new post in Jiangxi, but although the content of "Poem Sending Off the Supervisor" is insignificant, the calligraphy itself is extraordinarily rare. It is unusual for so early a work by any artist to survive, but it is especially so for Mi Fu, who at age thirty is said to have destroyed all his early writings.[21] The fortuitous survival of this poem written when Mi Fu was in his mid-twenties allows the first clear picture of how his search for a personal style developed.

Equally fortuitous is the survival of an even rarer piece of calligraphy, original writing from the hand of the great Ouyang Xun himself (fig. 23). "The Oblationers of Confucius" is one of a series of writings by Ouyang collectively termed "Historical Matters." Mi Fu acquired another of the series from Wei Tai in 1079, a fact that underscores the significance this Ouyang Xun calligraphy holds for understanding Mi Fu's early style.[22] Similarities between Mi Fu's and Ouyang Xun's writing are found in the sharpness and angularity of the brushstrokes and the tightly compressed internal structuring of characters that tend to be vertically elongated (fig. 24). Ouyang Xun's calligraphy emphasizes internal structure rather than external flow, or "bone" over "blood," but this is not to deny its vitality. The flow of Ouyang Xun's writing relies on delicate balances between the energies generated from each character—a sense of movement within stasis. Such subtlety would have been difficult to learn without adopting the Tang calligrapher's meticulous attention to detail. Unfortunately, this seems to be precisely where Mi Fu's personality failed him. There is an abruptness to "Poem Sending Off the Supervisor" that betrays Mi Fu's frustration and incompatibility with Ouyang Xun's style. By trying to engender movement down his columns, from character to character, in the end Mi Fu replaces the stately grace of Ouyang Xun's writing with a jerky impatience.

The first half of a much later and celebrated self-account of Mi Fu's development as a calligrapher allows us to plot more precisely the course of his search for a style and to determine the specific juncture represented by "Poem Sending Off the Supervisor":

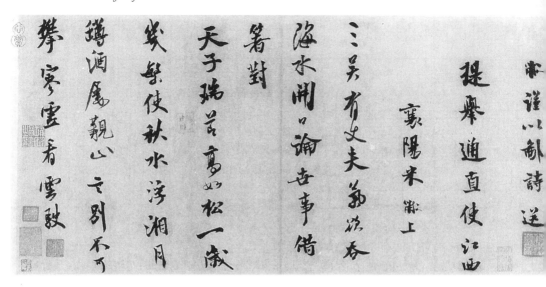

22. *Mi Fu (1052–1107/8), "Poem Sending Off the Supervisor." Datable to ca. 1080, Northern Song period. Detail of an album leaf, ink on paper, 30.6 × 63 cm. Collection of the National Palace Museum, Taipei, Taiwan, Republic of China*

At first I studied Yan Zhenqing. I was seven or eight at the time. My characters were as large as the paper itself and I was incapable of writing notes. Then I saw Liu [Gongquan] and yearned after his tight structures; so I studied Liu (his "Diamond Sutra"). After a while I realized that Liu came out of Ou[yang Xun], so I studied Ou. With the passage of time my calligraphy resembled counting slats, and I looked with longing toward Chu [Suiliang]. I studied him the longest. I also was attracted to Duan Ji [Duan Jizhan, eighth century] and his calligraphy's twists and turns and plenteous beauty. The eight sides were complete. After a while I realized that Duan had developed completely from the Orchid Pavilion Preface, and thus I began to look at rubbing compendia of model writings and entered the *pingdan* of Jin and Wei.[23]

When this account is combined with Mi Fu's other comment on his early training in calligraphy it becomes evident that two concurrent developments began to affect each other. The first is Mi Fu's study of the standard script, which began with Yan Zhenqing. He struggles with the process of learning how to build strong, viable structures and finally turns to another model of standard script writing, Liu Gongquan's "Diamond Sutra."[24] The lessons Mi Fu was learning from Yan

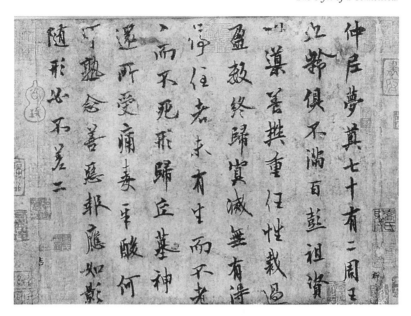

23. Ouyang Xun (557–641), "The Oblationers of Confucius." Seventh century, Tang dynasty. Detail of a handscroll, ink on paper, 25.5 × 33.6 cm. Liaoning Provincial Museum. From Tang Ouyang Xun Mengdian tie.

and Liu ultimately were not limited to his essays in standard script writing but applied as well to the structural principles for his characters in the semicursive script, which, as we have seen, were based on the writing of Zhou Yue and Su Shunqin. By the time of "Poem Sending Off the Supervisor" the two courses had begun to interact. Perhaps through exposure to Ouyang Xun's calligraphy at Changsha, Mi Fu realizes that the structural tightness admired in Liu Gongquan's writing derived from this early Tang calligrapher, whom he thereupon adopts as a new model. As he masters Ouyang Xun's density, however, Mi Fu realizes that his writing has lost its fluidity. He adjusts his calligraphy by choosing new models: Chu Suiliang and Duan Jizhan, Tang calligraphers whose writing was filled with "twists and turns." This important adjustment in Mi Fu's writing began at Changsha, if not yet with Chu and Duan, then with the calligrapher to whom Mi Fu turned in order to distance his writing from Li Yong's vulgarity: Shen Chuanshi. While at Changsha, Mi Fu borrowed for half a year a wood plaque with a poem by Shen from the Daolin Temple that he described as possessing "subtly circular, flying movements."[25] Mi Fu's attempt to bring lightness and movement to his calligraphy is noticeable in "Poem Sending Off the Supervisor," though the ensuing collision with Ouyang Xun's influence produces results that are far from ideal.

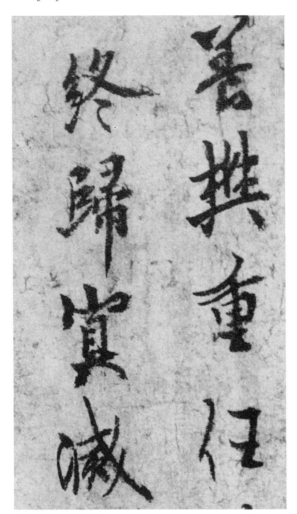

24. Details from, left, Ouyang Xun's "Oblationers of Confucius" and, right, Mi Fu's "Poem Sending Off the Supervisor."

Juvenilia is always interesting, for its immaturity can reveal influences and intentions with a particular clarity. Through its ties to Ouyang Xun, "Poem Sending Off the Supervisor" demonstrates how Mi Fu could become absorbed in the study of an earlier calligrapher. Through its modifications of that earlier writer's style it reveals Mi Fu's awakening to those qualities that accord with his understanding of who he was and who he wished to be. He could have stopped here, aged roughly thirty, harvested what he had already learned, assimilated and refined it, and like most of his contemporaries established *his* style. But Mi Fu was just

beginning, his appetite for the study of calligraphy barely whetted. He turns from calligrapher to calligrapher, adjusting this one's faults with that one's strengths and, whenever possible, analyzing those strengths by determining their sources. Consequently, it was inevitable that Mi Fu would turn from the Tang masters of the orthodox tradition to their predecessors of the Jin and Wei. This would prove a lifelong challenge, but it must have begun in relative ignorance, for in this early stage Mi Fu—as he admits in his self-account—relied largely on compendia of rubbings like the early Northern Song *Model Writings from the Chunhua Pavilion.*

25. Mi Fu, "Record of the Fangyuan Studio at Longjing." Dated 1083, Northern Song period. Detail of a Song dynasty rubbing. From Mi Fu, Song ta Fangyuanan ji.

The immediate results of Mi Fu's study can be seen in the next datable ex-
ample of his calligraphy, "Record of the Fangyuan Studio at Longjing," which
Mi Fu wrote in 1083 while in Hangzhou (fig. 25).[26] Some elements of Ouyang
Xun's style remain, but there is the sudden appearance of new morphological
types, characters whose graceful, dashing forms suggest emulation of the Jin
tradition. Interestingly, however, traditional critics have pointed not to *Model
Writings from the Chunhua Pavilion* as the source for Mi Fu's new forms but to the
famous stele of Wang Xizhi writing, "Preface to the Sacred Teachings" (see fig.
7). The overall resemblance is close, but beyond the question of direct borrow-
ing—which can be approached only through a character-by-character compari-
son—there is a certain logic to this observation that emerges once "Preface to
the Sacred Teachings" is considered for what it is. This is not a text written by
Wang Xizhi; he merely supplied the characters. The text was written three hun-
dred years later by Tang Taizong. After that a monk named Huairen artfully
combined the two after compiling an assortment of the earlier master's written
forms.[27] The idea was to bring Wang Xizhi into the seventh century, where he
could pay tribute to the emperor who appreciated him most, and one can only
admire Huairen for how well he suggests Wang's immediate presence through
his skillful integration of the compiled characters. Nevertheless, discordance is
the inevitable result when characters are transplanted from any number of unre-
lated sources. Similarly, one finds discordance in Mi Fu's "Record of the Fangyuan
Studio," with characters ranging markedly in style and tone. This, too, can be
described as a pastiche, not because it was compiled by a second party but be-
cause the calligrapher is still learning, absorbing new forms whole and undi-
gested to take their place in a growing pool of mastered motifs. The Hangzhou
stele demonstrates why Mi Fu's early calligraphy was criticized as being a com-
pendium of ancient characters.

By late 1081, Mi Fu and his family had left Changsha, traveled north to the
Yangtze River, and followed it into the Yangtze River Valley. Mi Fu's movements
over the next seven years are difficult to trace owing to the rapidity of the changes.
From Shanyang (Huaian, Jiangsu Province) to Jiangning (Nanjing) to Hangzhou
to Suzhou, Mi Fu crisscrossed the regions north and south of the Yangtze River
serving as an assistant to prominent officials and pursuing always ancient works
of calligraphy. It was a peripatetic existence but one that served his studies and
collecting well. By 1086, some sixteen years after he had left the capital for the
south of China, Mi Fu returned to Kaifeng (Dongjing). Here, and in Luoyang to
the west, Mi Fu fraternized with the most eminent of collectors. It was a trium-
phant return; he had traversed the vast span of the empire and seen as much as

any individual could possibly see. On the ninth day of the eighth month, 1086, Mi Fu proudly pronounced his expertise by writing his first chronicle detailing his experiences with calligraphy, "Record of Visits with Precious Writings" (*Baozhang daifang lu*), a record of all he had seen by the age of thirty-four. It was an impressive array of credentials to impress his friends in the capital and those collectors whose gates had not yet been breached. By the end of 1086, Mi Fu was well on his way to gaining a reputation as the greatest connoisseur in the history of Chinese art.

Entering the Chamber of Jin

Connoisseurship can be a strong determinant of style. One learns from what one sees, and the broader one's experiences with calligraphy or painting the more one sees within any given work, which ultimately benefits one's own hand and brush. This principle has been entrenched in Chinese art for much of its long history, and it explains why to this day in China art history, connoisseurship and the making of art are considered inseparable.[28] But connoisseurship also determines style in another, subtler way. Connoisseurship is elitist, nurtured on experiences gained through privilege and founded on the premise of a special gift: the sharpness of vision that can determine "the pearls from the fish eyes." Such elitism can become a powerful motivating force that colors one's art in various ways. It can lead to gamesmanship and to self-conscious displays of erudition. Most important, the exclusiveness of connoisseurship allows the artist to dwell in a realm of intangibles. Beyond the particulars of a brush technique or motif, the connoisseur-artist can exploit the mystique of this special gift and engage in what is projected as a highly meaningful communion with the secrets of the ancients. The "vulgar" will not be able to understand, and the privileged cognoscenti will receive the distinct message that what they believe they understand is but a limited portion of a greater mystery.

Exclusiveness becomes one of the defining characteristics of the Mi family style, and it first emerges in the 1080s, as Mi Fu's studies of calligraphy ultimately led him past fatie compendia to the genuine writings of the Jin dynasty. Jin writing presented the ultimate challenge to the connoisseur, who had to work his way back through generations of misrepresentation to catch a glimpse of the real thing. Mi Fu demonstrates peerless skills in this game by revealing a world of hidden secrets and duplicitous actions unknown to his contemporaries. With the tenacity of a private eye, he traces the corruption of the Two Wangs tradition to an earlier time, the reign of Emperor Tang Taizong (r. 626–49), and to a less able connoisseur, Liu Gongquan (778–865). This celebrated coup is well introduced in Lothar Ledderose's study of Mi Fu and the classical tradition of

Chinese calligraphy.[29] It is such a representative event in Mi Fu's life, however, that it bears recounting.

The controversy centered on a scroll of two short letters attributed to Wang Xianzhi owned by a dedicated collector named Liu Jisun (ca. 1033–92).[30] It bore an inscription by Liu Gongquan that explained that the first, which was known by the title "Sending Pears," had originally been mistaken as a work by Tang Taizong. Liu reattributed it to Wang Xianzhi and mounted it with the second letter, called "Longing to Speak to You," which he also attributed to the second Wang. Mi Fu agreed with Liu Gongquan's reattribution of "Sending Pears" to Wang Xianzhi, recognizing under the initial confusion a complicated relationship between Tang Taizong and Wang Xianzhi: even though the Tang emperor criticized and suppressed Wang Xianzhi's calligraphy in his active promotion of the father, Wang Xizhi, Mi Fu suggested that Taizong secretly emulated Wang Xianzhi's writing. However, Mi Fu disagreed with Liu's attribution of the second letter, "Longing to Speak to You," claiming that it was by Wang Xizhi. In his long description of his experiences with this scroll, Mi Fu lambastes Liu Gongquan as a connoisseur, mocking him for confusing, on another occasion, the writing of a Tang dynasty sutra scribe for that of Chu Suiliang. Mi Fu pronounced his reattribution in an inscription added to the scroll.[31]

How did Mi Fu's contemporaries view this display of expertise? We can gain Su Shi's perspective from an exchange of poems that must have taken place about the same time. According to Su Shi's commentators, the year was 1087. Power was in the hands of the conservative Yuanyou Party, with which Su Shi was associated, and he and many of his friends were stationed in the capital. Taking great pride in his restoration of Liu Jisun's scroll, Mi Fu composed three poems and circulated them among the talented members of this circle. They were rhymed by Huang Tingjian (1045–1105), Jiang Zhiqi (1031–1104), Lü Shengqing (1070 jinshi), Lin Xi (1057 jinshi), Liu Jing (1073 jinshi), and Yu Zhang, whose poems, along with two more by Mi Fu, were inscribed on a scroll that contained a Tang tracing copy of another letter by Wang Xianzhi, "The New Bride, Fan."[32] Su Shi's two poems, for reasons that soon become apparent, were not included by Mi Fu. First Mi Fu's three poems:

> The Zhenguan signature on this scroll of two pieces, a yard in length,
> Will not allow the son's rarity to eclipse the father's beauty.
> Why are treasures like this now so rarely seen?
> Encountering disaster, the genuine meet with the perils of water and flame.
> One thousand years later who can continue the path?
> If not a master of his own, indeed no way to know.

Hi ho! Just arrived, my eyes I must clean,
Jade rollers and gold title slip are halfway to Mi!

Cloud forms, dragons, and snakes in abundance stir the paper,
The Two Wangs, father and son, truly inherited the ways of the past.
How could Yu Yi's children come close to resembling this?
One might as well compare the limitless ocean to the puddle in a horse-hoof track.
Bounding snakes are without feet, squirrels have many toes,
To trade a fake for the real thing you must be "in the know."
Though already cracked and bleached from scrubbing I wash my hands some more,
When it comes to keeping a scroll from smudging, who can compete with Mi?![33]

The tear is straight, the fibers even, indeed it is ancient paper;
Seals and inscriptions of many years: beauty before vulgar eyes.
Chengxuan mistook that which looks like but is not;
There must be a Wei River before the Jing's waters can be known.
Genuine and fake, head and face, fists, heels, toes;
Long among the spurious, it determines the wise from the dopes.
When this precious scroll is unrolled my heart is thoroughly cleansed;
Who among the hundred clans will pass this scroll to Mi?

Mi Fu's poems have a delightfully nonsensical quality appropriate for what could only have been considered a frivolous subject. Nevertheless, under the playful, self-mocking tone lies a persistent message that reflects a certain seriousness, and ironically it is this seriousness that provides the true humor in the poems. The Zhenguan signature in the first poem refers to Tang Taizong, ruler during the Zhenguan reign. His name had probably been falsely added to "Sending Pears" by someone who mistook Wang Xianzhi's calligraphy for that of the Tang emperor. The consequence of this mistake is raised in the second line, which also alludes vaguely to the suppression of Wang Xianzhi's calligraphy that took place under the aegis of Taizong. Mi Fu establishes himself as the one who can determine the true from the false. In contrast there is Chengxuan (Liu Gongquan), whose connoisseurship in the third poem is likened to the murky waters of the Jing River.[34] The object of admiration is the writing of the Two Wangs, supreme masters of their art. Mi Fu uses the story of Yu Yi (305–45) to establish the Wangs' inimitability. When serving in Jingzhou (Hubei Province), Yu Yi complained that the younger generation all practiced the style of Wang Xizhi simply because his calligraphy, like a wild pheasant, was rarely seen. Yu Yi likened his own calligraphy to that which is too familiar to be valued—the domestic chicken.[35]

Two last points about these poems are noteworthy. The first is Mi Fu's admis-

sion to an obsession with cleanliness found at the end of the second poem, thus confirming at least one of Mi Fu's celebrated quirks. The second is his uncontained excitement over the expected acquisition of this prized scroll. The last line of the first poem suggests that a deal may already have been arranged. Mi Fu describes how Liu Jisun had agreed to exchange the scroll for the hefty sum of two calligraphies by Ouyang Xun, a set of six snowscapes by Wang Wei (699–759), a belt made of rhinoceros horn, a coral tree in a jade stand, and an inkstone shaped like a miniature mountain. The last item, however, was borrowed by the mischievous Wang Shen, who failed to return it. In a letter written to Liu Jisun, we find Mi Fu trying to restructure the price by offering in addition calligraphy by the Tang cursive master Huaisu, "and the inkstone mountain will be returned tomorrow," he promises. But in fact Wang Shen did not return the inkstone until two days after Liu left for a new post, and the deal was scuttled. In the end, much to Mi Fu's chagrin, this now celebrated scroll with the calligraphy of the Two Wangs was sold to another collector at twenty times the price originally paid by Liu Jisun.[36] This presumably took place after Su Shi wrote his poem, and his admonitory tone is thus proved justified.

> Following the Rhymes of Mi Fu's Verses Inscribed after the Two Wangs' Calligraphy (one of two)
>
> The Imperial Library suns its scrolls to prevent the harm of insects,
> And a glimpse is caught of [Wang Xizhi's] "Crabapple" and "Green Plum."
> Autumn snakes and spring worms long entangled together,
> Wild pheasant and domestic chicken—which is to be judged more beautiful?
> Jade case and golden flute have descended from the heavens;
> The purple-robed imperial messenger honors me with the announcement.
> Profuse and abounding they pass by my eyes, not easy to recognize;
> Jumbled and chaotic, hung on the wall: clouds twisting in the void.
> The marvelous idea of returning home I alone pursue;
> For twenty autumns I have sat and dreamed of the magic mountain of Peng.
> I ask you, Sir, where on earth did you ever find this scroll?
> Surface stains—oil from the cakes Huan Xuan served years ago.
> Clever thieves and extorting brigands have been known since ancient times,
> But who resembles Foolish Tiger-head when it comes to a single smile?
> Have you not seen, Sir, the Yongning District of the capital at Chang'an?
> Who will repair the broken walls of the mansion of the Wangs?[37]

Su Shi begins his poem by dragging Mi Fu's treasure down to a level of mundane materiality. Transience is the theme, following Mi Fu's lead, only now it is not the apocalyptic that threatens the preservation of the calligraphy but the natu-

ral course of physical decline: insects eating paper, cleverly turned into decomposable fruit with the summoning of a famous work of calligraphy by Wang Xizhi.[38] The third line is particularly cruel. Autumn snakes and spring worms are the metaphors Tang Taizong used to dismiss Wang Xianzhi's calligraphy, which, he claimed, did not present the air of a gentleman.[39] By reducing the calligraphy to an entangled and unappealing mass of serpentine forms, Su Shi dismisses Mi Fu's connoisseurship as a matter of inconsequence. He confirms this with the following line's rhetorical question, using the allusion of Yu Yi and Wang Xizhi to oppose Mi Fu's judgments of quality.

The middle portion of Su Shi's poem teasingly contrasts an imperially dressed Mi Fu, conveyor of the important proclamation that great treasures have descended from the sky, with himself, ingenuously appreciating the "clouds and mist" that pass by his eyes. He demonstrates the true value of the calligraphy, which is the opportunity it provides through association for self-reflective musing: the great age of the calligraphy and the milieu of the Two Wangs prompt Su Shi to think of the famous poet Tao Yuanming (365–427), who gave up the petty life of the bureaucrat to return home; the graceful cloudlike forms of the writing perhaps remind Su Shi of the legendary immortal islands of the Eastern Sea, whose mountain peaks were said to appear from afar like twisting clouds. The focus shifts subtly to Su Shi himself, creating a contrast with those who collect only for the sake of collecting, those who fix their minds on objects and who thus, as he warned Wang Shen, risk calamitous ruin.

The final six lines bring the contrast to its conclusion. Perhaps troubled by Mi Fu's boast of being able to trade upward at the expense of the unknowing, Su Shi moralizes. The reference to Huan Xuan (369–404) appears at first to be a compliment to the calligraphy's great age and value—an anecdote recounts how this famous early collector regrettably served a greasy snack to some careless guests handling his treasures. It soon becomes apparent, however, that the focus of the allusion is Huan Xuan, a rapacious scamp who was not above stealing valuable artwork. One of his victims was the painter and celebrated tomfool Gu Kaizhi (ca. 344–406), or Tiger-head, who once sent a sealed chest containing his most precious paintings to Huan Xuan. Huan opened the chest from the rear, stole the paintings, repaired the chest, and sent it back looking just as it had arrived. When Gu Kaizhi discovered that the paintings were missing he remained angelically nonplused and exclaimed, "Marvelous paintings communicate with the numinous—they have transformed and departed, like a human ascending to become an immortal."[40] What happens to the collections of men like Huan Xuan? The last allusion is to another famed collector, the Tang dynasty official Wang Ya, who spent countless sums in gold and influence amassing a tremendous col-

lection of painting and calligraphy, which he housed in an elaborate system of safes in the walls of his house. When Wang became embroiled in a court intrigue and lost his life, the walls of his home were torn down, the precious gold and jade baubles were removed, and the paintings and calligraphies were discarded in the streets.[41] In a word, Su Shi's poem is a warning about the vagaries of collecting art and a pointed suggestion to Mi Fu that he expend his energies on more worthwhile activities.

Mi Fu first met Su Shi in autumn 1081, when he and his young family, having left Changsha, passed through Huangzhou, in present-day Hubei Province, the site of Su Shi's first exile. Su Shi's years in Huangzhou (1080–84) were extremely important for his development as a poet and calligrapher, and Mi Fu seems to have been impressed by his painting as well.[42] Yet one wonders how much these two men had in common. In utter contrast to Mi Fu, who was then beginning to establish his identity as a connoisseur and collector, Su Shi wrote during this period in Huangzhou that he now saw ancient works of art and curios as no better than dung.[43] A near-contemporary of Mi Fu is quoted as saying that Mi Fu began to study Jin calligraphy after Su Shi advised him to do so when they met in Huangzhou.[44] But Su Shi was never a vocal supporter of Jin calligraphy. In his middle years, writes Huang Tingjian, Su Shi took inspiration from Yan Zhenqing and Yang Ningshi, two of the three calligraphers Huang also indicates are sources for Su Shi's Huangzhou masterpiece, "Cold Food Festival Poems Written at Huangzhou" (see figs. 5, 6). It is possible that an eleventh-century writer saw some spiritual, if not stylistic, kinship between the untrammeled Yang Ningshi and Jin calligraphy, but nothing could be further from the elegance of the Two Wangs than the muscular forms of Yan Zhenqing.

The differences between Mi Fu and Su Shi should not be misconstrued: their friendship was genuine and Mi Fu clearly hungered after the elder man's respect. Nevertheless, the differences are also very real and important. Their personalities and to a certain degree their values were different, resulting in diverging paths toward the development of their styles. Mi Fu, cultured free spirit, was drawn like a magnet to Jin writing. Su Shi, the statesman, placed it in a broader perspective. He genuinely admired its grace and élan, but he also recognized its incompatibility with the voice of public responsibility. In this regard, Su Shi followed the lead of his mentor, Ouyang Xiu, who deeply admired the short personal notes of such figures as the Two Wangs but recognized their style as fundamentally incompatible with public service. For the public voice there was the style of the great Tang minister Yan Zhenqing, praised by Ouyang Xiu for presenting an image of stalwart integrity: "I would say of Yan's calligraphy that it resembles a loyal minister, an exemplary scholar, or a morally impeccable gentle-

man. It is so correct, severe, serious, and forceful that upon first glance it is intimidating. But the longer one looks at it the more attached one becomes to it."[45]

A strong sense of ambiguity pervades the comments on Jin calligraphy by such Northern Song writers as Ouyang Xiu, Su Shi, and Huang Tingjian. For every praiseworthy inscription there is one that criticizes. This ambiguity has diverse and complex underpinnings, but one in particular stands forth: the graceful beauty of the calligraphy, which was susceptible to an association with weakness, superficiality, and obsequiousness.[46] There was no ambiguity, however, in Mi Fu's decision to champion Jin dynasty calligraphy, just as in later years he had little hesitation in expressing his distaste for Yan Zhenqing's calligraphy, to which the more he looked the more *unattached* he became. There is no greater testimony to Mi Fu's independence and the strength of his personality than the minimal influence Su Shi seems to have exerted on him in matters of calligraphy.

Mi Fu's interaction with Jin calligraphy would prove to be a watershed event in the history of Chinese calligraphy. Almost single-handedly he resurrected the tradition, established its monuments and standards while weeding out the chaff, and defined its aesthetic parameters. His exploration of Jin writing may have begun simply as an extension of young Mi Fu's studies of calligraphy and exercises in connoisseurship, but he quickly recognized in its style those characteristics to which he naturally aspired for his own writing. Its sense of movement and grace bespoke an untrammeled, detached beauty that appealed to the connoisseur's sense of exclusiveness. Most important, what one saw in the forms of the calligraphy was informed by the rich lore associated with the men of Jin. Jin was romantic and refreshing, defined by anecdotes of men ever in pursuit of the refined, the natural, the spontaneous. Their wit, their eccentricities, their utter distaste for the vulgar—all struck a note of accord with Mi Fu's personality. Mi Fu turned to these figures of the fourth century almost as if they were an adopted family, revealing in the process an extraordinary familiarity with every aspect of their lives and art. It is not an exaggeration to say that the Jin became Mi Fu's personal legacy.

Mi Fu's discovery of Jin calligraphy during the 1080s coincided with his presence in the gentle, riverine landscape of Jiangnan, the land south of the Yangtze River where the Jin dynasty had been centered (map 3). From Hangzhou, probably in 1084, Mi Fu moved to the cultured city of Suzhou. Here genuine works of Wang Xizhi and Wang Xianzhi, as well as careful Tang dynasty tracing copies, were available for study in the collections of the Su and Ding families. Mi Fu's own collection increased dramatically during the year or two he spent in Suzhou, as a number of old families in economic difficulty were forced to sell their collections through elderly female brokers. The most important treasure Mi Fu ac-

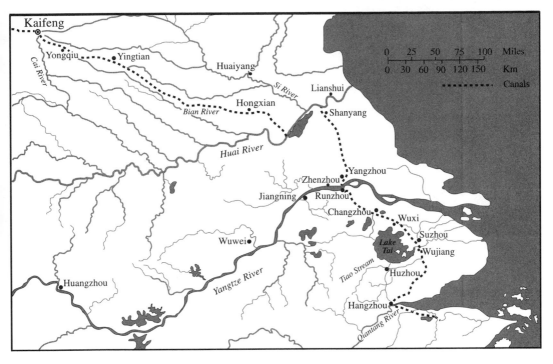

Map 3. The Huainan East and West Circuits (ca. 1100).

quired was Wang Xianzhi's "Twelfth Month," which came from his good friend Su Ji in 1084 (see fig. 31). Mi Fu received two more important works of Jin calligraphy from Su Ji two years later in Kaifeng: Wang Xizhi's "Clearing after a Sudden Snow" and a scroll with the writing of thirteen Jin calligraphers.[47]

The fruits of Mi Fu's study of Jin calligraphy are readily apparent in the next two dated works of his calligraphy, "Poems Playfully Written and Presented to My Friends, About to Embark for Tiao Stream," and "Poems on Sichuan Silk" (figs. 26, 27). Together, these two scrolls offer a rare extended glimpse into the life of Mi Fu at a moment in time. By the sixth month of 1088, Mi Fu had left the capital and was back in Jiangnan residing in Wuxi, just north of Lake Tai. Lin Xi, the prefect of Huzhou, on the south shore of Lake Tai, invited Mi to participate in an outing along the Tiao Stream. Mi Fu responded with the first scroll of six poems, dated the eighth day of the eighth lunar month. During their excursion Mi Fu composed a number of other poems, seven of which Lin requested his young friend to transcribe on a piece of treasured silk from Sichuan that had been in his collection for twenty years. "Poems on Sichuan Silk" is dated the twenty-third day of the ninth month.[48]

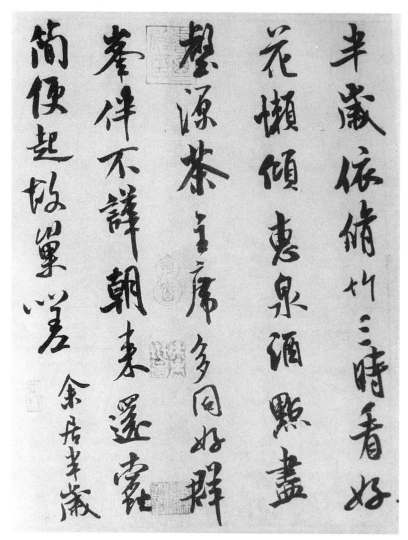

26. *Mi Fu, "Poems Playfully Written and Presented to My Friends, About to Embark for Tiao Stream." Dated 1088, Northern Song period. Detail of a handscroll, ink on paper, 30.3 × 189.5 cm. The Palace Museum, Beijing. From* Gugong bowuyuan cang lidai fashu xuanji, *vol. 3.*

The influence of Jin dynasty calligraphy on Mi Fu's writing is apparent at a glance. "Poems Written About to Embark for Tiao Stream," in particular, written on paper with fluid, even brushstrokes, demonstrates a fundamental affinity with the fine Tang dynasty tracing copies that best exemplify Wang Xizhi's calligraphy (see fig. 3). But it takes more than a glance to understand what has happened to Mi Fu's calligraphy. Character-by-character comparisons between the 1088 scrolls and Mi Fu's earlier calligraphy reveal that many of Mi Fu's character

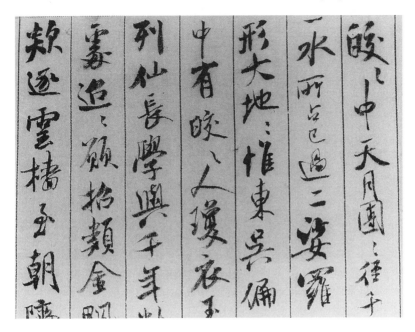

27. Mi Fu, "Poems on Sichuan Silk." Dated 1088, Northern Song period. Detail of a handscroll, ink on silk, 27.8 × 270.8 cm. Collection of the National Palace Museum, Taipei, Taiwan, Republic of China. Chang *is the third character of the fifth column from the right.*

compositions have in fact not changed at all. What is different is the calligraphy's unity. Within the playful dancing movements lies the confidence of a hand that no longer hesitates as it writes. Sudden morphological shifts between styles are still discernible if one looks closely enough, but what initially gave an appearance of disarrangement is now made smooth, even personal.

With his vocabulary of forms set, style for Mi Fu becomes largely a matter of choosing how to inflect his voice, and, as a number of the poems on these two scrolls demonstrate, in 1088 it was a voice fine-tuned to the thoughts and lives of men who lived some seven hundred years in the past:

> I remain by pine and bamboo in the summer,
> And go wandering to the streams and mountains in fall.
> Long I have been chanting the tune "White Snow,"
> Now I continue with the song "Picking Waterchestnuts."
> Threads of jade: perch heaped on the table,
> Masses of gold: oranges fill the isles.
> An endless vista of the Water Palace,
> A travel with Lords Dai and Xie.

The life of leisure that Mi Fu describes in this first poem written in preparation for the Tiao Stream travel is that of a man among hills and streams. Away from worldly concerns, he occupies himself with a new song, one whose tune is rooted in the lore of Jiangnan. Geographical space exists in a timeless cultural continuum: the Lords Dai and Xie with whom Mi Fu anticipates his outing are Dai Kui (died in 396) and Xie An (320–85), two colorful figures of the fourth century.[49] Past and present merge in a fantasy inspired by Mi Fu's immersion in Jin calligraphy. The oranges filling the isles of the sixth line, for example, refer not to the autumn landscape near Lake Tai but to a specific note written by Wang Xizhi that mentions his presentation of a gift of three hundred oranges.[50] Indeed, the second poem of the Tiao Stream series cannot be understood properly without considering Mi Fu's total involvement with the world of the fourth century read from those brief letters:

> Half a year amid stately bamboo,
> Viewing fine flowers spring, summer, and fall.
> Lazy, my preference is for Hui Spring Wine,[51]
> And I brew endless pots of mountain water tea.
> My hosts are all men of similar tastes;
> The many peaks provide peaceful companions.
> Morning I return worm-eaten epistles,
> And give rise to sighs for the "old nest."

> I have resided here half a year. The gentlemen have constantly plied me with wine, and I have been hurrying from one gathering to the other for fine feasts and pure conversation. Moreover, I have borrowed calligraphy from Masters Liu, Li, and Zhou.

The last line of Mi Fu's verse strikes an incongruously sad note with the rest of the poem until one realizes that his lament is probably dislocated in time. It has nothing to do with Mi Fu in autumn 1088, at which time there probably was no place that Mi Fu could even call "old nest." The plaint, rather, is that of an empathetic and imaginative Mi Fu who relives the escape and exile into the south following the collapse of the Western Jin in the early fourth century. It was a flight of fancy probably inspired by the content of those ancient letters Mi was borrowing from his friends Liu, Li, and Zhou.[52]

The clearest demonstration of how the persona Mi Fu chose to project could be informed by his studies of calligraphy is found in the fourth poem of the "Sichuan Silk Poems" scroll. Lin Xi's party is celebrating the Double Ninth Festival, held on the ninth day of the ninth lunar month, with the customary drinking of chrysanthemum wine and the picking of the red *zhuyu* plant to ensure long

life. Mi Fu uses the occasion to recall the famous gathering at the Orchid Pavilion, which took place on the spring purification festival in 353, and the most celebrated work of calligraphy ever written, Wang Xizhi's preface to the poems composed by the members of the party that day (see fig. 8). Mi Fu quotes Wang Xizhi's "Orchid Pavilion Preface" in the fourth line of his poem:

Gathering at the Prefectural Tower on the Double Ninth Festival

Mountains pure, air bracing, Double Ninth of autumn,
Yellow chrysanthemums and red zhuyus fill the floating skiff.
Vows made over a thousand miles, will they come to pass?
"All the worthy men have arrived"; I unworthily sit before them.
Young Du, the idle guest, is he here today?
Magistrate Xie's romantic airs have been told since days of old.
Alone holding autumn flowers, what is the reason why?
As I grow older my feelings incline toward the writing of poems.

Melancholy reflections on mortality had been deeply associated with the Double Ninth Festival ever since Tao Yuanming wrote a poem on the subject in the fifth century, and indeed, Mi Fu suggests the presence of this poet recluse, holding his beloved chrysanthemum, at the end of the verse.[53] In this regard, Mi Fu's skillful blending of the Orchid Pavilion allusion is entirely natural, as Wang Xizhi's preface, too, takes as its theme the passing of time and the fragility of life. Young Du, of the fifth line, is Du Yi, a delicate youth of refined and gentle airs who died prematurely. By questioning Du Yi's whereabouts Mi Fu not only carries forth the theme of mortality but also subtly suggests a personal identification with Wang Xizhi, for it was Wang's description of Du Yi's beauty that defined this young man's image for later times.[54] Mi Fu's quotation from the "Orchid Pavilion Preface" in the previous line, in any case, already implies the identification, which must be considered both outrageous and immodest regardless of his protestations of unworthiness. Lin Xi, the party's host, is graciously awarded the role of Magistrate Xie An.

One might argue that Mi Fu's reference to the "Orchid Pavilion Preface" in "Gathering at the Prefectural Tower on the Double Ninth Festival" was simply inspired by the festive circumstances of Lin Xi's party and the appropriateness of the preface's content to the poetic tradition established. The "Orchid Pavilion Preface," however, had most certainly been on Mi Fu's mind in the autumn of 1088. Earlier in the year, probably on the eve of his departure from the capital, he had obtained a superb Tang dynasty tracing copy of the masterpiece from Su Ji in exchange for a number of paintings. Mi Fu's scrutiny of this tracing copy is evident in his careful description of individual characters, and as Lothar Ledderose

28. *Details from, left, Mi Fu's "Poems Playfully Written and Presented to My Friends, About to Embark for Tiao Stream," and, right, copy of Wang Xizhi's "Preface to the Poems Composed at the Orchid Pavilion" attributed to Feng Chengsu (see fig. 8).*

has pointed out, there is evidence in his composition of one of these characters on the "Sichuan Silk Poems" scroll to suggest that he was putting his study into practice: the compression of the two internal horizontal *heng* strokes in the upper half of the character *chang* (long) are exactly as Mi Fu describes in this version of the preface (see fig. 27).[55] Such subtleties may have been lost on all but the most informed of connoisseurs, but Mi Fu, no doubt, would have been happy to point them out, presuming that he brought his prized tracing copy of the "Orchid Pavilion Preface" with him on the outing.

An interesting detail in the "Poems Written About to Embark for Tiao Stream" scroll is worth mentioning in this regard. The fifth character in the first line of Mi

Fu's third poem, *you* 友 (friend), appears as an unsightly blemish, written over a
number of times with a massive charge of ink (fig. 28). One presumes that Mi Fu
had first written another character he then wished to change. Corrections of mis-
taken characters are common, appearing in many of the greatest works of callig-
raphy. Normally, however, a small deletion mark is simply made next to the mis-
take. Mi Fu used such marks, for example, near mistaken characters in the "Sichuan
Silk Poems" scroll, so why this unattractive solution for "Poems Written About
to Embark for Tiao Stream"? A number of times in the original "Orchid Pavil-
ion Preface" Wang Xizhi altered characters in his composition of the text, the
final one being the last character, which was changed from *zuo* 作 to *wen* 文 (fig.

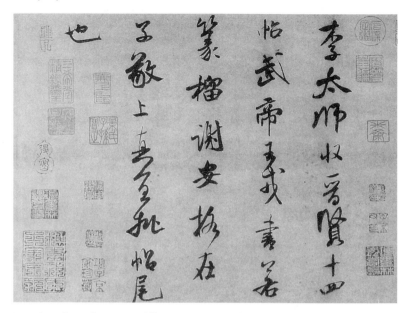

29. Mi Fu, "Grand Preceptor Li." Ca. 1086–88, Northern Song period. Album leaf mounted as a handscroll, ink on paper, 27.3 × 34.3 cm. Tokyo National Museum.

28). In each case Wang Xizhi wrote directly over his initial choice. Perhaps Mi Fu's misshapen *you* is not a correction at all but rather a conscious evocation of Wang Xizhi's preface. The compositional structure of *you* is closely related to *wen*, and when it came time to write the character there may well have been temptation to play this connoisseur's game.[56] With this less than subtle hint, Lin Xi and company would have recognized the bold announcement of the imminent arrival of a new sage of calligraphy, a Song dynasty Wang Xizhi.

It was said of Mi Fu that his voice was so loud and penetrating that those who heard it instantly knew who it was, even if they had never met him before. If Mi Fu did not speak one still might recognize him by his penchant for dressing in the fashion of some three centuries earlier.[57] This was a man who sought attention, and as the 1088 scrolls show, Mi Fu used his talents and understanding of calligraphy to attract it. But although his immersion in Jin calligraphy and culture may have been eccentric, it was not superficial. For the remaining twenty years of his life Jin calligraphy would absorb most of his attention, his understanding and appreciation of it evolving over time. In many respects, to study Mi Fu's style is to study his study of style, for the changing aesthetic values that he chose to emphasize in the earlier calligraphy provide the clearest indication of the changing values in his own writing.

Fortunately, Mi Fu was not shy about voicing his opinions, and he used more than the recorded word to express them. Periodically, Mi Fu wrote notes on various aspects of the arts, predominantly calligraphy, which are distinct from anything anyone else ever wrote. What makes them unique is how Mi Fu fashioned his calligraphy to provide a graphic correspondent to the content of his note. The first to appear are two short comments titled "Grand Preceptor Li" and "Zhang Jiming" that were probably written together on a single scroll by Mi Fu sometime in the latter half of the 1080s (figs. 29, 30). Although their content at first appears unrelated, they are united by Mi Fu's calligraphy, which pronounces a single standard of style.

> The Grand Preceptor Li has in his collection a scroll with the calligraphy of fourteen sages of the Jin dynasty. The writing of Emperor Wudi and Wang Rong is like the archaic seal script. Xie An's character was superior to that of Zijing [Wang Xianzhi], and it was certainly appropriate that he appended his notes to the end.

> I have collected a short missive written by Zhang Jiming [Zhang Xu] that reads, "It is deep autumn. I do not know if your health has returned or not." The calligraphy is a mixture of standard and semicursive scripts. It is Aide Zhang's number one tie extant. Next comes "He Eight." The others cannot even be considered calligraphy.

The first note describes a celebrated scroll owned by Li Wei, an important collector Mi Fu knew in the capital.[58] In his comment Mi Fu mentions three of the calligraphers represented on the scroll: Jin Wudi (r. 265–90) and Wang Rong (234–305), whose writings' archaic qualities fascinated Mi Fu, and Xie An, the eminent fourth-century statesman and cultural figure. A well-known early story told of the high-minded Xie recounts how he repeatedly rebuffed the younger Wang Xianzhi's attempts to impress him with his calligraphy by sending Wang's letters back with his answers appended, rather than keeping them.[59] Mi Fu's second note concerns his acquisition of the Tang calligrapher Zhang Xu's "Deep Autumn," one of the original group of five tie in the collection of the Lu clan of Hangzhou that Mi Fu learned about from Guan Ji in Lingui. Together with one other work of calligraphy, it was the only writing by Zhang Xu about which Mi Fu had anything positive to say.[60]

Both of these notes concern elitism and rejection, and Mi Fu's calligraphy, unparalleled in its technical refinement and cool beauty, perfectly matches the theme. Although Wang Xianzhi does not appear in a positive light, his presence informs both notes. As Lothar Ledderose and Nakata Yūjirō have pointed out, the third line of "Zhang Jiming" is written with the so-called one-stroke tech-

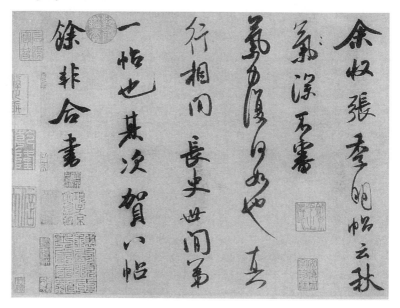

30. *Mi Fu, "Zhang Jiming." Ca. 1086–88, Northern Song period. Album leaf mounted as a handscroll, ink on paper, 27.3 × 32.6 cm. Tokyo National Museum.*

nique associated with the calligraphy of Wang Xianzhi, specifically his "Twelfth Month" (fig. 31), which Mi Fu acquired in 1084 and described thus: "The brush in this tie moves like a firehook drawing in ashes. The strokes are continuously connected with neither beginning nor end. It is as if he wrote it unconsciously. This is the so-called one-stroke writing. It is the number one piece by Wang Xianzhi under heaven."[61]

Wang Xianzhi may have written unconsciously, but the same can hardly be said for Mi Fu and these two notes. It is clear that he has carefully studied the one-stroke technique and employed it here, connecting characters to evoke the spirit of Wang Xianzhi. Both notes establish Mi Fu's alliance with Jin. In "Grand Preceptor Li" he responds to the scroll of fourteen Jin masters—the connoisseur sorts out their specific merits. In "Zhang Jiming" there is such certainty in the tone of his comments that Mi's attitude exceeds condescension. Song rejects Tang by affirming its destiny with Jin, and we are shown the essence of Jin in a single line of cascading characters: ribbons in the wind—the very image of untrammeled ease. Mi Fu writes that after studying the calligraphy of Shen Chuanshi he changed many of his characters to the style of Wang Xianzhi and captured his "conception of being aloof from the crowd."[62] Nothing could better describe the

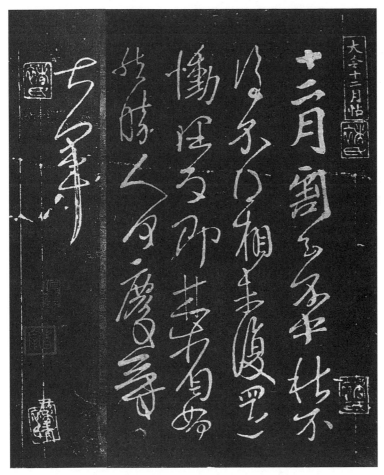

31. Wang Xianzhi (344–88), "The Twelfth Month." Rubbing from Bao-Jinzhai fatie. *From* Song ta Bao-Jinzhai fatie, *juan 1.*

aloofness that Mi Fu perceived in his mentor's writing than his calligraphy in these two notes.

Judging from the fact that the character *zhang* (*chang*) in "Zhang Jiming" does not reveal the influence of the Su family copy of the "Orchid Pavilion Preface," it is possible that "Grand Preceptor Li" and "Zhang Jiming" predate the poetry scrolls of 1088 by a year or two, in which case the orientation of Mi Fu's calligraphy perhaps shifted subtly from Wang Xianzhi to Wang Xizhi, son to father, guided by his acquisition of those two influential works of calligraphy. In the larger scheme of things it matters relatively little. Mi Fu may have had a clear

distinction in mind between the calligraphy of the Two Wangs, but it is enough for us to be aware of his awareness. We can adopt Su Shi's position—autumn snakes and spring worms entangled together—and simply recognize that for Mi Fu in the late 1080s Jin calligraphy represented the epitome of grace. At this moment in time, as his personal hand emerges, this was the image to which Mi Fu's style aspired. From a broader perspective we recognize that by 1088 the first stage in the development of Mi Fu's style has largely culminated. It is defined less by the specific models he adopts than by the more fundamental truth that his style is that of an artist who would dedicate his life to pursuing the secrets of his art.

Styles In and Out of Office

A portrait of the Yuan dynasty painter Ni Zan (1301–74) presents the quintessential image of the refined connoisseur (fig. 32). He sits with paper and brush in hand, promising the imminent descent of some inspired note or verse from the elevated altar of culture. An inkstone and roll of scrolls are his emblems of state. On the table to his left lie other insignia of the Chinese collector, including a brush-rest in the shape of a mountain. Guardlike, a servant holds his standard: a feather fan ready to fend off the ill winds of vulgarity. The flanking maiden displays the last line of defense: basin and towel for whatever lingering flecks of mundane dust might threaten to soil the artist's hand. Behind the aloof Ni Zan are his "hills and valleys," a backdrop that suggests his ideal realm of naturalness and purity. Expansive and placid, the landscape accords with this image of the man himself, calmly seated above a soiled world like a white lily floating on a still pond.[1]

The distinct echoes of the earlier connoisseur Mi Fu in Ni Zan's portrait are not coincidental. According to an accompanying encomium by Zhang Yu (1283–1350), Ni Zan thought of Mi Fu as a soulmate across time, and one is thus prompted to wonder whether Ni Zan's celebrated eccentricities, compulsive cleanliness foremost, were not to some degree modeled after his Northern Song predecessor. In any case, the image por-

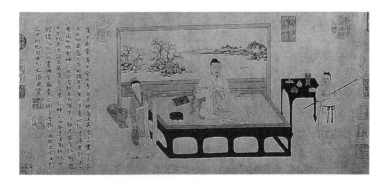

32. Anonymous, "Portrait of Ni Zan." Ca. 1340, Yuan dynasty. Handscroll, ink and light colors on paper, 28.2 × 60.9 cm. Collection of the National Palace Museum, Taipei, Taiwan, Republic of China.

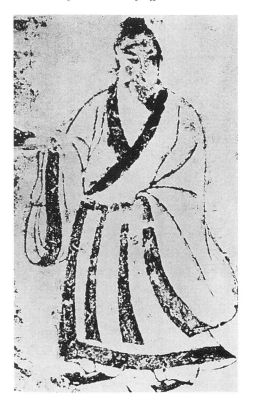

33. Left, Mi Fu, "Self-Portrait." Rubbing from an engraving at Fubo Hill, Guilin, Guangxi Province. From Shoron *11, p. 83.*

34. Right, attributed to Gu Kaizhi (ca. 345– ca. 406), "Admonitions of the Court Instructress." Detail of a handscroll, ink and colors on silk, 25 × 349.5 cm. The British Museum.

35. Anonymous, "Portrait of
Zhong You, Disciple of
Confucius." Formerly attributed to
Li Gonglin (1049–1106). 1156,
Southern Song period. Rubbing
from an engraving at the Confucius
Temple, Hangzhou, Zhejiang
Province. From Li Gonglin
shengxian tu shike, 10.

trayed here of the scholar at leisure is an archetype, and one that is largely formed
on the perception of Mi Fu by later generations. But is this how Mi Fu viewed
himself? And how did he appear to his contemporaries?

Consider a rubbing taken from a worn engraving of Mi Fu's self-portrait (fig.
33).[2] With robe loosely fashioned and chest partly bared, Mi Fu portrays himself
as the casual and gallant scholar. Both arms rise to the left, the same direction his
lower body moves, but his upper body twists toward us, and his head turns back
to the right. It is as if Mi Fu portrays himself in a moment of animated conversa-
tion, excitedly explaining one point, with two fingers of one hand extended, while
his attention is suddenly pulled in the opposite direction. The pose is clarified by
a detail from a much earlier painting, "Admonitions of the Court Instructress,"
attributed to the Jin dynasty painter Gu Kaizhi (ca. 344–406) (fig. 34). In the
famous rejection scene ("No one can endlessly please; affection cannot be for
one alone") a gentleman is shown in similar contraposto, turning back to rebuff
a pursuing woman. Mi Fu admitted a special debt to Tiger-head when it came to

his figure painting ("I adopt the lofty antiquity of Gu," he wrote), so the resemblance is not coincidental, but there are subtle differences in the presentation of this corkscrew posture. Gu Kaizhi's figures all maintain a quiet decorum, even in the most animated scenes. The energies generated by his gossamer lines and poses always pull inward, as if moving in self-contained circles. The same is not quite true of Mi Fu's self-portrait. The bottom of the robe, the sleeves, and the gesturing hand all propel the figure's energies outward with centrifugal force. Inspired by what he knew of Gu Kaizhi's painting, Mi Fu portrays himself as a man of Jin to speak of lofty antiquity. This, however, is the image of a man who speaks it a little too loudly.

The irrepressible energy that was Mi Fu is always apparent. It is what differentiates his calligraphy from that of the Two Wangs, just as it distinguishes his self-image from Gu Kaizhi's figures. Unclear as he appears in this rubbing, he stands in contrast to his reputed admirer, the fastidious Ni Zan. Confirmation of that difference is apparent in Huang Tingjian's incisive and not entirely flattering evaluation of Mi Fu's calligraphy: "I once critiqued Mi Yuanzhang's writing as being like a swift sword that mows down a phalanx of troops, or like a powerful bow unleashing an arrow that travels a thousand miles before piercing its target. A calligrapher's brush force can go no further than this. It also, however, somewhat resembles the character of Zhong You* before he met Confucius."[3]

According to the Han dynasty historian Sima Qian, the young ruffian Zhong You* was fond of martial heroics, wore a chicken-feather hat, carried a sword in a pigskin scabbard, and was known for his straightforward if vulgar and rambunctious nature until he encountered the civilizing influence of Confucius and became his disciple.[4] That blustery nature is well suggested in a twelfth-century portrayal of Zhong You*, which is added to our small picture gallery of personae and alter egos (fig. 35).

Ni Zan's and Mi Fu's portraits are acts of presentation. They depict their subjects as the subjects wished to be seen. As Huang Tingjian reminds us, however, this portrayal can sometimes be in contradiction of the real picture. For centuries, commentators have dutifully applied Mi Fu's high praise for what he calls the lofty antiquity of Jin to his writing, yet to do so is simply to accept a portrait at face value, to ignore the motivations, intentional posturing, and, ultimately, real achievements of a complex person. Emulation of the Two Wangs was only the end of the beginning for Mi Fu. With the emergence of a settled hand by the late 1080s, Mi Fu turns his attention to modulating it, so that his calligraphy is able to communicate different ideas and moods, to present himself, so to speak, in a variety of guises.

This chapter and the one that follows treat Mi Fu's calligraphy during the 1090s. This is a decade of radical stylistic shifts in Mi Fu's writing, as the con-

noisseur-calligrapher considers appropriate manners of presentation to accord with personal and cultural perceptions. Underlying the twists and turns is a familiar paradigm: the contrast between the restrictive social codes of Confucian propriety, associated with the rites and regulations of court or official life, and the unrestricted freedom of the Daoist who seeks communion with the greater forces of nature among hills and streams. Ni Zan's position in his portrait metaphorically suggests the narrow middle ground between the dust of public service below and the unsullied landscape of reclusion behind. In the first half of the 1090s, Mi Fu learns of both firsthand and adjusts his calligraphy accordingly.

From Immortal of Chu to Magistrate of Yongqiu

In the 1080s the combination of Jiangnan's beauty with Jin dynasty history and art allowed Mi Fu to discover a home. His wanderings would continue, but there was now a place to which he could return. It only remained for him to decide on Runzhou, the modern-day city of Zhenjiang, as the place where home would be centered. Conveniently located where the Grand Canal meets the Yangtze River, Runzhou was a thriving economic and cultural center in the late eleventh century. It was, moreover, a beautiful city, facing the Yangtze with the islands of Jiaoshan and Jinshan on one side and backed by rounded, forested hills that meander into the city from the southern suburbs (see map 2). Mi Fu adopted Runzhou, but in a sense it was merely the roost from which he could survey a much broader realm. When Mi Fu rebuilt his Studio of Oceans and Mountains on a hill slightly east of the city, his young friend Zhai Ruwen (1076–1141) literally immortalized Mi Fu and the studio in a poem that begins,

> Mi, Immortal of Chu, prefers "tower-living";
> He plants firmianas atop a lofty hill and builds an elegant studio.
> He gazes down upon the crimson realm, housing toad-moon and crow-sun,
> East to west he juggles marbles, dashing across the heavens.[5]

In the Han dynasty it was believed that winged immortals called *xian* could be lured to earth to drink the dew that gathered in basins held by their bronze replicas set atop lofty terraces, "because immortals like tower-living."[6] More than a thousand years later a different kind of immortal descends to earth, not for dew, but for the beauty of oceans and mountains. As Zhai Ruwen suggests, Mi Fu's domain extended at least as far as the ancient realm of Chu to the west, the southern state that included Mi Fu's native home, Xiangyang, in Hubei Province.

Mi Fu fancied himself a man of Chu. His signatures and seals make this abundantly clear: "The Reckless Scholar of Xiangyang," "The Layman of Deer Gate Mountain" (near Xiangyang), "Mi Fu of Chu," and so forth. But Mi Fu's

identification with Xiangyang and Chu was not limited to physical territory alone. With such monikers as "Mi Fu of Danyang" he sought to establish roots with the very beginnings of Chu history—Danyang was the original site of enfeoffment of the state of Chu. Then there were such sobriquets as "The Descendant of Huozheng" and "The Descendant of Yu Xiong." *Huozheng*, Regulator of Fire, was the office of Zhong Li, a meritorious official during the reign of the legendary Emperor Ku who was a fifth-generation descendant of the Yellow Emperor and third-generation descendant of Gao Yang, progenitor of Chu. Yu Xiong was a sagely adviser to King Wen of Zhou. His grandson, Xiong Yi, was enfeoffed in the land of Chu with the surname Mi. Xiong Yi's clan lived in Danyang.[7]

Mi Fu's choice of sobriquets can be dismissed as artistic conceit, but they may also reflect personal insecurities. These attempts to establish historical connections with the earliest moments of Chu culture are extraordinary because they run directly counter to the fact of his own foreign ancestry. This was no joking matter in the Song dynasty, and others would not allow Mi Fu's true beginnings to rest forgotten. In an official document from later in Mi Fu's life that charges him with various forms of pernicious behavior it is pointed out that Mi's familial origins were "lowly and muddled."[8] This is precisely why Huang Tingjian's critique of Mi Fu's calligraphy is so biting; a contemporary familiar with the Mi family background could not but see a connection between the well-meaning but uncivilized Zhong You* and Mi Fu's brutish ancestor, Mi Xin, and, if one goes back far enough, with a tribe of people (the Xi) known primarily for their skill in hunting wild pigs. A desire to shed familial origins also underlies Mi Fu's attempt to change his name, which according to Weng Fanggang's (1733–1818) analysis took place in 1091, just as Mi Fu was settling into his life in Runzhou.[9] It is well known that Mi Fu changed the character of his personal name Fu 黻 to Fu 芾, but as a note by Mi Fu reveals, his surname was also involved, and an extremely clever if dishonest pun: "Fu Fu 芾芾 : this is a merging of personal name and surname. The surname of the kingdom of Chu was Mi 米 ; Mi 芈 is the ancient character. Bend the ends of the lower horizontal stroke and you have Fu 芾 ."[10]

The character for the original surname of Xiong Yi's clan in Chu was Mi 芈 (the sound of a bleating sheep), not Mi 米 (rice), and Mi Fu knew this. He turns Mi Fu 米黻 into Mi Fu 米芾 and pretends that this is simply another way of writing Mi Mi 芈芈 , or a doubling of the surname of the progenitors of Chu. By sleight of hand, a Turkic tribe thus becomes the original people of Chu. Here is Huang Tingjian's reaction to Mi Fu's nonsense:

Mi Yuanzhang, affixing his signature and in his use of seals, sometimes writes Mi 米 , sometimes Mi 芈 , sometimes Fu 芾 , sometimes Fu 黻 .

Fu 黻 and Fu 芾 can be interchanged, but Mi 芈 is the surname of Chu, while the Mi 米 clan originated in the country of Mi in the western regions. Their ancestors entered China and used their country's name for a surname.... It is not like Lou 樓 and Lou 婁 or Shao 邵 and Shao 召, which come from the same ancestries. A surname is something that cannot be changed under any circumstance. Just because the sounds are similar is no justification for mixing them and making them one.[11]

Huang Tingjian's appreciation of Mi Fu was tempered by his sense of propriety, something Mi Fu seems to have tested in everyone. In a society governed by rules of decorum the nonconformist was regarded with suspicion by some, admiration by others, curiosity by all. A favorite pastime of those who knew Mi Fu was to debate his sanity. Huang Tingjian seems to have convinced himself that Mi Fu was not crazy, though his reasons are not particularly convincing: "Mi Fu, Yuanzhang, in Yangzhou plays with brush and ink, and his name is quite well known. His headgear, belts, and clothing are often unconventional. His actions and speech are generally governed by his own ideas and feelings. People often call him crazy, but when one looks at the way the lines of his poems come together one knows that he is anything but crazy. This man just does not wish to associate with vulgar people, and his 'off-the-track' behavior is intended to startle the vulgar."[12]

Huang Tingjian deduces premeditation in Mi Fu's unconventionality, but if such premeditation existed it was motivated by the desire to emulate the great paragons of unconventionality, such as the Seven Sages of the Bamboo Grove, or the untrammeled men of fourth-century Jiangnan. Mi Fu may have been in possession of his faculties, but he was not exactly normal, and it seems unlikely that his unusual behavior was simply for scaring off "the vulgar."

Mi Fu gave full rein to his imagination, and it roamed through the history and folklore of China with the lightness of a xian immortal. Runzhou's landscape lent itself well to Mi Fu's fanciful wanderings. When the mist hangs low over the Yangtze River the water's expanse seems endless, with only the islands of Jinshan and Jiaoshan faintly visible. At times Mi Fu would ascend the Ganlu Temple's Duojinglou (Tower of Many Scenes), which overlooks the river atop Beigu Hill, in order to pursue what he called "grand vistas" (*zhuangguan*). A poem he wrote on one such occasion, undated but probably of this first period in Runzhou, circa 1091–92, well demonstrates how he reached at once outward and backward—out to the rivers and mountains below him, back to the time of ancient legends (fig. 36):

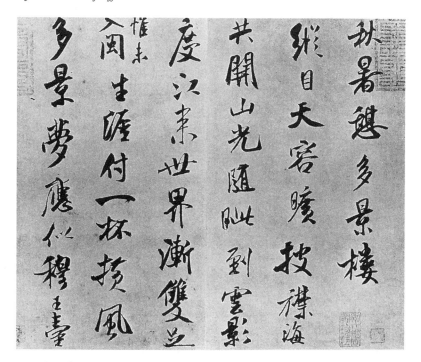

36. *Mi Fu, "Poem Written Resting in the Tower of Many Scenes during the Autumn Heat."*
Ca. 1090–92, Northern Song period. Album leaf, ink on paper, 27.6 × 34.3 cm. The Palace
Museum, Beijing. From Chūgoku shodō zenshū, *5:8.*

Resting in the Tower of Many Scenes during the Autumn Heat

I unleash my eyes—heaven yields its breadth,
And untie my robe—the sea joins in opening.
The glow of mountains follows to where my gaze alights;
The shadows of clouds come toward me, crossing the river.
This world traversed by these two feet (I have only missed Min),
This life entrusted to a single goblet.
Crosswinds, dreams of many scenes;
The terrace of King Mu must have been like this.

The terrace of King Mu of Zhou (r. 1001–946 B.C.), built specifically for a
star-treading shaman who had earned the king's admiration, exhausted the impe-
rial coffers, stood seven thousand feet high, overlooked the tops of the Zhongnan
Mountains, and was called the Tower in the Middle of the Sky.[13] With this refer-
ence Mi Fu suggests that he be compared with those ancient magicians who sported
with the xian immortals and whose fabulous journeys through the heavens, ap-

propriately enough, were best known from the ancient anthology of poems from the kingdom of Chu, *Chu ci*.[14] Mi Fu's persona is *haofang*, "unbridled and heroic." The haofang character is one of action, and Mi Fu's credentials are well established by the fact that by age forty he has seen most of the empire, having missed only Min (Fujian Province). In this poem, however, the ultimate measure of Mi Fu's unbridledness resides in his very stillness and the magnetic power he wields over an attentive landscape.

Mi Fu remained in Runzhou until 1092. He held a minor post as instructor in the prefectural school, but his duties must have been minimal. These were years of leisure and comfort, spent in the company of such old friends as Lin Xi (now prefect of Runzhou) and devoted to the continued collecting and studying of calligraphy. In an inscription added years later to some of Mi Fu's copies of Wang Xizhi calligraphy from about this time, Mi Youren describes how his father never let a day pass without unrolling his treasures to study and copy; nor could he sleep at night if they were not first gathered into a small container and placed by his pillow.[15] Runzhou had been an important center during the Six Dynasties period, and it would seem that Mi Fu continued to live its dream, inspired both by the beauty of the landscape and by the ancient letters he kept by his bedside. At home in Runzhou, Mi Fu was, as Zhai Ruwen called him, the Immortal of Chu.

Mi Fu had slowly nurtured the persona of the haofang free-spirit over the course of his journeys through Jiangnan in the 1080s. Increasingly, however, this persona becomes linked in a specific manner to Runzhou itself. The reason for this is simple but important: Runzhou would always be the home to which Mi Fu returned from periods in office, the spiritual and spatial domain in which Mi Fu could pursue an unfettered existence. At this stage of his life the distinction may not have been clear, for Mi Fu had not yet truly tasted the constraining circumstances of office-holding. Over the next few years, however, the pattern develops with increasing sharpness, and with important consequences for Mi Fu's calligraphy. Through his studies of Jin writing Mi Fu recognized an expected correlation between lifestyle and handwriting. Specifically, he was aware of a story that involved an ancient rivalry between Wang Xizhi and Wang Shu (303–68). Wang Xizhi thoroughly despised Wang Shu, whom he described as morally upright and boring. When Wang Shu went into mourning after his mother's death, Wang Xizhi, who had replaced Wang Shu as administrator of Kuaiji, was purposely insulting during his single condolence call. Mutual animosity grew over the succeeding years until Wang Shu, much to Wang Xizhi's horror, was appointed his superior as regional inspector of Yang Province. The subsequent detailed investigation of Kuaiji's finances that Wang Shu initiated revealed improprieties in Wang Xizhi's handling of the area's taxes. Humiliated and embittered, Wang Xizhi claimed illness and retired from office. He vowed before his

parents' graves never again to serve as an official and spent his remaining years happily wandering the beautiful landscape of the southeast in the company of fishermen and Daoists.[16] Mi Fu explains the effect this had on his calligraphy in the following short note written about some unidentified writing by Wang Xizhi: "As one finds the official seal of capital supervisor affixed the calligraphy has an air of vulgarity. It is not until the general of the right's [Wang Xizhi] late years that his calligraphy becomes marvelous, and this accords with his period among mountains and forests. In my collection is a letter Wang Xizhi wrote to Wang Shu while serving in Kuaiji. Constrained, it is tainted with vulgar, dusty airs. This is certainly proof."[17] The significance of this story for Mi Fu is proven by the title that Mi Fu chose for his original collected works: *Shanlin ji,* or *Writings of Mountains and Forests.*

The calligraphy of Mi Fu's poem written atop the Tower of Many Scenes has an expansive quality. The structures are generously spaced and the horizontal heng strokes are markedly flexed to convey the power of the heroic spirit that has generated this haofang verse. A comparison of individual characters found here and in the poem scrolls of 1088 reveals a slower, more even tempo in the Runzhou poem and a more precise attention to individual strokes, as Mi Fu elicits the full and solemn majesty of his moment atop the world. The writing may be a little too early to be called Mi Fu's calligraphy of "mountains and forests," but it is not inappropriate to consider it an adumbration of one side of the paradigm's equation. Mi Fu would become acquainted with the other side after his posting to Yongqiu (Henan Province) in the summer of 1092 (see map 3).

The only real measure of personal and family success in traditional China was one's official career, and claims to the contrary—expressed yearnings for a life of reclusion far from the dusty entanglements of court politics—were still reactions to this basic truth. Mi Fu's promotion to district magistrate of Yongqiu thus was an important and felicitous occasion. The nearness of Yongqiu to the capital made the position particularly attractive; it meant that Mi Fu could once more fraternize with the talented men of Su Shi's circle. Su Shi himself had been experiencing the ups and downs of court life: he had left the capital for an assignment to Hangzhou in 1089, been recalled to Kaifeng in 1091, transferred to Yangzhou in 1092, but was then recalled once more, this time to serve as minister of war and minister of rites—his highest official positions—in that autumn of that same year.

How did the Immortal of Chu adapt to the regimen of responsible administration? Fortunately, Mi Fu could adopt another persona that made the transition surprisingly natural, that of the fabled Daoist sage described in Laozi's *Daode jing,* who "keeps to the deed that consists in taking no action [*wuwei*] and prac-

tices the teaching that uses no words." "Do that which consists in taking no action, and order will prevail,"[18] the quietist philosophy pronounces, and Mi Fu, judging by a letter titled "Abundant Harvest" that he wrote early during his tenure at Yongqiu, found this good advice for good government. At least, he claims to have reached this enlightened stage already, as he offers "experienced" counsel to an unnamed colleague who, as an apparent novice at governing the common people, was not quite ready to leave behind the benevolent activism of a good Confucian (fig. 37):

> In my district we are blessed with an abundant harvest and no matters of concern. It has been enough for me to cultivate incompetence while receiving a salary. There is no need to do [*wei* 為] anything. But you, good Sir, first assuming the role of the central axis about which all revolves, should lead the people to the virtues of humaneness and longevity. The district magistrate follows the prevailing current while spreading his own civilizing influence. Daily he wipes his eyes clean and inclines his ear [in anticipation of the sage teachings of the emperor], and slowly he and his subjects together are moulded and transformed. That's all there is to it.[19]

In spite of its pretensions, Mi Fu's letter appears to be entirely serious. Judging from this and at least two other letters he wrote while at Yongqiu, Mi Fu relished his role as magistrate, for it gave him the opportunity to demonstrate that his capabilities were not limited to the arts. In one letter, for example, Mi Fu boldly offers his services to an influential official in the directorate of waterways to solve the serious "river problem" outside of Kaifeng, adding in a postscript his own succinct hypothesis of the nature of the Bian River between the capital and Yingtian (Shangqiu, Henan Province).[20] In another, titled "Many Laborers," we find that when Mi Fu dropped the wuwei facade and did do something, this quickly led to delusions of grandeur. In reference to a public works project he boasts of his leadership, having mobilized the common laborers like imperial guardsmen (fig. 38): "We marched solemnly through the prefectures, two men abreast, without making a sound. The work was finished three days ahead of schedule. Chief Zhang, Supervisorates Bao and Lu, the construction foreman's office, and the left storehouse all considered our work the best of the various municipalities. What do you think? If I had 120,000 men like this, with me leading the way, we would take control of the Helan range. And that's no joke!"[21]

The Helan range was north of Song borders, just outside the capital of the hostile Xi Xia state of the Tangut (in modern-day Ningxia Province). Because the region had long been considered Chinese territory, recovering it, as well as

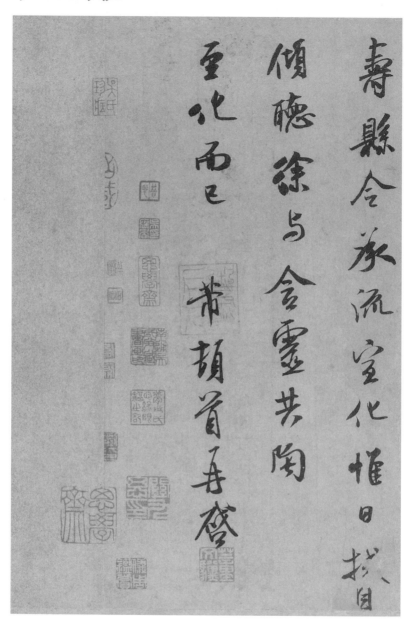

37. Mi Fu, "Abundant Harvest" (from "Three Letters"). Datable to ca. 1092, Northern Song period. Album leaf, ink on paper, 31.7 × 33 cm. The Art Museum, Princeton University. Anonymous loan. Photo by Bruce M. White.

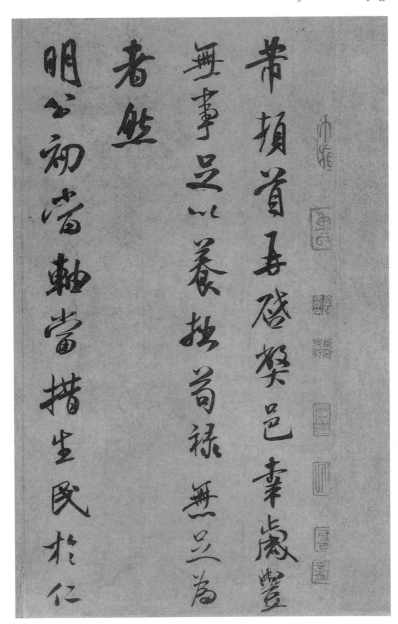

帶頓首再啓樊邑幸歲豐
無事足以養拙苟祿無足為
者然
明公初當軸當措生民於仁

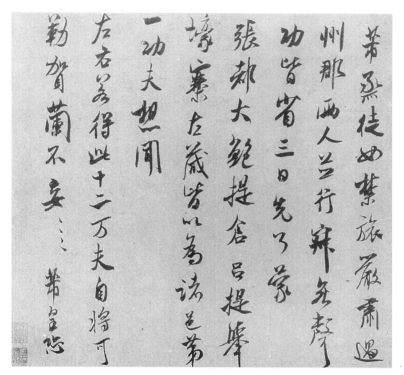

38. Mi Fu, "Many Laborers." Ca. 1092, Northern Song period. Album leaf, ink on paper, 29.9 × 31.6 cm. Collection of the National Palace Museum, Taipei, Taiwan, Republic of China.

some of the other northern border areas, was a dream that the Northern Song court had never relinquished. Mi Fu's claim, of course, was pure bluster—more fuel for those who insisted that he was crazy.

Unfortunately for Mi Fu, the job of district magistrate involved more than he describes in "Abundant Harvest." Twice a year taxes had to be collected and presented to the court, and when the harvest was ruined by inclement weather the burden on the common people could be overwhelming. Heavy rains inundated central China in early 1093, and by the fourth month it was apparent that Yongqiu would have difficulties paying its summer taxes. Mi Fu found himself in the ironic position of at once attempting to collect relief from one bureau of the government while another bureau came to expedite payment of owed revenues.[22] In a letter that Wen Fong relates to these events we find Mi Fu "escaping the

summer heat," a possible reference not only to the hot weather but to judicial commissioner Lin, who had come to investigate the delay in payment (fig. 39). Mi Fu and family had left Yongqiu for a mountain hideaway, where he planned to remain until autumn.[23] Ultimately, however, there was no escape from dealing with his superiors, and sometime in late 1093 or early 1094, Mi Fu's dispute with the circuit supervisor came to the attention of the court of judicial review. Mi Fu appears to have been cleared of charges, but he nonetheless requested to be relieved of his duties on account of illness. Or at least so he claimed. It is clear that during the course of this affair Mi Fu had offended important people, and although the court granted his request by assigning him the honorary sinecure of superintendent of Zhongyue Temple, the post signified a demotion owing to the improper handling of his official duties.[24] The Zhongyue Temple literally refers to the Chongfu Palace atop Mount Song in Henan Province, the central peak of the five sacred mountains of China. Mi Fu's position as superintendent, however, entailed few if any responsibilities, and he was free to pass his tenure at his home in Runzhou. Thus ended Mi Fu's first true taste of the world of officialdom in 1094. Much of the Yongqiu affair—Mi Fu's improper handling of taxes, personal conflicts with regional inspectors, and petition to be relieved of his charge owing to illness—bears a striking resemblance to Wang Xizhi's experiences with Wang Shu seven hundred years earlier. Mi Fu must have appreciated the coincidence.

The extant letters written at Yongqiu provide an excellent introduction to Mi Fu's genius as a calligrapher. The letter, or personal note, precisely because of its casual nature and presumed spontaneity, was especially prized in China as the genre of writing that most directly and truthfully reflected the person behind the brush. When calligraphy first began to be recognized for its self-expressive potential in the first century, letters of notable personalities with fine writing skills were carefully preserved by their recipients. Three hundred years later the art of letter writing attained a peerless level of refinement and appreciation in the Jin dynasty. The reason why the anecdote of Xie An returning Wang Xianzhi's letters with his own answers appended was so celebrated is that it illustrates an insult of the most sophisticated order: by not keeping the Lesser Wang's writing, Xie An was essentially telling him that his calligraphy, and by consequence his person, commanded little attention. That Xie An and Wang Xianzhi were so conscious of the potential aesthetic value of their letters suggests a degree of artifice underlying their spontaneity. Nevertheless, in the Song dynasty it seems to have been an unquestioned belief that these fourth-century letters and notes were written in a thoroughly unself-conscious manner, "the whimsy of their free-flowing brushes splattering and splashing the page," as Ouyang Xiu wrote.[25] This

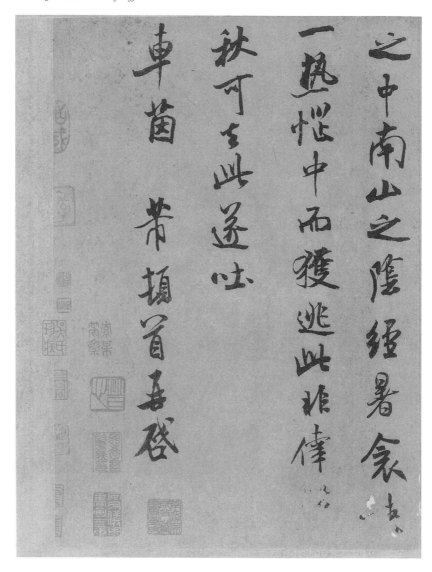

39. Mi Fu, "Escaping Summer Heat" (from "Three Letters"). Datable to ca. 1093,
Northern Song period. Album leaf, ink on paper, 30.9 × 40.6 cm. The Art Museum,
Princeton University. Anonymous loan. Photo by Bruce M. White.

芾頓首再啟芾逃暑

山壑辭安適人生幻法中

為瘵而熱為惱諒以貴

所同者熱耳 評蓺右清

was the tradition to which Mi Fu considered himself heir, fully recognizing that the format of the letter allowed him to present in the most direct way possible his two greatest assets: his personality and calligraphic skill.

The importance that Mi Fu placed on his letters is well demonstrated by "Many Laborers" and "Abundant Harvest," two letters that must have been written fairly close in time (1092–93) yet with styles that are remarkably unalike. "Many Laborers" was written quickly and with the brushtip mostly slanted (see fig. 38). The thin, razorlike strokes give an overall impression of cutting speed and lightness. This style well expresses the ease and effectiveness with which Mi Fu marshaled his army of laborers to finish the project three days ahead of schedule. Because this style is also employed in "River Problem," Mi Fu's other letter bragging about his engineering abilities, we may assume that Mi Fu intended this style of writing to represent his skill as an active leader (fig. 40). For the image of a *nonactive* leader, however, we find something different. In "Abundant Harvest" the brushtip is mostly centered and the brush moves at an even pace to form characters of a classical elegance (fig. 41). The style speaks of easy grace—prosperity realized simply by moving along with the rhythms of the great Daoist Way. The orderliness of the writing conveys the impression of good government and civilization, the responsibilities of the district magistrate.

These interpretive descriptions may not be exactly what Mi Fu had in mind, but that matters less than the simple recognition that in these two letters Mi Fu is attempting to communicate different messages to different people and does it with great skill. With an impression in mind, a mood, he trusts his brush to present it, preserving the illusion of absolute spontaneity. These styles may correlate specifically to those of earlier writers, as Wen Fong has suggested, but it is also possible that the nuance of personality and emotion that these letters demonstrate transcends art-historical typology. The third letter, "Escaping Summer Heat," well illustrates this. The fundamental style is that of "Abundant Harvest": the style of the district magistrate who does best by doing nothing. Now, however, the brush stutters and there is a ragged edge to the style's clean veneer (fig. 42). Whatever the source of the rising temperature and Mi's problems, one senses a pensive and disturbed frame of mind behind the brush. An attempt is made to present the transcendent élan of the author of "Abundant Harvest"— according with the letter's description of the Mi family's good fortune to have found a cool mountain where they can sleep under covers, far from the world's vexations—but the persona, nevertheless, appears to be wilting. One need only compare the first character of both letters, Mi Fu's name, Fu 芾, at the upper right, for a graphic illustration of the change (fig. 43). The proud, strutting form of "Abundant Harvest" seems to be saddled with a heavy weight in "Escaping

40. Mi Fu, "River Problem." Circa 1092, Northern Song period. Detail of an album leaf, ink on paper. Collection of the National Palace Museum, Taipei, Taiwan, Republic of China.

41. Detail of "Abundant Harvest." Photo by Bruce M. White.

42. Detail of Mi Fu's "Escaping Summer Heat." Photo by Bruce M. White.

43. The character Fu from, left, "Escaping Summer Heat" and, right, "Abundant Harvest." Photos by Bruce M. White.

Summer Heat": the shoulders sag, the arms droop; the whole character barely stands upright on a vertical post that appears in danger of imminent collapse. Perhaps if Mi Fu saw this letter again later in life he would have seen the same inhibited, dusty airs that tainted Wang Xizhi's letter to Wang Shu.

Landscape and Calligraphy

Late in life, gravely ill and close to death, Su Shi visited the Buddhist temple on Jinshan, the Yangtze River island just off Runzhou's shores, where he encountered a portrait of himself painted some years earlier by his close friend Li Gonglin (ca. 1049–1106). Su Shi inscribed a short poem on the painting and addressed a pressing question:

> This mind is already ash from wood,
> And this body like an unmoored boat.
> I ask of your accomplishments in life—
> "Huangzhou, Huizhou and Danzhou."[26]

Huangzhou, Huizhou, and Danzhou are the three places of exile to which Su Shi was banished during his checkered official career, and his likeness's response to the question he poses thus sounds ironic and resigned. The allusions in the first half of this poem, however, suggest otherwise. They are drawn from the Daoist classic *Zhuangzi* and refer to the superior man who, unencumbered by worldly ties, transcends the caprices of emotion to realize a natural existence in accordance with the Dao.[27]

In a society where government service was the only realistic path to status and financial reward, it may seem strange that banishment, whether in its most extreme form as exile or as the more common demotion or forced retirement, could be viewed positively. But this was a long-standing perspective, and one

that Su Shi knew firsthand. Demotion meant removal from the center, removal from the unpleasantries of political infighting. Victors in such skirmishes were often viewed as unscrupulous manipulators, whereas losers could earn acclaim for uncompromising integrity, their punishment a consequence of personal virtue. Demotion and exile were understood as a journey to the wilderness, to landscape. Whatever this meant in real terms, symbolically, banishment represented an opportunity to pursue the Daoist ideal of self-cultivation, and it could be highly romanticized. In a poem added to the painting of a paradisaical landscape by his friend Wang Shen, Su Shi notes that he, too, once knew a place like this, a magical place like the fabled Peach Blossom Spring, where for five years Su Shi passed the four seasons in drunken sleep. That place was Huangzhou.[28]

Another important aspect to the view of the failed scholar who journeys to the hinterlands was the belief that deprivation of the privileges of officialdom would cause him to write genuine, hence superior poetry. When the hard-luck poet Meng Jiao (751–814) was dispatched to a lowly post in 803, his friend Han Yu consoled him with the reminder that it is when one is in a state of disequilibrium that one sounds forth, *buping er ming*, or, in other words, creates great literature.[29] Northern Song scholars, considering such earlier figures as the reclusive landscape poet Meng Haoran (689–740), Du Fu, Meng Jiao, and Mei Yaochen of their own dynasty, associated the suffering of poverty with direct experience of landscape and good poetry.[30] Expectations of one's artistic performance were thus often heightened during periods out of office.

Certainly this is one reason Su Shi's "Cold Food Festival Poems Written at Huangzhou" has been so highly regarded throughout history (see figs. 5, 6). Educated viewers have always known the significance of Huangzhou, where Su Shi became the Layman of East Slope and defined the lasting image of the sage poet who learns to appreciate the simple, unadorned pleasures of rural life.[31] More important, Su Shi seems to have had related expectations when he wrote "Cold Food Festival Poems." The boldness of the writing—its singular lack of restraint—is the consequence of a conscious pursuit of naturalness to accord with the role Su Shi saw for himself during this first period of exile:

The spring river is about to enter the window;
The rain's force comes without cease.
A small hut like a fishing boat,
Lost amid water and clouds.
In an empty kitchen I boil cold vegetables;
In the broken stove I burn damp weeds.
How do I know it is the Cold Food Festival?
Crows are seen carrying paper money in their beaks.

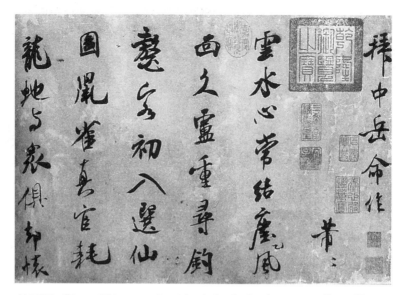

44. *Mi Fu, "Poems Written upon Receiving Orders for the Zhongyue Post." Datable to 1094, Northern Song period. Detail of a handscroll, ink on paper, 29.3 × 101.8 cm. The Palace Museum, Beijing. Mi Fu's signature, "Fu Fu," is seen in the second column from the right. From* Gugong bowuyuan cang lidai fashu xuanji, *vol. 1.*

My lord's gates are nine layers deep;
My family tombs are ten-thousand *li* away.
Will I, too, weep that the road is at an end?
Dead ashes, blown, will not reignite.[32]

"Ash from wood," "an unmoored boat"—Zhuangzi's images echo forcefully in this, the second of Su Shi's "Cold Food Festival Poems." Su Shi plainly states his miserable status: far from the capital, far from home, an empty kitchen, a broken stove, and in the endless rain a small house like a fishing boat lost in the clouds and water. The last lines allude to a famous story told of the early eccentric Ruan Ji (210–63), who was fond of aimlessly following country lanes only to weep uncontrollably on reaching the end.[33] Su Shi, in contrast, asserts quiet detachment, and the calligraphy grows ever more vigorous and vital.

Awareness of heightened expectations for calligraphy written in the wilderness can also be deduced in the work of Su Shi's close friend and pupil, Huang Tingjian. During his exile in Rongzhou (Sichuan Province), Huang transcribed for his nephew, Zhang Datong, a guwen "ancient prose" essay (see fig. 14).[34] In his surviving colophon (the essay is lost), Huang presents himself as an old, dis-

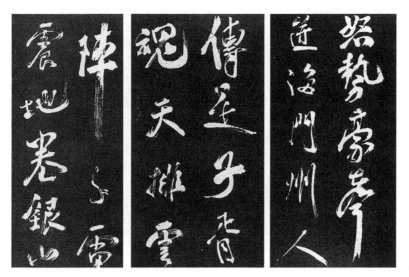

45. Mi Fu, "*Watching the Tidal Bore.*" Dated 1095, Northern Song period. Details of a rubbing from Bao-Jinzhai fatie. *From* Song ta Bao-Jinzhai fatie, *juan 10.*

carded survivor—one to be contrasted with the ambitious young men of the village who seek his tutelage in matters of composition and calligraphy, "still preserving the habits of those exam candidates in the capital area." As it was for Su Shi, Huang Tingjian advertises his wretched conditions. He suffers from stomach and chest pains; foot trouble keeps him from bending over. His home is to the south, near a butcher's slaughterhouse, "where weeds grow as high as the roof and wild rats share the narrow path." And yet, as Fu Shen's careful research has shown, in other documents Huang describes his life at Rongzhou as almost bucolic, leisurely watching gentle winds bend the flowers and grasses, growing vegetables and eating simple but nourishing food. At Rongzhou he calls his studio Renyuntang, Studio of Accepting One's Fate, and in explaining its name writes, "Today fate rises me up; tomorrow I'll rise above fate. . . . My body is like dried-up wood and my mind like dead ashes."[35] Huang Tingjian's clear message is that he has transcended his surroundings and ill health. By emphasizing the misery of his lot he signals the viewer of his calligraphy to marvel at such transcendence, just as Huang does, writing at the end of his colophon, "I don't know if on a later day I could ever write such characters again." The correlation between the fact of Huang's exile and this magnificently gaunt and powerful writing would have

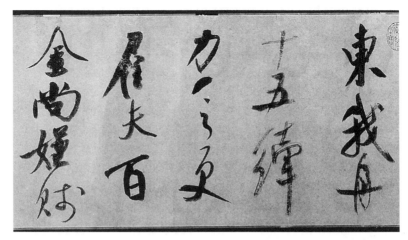

46a. Mi Fu, "Sailing on the Wu River." Ca. 1095, Northern Song period. Handscroll, ink on paper, 31.3 × 559.8 cm. The Metropolitan Museum of Art. Gift of John M. Crawford, Jr., in honor of Professor Wen Fong. First section, beginning at the right.

been even clearer had the original text that preceded this inscription survived. It was the same essay Han Yu had written for the long-suffering Meng Jiao, in which we learn that one sounds forth from a state of disequilibrium.[36]

Disequilibrium is precisely the word to describe Mi Fu's state of mind immediately after the problems of Yongqiu, and he sounds forth. Moreover, as with Su Shi and Huang Tingjian, we hear claims of transcendence. Mi Fu, however, appears less convincing, and his tone is far more defiant than detached. The following two poems, written in 1094, present a somewhat contradictory mix of complaint and Daoist buoyancy (fig. 44):

> Upon Receiving Orders for the Zhongyue Post
>
> This heart forever entwined with clouds and water,
> But this face long black from wind and dust.
> Once again I seek the Angler of the Great Tortoise,
> And for the first time enter the gameboard Choosing Immortals.
> Rats and sparrows are truly the scourge of officialdom;
> Dragons and snakes are mixed together in the crowd.
> But I cherish the kindness of a salary for doing little,
> And thus dare not compose a "Discussions of the Submerged Gentleman."
>
> Forever poor, need be a wandering official,
> So a sinecure stipend is a personal honor.

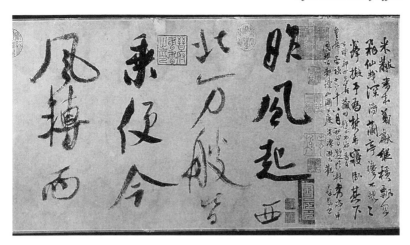

I do not make requests at the gates of gentlemen;
In the end I will be known as a useless official.
Once again I seal my law-discussing mouth,
And in quietude cleanse my mountain-viewing eyes.
Yi and Hui, what was it in their midst?
Paintings and writings to grow old with.

The distinction between a life in office and a life out of office is explicitly revealed. The honest official is a poor official, destined to wander from post to post and consigned to anonymity. His dragonlike virtue is obscured by the snakes around him; his value passes unrecognized. Embittered by his encounters with the "rats and sparrows" who devour the country's wealth, Mi Fu is tempted to emulate Wang Fu (ca. 76–157) and write his own critique of contemporary society, or "Discussions of the Submerged Gentleman."[37] Honored by his modest stipend, however, he restrains his criticisms. The real reason, of course, is Mi Fu's hope that he will not remain submerged for long.

In contrast, life out of office promises a return to the scholar's original nature, represented by landscape. Clouds and water, boundless and ever-changing, symbolize the expansiveness of his heart; the grandeur of mountains slowly cleanses the dust of the soiled world from his eyes. The return to freedom demands an adjustment in manner of living, and Mi Fu thus seeks rejuvenation in a persona that transcends pettiness and embodies haofang unbridledness. He de-

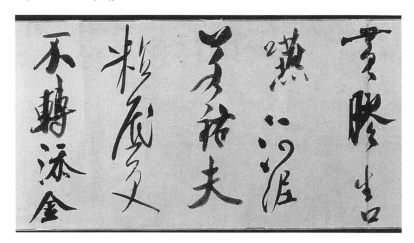

46b. "Sailing on the Wu River." Second section, beginning at the right.

clares his intention to model himself after the Angler of the Great Tortoise, the Tang poet Li Bo (701–62), who claimed to use rainbows for his line and men who lacked moral fortitude for his bait when fishing for the mythical giant *ao* tortoise.[38] Mi Fu seeks, literally, to become an immortal: the objective of the board game Choosing Immortals was to rise through the various categories of immortalhood until one reached the ultimate paradises of Penglai and Daluo; a wrong move might mean a demotion to firewood-gathering.[39] The most telling allusion appears at the end of the second poem. Yi and Hui refer to Boyi and Liuxia Hui (Zhan Qin), historical figures of impeccable moral integrity who suffered for their righteousness. With the fall of the Shang dynasty Boyi and his brother Shuqi chose to flee to the wilderness and starve to death rather than serve the new Zhou dynasty. Liuxia Hui was demoted three times in his service to the state of Lu, yet he chose to remain and serve rather than leave the land of his parents.[40] There is nothing unusual in Mi Fu choosing these paragons of purity and correctness to refer to his own situation, but his justification of a life involved with the collecting and making of art by imagining that Boyi and Liuxia Hui were similarly engaged is outrageous. The Immortal of Chu is back, and to punctuate that fact Mi Fu signs this scroll of two poems with his pedigree-establishing signature Fu Fu 芾芾 , which he would prefer we read Mi Mi 芈芈 .

The style of calligraphy in which Mi Fu writes "Upon Receiving Orders for the Zhongyue Post" is fundamentally the same as that employed in the earlier poem scrolls of 1088; Mi Fu's new status as a man on the outside shows no immediate effect. But perhaps this is only natural, since Mi Fu was largely picking up the patterns of a familiar way of life in a familiar place. Letters, poems, and

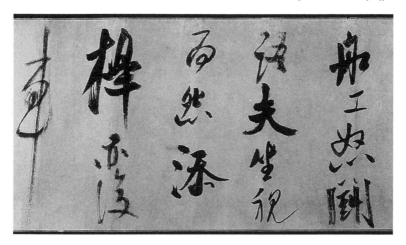

inscriptions of this period testify that life in Runzhou was exceedingly genteel. Far from the rigors of true reclusion, Mi Fu could indulge what he calls his "rivers and lakes heart" with literary gatherings and visits to the local temples on Jiaoshan and Jinshan and in the southern suburbs of the city. Nevertheless, there is evidence that a highly distinctive new form of calligraphy appears in Mi Fu's oeuvre around this time: a combination of semicursive and cursive forms written noticeably larger than anything seen before by Mi Fu and in a style unusually bold even by his standards.

The evidence is not without controversy. Dated calligraphy in this unbridled style is limited to a handful of poems and lyric songs (*ci*) found in the Southern Song compendium *Bao-Jinzhai fatie* (*Model Writings from the Bao-Jin Studio*), and rubbings present particular problems of authentication (fig. 45). Indeed, the style of Mi Fu's calligraphy here is different enough from his typical smaller-sized semicursive writing for some to have questioned its reliability. Yet there is no question that Mi Fu did on occasion write large-sized calligraphy, and at least one undated extant scroll, "Sailing on the Wu River" (fig. 46), has the same mixture of semicursive and cursive elements as that found in the *Bao-Jinzhai fatie* rubbings. The example from the compendium chosen here to accompany "Sailing on the Wu River" is "Watching the Tidal Bore," dated to the autumn of 1095. Although it must be used with caution, "Watching the Tidal Bore" could provide a key for dating "Sailing on the Wu River." Mi Fu would have passed through Wujiang (Jiangsu Province), where "Sailing on the Wu River" was written, to and from Hangzhou (site of the tidal bore) and Runzhou (see map 3). In any case, characteristics shared between the two poems are worth noting with

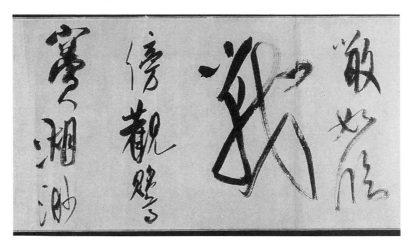

46c. "Sailing on the Wu River." Third section, beginning at the right.

respect to this particular genre of large-character writing and its appropriateness for someone removed from the center stage of official life.[41]

Watching the Tidal Bore

Angry forces and unbridled sounds burst the ocean gate,
"'Tis the ghost of Zixu," local legends say.
Heavens arrayed, clouds marshaled, a thousand thundering quakes,
The earth rolled up in a silver mountain, ten thousand charging steeds.
High as the round full moon, it joins the lunar phases,
Trustworthy as the clepsydra that announces evening and dawn.
Wu struggles, Yue battles, to what does it all amount?
The single tune of a fisherman's song passes the distant town.

The regularity of the Qiantang River tidal bore suggests the grand sweep of time and thus kindles thoughts of historic figures of the distant past: Wu Yuan (Zixu), whose tragic tale of revenge and betrayal encapsulates the violence of the Eastern Zhou and the battles of the ancient states of Wu and Yue.[42] The calligrapher was clearly impressed by this grand display of nature, and he demonstrates it by allowing his calligraphy to become caught up in the dramatic fervor of the poem's images. Unrestrained, the brush moves quickly to produce the *feibai* "flying white" effect, and the writing thus provides an effective pictorial complement to the poem's description of onrushing water. In contrast to the vigor of the calligraphy, the poet assumes the quiet stance of observer. He merely describes, detached, like the lone fisherman in the final line who pursues his own timeless pattern unconcerned with the passage of history.

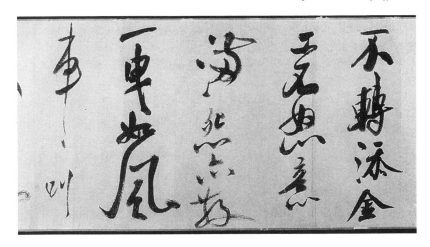

"Sailing on the Wu River" presents a similarly removed perspective, though it is a different kind of landscape that Mi Fu observes (fig. 46). Here the focus is on the mundane affairs of human relations, with the poet himself acting out one of the parts. Yet despite Mi Fu's presence in the poem, the poetic voice is detached as it describes how the boatmen wrestle with the contrary wind that has suddenly delayed his boat's progress.

Sailing on the Wu River

Yesterday's wind arose in the northwest,
And ten thousand boats took advantage of its favor.
Today's wind, shifting, comes from the east,
And my boat has to be pulled by fifteen men.
Their strength spent, I hire some more,
But they consider one hundred in gold too little.
The boatmen get angry, and there are challenging words,
The laborers sit watching, their resentment mounting.
We add winches and pulleys for the ropes,
Yellow gorge rises in the boatmen's throats.
But the river mud seems to side with the laborers,
Stuck on the bottom, the boat won't budge.
I add more money and the boatmen are no longer angry,
Satisfied, all resentment disappears.
With a great pull the boat glides like a flying chariot,
The men shout out, as if rushing into battle.

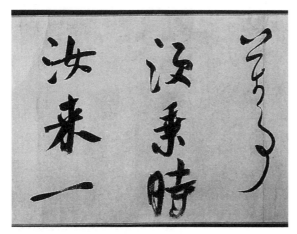

46d. "Sailing on the Wu River." Fourth section, beginning at the right.

To the side I look toward Yingdou Lake,

So vast, its shores are unseen.

When even a drop of water cannot be drawn,

What use is the distant West River?

All matters must find their proper time,

So why have you come so late?

From the start, Mi Fu's calligraphy suggests the vagaries of external circumstances, slanting first one way, then another in the first two columns, paralleling the shifting of the wind. The calligraphy proceeds almost tentatively, but somewhere amid the anger of the boatmen in the tenth column the writing loosens and the images become increasingly dramatic. The episode with the boat reaches an explosive climax with the character *zhan*, "battle," written large enough to subsume two entire columns and in a manner that unmistakably shows Mi Fu's awareness of how the semantic meaning of character and poem can be expressed through calligraphy. After this outburst the writing steadies to an even pace as the boat continues on its journey and the poet waxes philosophically. The allusion at the end is to a story told in *Zhuangzi*. A small perch is trapped in a puddle formed by a carriage rut in the road. Although Zhuang Zhou offers to divert the entire West River during his trip south, the fish retorts that by the time it arrives he will be hanging in the dried fish store.[43] The theme of the poem, so clearly stated here, is that everything must be done at the proper time. One must be attuned to the moment and be willing to act accordingly—Zhuang Zhou with a dipperful of

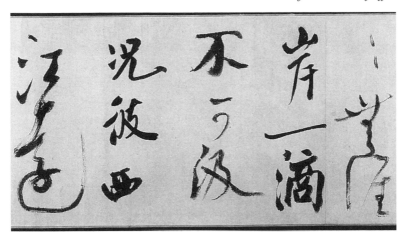

water, Mi Fu with some extra cash. Emphasizing the immediacy of the here and now, "Sailing on the Wu River" shares with "Watching the Tidal Bore" a perspective that focuses on the world around the poet.

"Sailing on the Wu River" can be described as the calligraphy of landscape, with landscape defined most broadly in this context to include most of what exists exterior to the writer, his ego, and his emotions. The association of this type of bold, energetic calligraphy with a mind detached of affections had already been established within Chan (Zen) Buddhist circles. The issue arose 250 years earlier in a preface written by Han Yu for the monk calligrapher Gaoxian, a specialist in the kuangcao "wild cursive" form of calligraphy. Kuangcao was customarily linked to wine, drunkenness, and the disappearance of inhibitions. This was the legacy of the eighth-century calligrapher Zhang Xu, its most famous practitioner. Han Yu, however, chooses to interpret Zhang Xu's art differently. He attributes the power and abandon of the style to Zhang Xu's emotions. Gaoxian, he argues, as a Buddhist who wishes to still his heart, should not experience the wide-ranging feelings of one such as Zhang Xu, and consequently, he reasons, the wild forms of Gaoxian's cursive calligraphy must be based on trickery and illusion.[44] This was a serious criticism, assuming artifice in an art that prized naturalness above all else. How Gaoxian may have responded to the unsympathetic Han Yu is unknown, but Su Shi made a defense on his behalf in a poem he wrote to the prominent late-eleventh-century monk Daoqian. Su Shi's focus is on the writing of poetry, but his reference to Han Yu's preface for Gaoxian

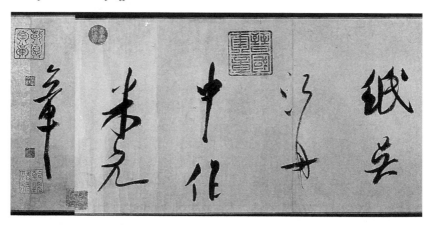

46e. "Sailing on the Wu River." Fifth section, beginning at the right.

makes it clear that poet and calligrapher here share analogous roles. The follow-
ing translation of the poem's relevant lines is based on that of Ronald Egan:

> Tuizhi [Han Yu], discussing cursive calligraphy, remarked
> That it could well reflect any human concern.
> Anxiety, sorrow—all such disquiet,
> Could be lodged in the darting of the brush.
> So he found the Buddhist to be somewhat strange,
> This man who looked upon his body as a dried well.
> Self-effacing, the monk should entrust himself to the "light and bland,"
> Who could elicit from him the "unbridled and fierce"?
> After careful thought I find this to be incorrect;
> True skill is not a matter of trickery and illusion.
> Wishing for one's poems to be marvelous,
> One does not shun emptiness and quietude.
> In quietude one comprehends the myriad movements,
> In emptiness one absorbs the ten thousand scenes.
> In order to observe the world you move among men,
> For self-examination you recline atop a cloudy peak.[45]

Internal emotions need not be the source of the calligrapher's inspiration when
all phenomena, images, and movements are apparent in the external world. More-
over, it is only with emotions stilled that poet and calligrapher can act as conduit
for what is seen outside. Judging from the two poems written on receiving orders
for his new post as keeper of the Zhongyue Temple, Mi Fu sought equilibrium

amid the disequilibrium caused by his abrupt exit from Yongqiu, and if "Sailing on the Wu River" belongs in this context of Mi Fu's life, he employed an unbridled style of calligraphy to establish the fact that he had found it.

A correlation is thus suggested between the bold, large-character format of calligraphy and Mi Fu's life out of office. But does the correlation bear the test of the handful of other writings by Mi Fu extant in this style? The answer is a qualified yes. Besides the *Bao-Jinzhai fatie* examples, these include an inscription for an inkstone in the shape of a mountain, a poem on the subject of Beigushan's Tower of Many Scenes, Mi Fu's self-statement on calligraphy, and a very late scroll of poems written during a trip to Hongxian in northern Jiangsu Province (see fig. 74).[46] Of these, evidence strongly suggests that Mi Fu was again experiencing a period of official disfavor when he wrote the Hongxian poems; the other three cannot be dated precisely.[47] But it may be wrong to look at the fact of exile or demotion as the deciding factor in the writing of this kind of calligraphy. There was, after all, the long-standing model of the "hermit in the marketplace"—the individual who adopts a spirit of detachment while in office.[48] What is important is that in each of these works Mi Fu presents himself engaged in the objects and activities associated with a life removed from the responsibilities of office. Sometimes it is seen in his adoption of the Immortal of Chu persona: Daoist immortal imagery colors the imaginary landscapes Mi Fu envisions from his perch atop Beigushan and in contemplation of his mountain inkstone. When the subject is calligraphy and collecting there is again an implicit association with a life removed from the stifling conventions of the Chinese bureaucracy. This is especially true late in Mi Fu's life, when both his self-statement and the Hongxian

poems were written. The common denominator is a pronounced effort to show Mi Fu as a free spirit untouched by the dust of officialdom.

The imagistic mapping of calligraphy with exterior scene suggested in "Sailing on the Wu River" is not necessarily present in these other examples of Mi Fu's large-character unbridled writing. Yet each of these works can be labeled Mi Fu's calligraphy of "mountains and forests," for each suggests the freedom and spontaneity that Mi Fu saw in the calligraphy of Wang Xizhi after his retirement from office. In this regard we might consider Huang Tingjian's comment on the scenery he enjoyed during his first exile in Qianzhou (Sichuan Province) and its salutary effect on his calligraphy: "Every time I write calligraphy in cursive style here, it seems that I am being helped by the mountains and rivers."[49] Presumably, Huang Tingjian refers not to any direct stimulus—such as the summer clouds that are said to have inspired the cursive calligraphy of the Tang monk Huaisu—but simply to the pleasantness of his surroundings, his relaxation, and the opportunity for his writing to flow freely and naturally.

Calligraphy written without encumberment or inhibition is calligraphy that most accurately reflects the person wielding the brush. Witness Su Shi's humorous reference to the "three contradictions" in Huang Tingjian's calligraphy, two of which specifically concerned the appearance of the calligraphy in relation to Huang's person: the calligraphy was slanted and off-balance despite Huang's outlook of "the equilibrium of all things," and it exhibited playfulness despite his very straightforward and earnest countenance.[50] The important implication is not that Huang Tingjian's writing failed to convey who he was but just the opposite: Huang Tingjian's personality had hidden dimensions that appeared in his calligraphy. Even a brief survey of Huang's calligraphy shows that these qualities described by Su Shi are most clearly and unabashedly displayed in the magnificent large-character calligraphy Huang wrote in exile, such as the colophon for his nephew Zhang Datong (see fig. 14). In calligraphy that sounds forth, what is heard most clearly are the unique patterns of the individual's voice.

The same can be said for Mi Fu and his large-character calligraphy. In contrast to the measured, thoughtful ambling of Huang Tingjian's quirky structures, Mi Fu demonstrates a raw, fast-moving power in "Sailing on the Wu River." He opens his eyes, directs his gaze outward, and trusts the hand that guides the brush. Curiously, with the self forgotten, the true self is revealed: buoyant, unpredictable, and, as Huang Tingjian described, with the energy of an arrow that travels a thousand miles before piercing its target.

F·O·U·R

The Pingdan Aesthetic

The aesthetic idea *pingdan*, "the even and light," is well known to students of Chinese art through the writings of Mi Fu. The term appears frequently in his histories of calligraphy and painting and is used almost exclusively to describe an artist or work he upholds as exemplary. It is not surprising that in the centuries that have followed the Northern Song pingdan has also become closely associated with Mi Fu and his own calligraphy and painting. Yet no other aesthetic term in China may be quite as misleading or misunderstood. The potential for conflict should be clear: as we saw in chapter 3, "even" and "light" hardly seem appropriate words to describe the calligraphy of "Sailing on the Wu River."

An exploration of Mi Fu's use of the term *pingdan*, in particular the context of its usage in Song dynasty criticism and its origins and associations, proves enlightening. Evidence suggests that Mi Fu first became absorbed with the pingdan aesthetic during his official posting as prefect of the military commandery at Lianshui, in what is now northern Jiangsu Province (see map 3). The opportunity to trace some of the historical roots of what became a foundation block of later literati art theory is rare: it is easy to forget that even universal creeds are shaped by individuals at certain times and under particular circumstances. In this regard, Lianshui has the same place of importance in Mi Fu's life and art as Huangzhou does for Su Shi. The critical theories that coalesced here lead directly to the development of Mi Fu's mature style of calligraphy.

Cursive Calligraphy

Nearing the end of his tenure as superintendent of the Zhongyue Temple in late 1096, Mi Fu recounts the troubles of Yongqiu and announces his hope to resume an official career in a letter addressed to someone called Brother Le. "Regretfully," he writes, "scurrying about in the yellow dust [of officialdom], I will be unable to recline in [my present] loftiness."[1] Mi Fu's plan to reenter government service marks a new phase in his life and a notable departure from the model established by Wang Xizhi.

Mi Fu's troubles of 1093–94 coincided with the death of his original benefactor, Empress Gao, who died in the ninth lunar month of 1093. The grand empress dowager had also been the primary supporter of the con-

servative Yuanyou Party. With her passing, the young emperor Zhezong (r. 1085–1100) began to restore the reformers to power and reimplement the "New Policies" of Wang Anshi. Mi Fu's departure from the environs of the capital thus more or less coincided with the fall from power of Su Shi, who was banished to the far south in the autumn of 1094, and Prime Minister Lü Dafang (1027–97), nominal leader of the Yuanyou Party. Lü's demotions were more gradual than Su Shi's. It was not until the spring of 1097 that he was sent "south of the passes," where he died in the fourth month.[2] Sometime before this occurred, Mi Fu was reassigned as prefect of the military commandery at Lianshui. On the eve of his departure he wrote a long and intriguing poem for his senior friend. It begins:

> There is a tree of coral, one hundred feet tall,
> Submerged beneath waves ten thousand fathoms deep.
> I would like to break off a branch for myself,
> But know the difficulty of measuring the ocean with a gourd.
> It has been here on earth a number of times,
> So why not investigate further?
> Towering high, Lord Lü Dafang,
> Serving the sun, he blocks the blue sky.
> Simply put, we harbor like aspirations,
> So what does this spokesman have to say?
> Resolving to raise high the great enterprise of Song,
> We have no heart for party politics.
> With the pellucid, uncarved jade in hand, dazzling jasper can be distinguished,
> Covering shrubs must be cut away to reveal the fragrant orchid.[3]

The poem raises interesting questions about political allegiances. Mi Fu became acquainted with Lü Dafang while serving at Yongqiu, near the capital, and although he was not counted as a member of the Yuanyou Party, the possibility cannot be ruled out that Mi Fu's problems of three years earlier were compounded by his friendships with such people as Lü and Su Shi once the reform faction returned to power.[4] Yet Mi Fu's friends included those on the opposite side of the political fence: Lin Xi, Zhang Dun (1035–1105), and later Zhang's protégé, Cai Jing (1046–1126). Mi Fu, it appears, truly did not play party politics. More important, he was fundamentally insignificant in the political arena. It would hardly seem wise to throw his lot in with the leader of a discredited party about to be banished to the malarial jungles of the south. Mi Fu's resumption of his official career is proof that he simply did not matter that much.

This poem for Lü Dafang is important, in that the images and ideas presented here reappear in Mi Fu's writings over the next few years to form the dominant

themes of his life and art. The poem begins with the giant coral-like *langgan* tree, described in ancient texts as being formed of piled-up rocks and bearing pearls as fruit to feed the phoenix of the south.[5] Mi Fu transports it from the nether regions of China's geo-mythology to an ocean bottom and merges it with another magical tree, the cassia of the moon, whose garnered branch symbolized success in the examinations and a public career. The tree is submerged, like the man it represents, Lü Dafang. This image of an unseen treasure, or a force of moral energy beneath a shrouding surface, is significant. It is the fragrant orchid hidden by covering shrubs or the unsullied jade, whose purity, once revealed, demonstrates the true nature of stones that glitter superficially.

The poem continues with shots aimed at the reformist clique ("corrupt officials adept at reciting the words of the Classics") and reassurances to Lü that their time will come ("for the ancient worthies recognition always came late"). "How could I vainly chisel empty words?" Mi Fu asks, suggesting in his person some of the same substance as the uncarved jade. In contrast are the villainous phrases issued from immoral mouths designed to "blind the masses." Mi Fu counsels patience to Lü Dafang, yet as the poem unwinds he reveals his own fundamental inability to lay low:

> I will not seek others to rhyme my morning chants,
> Nor raise banners with my evening songs.
> I will not lament that the times are not for me;
> My only fear is that this life will be in vain.
> I wish to lay myself open and be tested against the past;
> A great shout emerges from my lungs and bowels!
> My sincerity is revealed, as white as white can be,
> Penetrate my depths, as solid as metal and rock.

"Uncover me, look within," Mi Fu begs with the conviction of one absolutely certain in the quality of his personal virtue. In *Zhuangzi* it is written that the consummate state of sincerity (*jingcheng*) is *zhen*, "genuineness,"[6] and Mi Fu informs us that this paramount value radiates from within. The poem continues with a series of policy declarations—promised guidelines for his imminent service. As the somber tone of the end suggests, however, Mi Fu recognized the likelihood that he would remain covered from view:

> I will not lament having to bow at the waist,
> Rather, I lament not being able to proclaim my will.
> Time! In that sudden instant it passes, lost;
> Our hair turns white, and we lose our firm resolve.
> At ease I linger, finally to depart from home;

Smoothly it flows, this long river I face.

If in the end this will I do not follow,

Rivers and lakes will yet remain unbounded.

Between the lines one discerns Mi Fu's awareness of the undesirability of his new post. Located on the northern bank of the Huai River, Lianshui was little more than a hundred miles due north of Runzhou, but the desolate landscape—composed mostly of saline flats and susceptible to natural disasters—combined with the crude character of the commandery to make the distance seem much greater. Lianshui was an unpleasant backwater post with no culture to offer. In fact, according to the following letter by Mi Fu, practically all that Lianshui did offer were sailors from Fujian Province (Min) and locusts that came flying over the Yellow Sea from the Shandong Peninsula:

> Lianshui is a lowly place. Lin must already have told you. To date he still has not found a place to settle, but then a puddle cannot very well hold a ship. Sailors from Min are extremely numerous, and there are always tens of people seeking lodging. The temples are all full. That's where Lin is staying. They say that locusts have come from Shandong across the sea and are at the outskirts of this menial town, but they have not crossed over. "The realm is lacking" with regard to places to live in this commandery [hence the locusts' hesitation]. Could this be an omen portending the imminent departure of a sage? Ha ha! Relishing poverty and delighting in the bland—these are the eternal affairs of the scholar.[7]

The sage who hopes for a quick departure is, of course, Mi Fu. As it turned out, however, Mi Fu languished in Lianshui for three years, providing him ample time to "relish poverty and delight in the bland."[8] The three years Mi Fu spent in Lianshui amounted to de facto exile. From the numerous poems, letters, and other writings that exist from this period, it is clear that Mi Fu was homesick. He built a studio called the Hall of Auspicious Ink; behind it was his Ink Pond for washing inkstones. He collected strange rocks and erected pavilions with otherworldly names, such as the Tower of the Precious Moon.[9] These were his responses to Lianshui. His poems and ci lyric songs from this period describe fanciful worlds that offer little hint of the meanness of his surroundings. Night scenes in particular, aglow with the moon's magic, transform Lianshui's plain looks into a timeless landscape of enchantment and Mi Fu into a man of another time and place.

Under such conditions, Mi Fu's imagination was a powerful asset, capable of creating compelling internal worlds both for himself and for others who appreciated his unconventionality. Two friends in particular were kindred spirits, sharing a love of art and collecting that provided the basis for an affectionate camara-

derie. Liu Jing (1073 jinshi), a scholar painter of some renown, was one. Protégé of Wang Anshi, he was, like Mi Fu, an ambitious and colorful man whose efforts to climb in the bureaucracy were frequently frustrated by detractors.[10] It was the other friendship, however, that best reflects Mi Fu's development in Lianshui. This was with Xue Shaopeng, a man of much quieter temper. Descended from a line of prominent officials, Xue Shaopeng shared Mi Fu's interests in the subtler aspects of art and collecting.[11] He was a fine connoisseur of Jin dynasty writing in particular, eliciting Mi Fu's pronouncement that the two were soulmates in the appreciation of painting and calligraphy. Xue's writing reveals a calm, unhurried hand (fig. 47). So strongly does his calligraphy suggest the received tradition, from Wang Xizhi to Tang orthodoxy, that it seems anachronistic in the context of late Northern Song individualism. But Mi Fu appreciated this, for he knew that the careful brushwork and understated aesthetic values were based on Xue's meticulous study of genuine early works. There was a seriousness of purpose here and a knowledge that Mi Fu fully understood.

The significance of Mi Fu's friendship with Xue Shaopeng is revealed in a reinvigorated absorption in the practice and study of calligraphy, much of which was specifically communicated to Xue. Although Mi Fu's activities as a connoisseur had not declined in the years just before his service in Lianshui, these new and depressing surroundings unquestionably pushed Mi Fu to seek escape in ancient works of art. The blossoming of this internal world is revealed in a poem Mi Fu sent from Lianshui to Xue Shaopeng:

Old now, my interest in calligraphy is all that has yet to fade;
At least there is Old Xue, who can join me in these games.
Among the world's knowledgeable men, who will judge true from false?
Even the Dragon Palace lacks the skill to doctor an incurable ill.
The Huai wind rattles my halberd, official matters are few;
The steward for foreign guests locks his chamber, idle with his jug of soup.
Soughing trees and facing mountains: the various scenes assemble;
At Ink Pond I wash my stone; turtles and fish take cover.
The precious auras over Pearl Terrace each time penetrate the moon;
The cassia matures atop Moon Tower: an occasional drifting fragrance.
The Silver River illumines the heavens, impeding the Weaving Maiden;
A sea of mist embraces the terrain, generating numinous lights.
My hand-holding children now serve as companions for brush and ink;
With bamboo on either side there is no need for sedan and flanking guards.
Ivory brush and gold-touched scrolls illuminate auspicious brocades;
Jade unicorn and yew table are for spreading the cloud-marrow paper.
Softly clinging, wisps of mist move in twisting swirls;

Bold and upright, dragons and snakes arise from the primal substance.
This I hold as a mate for wind and moon,
A joy for all seasons, a trough that never runs dry.
The regional inspector fails to rectify my errors of brush and ink;
An imperial benevolence keeps him sated in the land of forests and springs.
Wind and dust that fill the sky are the black-capped scholars here;
Why not come for a journey east and join me in this wasteland?[12]

Mi Fu's poetry is defined less by a lyrical sensibility than by a seemingly inexhaustible talent for stringing together couplets and rhymes whose formal structure frequently belies a nonsensical content. The result is comic, though in this case the jokes come largely at the expense of Mi Fu's loneliness. Mi Fu plays steward for foreign guests, official caretaker of the needs of important visiting dignitaries at the court, to Xue Shaopeng's regional inspector, whose job was to provide disciplinary surveillance. But the regional inspector, whose duty here is to correct Mi Fu's handwriting, fails to arrive, and the steward is left alone in his chamber holding the pot of soup intended for his "foreign" guest. This is a particularly clever allusion, with Mi Fu transporting Xue Shaopeng back to the Jin dynasty to play the role of Wang Shu to his own Wang Xizhi. When Wang Shu was appointed regional inspector for Yang Province he made a tour through all the commanderies but, in a deliberate affront, did not pass by Wang Xizhi's place.[13] In this barren world, alleviated only by the moon's nightly transformation of Lianshui into the immortals' abode of Mi Fu's imagination, there remains calligraphy. And the only two who truly fathom its depths, with an astuteness of vision not found even in the mythical thirty chambers of medical secrets hidden in the Dragon Palace of Kunming Lake, are Mi Fu and Xue Shaopeng.

The pattern is an old one, the connoisseur's exclusiveness reminiscent of the poems Mi Fu circulated in the capital ten years earlier. Mi Fu's present situation, however, differs from those comparatively carefree days of shameless self-promotion. His connoisseurship is now a private matter shared between two good friends, and if only for an absence of ulterior motives, there is a hint of seriousness underneath the jokes, allusions, and fanciful metaphors. This seriousness is born from an awareness of the passage of time, of the possibility of a life spent in vain, and it is manifest in the emergence of art historical and critical comments on calligraphy. These are well voiced in another poem Mi Fu sent to Xue Shaopeng. The tone, again, is nonsensical, but there is no mistaking the conviction of the opinions expressed:

A letter from Xue arrived in which he announces that he has purchased a work by Wang [Xizhi] from Mr. Qian. I answered by telling him that Li

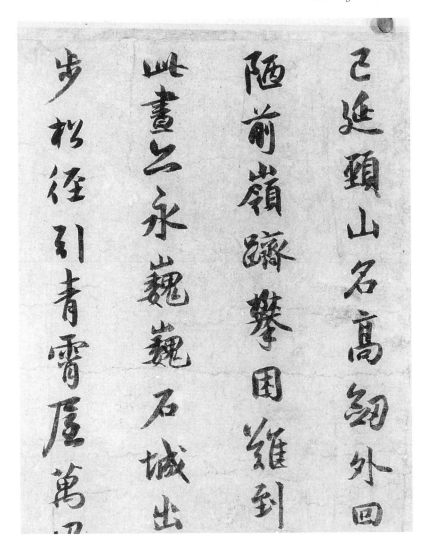

47. Xue Shaopeng, "Yunding Mountain," from "Scroll of Four Poems." Dated 1101,
Northern Song period. Detail of a handscroll, ink on paper, 26.1 × 303.5 cm. Collection of the
National Palace Museum, Taipei, Taiwan, Republic of China.

Gongzhao [Li Wei] owns a scroll of calligraphy by masters who lived
before the Two Wangs that is worth spending one's last penny to
acquire. I then sent him this poem:

Ou's strangeness and Chu's charm were not self-reliant,
Able still to half leap back to the rules of ancient writers.
Gongquan, ugly and weird, ancestor to horrid writing,
From this time forward the ancient methods disappeared without a trace.
Crazy Zhang's crime, more or less the same as Liu's:
He incited vulgar fellows to give rise to utter chaos.
Huaisu, that southern cur, showed a little understanding;
Diligently he chased after "the even and light," like a doctor who is blind.
Then there is Zhiyong, pitiable, laboring in vain at his inkstone,
A single step removed from his roots, yet there appeared a thousand jeers.
[Mi Fi's note: This can be seen in what is printed in the fatie]
Alas, a life spent mired in these problems,
My mouth knows how to voice them, but the hand won't seem to follow.
Who says if the heart is present the brush will attain its goal?
Natural skill, as itself affirms, is the subtlest of secrets.
Before the Two Wangs there existed lofty antiquity;
The intent is there, I wish to buy, forgetting how steep the price.
Attentively dispensing his cures, there's Xue Shaopeng,
Scattering gold and purchasing, scribbling inscription after inscription.[14]

The catalyst for Mi Fu's poem is Xue Shaopeng's announcement of a new
purchase attributed to Wang Xizhi, and in the spirit of one-upmanship, Mi Fu
lets it be known that his interests lie with the ultimate acquisition: a scroll he had
seen many years earlier in the collection of Li Wei with specimens of writing by
fourteen Jin dynasty calligraphers who predated Wang Xizhi. This Mi Fu calls
"lofty antiquity." The question becomes how to attain it—materially *and* artisti-
cally.

The fundamental theme of Mi Fu's poem is the ever-growing distance from
one's roots. He begins with the early Tang dynasty calligraphers Ouyang Xun
and Chu Suiliang, whose writing presented a model of polarity: angular, rigid
strength versus pliant, seductive charm. In spite of their differences, both men
were considered followers of Wang Xizhi, choosing different directions of de-
parture from their model or, as Mi Fu writes, "the rules of ancient writers." By
the time of the later Tang calligrapher Liu Gongquan, however, a line has been
crossed. Liu's standard script writing passes the acceptable strangeness of Ouyang
Xun and points the way to a realm of excessiveness. Roots and foundation are

lost. In the same category belongs Crazy Zhang, or Zhang Xu (ca. 700–750). This part of the poem is clarified by one of Mi Fu's most remarkable extant works of handwriting: a comment on cursive calligraphy written at this time in Lianshui and titled, by someone who was either remarkably witless or ironic, "The Sage of Cursive Calligraphy" after another Zhang Xu moniker (fig. 48).

> If one's cursive calligraphy does not partake of the character of the Jin writers it then becomes a work of the lowest category. Crazy Zhang, that vulgar fellow, altered and confused the ancient methods, inciting the common masses [to rise up and follow his lead]. There were a few who comprehended. Huaisu somewhat added "the even and light" and to a slight degree reached a level of naturalness. But the times were against him and he was unable to achieve "lofty antiquity." Gaoxian and those below him can be hung in wineshops. Bianguang is especially detestable.

Two basic historical transformations are recognized in the cursive script tradition. The first occurred around the fourth century and the milieu of Wang Xizhi with the development of what was then called modern cursive (jincao). Four hundred years later another epochal change took place with the appearance of wild cursive, kuangcao. The emergence of kuangcao was associated almost exclusively with Zhang Xu. He was one of Du Fu's celebrated Eight Immortals of Wine, a spirited fellow given to fits of wild tantrums while in his cups and taken to alleviating his drunken energy by channeling it through an ink-charged brush. Some sources claim that on occasion he even dipped his unbound hair into the ink and used that to write. Zhang Xu's own sober, post-performance conclusion was spirit possession. More mundane explanations offered for the inspiration behind Zhang Xu's wild cursive writing inevitably involve external stimuli, such as porters struggling on a road balancing heavy loads or the famed sword dance of Lady Gongsun (Gongsun daniang).[15] Whatever the source of Zhang Xu's inspiration, the results were extraordinarily different from the preceding orthodoxy of the Wang Xizhi tradition of cursive calligraphy. This clear distinction has led Nakata Yūjirō and others to regard Zhang Xu as one of the leaders of a revolutionary movement in art that occurred in eighth-century China.[16] The monk calligraphers Huaisu (725?–85?), Gaoxian, and Bianguang were all famed practitioners of kuangcao who followed Zhang Xu's lead.

Differences between the orthodox cursive tradition and wild cursive writing are illustrated by contrasting Sun Guoting's renowned "Treatise on Calligraphy" of 687 (fig. 49) with a scroll of four poems, two by Yu Xin (513–81) and two by Xie Lingyun (385–433), transcribed by an anonymous kuangcao specialist of the eleventh century (fig. 50). The scroll of four poems was once attributed

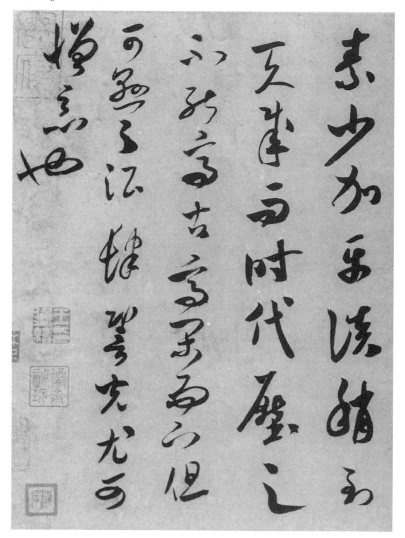

48. Mi Fu, "The Sage of Cursive Calligraphy." Ca. 1097–99, Northern Song period. Album leaf, ink on paper, 24.7 × 37 cm. Collection of the National Palace Museum, Taipei, Taiwan, Republic of China.

to Zhang Xu himself, but as recent scholars have shown, a changed character in one of the verses possibly reflects the avoidance of an early Northern Song taboo character and by consequence ensures a date no earlier than 1012.[17] This suits our purposes well, for although Zhang Xu is Mi Fu's immediate target, his real complaint is aimed at Zhang's followers.

Sun Guoting's writing exemplifies early Tang care and precision, now employed for the cursive script. The forms are orthodox, each character following

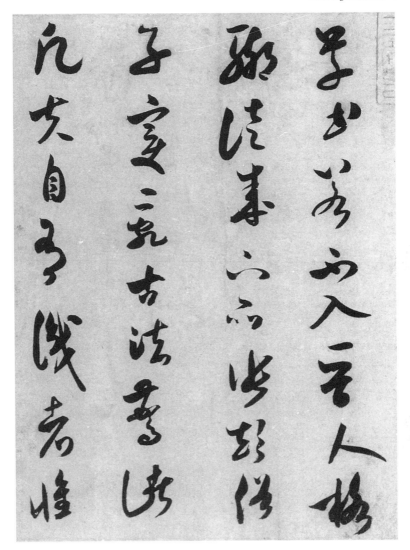

standard conventions of abbreviation, and harmoniously composed. The brush-work is at once sharp and fluid. There are occasional connections between char-acters, but Sun Guoting was meticulous in maintaining the integrity of each one so that the pace remains even and measured. Throughout the calligraphy em-phasizes a strong vertical flow, with individual characters tightly composed so that each column remains inviolate. The writing moves like a steady stream of water, subtle and deep. In contrast, "Poems" assails the senses like exploding

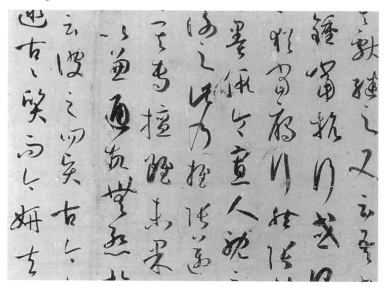

49. Sun Guoting, "Treatise on Calligraphy." Dated 687, Tang dynasty. Detail of a handscroll, ink on paper, 26.5 × 900.8 cm. Collection of the National Palace Museum, Taipei, Taiwan, Republic of China.

rockets. The characters vary wildly in size; their forms are often distorted. In places, the writing narrows to a thin defile. More often the brush zigzags violently, with a horizontal emphasis that obscures individual columns. *Kuang* means inconstancy of behavior, and surely this sense of unpredictability was the writer's goal. Whereas Sun Guoting's "Treatise" demonstrates the propriety and control of orthodoxy, "Poems" represents a primal, uncapped energy.

The attraction of kuangcao is its rawness. In a society governed by strict codes of behavior there was a strong fascination with the unbounded and a genuine yearning for that which existed somewhere beneath those countless strata of learned rules and manners: one's original nature. Kuangcao promised a glimpse of that nature, especially when inhibitions were first dissolved by a generous dose of alcohol. But there were also troubling aspects to the wild cursive script. For one, chaos in its true, unadulterated form was frightening and in frank opposition to the model of civilized control the scholar-official represented. Second, wildness did not necessarily mean genuineness, in the sense of that which comes naturally and spontaneously, especially when there was a ready audience and market for this new, exciting form of performance calligraphy.

These concerns are reflected in the late Northern Song critique of Zhang Xu. Both Su Shi and Huang Tingjian were careful to emphasize that Zhang Xu's wild

cursive writing was built on a solid foundation of orthodox study, without which his wilder experiments would have been unacceptable. The proof lay with a stele exhibiting Zhang Xu's kai standard script, "Record of the Langguan Stone" of 741, which was considered a model of Tang discipline (fig. 51).[18] Su Shi described the writing's generous, open structures as "simple and distant," associating it with the Jin tradition. Huang Tingjian called it simply the best of the Tang dynasty.[19] In these two gentlemen's comments it becomes apparent just how important "Record of the Langguan Stone" was. It validated Zhang Xu's unconventional cursive because it proved that Zhang was steeped in rules and methods. Huang Tingjian prided himself on the ability to spot Zhang Xu fakes—wild writing by pretenders and followers—precisely because in such work rules and methods were lacking. Both Su Shi and Huang Tingjian strongly emphasized the propriety envisioned between the dots and dashes of Zhang's drunken brush. It was what separated Zhang Xu from his followers, who by merely imitating the wildness of his writing were guilty of using conscious intent to write that which should have emerged spontaneously from a solid foundation rooted in orthodoxy. A curious aspect of Su Shi's and Huang Tingjian's assessment of Zhang Xu is the strong implication that Jin calligraphy and the Two Wangs tradition were part and parcel of Zhang's methods.[20]

Kuangcao attributions to Zhang Xu are largely problematic, stymying any attempt to pursue the question of orthodoxy in his wild cursive, but the perceived indiscretions of his followers can be illustrated by the eye-dazzling "Poems" (figs. 50, 52). In order to enjoy the full experience one must be able to read the text. Here is the first poem, one of ten verses by Yu Xin titled "The Daoist Master Strolls through the Empyrean":

> With the nine-mushroom canopy of East Radiant Lord,
> And the five-cloud carriage of the Immortal Bei Zhu,
> Wafting and floating he enters Topsy-turvy Land,
> Emerging and disappearing, ascending the rosy mists.
> From a spring brook descends a jade flow;
> The jasper bird heads for Gold Flower Palace.
> The Han emperor regards the magic peach pit;
> The Marquis of Qi inquires of the jujube's flower.
> One ought to pursue Lantern Festival wine,
> By joining on a visit to Cai [Jing's*] house.[21]

The poem is a celebration of inspired drunkenness that takes the form of an immortal's wild ride through a celestial ether populated with figures and images from popular myths. One need not recognize all the characters and allusions to

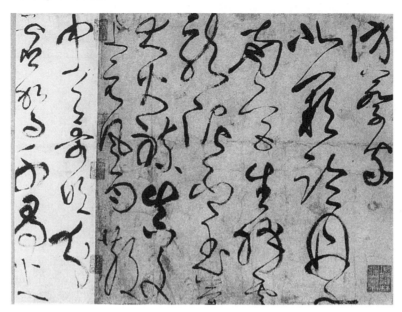

50. *Anonymous, "Poems by Yu Xin and Xie Lingyun." Datable to the eleventh century, Northern Song period. Detail of a handscroll, ink on "five-colored" paper, 29.1 × 195.2 cm., from the right. Liaoning Provincial Museum. From* Tang Zhang Xu caoshu gushi sitie.

appreciate the vivid images, and this, no doubt, was why the calligrapher chose the poem. Reading up and down the columns creates the sensation of riding in an immortal's cloud-chariot, floating in the upside-down world of Topsy-turvy Land, or journeying, like the jasper bird of the Queen Mother of the West, to Han Wudi's (r. 140–87 B.C.) Gold Flower Palace. This roller-coaster movement is emphasized by some noteworthy conceits in the calligraphy, especially the manipulated placement of the poem's directional words to prompt awareness of the writing's physical dimensions. *Dong* (east) begins the poem at the upper right, while *bei** (north, part of Bei Zhu's name) is found at the opposite end of the column. This can hardly be coincidental, since the fourth and fifth columns open, respectively, with the characters *shang* (up) and *xia* (down), and in the next poem the characters *bei** (north) and *nan* (south) top adjoining columns. Conscious intent probably also underlies the writing of the character *chu* (emerging) with a thick charge of ink that quickly fades into a pale *feibai* (flying white) effect in the next character *mo** (disappearing) at the bottom of the third column (fig. 52). Perhaps there are other games as well. This is precisely the kind of writing Mi Fu

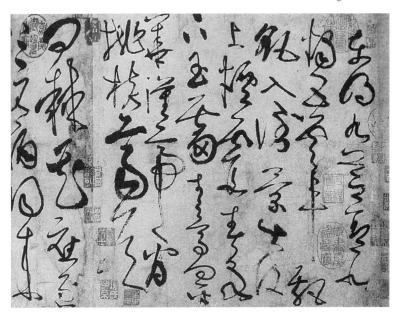

would have laughingly dismissed as fit only for wineshop walls, where it no doubt would have served a proprietor well as an advertisement for the local hooch.

Su Shi, Huang Tingjian, and Mi Fu probably would have enjoyed "Poems," but they would not have regarded it seriously. The writer's exaggerations and none-too-subtle manipulations qualify him for Mi Fu's category of "vulgar fellows." Ironically, such writing by Mi Fu as "Sailing on the Wu River" could easily be associated with this kind of kuangcao (and in fact has been[22]), but then this is not the kind of calligraphy seen at Lianshui. A major change occurs. In Mi Fu's unhappiness he turns to calligraphy, and in calligraphy he seeks a new persona, one that denies the meanness of his surroundings, the meanness of what calligraphy had become, by invoking "ancient methods." Drawing a fine line between Zhang Xu and his followers would not do. Ancient methods had not only to be present; they had to be emphasized, and with this mission in mind, Mi Fu set out to realign the cursive tradition.

Our understanding of Mi Fu's calligraphy at Lianshui derives largely from a set of writings collected during the Southern Song and titled "Nine Works of

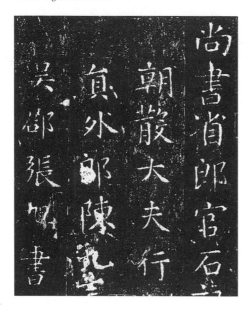

51. Zhang Xu, "Record of the Langguan Stone." Dated 741, Tang dynasty. Detail of a rubbing. From Zhongguo meishu quanji, "Shufa zhuanke bian," 3:120.

Cursive Calligraphy."[23] As a group these writings provide a vivid picture of Mi Fu's attempts to cope with his surroundings. Echoing the poems he sent to Liu Jing and Xue Shaopeng, Mi Fu constantly expresses homesickness and laments his lack of visitors. The letter quoted above, with its joke about the reluctant locusts, is one example, sent to an acquaintance back in Runzhou. Other writings focus specifically on calligraphy, and of these the most important is "The Sage of Cursive Calligraphy" (see figs. 48, 53). The style that unites the "Nine Works of Cursive Calligraphy" is presented here with particular clarity and emphasis. It should be recognized as the graphic correspondent to the new aesthetic position Mi Fu delineates in the content of his writings from Lianshui.

In utter contrast to "Poems," "The Sage of Cursive Calligraphy" was written slowly, following a measured beat. The characters are unconnected and the brushtip generally remains scrupulously centered, resulting in writing that is luxurious, generous, and rounded. Liveliness is displayed through understatement: characters play off one another through subtle balances, creating movement that might be likened to a stately dance. These qualities are illustrated in a detail from the first two columns: *bu ru Jin ren* and *xia pin Zhang dian* (fig. 53). Each stroke in the right column is like velvet. Mi Fu keeps the spacing meticulously even, opening up the character *Jin* by raising the top heng stroke so that one's eye gently floats down from the character *ru* above to ensure unbroken continuity. At the

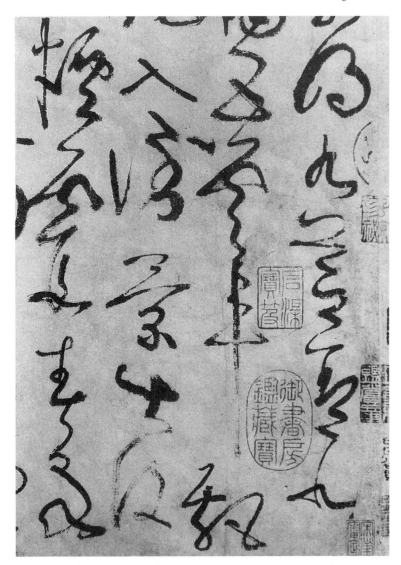

52. Detail of "Poems by Yu Xin and Xie Lingyun." The characters chu mo *appear at the end of the third column from the right.*

same time, the visually congruent *ru* and *ren* pull ever so slightly left, generating an undercurrent of shifting energy down the column: *yun* resonance. *Bu* and *ru* are simple characters, comprising few strokes, and when Mi Fu reached this same point in the adjoining column he had, by design or accident, happily arrived at two equally simple, visually similar characters: *xiapin*. Written with staccato

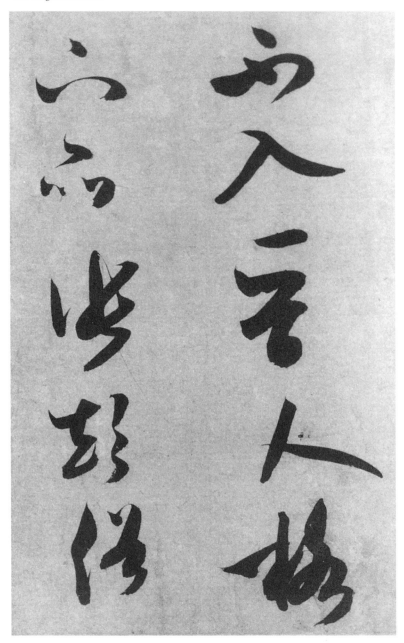

53. *Details of Mi Fu's "Sage of Cursive Calligraphy." Right column:* buru Jin ren ge. *Left column:* xiapin Zhang dian su.

punch, these two characters marshal their forces from left to right, countering the leftward-tilting *buru* like an opposing team on the pitch. More energies are thus generated, this time across columns. Perhaps this subtle contrast was intended to continue with the following two pairs, this time semantically: directly across from *Jinren*, "men of Jin," we find *Zhangdian*, "Crazy Zhang," written with all the grace and condescension Mi Fu could muster.

"The Sage of Cursive Calligraphy" is Mi Fu's demonstration of "lofty antiquity." This is a relative term, and the writing demands further stylistic analysis to determine Mi Fu's meaning in this context. Our initial concern, however, is not with specific models but with the persona represented by this style of writing. The best indication emerges in the letter cited above, and the short but significant phrase, "Relishing poverty and delighting in the bland—these are the eternal affairs of the scholar." At Lianshui, Mi Fu aspires to the role of the scholar who "uncomplainingly" accepts his lot. We are reminded once more of Han Yu's consolation for Meng Jiao, that one sounds forth when in a state of disequilibrium, only now it is not with the unbridled shouts of a person among mountains and forests. From *this* state of disequilibrium Mi Fu reaches for balance and order by pursuing pingdan, "the even and light." He repudiates unrestraint and retreats into a cocoon of moral integrity, the patterns of which are defined by the orthodoxy of antiquity.

Although much has been written of pingdan and its various related terms, its importance to Mi Fu necessitates a brief summary of its salient features.[24] The concept, if not the literal term, first appears in the Daoist classics *Daode jing* and *Zhuangzi*, where the Dao, itself, is described as flavorless, calm and bland, silent and inactive.[25] As Jonathan Chaves observes, this is a typical Daoist paradigm, in which the very qualities that appear void of substance are assigned positive value as attributes of the absolute. Calmness and blandness suggest harmony—from the emptiness of the Dao all things emerge in equal balance. A parallel was thus drawn for the superior man, whose character, rooted in equanimity, allowed balanced judgments. The persona Mi Fu seeks to emulate at Lianshui is best described by the Wei period (220–65) scholar Liu Shao in his *Monograph on Personalities (Renwu zhi)*. The translation is by Jonathan Chaves: "In a man's character, it is balance and harmony that are most prized. A character which is balanced and harmonious must be even, bland, and flavorless. Thus, such a man is able to develop in equal measure the five virtues [courage, wisdom, humaity, faithfulness, and loyalty] and to adapt himself flexibly to the situation. For this reason, in observing a man and judging his character, one must first look for the 'even and bland,' and then seek intelligence."[26]

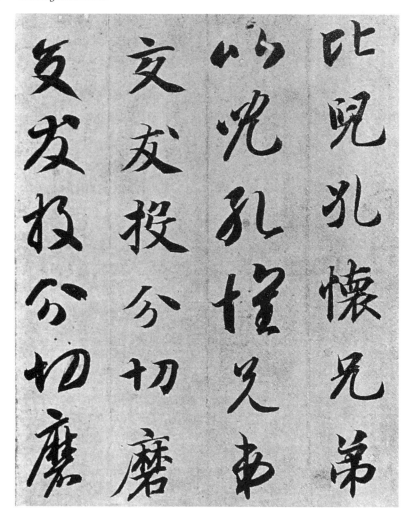

54. *Zhiyong, "Thousand Character Essay in Standard and Cursive Scripts." Sixth century, Sui dynasty. Detail of a handscroll, ink on paper, Ogawa collection, Japan. From* Zui Chi'ei Shinsō senjumon, *21.*

Liu Shao adds a veneer of Confucian morality to the Daoist model. Nevertheless, the concept that all things flow along their natural course from the equilibrium of pingdan remains. It is not surprising that in the mid-eleventh century scholars such as Ouyang Xiu and Mei Yaochen recognized in pingdan a potential model for literati expression, because the Dao that was flavorless, calm, and bland suggested a parallel with their preference for writing that did not rely on beauti-

ful diction and flowery words to express profound thoughts and feelings. It was a model, in other words, entirely consonant with the guwen ancient prose movement. The implicit is valued over the explicit, and inner substance and genuineness are prized over outward appearance and artifice. We see this most clearly in Su Shi's comments on the poetry of Tao Yuanming, who, among all of the earlier poets, was most commonly associated with pingdan in the eleventh century. "Tao's poems," Su Shi is quoted as having said, "though simple and direct, are in fact beautiful and elegant; though emaciated, they are in fact extremely rich."[27] In Su Shi's usage, the plainness of pingdan is limited to the surface; within lie hidden riches. Elsewhere he writes, "What is prized in the withered and bland is that the exterior is withered but the interior is moist. It appears bland but is actually beautiful. If both exterior and interior were withered what would be left worth commenting upon?"[28]

Indeed, in its first application in literary criticism pingdan appears to have had pejorative connotations precisely because it was applied to poetry that was withered, or empty, inside and out. The preface to Zhong Rong's (early sixth-century) *Gradings of Poets* remarks that during the Yongjia reign (307–13), poets, in their esteem for Daoism, "tended toward vapid discussions. At that time, the content of their poetry exceeded its diction, and their work was bland, with little flavor."[29] This raises an important issue underlying the pingdan aesthetic, one that sets its application in the arts apart from its original intended meaning in philosophical discourse. The emptiness of the Dao, its blandness, cannot be qualified. To borrow the jargon of a third-century commentator, the Dao's fundamental nature is fundamental nothingness. For the Song Confucian scholar whose feet are firmly planted in the phenomenal world, however, the pingdan poem must exhibit some measure of the good fruits born from the pingdan personality. There must be something of substance. Thus we find as a critical element in the Song definition of the pingdan aesthetic the idea of concealment. The true substance of a Tao Yuanming poem may not be apparent in the plainness of its surface, but it is most certainly present.

Pingdan begins with no true stylistic characteristics, but in practice it develops them. Moreover, they are characteristics generally associated with antiquity. Notable exceptions exist, especially in poetry, but it is clear that the qualities of simplicity and unpretentiousness that are fundamental to the concept of pingdan were also qualities attributed to the distant past.[30] This is especially evident with calligraphy, where we find pingdan and its related terms consistently applied to pre-Tang writing. Su Shi, for example, drew a parallel between the calligraphy of the sixth-century monk Zhiyong (Yongchan), who was an important link in the transmission of Wang Xizhi's style, and the poetry of Tao Yuanming. A

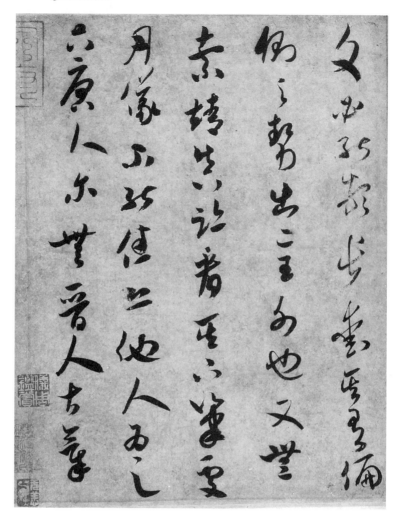

55. Mi Fu, "My Friend." Ca. 1097–99. Album leaf, ink on paper, 26.8 × 43.3 cm. The Osaka Municipal Museum of Art.

detail from Zhiyong's "Thousand Character Essay in Standard and Cursive Scripts" illustrates Su Shi's comments (fig. 54). "The bone-spirit of Master Yongchan's calligraphy is deep and stable, and the structures of the characters combine a myriad subtleties. But at the consummation of refined ability, he unexpectedly creates the sparse and bland. It is like a Tao Pengze poem. At first it seems scattered and unresolved, but after looking at it again and again one comes to recognize its rare flavor."[31]

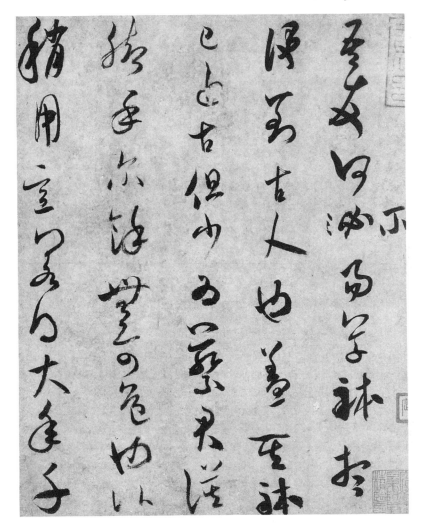

Elsewhere, Su Shi describes the calligraphy of the earlier writers Zhong You and Wang Xizhi—which can be considered in this context a generic reference to all Wei-Jin calligraphy—as "detached and scattered, simple and distant." "Its marvelousness," he writes, "lies outside the actual brushstrokes."[32] To Song viewers, Jin calligraphy had a clean simplicity. The brushwork was fluid, with limited modulation, and the character compositions were straightforward and loose. This unpretentiousness enhanced its beauty and, as Su Shi reveals, belied subtleties

56. *Mi Fu, "Copy of Wang Xizhi's 'National Territory.'" Northern Song period. Rubbing from* Bao-Jinzhai fatie. *From* Song ta Bao-Jinzhai fatie, *juan 9.*

apparent only after repeated viewings. He suggests that complexities exist, but they are the complexities of natural process rather than human invention. The beauty of the sparse and bland lies in the paradox that colors appear ever brighter where they are most faded, flavors grow ever deeper when they are most subtle.

These are the qualities Mi Fu hoped his calligraphy would express at Lianshui, and toward that goal he chose as his model the earliest known form of epistle writing. The contemporary scholar Qi Gong has perceptively observed that "Nine Works of Cursive Calligraphy" represent Mi Fu's foray into zhangcao, draft cursive calligraphy.[33] Zhangcao is an early form of cursive that arose during the Han dynasty from the practical need of writing complicated characters quickly. The details concerning its development and possible interpretation in the Song dynasty are murky. Nevertheless, the prevalence in Mi Fu's Lianshui calligraphy of squat, abbreviated characters written with short brushstrokes that occasionally flare where the brush is laid down and the notable tendency away from linking characters in vertical columns are subtle indications of an interest in this form of writing widely practiced by Wang Xizhi's immediate predecessors. The style and content of one of the nine cursive tie from Lianshui, titled "My Friend," substantiates this (fig. 55):

My friend, why don't you change the form of your cursive calligraphy? If you do, I believe you will then reach to the ancients. Now, your form of writing already nears the ancients, but it has a bit of the "feet and hands" of Cai Junmo [Cai Xiang]. Need I say more? Recently you have begun to use ideas. If you can acquire [Zhao] Danian's "Thousand Character Essay" then you will undoubtedly be able to achieve a sudden breakthrough. I love its slanted and tilted forces, which are something from outside of the Two Wangs. Also, there are no genuine works by Suo Jing. [You know by] looking at how the brush begins each stroke. "Yue yi" cannot be genuine. I am afraid it was written by someone else—undoubtedly a Tang calligrapher. It doesn't have that antique spirit of the men of Jin.[34]

Mi Fu denies the existence of genuine works by Suo Jing (239–303), but the very fact that this zhangcao master's name is raised indicates that the true topic of conversation here is alternatives not to the wild cursive of Zhang Xu—presumably that was beyond discussion—but to what was broadly recognized as the standard Two Wangs tradition of cursive calligraphy, represented most prominently in the second half of the eleventh century by Cai Xiang of the preceding generation. Zhao Lingrang's "Thousand Character Essay," we learn elsewhere, was written by the eighth-century calligrapher Zhong Shaojing, a tenth-generation descendant of the famed Wei period calligrapher Zhong You (151–230).[35] Mi Fu is saying that this genuine Zhong Shaojing is more valuable than all of those spurious "Suo Jings," especially because it has qualities *outside the Two Wangs tradition*.

The ramifications of this apparent reevaluation of the Two Wangs are considered in the next chapter. For now, it is enough to recognize that Mi Fu is not so much repudiating the Two Wangs as he is pushing his pursuit of the antique spirit associated with Jin into territories largely unrecognized by his contemporaries. The poem cited above that Mi Fu sent to Xue Shaopeng already raises this theme ("Before the Two Wangs there existed lofty antiquity"), written in reference to Li Wei's scroll of fourteen Jin dynasty calligraphers. In all likelihood, it was this valuable scroll of various writers that Mi Fu has chosen to emulate. As the poem makes clear, Mi Fu did not own it, but presumably he possessed careful copies that accompanied him to Lianshui.

Li Wei's scroll has long since disappeared, making it impossible to know which of the individual tie may have influenced Mi Fu's writing at Lianshui. Perhaps there was no specific model, the overall antique air of the writing being enough to encourage Mi Fu to explore the zhangcao mode of writing. There is, however, an important work of calligraphy highly admired by Mi Fu that may have been

directly influential. This is Wang Xizhi's "National Territory" (also known as "Lord Huan Reaches Luoyang"), a letter of nine lines that Mi Fu called nothing less than "the number one work of calligraphy under heaven" (fig. 56).[36] It may seem contradictory for Mi Fu to praise calligraphy outside the Two Wangs tradition while adopting as a model one of Wang Xizhi's own writings, but there is a possible explanation. Although Wang Xizhi is generally associated with jincao, or modern cursive—the style of cursive calligraphy that developed out of draft cursive—the line between these two forms of writing is not always clear. This is especially true with Wang Xizhi, a number of whose important attributions are clearly written in zhangcao.[37] Only rubbings now exist of "National Territory," one of the original calligraphy and one of Mi Fu's own copy, and neither of these provides a particularly clear image of this writing that Mi Fu held in such high esteem. Nonetheless, through the dim forms of the cut stone emerges an intriguing resemblance with Mi Fu's "Sage of Cursive Calligraphy." It is more noticeable in Mi Fu's copy of "National Territory," and it is seen in the gradual shift from evenly modulated brushstrokes to a slightly increased pace of writing, especially toward its end.

The resemblance is far from conclusive, and in truth this is the only evidence to suggest the potential influence of "National Territory." Mi Fu never mentions it in any of his writings datable to Lianshui, and by all indications he did not own it until some years later.[38] Nevertheless, he was well aware of the calligraphy, having attempted to acquire it over a period of many years, and as with Li Wei's scroll, it is likely that Mi Fu kept his own personal studies. The reason why this possible influence from "National Territory" is of interest concerns Mi Fu's understanding of the letter and his reasons for regarding it as highly as he did. Mi Fu wrote: "If a day passes without writing calligraphy I feel that my thoughts become clogged. I believe the ancients never let a moment be wasted without writing. Because of this I think of the scroll 'Lord Huan Reaches Luoyang' in Su Zhichun's collection. The characters clarify [Wang Xizhi's] ideas. It is especially skillful—the number one work of calligraphy under heaven."[39]

The ideas that the calligraphy clarified can only be the joy Wang Xizhi experienced on hearing that the old capital Luoyang had been recaptured by the Eastern Jin general Huan Wen (312–73), and the relief he felt learning that the health of the newly appointed military commander Xie Shang (308–57) appeared to be improving. This, as Lothar Ledderose has described, is the content of "National Territory," and we thus conclude that what Mi Fu appreciated most about the calligraphy was its direct and honest expression of Wang Xizhi's feelings. Did Mi Fu perceive a quickening in Wang Xizhi's hand as the letter unfolded, a

reflection of Wang's happiness in a shift of pace, as the act of writing found its natural rhythm in accordance with what the heart/mind dictated?

"National Territory" effectively illustrates both the fundamental paradox that underlies the pingdan aesthetic and the fundamental contradiction that informs Mi Fu's calligraphy at Lianshui. Mei Yaochen, championing the "even and light" in Tao Yuanming, wrote that poetry is little more than stating one's feelings; there is no reason to shout them aloud.[40] "National Territory" exemplifies that principle in calligraphy. Quiet and contained in appearance, it was simply a letter, yet between the strokes Mi Fu claimed to perceive Wang Xizhi's every thought and emotion: the intangible substance that defined his virtue. With "The Sage of Calligraphy," Mi Fu may have sought to convey this same impression of virtue concealed. "I wish to lay myself open and be tested against the past; a great shout emerges from my lungs and belly," Mi Fu wrote in his poem for Lü Dafang before he left Runzhou. But in Lianshui, Mi Fu felt that this great shout should be decorous and muted, so he retreats behind an opaque screen of equanimity. He presents himself as pingdan, knowing that this is what pingdan looks like. Yet by striving hard to appear what in fact he was not, Mi Fu subverts its very premise.

One hundred thirty years later, Yue Ke, the Southern Song collector and connoisseur who played such an important role in compiling Mi Fu's scattered writings, acquired a handwritten poem by Mi Fu that carried an authentication from the hand of Mi Youren identifying the poem as "Daolin." Daolin presumably refers to the Daolin Temple west of Changsha in present-day Hunan Province, and the poem, trusting that Mi Youren's identification was correct, would thus probably date from Mi Fu's early tenure in the southern city in the latter half of the 1070s. After the short poem, however, Mi Fu added the notation that he was writing this calligraphy at the Hall of Auspicious Ink in Lianshui. This discrepancy puzzled Yue Ke, who seems never to have considered the possibility that Mi Fu would rewrite a poem from some twenty years earlier, and he suggests that perhaps Mi Youren's authentication had been improperly removed from some other source and attached to this verse. We, of course, have no way of solving this small mystery today, and the poem is too minor to merit much concern. Nevertheless, Yue Ke's comments are of interest because he had visited Lianshui some twenty years earlier and was even more puzzled by discrepancies between what he had seen and what he read in the poem. Mi Fu's poem and most of Yue Ke's inscription follow:

When I climbed the small mountain there was no expectation
Of the solitary cloud suspended above the pines.

There was barely time for a single greeting
Before the cloud flew off, leaving no trace.
The cloud is already gone;
The stream remains long.
Clouds and streams—these are lifelong friends,
We share an understanding, and then forget one another.

In the year 1206, as an official in the granary at Nanxu [Runzhou], I was dispatched to accompany provisions for our troops. I spent the night on the Si River and reached Liandi [Lianshui]. Amid the ruined ramparts and crumbling city walls there were a dozen or so standing rocks. They were all *lingbi* rocks, and exceedingly strange. It was desolate and overgrown with brush. Unattended, it had become little more than a plot of wasteland. Someone pointed to it and said to me, "That's the old site of the Hall of Auspicious Ink." Twenty-three years later I acquired this calligraphy at Jingkou [Runzhou]. But Daolin is in the region of the Three Xiangs [surrounding Changsha]. How could Liandi have this alternative name? As far as my eyes could see it was barren country. How could there have been clouds and streams and the shade of lofty pines? With the passage of time things move and change. Otherwise, perhaps Mi Youren's authentication came from some other piece of calligraphy. If so, then this poem is not the real "Daolin." . . . I have written the following encomium to express my suspicions:

> *As for the name Daolin, I have no way of knowing. He has written about the clouds, streams, pines, and rocks at Liandi. This must have been the scenery of this region for him to have inscribed the poem this way. Today such traces have disappeared; there is nothing left. In the past I climbed atop the foundations of the Hall of Auspicious Ink and gazed out at the rolling contours of the land. Nowhere did I witness the marvels of what Mi Fu calls the mutual disregard of lifelong friends. The streams have moved on, and the clouds have returned to their roosts. Pines have been turned into bridges, following the cut of the ax.*[41]

Of course, Yue Ke's explanation that the landscape had changed radically over that period of time is not convincing, especially since Mi Fu's own writings confirm the dreariness of Lianshui. Whatever the answer to the problem of the poem's title, it is evident that what Yue Ke found, and what he failed to understand, was the distance that existed between Mi Fu's ideals and reality. A poem about Daoist detachment may well reflect concern over one's inability to escape

the entanglements of human affairs, just as the emergence of a style that strives to be "even and light" reflects a state of mind in agitation over self-appearance— precisely what pingdan is not. Mi Fu's calligraphy at Lianshui presents in microcosm Northern Song self-consciousness and the dialectic it forms with the elusive goal of naturalness. The fruits of this conflict are among the most engrossing traces from anyone's brush in the history of Chinese art.

Naturalness

Many centuries after the Northern Song, the accomplished calligrapher and painter Xu Wei (1521–93) offered a casual assessment of the writing of past masters, including Mi Fu. Xu Wei praised the sublime quality of Mi Fu's calligraphy, which he considered unattainable by others, but he was puzzled by its unevenness, appearing at times refined, at times rough. In contrast there was Huang Tingjian, whose writing was relatively uniform.[1] Xu Wei's comment is not about quality but about style, and it reflects the complexities of understanding the style-conscious artist. For instead of following a consistent path, or an organically evolving style whose pattern of growth permits some degree of forecast, one must decipher a map of individual decisions, the precise contours of which remain largely unpredictable. This is the primary reason why disagreements exist to this day over the dating of a number of Mi Fu's extant writings.

Diversity characterizes Mi Fu's calligraphy, and it is never so apparent as during the 1090s. This was a period of constant tinkering, exploration, and modulation, as individual voices alternately blossomed and receded within the greater superstructure of a personal hand. As Xu Wei's unease suggests, however, this diversity was also problematic, for style-consciousness and "ideas" tend to be antithetical to the ideal of natural calligraphy. Ideas represent effort and molding—a loss of innocence as one favors the mind over the hand. Interestingly, when ideas govern calligraphy, the consequence is likely to be a concern for naturalness. Not only is this concern present in the late Northern Song, but it dominates much of the theoretical debate of the arts from Ouyang Xiu's generation to Su Shi's and beyond.

Naturalness gradually became Mi Fu's paramount concern. It was arguably a theme that was present throughout his life: his early attraction to Jin calligraphy, for example, was largely a response to the apparent naturalness of the fourth-century writers. Moreover, Mi Fu's unbridled style derived from the naturalness presumed to accompany life out of office, and his critical remarks on the wild cursive tradition of Zhang Xu reveal related concerns. But it is not until sometime after the "Nine Works of Cursive Calligraphy" that Mi Fu's own writing consistently matches the rhetoric of naturalness. Mi Fu's ideas become less transparent; his hand

and brush do as they please, or at least appear to do so. This was an important transformation in Mi Fu's calligraphy, and one that he recognized himself, as the following note written to an unspecified friend reveals:

> From the time I first began studying calligraphy to the present I must have written on one hundred thousand pieces of paper. Now they are all scattered among the people. But with old age my writing has become even more remarkable. [Whenever I come across] a work of my youth I immediately try and make a trade—some new characters for the old letter. Often, however, people will not allow it. They do not realize that my old-age writing, which lacks those beautiful, graceful airs, is natural. People say that one's old age calligraphy has bone structure and does not convey refinement and beauty, but few are those capable of recognizing the spontaneous and natural. Commonly there are many who think that [my late writing] is not as good as that of my youth.[2]

Mi Fu's so-called old-age calligraphy and the personal circumstances surrounding its emergence are the subjects of the next chapter, but a glimpse at a detail of one excellent example demonstrates the profundity of this transformation. This quickly written short note, "Purple-Gold Inkstone," exemplifies writing that lacks beautiful, graceful airs (fig. 57; see also fig. 71). Little attention is paid to the propriety of individual strokes and characters. In places the strokes merge as indistinguishable blots of ink, as in the character *zi* (purple). The characters occasionally tend toward imbalance and misshape. The writing appears not only sloppy but perverse, especially when contrasted with such early works of crafted beauty as "Zhang Jiming" of about twenty years earlier (see fig. 31). It is not difficult to understand how the realm of Mi Fu's spontaneity and naturalness was not for everyone.

An exploration of the concepts that underlie this transformation in Mi Fu's calligraphy must begin with Mi Fu's own writings: the process of building a theoretical structure, initiated at Lianshui, continues and culminates, providing the model by which Mi Fu's late calligraphy should be evaluated. One set of writings datable to the period after Lianshui in particular stands out for its clear presentation of aesthetic values. This is Mi Fu's *Haiyue mingyan*, otherwise known as *Famous Words from the Studio of Oceans and Mountains*. As a prelude to Mi Fu's *Famous Words*, however, we reconsider some questions concerning pingdan. Certain elements of the aesthetic as practiced by Mi Fu in his cursive calligraphy at Lianshui are frankly contradictory. Recognizing them and understanding the road to their resolution with regard to Mi Fu's embrace of the natural is a first step in delineating the transformation of his calligraphy.

57. *Mi Fu, "Purple-Gold Inkstone." After 1101, Northern Song period. Detail of an album leaf, ink on paper, 28.2 × 39.7 cm. Collection of the National Palace Museum, Taipei, Taiwan, Republic of China. The character* zi *is at the upper right. Refer to figure 71.*

As readers may have ascertained, chapter 4 was in part an indictment of the common notion that Mi Fu embodied the "even and light." And in fact, this idea is not new. Xu Fuguan has shown that Dong Qichang came to this conclusion more than three hundred years ago: "Mi wrote that it is the 'configural force' [*shi*] that plays the most important role in calligraphy, but I find fault with his lack of 'blandness' [*dan*]. Blandness is carried forward by natural structure [*tiangu*]. It is not something that can be learned. This is what the sutras refer to as the knowledge attained from no teacher, and what painters call 'breath-resonance' [*qiyun*]."³ "Natural structure" may refer to the fundamental composition of one's written characters—personal style reduced to its indivisible level, or what remains relatively constant despite later accretions and transformations. What it literally means is the skeletal structure with which one is born and, by inference, one's basic personality and character. Dong Qichang is saying that Mi Fu's calligraphy is not pingdan because he, the person, was not. In general, I agree with Dong Qichang and have presented ample materials to show Mi Fu in his true unbland light. But a distinction must be made between pingdan as an attribute and pingdan as a style. Consideration of pingdan as a style, especially in calligraphy, naturally gravitates to a fixed definition: "even and light" translates as Jin writing, sparse, even-tempoed, calm, and self-contained. Dong Qichang had such an image in mind when he criticized Mi Fu's calligraphy, presumably thinking of documents other than his writings from Lianshui. As an attribute, however, pingdan by definition defies any such characterization. Like the Dao, it is literally empty, black, and formless. To associate that emptiness with a particular style is a convenience, a way of giving shape to that which is shapeless. The inherent contradiction is essentially the same as that announced in the first line of Laozi's *Daode jing:* "The Dao that can be told is not the constant Dao."

As an attribute pingdan becomes manifest not in a style but in one's approach to giving shape to a style. In this regard, pingdan becomes practically interchangeable with the concept of naturalness: what emerges without reflection from a state of equilibrium. So it was recognized for poetry. In his preface to the collected poems of the early Song poet Lin Bu (967–1028), Mei Yaochen wrote that when Lin "followed in harmony with things, enjoying his feelings, he would write poems that were even and bland, deep and beautiful."⁴ As Jonathan Chaves points out, Mei Yaochen may well have been influenced by the passage in *Zhuangzi* in which Tian Gen receives the following advice from the Nameless Man in response to his query of how to rule the world: "Let your mind wander in simplicity [*dan*, "blandness"], blend your spirit with the vastness, follow along with things the way they are, and make no room for personal views—then the world will be governed."⁵ The key phrase here is "follow along with things the way they are" (*shunwu ziran*), which is a call for naturalness. Naturalness means a lack of artifice,

and in poetry this was most commonly expressed as an avoidance of polished, wrought phrases. Skill could not be sought; it had to emerge of its own accord. Thus Huang Tingjian's answer to Wang Fan, who had sent some poems seeking advice:

> In the poems that you have sent to me are many fine lines, but I dislike the fact that your achievements are often the result of "fine carving and chiseling." To understand composition you need only thoroughly familiarize yourself with the poems in the ancient style meter written by Du Zimei [Du Fu] after arriving in Kuizhou. They are simple, yet a great skill emerges from within. They are "even and light," yet the mountains are tall and the waters deep. One wishes to imitate, but this is not something attained through seeking. In the accomplishments of literature, when there are no marks of the ax, then the results are truly excellent.[6]

There is an appealing simplicity and frankness to the unhewn words and phrases of a poet like Tao Yuanming or Du Fu, but commonly overlooked is the fact that the use of "unpoetic" language can also produce results that are difficult to digest. This helps explain a poem Mei Yaochen wrote to Yan Shu (991–1055), in which he claims to write poems, echoing his description of Lin Bu, "about that which is in harmony with my feelings and nature, trying as best I can to achieve the 'even and bland,'" but then describes how his rough diction "sticks in the mouth more harshly than water-chestnut or prickly water-lily."[7] Earlier, Han Yu described how Jia Dao (779–834) used "wild words" in his poems, often achieving the "even and light."[8] Jonathan Chaves expresses puzzlement over how wild words can be consistent with a pingdan style. Charles Hartman, considering the same passage, explains their juxtaposition as evidence of an eclectic spirit in Han Yu's concept of style in poetry, one that encompasses two contrasting poles. I would argue, however, that the root of the paradox lies precisely in our natural proclivity to see pingdan as a clearly definable style. When the "even and light" is perceived not by the associations of its two characters, *ping* and *dan*, but rather in terms of naturalness, then the paradox dissolves. It is confusing because in the eleventh century pingdan as a style clearly was often perceived as it is seen today. The difference is that we merely study it; Song poets had to wrestle with the problem of practicing it, and it was thus more readily apparent to them that a pingdan style hewn with an ax was a contradiction in terms. The issue is raised again in a letter that Su Shi wrote to his nephew:

> To my second nephew. I have received your letter and know that all is well with you. The logic of your discussion is quite enjoyable to read,

and your calligraphy has improved. There seem to be no problems with your [prose] writing, but there is one matter that I wish to address to you. When it comes to writing, a youth should work at making his style lofty and daring, so that the feeling is rich and dazzling. The older one gets, the more mature one becomes, and then one creates pingdan. Actually, it is not pingdan, but rather the culminating stage of "dazzle and richness." Today, all that you see is that your great-uncle's [my] writing is pingdan, so you straightaway study this style. Why don't you have a look at my writings from when I was preparing for the examinations? With its highs and lows, dips and turns, it is just like the ungraspable dragon. This is what you should study. With calligraphy it is also like this. Consider well what I say![9]

The conundrum of self-consciousness and style is rarely so well exposed. Su Shi's nephew models himself after his granduncle—clearly an acceptable practice—but the wrong period of Granduncle's life. It puts Su Shi in the uncomfortable position of having to tell his nephew to be natural, which by its very act reveals that a code of Confucian orthodoxy extends even over the problem of tapping one's original nature. It does not occur to Su Shi that it was perfectly natural for his nephew to emulate his famous uncle's style or that what came naturally to this generation was something different from what he had experienced as a youth. Pingdan, he believes, has to come afterward. It develops naturally after the energies of youth wane and transform into the placidity of advanced age. The whole problem with pingdan as a recognizable style is that it allows one to sidestep this process of organic development, thus, in a sense, making a mockery of what pingdan was supposed to be. Su Shi tries to explain this. One does not actually make pingdan, he corrects himself. It just happens.

Although the circumstances differ, the gist of this argument could be applied to Mi Fu's calligraphy at Lianshui. Like Su Shi's nephew he forges the pingdan style. Sometime thereafter he changes his approach. Already at Lianshui there are indications that Mi Fu increasingly thought of the "even and light" as integrally bound to naturalness. For example, one finds the association of naturalness with pingdan in "The Sage of Cursive Calligraphy," where Huaisu is perceived as having added the "even and bland" and somewhat attaining naturalness. But as one of the poems to Xue Shaopeng suggests, at this time Mi Fu still lacked the self-confidence necessary to embrace fully the virtue of naturalness:

Alas, a life spent mired in these problems,
My mouth knows how to voice them, but the hand won't seem to follow.
Who says if the heart is present the brush will attain its goal?
Natural skill, as itself affirms, is the subtlest of secrets.[10]

There is an important difference between naturalness and natural skill. Natural skill presupposes criteria of excellence, and as the distance that Mi Fu admits exists between his mind and his hand reflects, he was still striving to reach that level of excellence. For whatever reason, Mi Fu was not yet prepared to accept the results of the Nameless Man's advice to "follow along with things the way they are" before he left Lianshui. His willingness to embrace it after Lianshui is the most important explanation for the development of Mi Fu's late-style calligraphy.

Famous Words from the Studio of Oceans and Mountains

Among Mi Fu's extensive writings on the arts the best known are his two histories of calligraphy and painting, *Shu shi* and *Hua shi*, both probably completed between 1103 and 1105, and the earlier predecessor to *Shu shi*, *Baozhang daifang lu* of 1086. These are informal writings—assemblages of personal recollections, factual information, aesthetic judgments, anecdotes, poems—various things that Mi Fu chose to comment on as he recounted his experiences as a collector and connoisseur. Other remarks on painting and calligraphy are found in letters, poems, and casual notes, some of which are extant, some preserved as rubbings in fatie compendia, and others recorded in catalogues and literary collections, including the remnants of Mi Fu's *Shanlin ji* (*Writings of Mountains and Forests*). Among these is one source of Mi Fu wisdom that has not received the attention it deserves: a set of comments published under the title *Haiyue mingyan*, or *Famous Words from the Studio of Oceans and Mountains*. For in fact, *Famous Words* is the most lucid reflection of Mi Fu's aesthetic judgment.[11]

Famous Words from the Studio of Oceans and Mountains was first recorded in Zhang Bangji's *Mozhuang manlu* of circa 1144. Zhang introduces the text by commenting how Mi Fu prided himself on having attained the secrets of the ancients. *Famous Words* is the product of such self-satisfaction: two scrolls of superb writing consisting of a number of notes that Mi Fu wrote on Korean paper and presented to a contemporary named Zhang Daheng.[12] The scrolls were undated, but internal evidence suggests 1102–3.[13] Mi Fu's announces in the first scroll that his purpose is to provide concrete suggestions about writing calligraphy. He assails the time-honored practice of using indirect expressions and fanciful metaphors ("like a dragon leaping at Heaven's Gate, a tiger crouching at the Phoenix Tower") and promises to avoid effusive words of praise. One recognizes the same seriousness of purpose that marks Mi Fu's approach to calligraphy at Lianshui. Despite this, the comments themselves suggest little sense of internal order. They are thus incorporated here as the primary source material in a broader discussion and illustration of Mi Fu's late theories on calligraphy.

Dominating *Famous Words from the Haiyue Studio* and Mi Fu's other late writings is the rhetoric of naturalness. The term most commonly used to represent the concept is *tianzhen*. *Tian,* "heaven," refers to the natural process or order of the universe. *Zhen,* "authentic" or "genuine," is heaven's attribute. One important work of calligraphy that earns Mi Fu's label tianzhen is Yan Zhenqing's "Controversy over Seating Protocol," which Mi Fu described as bursting with Yan Zhenqing's righteousness (fig. 58). "Pulsing and twisting, his intentions were not in how the characters look. Tianzhen permeates throughout."[14] "Controversy over Seating Protocol" was Yan Zhenqing's draft of a letter addressed to a rival official named Guo Yingyi (d. 765) that angrily attacked the abrogation of court ritual in the service of party politics.[15] It was a universally admired piece of writing in the eleventh century because it laid bare, with graphic traces, the direct and forceful expression of Yan Zhenqing's moral rectitude. It was also, however, practically the only piece of Yan Zhenqing's calligraphy for which Mi Fu had a kind word.

"Controversy over Seating Protocol" is a fitting entrée to Mi Fu's discourse on naturalness because it marks the point from which Mi Fu's values sharply diverged from those of his contemporaries. Ouyang Xiu, helping to establish the indissoluble link between Yan Zhenqing's moral fortitude and the powerful forms of his writing, said that Yan's calligraphy resembled a loyal minister. In contrast, when Mi Fu looked at Yan Zhenqing's calligraphy, he found two behemoth warriors facing off: "stiff and unwieldy, like a pillar of steel being placed erect; powerful, it has an impenetrable air."[16] This assessment of Yan's writing is more descriptive than critical, but usually Mi Fu was remarkably biting in his censure of Yan Zhenqing, and always for one thing: his lack of naturalness. One interesting example in *Famous Words* is aimed at Yan Zhenqing's stone engravings:

> One cannot learn from stone engravings. Even if the person who writes
> the calligraphy employs someone to cut the stone it is no longer his own
> writing. For this reason one has to look at genuine handwritten
> specimens. From these you get the writing's true interest. Yan Zhenqing
> is an example. He always had his own house-servants carve the characters, and they proceeded in accordance with their master's wishes,
> adjusting and changing the *bo* [*na*] and *pie* slanting strokes and in the
> process completely losing the writing's genuineness [*zhen*]. Only his
> signatures on Mount Lu at Jizhou [are different]. This is because he
> wrote his name and immediately left, leaving the engraving to be done
> later. For this reason they all capture genuineness.[17]

58. *Yan Zhenqing (709–85), "Controversy over Seating Protocol." Datable to 764, Tang dynasty. Detail of a rubbing of a draft letter. From* Tō Gan Shinkei, Sai tetsu bunkō, Koku hakufu bunkō, Sō za'i bunkō, *26.*

Once one begins to go over the writing, retouching what the eye considers somehow unacceptable, the bond of trust that allows another to read personal truths within a matrix of time and place is destroyed, and the most basic of calligraphy's tenets is broken. Stelae, in general, undermine the self-expressive capabilities of calligraphy because the difficult process of transplanting the written traces to stone make it impossible to maintain the subtleties of the original. The gist of Mi Fu's comments is that no matter how skilled the engraver and how sharp the chisel, at best one is left with an opaque image of what originally had been written. But how much worse when the calligrapher remains present to oversee the carving. Instead of the quality control one might expect from the artist, Mi Fu argues that Yan Zhenqing consciously altered the diagonally slanting strokes of his characters to match his conception of what is proper. He compromised his spontaneity and therefore the integrity of the written forms. Interestingly, Mi Fu's comment is in direct contrast to Ouyang Xiu's explanation for differences perceived in Yan Zhenqing's stele calligraphy: Ouyang blames the skill of the chiseler, whose carelessness could mean the loss of the writing's zhen.[18]

Underlying Mi Fu's criticism of Yan Zhenqing is the assumption that at times Yan's calligraphy was guided by a preconceived image or concept that warped the writing's ability to be what it would otherwise be. With the Yan Zhenqing

59. Detail of Yan Zhenqing's "Record of the Yan Family Ancestral Shrine." Refer to figure 10. From Yan Zhenqing, *5:244.*

stele calligraphy that Mi Fu criticizes here, that self-consciousness intrudes after the fact, intentionally falsifying the original record. More commonly, Mi Fu aims his criticism at the manner in which Yan's ideas deliberately manipulate the forms of his characters as he writes. The primary focus is a peculiar conceit often seen in the terminus of Yan Zhenqing's right downward-slanting na strokes, in which the brush, rather than following smoothly to a placid ending, picks up slightly before finishing. This is illustrated in a detail from Yan Zhenqing's "Record of the Yan Family Ancestral Shrine" of 780 (fig. 59; see also fig. 10). Mi Fu refers to the resulting indentation as "kicking":

> Yan Zhenqing studied Chu Suiliang and succeeded. He then became famous for his "kicking strokes," which he used too often. Such writing lacks pingdan and is unnatural. This particular work employs much of Chu Suiliang's methods. The stone engravings from when Yan Zhenqing served as sheriff of Liquan and his "Record of the Immortal Magu" all partake of Chu's methods, but this tie is especially valuable because it is a genuine inkwork. It cannot, however, compare with Yan's "Controversy over Seating Protocol." In general, Yan Zhenqing's and Liu Gongquan's kicking strokes are the ancestors of the ugly and

detestable writing of later generations. From this time on the ancient methods floated aimlessly without a path.[19]

An important subtext to this inscription was the knowledge, purportedly conveyed by Yan Zhenqing himself, that just after leaving Liquan in the 740s he met and was influenced by that other great saboteur of ancient methods, Zhang Xu.[20] From Mi Fu's perspective, just as Zhang Xu profoundly influenced the cursive writing tradition, opening a path for his "vulgar" followers, so, too, did Yan Zhenqing and Liu Gongquan perversely influence the development of the kai standard script. Among the kinds of "ugly and detestable" writing to which Mi Fu refers were ordinary pharmacy signboards written in the styles of Yan and Liu, which, with their distorted and unnatural forms, struck Mi Fu as being as far from reality as the hundreds of so-called Li Cheng (919–67) paintings prevalent in his time, composed of exaggerated, wrathful forest trees, emaciated pine trunks covered with knots, and small trees that looked like lifeless firewood.[21] Mi Fu describes the trunk of a pine tree he once saw in a genuine painting by the influential master as sturdy enough to function as the great beam in a building. Li Cheng's followers, however, trying to emulate and enhance that sense of power and strength, exaggerated the pine's twisted, gnarly forms to suggest images of dragons and demons. The results, in Mi Fu's eyes, were laughably vulgar. Similarly, he found that the harder one tried to present an image of strength in standard script calligraphy by building on the affectations of Yan Zhenqing and Liu Gongquan the less successful were the results:

> When common people write large character calligraphy they grasp the brush with all of their might. But the stronger they grasp, the less their characters possess muscles, bones, and spirit. When they round the brush the stroke heads come out like steamed buns. This kind of vulgarism is really laughable. The essentials that apply to small-character writing are the same here: if the brush-tip forces are complete and there are no conscious mannerisms then the calligraphy will be good.[22]

A detail from Liu Gongquan's "Stele of the Xuanmi Pagoda of Master Dada," dated 841, well illustrates Liu's practice of the "muscles and bones" theory (fig. 60). His strokes are lean and singular with strong, punctuating hooks. The effect is striking but disjointed, especially because of the spaces left between strokes that normally abut. Yan Zhenqing's "Record of the Yan Family Ancestral Shrine" illustrates the source of Liu's mannerisms (see fig. 59): excessive attention paid to each stroke, arguably at the expense of overall compositional harmony. Both writers give an impression of monumentality and power, but it was not easy to

60. *Liu Gongquan (778–865), "Stele of the Xuanmi Pagoda of Master Dada." Dated 841, Tang dynasty. Detail of a rubbing. From* Liu Gongquan, *2:6.*

61. *The character* jun *from,* left, *Yan Zhenqing's "Record of the Yan Family Ancestral Shrine" and,* right, *Zhiyong's "Thousand Character Essay."*

duplicate, for would-be emulators gravitated toward the individual angry features without considering the overall complexity of Yan's and Liu's writing. One notes in "Record of the Yan Family Ancestral Shrine" how Yan Zhenqing's brush appears to have lingered in some of the stroke heads and dots, creating bulbous forms that Mi Fu elsewhere calls "silkworm heads." In the context of Yan Zhenqing's muscular writing such effects are not necessarily displeasing, but a follower writing large-sized calligraphy and seeking to project Yan's formidable strength could easily overemphasize such stylistic features. The result is steamed buns.[23]

By any criterion, the standard style writing of Yan Zhenqing and Liu Gongquan cannot be considered pingdan. Nothing is concealed. In fact, anatomically speaking, so strongly is the internal structure emphasized that the calligraphy might be called exoskeletal. The image of strength that is projected, Mi Fu would argue, is premeditated. There is a consistent manipulation of elements within the individual character compositions, as the traditional canon of proportioning, balancing, and evenly arranging the components that form any given character is largely ignored. This is particularly true with Yan Zhenqing's calligraphy, in which the characters seem to explode outward from within, fully filling their individual square boxes. A comparison of the character *jun* (gentleman) as written by Yan Zhenqing and by the sixth-century Wang Xizhi follower Zhiyong illustrates the point (fig. 61). Zhiyong's character is tightly composed, with each stroke smoothly integrated for overall harmony. Slightly tilted, the whole structure seems ready to take wing. Yan's "gentleman," in contrast, is a lumbering golem constructed of disparate parts. The pie stroke is shortened and the prominent heng stroke elongated, with a pronounced bulge at its end. The square underneath is markedly separated from the upper portion of the character so that the negative spaces between strokes are roughly uniform. The effect is engrossing, but hardly natural.

One could argue that herein lies the genius of Yan Zhenqing: the tension that is engendered by the complexities and friction of the internal structuring in his characters is a vital element in the calligraphy's overall power. The process, however, could also be considered an imposition of Yan Zhenqing's ideas on the natural structure of the characters. It must be remembered that the legendary begin-

nings of writing in China established that the characters were innate signs gleaned from the phenomenal world. The basic forms, once settled, could not be reconstituted without drawing sharp attention to a break not only with tradition but with the natural order itself. This is the most important theme in Mi Fu's *Famous Words from Haiyue*. In the following passage he first focuses blame for what he calls the crime of "equalizing the large and small" (*daxiao yilun*) on Xu Hao (703–82), one of Su Shi's purported models, but that blame quickly shifts to Yan Zhenqing and, ultimately, to Zhang Xu:

> People of the Tang dynasty considered Xu Hao a match for Wang Sengqian [426–85], but this comparison is totally inappropriate. Hao made the large and small uniform; his is truly the bureaucrat's standard script. Sengqian and Xiao Ziyun [487–549], transmitting Zhong You's [151–230] methods, were no different from Zijing [Wang Xianzhi]. The large and small each have their measure; there is no single norm. Xu Hao was an invited guest of Yan Zhenqing, and the general style of his calligraphy came from Crazy Zhang. [Zhang Xu] taught Yan to squeeze his large characters small and stretch his small characters large. These are not the methods of antiquity.[24]

The same idea is echoed in another passage in which Mi Fu begins by criticizing the calligraphy of Shi Manqing [Shi Yannian, 994–1041], a Northern Song follower of Yan Zhenqing and Liu Gongquan, for lacking the animation that allows the characters to respond to one another. Mi Fu continues,

> The small characters are expanded and thus forced large while the large characters are contracted and thus ordered small. This is the mistaken theory that Crazy [Zhang] taught to Yan Zhenqing. The characters each have their own calling in size. It is like the writing of the temple board *Taiyi zhi dian* 太一之殿 (the Hall of Ultimate Unity). If four equally sized squares are made for the characters, can the character 一 be so fattened as to fill a square and balance 殿? The characters each have their own calling in size; they should not be contracted or expanded. I once wrote the temple board *Tianqing zhi guan* 天慶之觀 (the Temple of Heavenly Felicitation). The characters 天 and 之 are both composed of four strokes. As 慶 and 觀 have numerous strokes I put them below. Each character was written in accordance with its own calling. Suspended and rising with spirit and force, they carried themselves along in such a manner that the characters all seemed to be of equal size. Though they were written in the standard script, these characters seemed to fly.[25]

This realigning of the characters' interior elements to force them into equal sizes was, in Mi Fu's eyes, a mechanical exercise producing lifeless results. His description of the writing as "counting slats" emphasizes how the stiff individual strokes fail to unite so that the character can function as a living organism.[26] Essential to standard script calligraphy, he writes, is *tishi*, "configurative" or "body" force. "Standard script calligraphy is extremely easy; it is only [infusing] configurative force that is difficult," he writes. "As long as the strokes are not evenly and methodically balanced then the force will come alive."[27]

As described earlier, Dong Qichang took note of Mi Fu's emphasis on tishi. He seems to have associated it with Mi Fu's lack of blandness, recognizing in this interest in engendering movement a link to Mi Fu's character. From Mi Fu's perspective, however, this was simply promoting the methods of antiquity. Configurative force in this context can be likened to the Promethean spark of life; it follows naturally if the organic unity of the characters is maintained. Construct a character whose limbs, so to speak, are in the right place and proportion, and it moves. Conform its shape to a square box with strokes of even modulation and it remains a flat and lifeless design. The body analogy presumes a three-dimensional presence, as if the character were suspended in space and viewable from any angle. Mi Fu refers to this as the "eight sides" of the character, and he considered it a salient characteristic of ancient writing:

> Characters possess eight sides, but they are only seen when written in the standard script. Large and small each have their own measure. Zhiyong's characters possess eight sides, though already by this time Zhong [You's] methods had faded. With Ding Daohuo, Ou [-yang Xun], and Yu [Shinan] the brush began to even out and the ancient methods were lost. Liu Gongquan modeled himself after Ou but his ability lagged distantly behind. Moreover, his calligraphy was the ancestor to ugly and strange writing. From the time of Lord Liu the world began to know vulgar calligraphy.[28]

One of the most interesting aspects of Mi Fu's *Famous Words from the Studio of Oceans and Mountains* is its reflection of an art historical mind. With remarkable acumen, Mi Fu looks back over the history of calligraphy and pinpoints key moments when seminal changes took place that profoundly influenced later developments. At times his judgments appear random, even contradictory, such as his attribution of the loss of ancient methods to various times and people, but this merely reflects the complexity and protracted nature of the historical process. Over all, Mi Fu equated the methods of antiquity with the calligraphy of the Jin dynasty and earlier, and he viewed their loss as gradual. Key figures such

as Zhang Xu, Yan Zhenqing, and Liu Gongquan are recognized as having contributed to their demise, but the true culprit is time itself. In another passage Mi Fu points out how the fat and vulgar calligraphy of the Tang emperor Xuanzong (r. 712–56) influenced the writing seen in official documents and Buddhist scriptures, "and the ancient airs from before the Kaiyuan reign [714–41] were never seen again."[29] But even before the Kaiyuan period, as the previous passage reveals, the methods of antiquity were receding from view. Ding Daohuo, Ouyang Xun, and Yu Shinan were all calligraphers of the late sixth and early seventh centuries, leading figures, in fact, in the development of the highly disciplined, precise style of standard script calligraphy associated with the Tang dynasty. In another passage, even the highly admired Chu Suiliang is grouped with "Ou, Yu, Liu, and Yan" as practitioners of "a single brush of calligraphy," which apparently refers to Tang calligraphy in its collective style.[30] Zhiyong, in the mid-sixth century, could still capture the spirit of Jin writing, but it came only through persistent practice, and even then the methods of Zhong You and calligraphy before the Two Wangs had practically disappeared: "Zhiyong's inkstone [through constant grinding of the ink] became concave, like a mortar, and he was thus able to reach the General of the Right [Wang Xizhi]. If he had ground it through to the other side then he would have begun to reach Zhong [You] and Suo [Jing]. [For success in calligraphy] there is no avoiding practice."[31]

In Mi Fu's comments on Zhiyong, this earlier follower of Wang Xizhi emerges as an erstwhile rival in a competition played out across time and history. Mi Fu looked at that worn inkstone and seems to have assumed that Zhiyong's motivation for writing so much calligraphy was the same as his own: to work one's way back to the pristine image, scraping away the accretions of time like so many layers of yellowed varnish. At the very bottom was the limits of the epistle tradition as Mi Fu knew it. In his writings he mentions no genuine works from the brushes of Zhong You or Suo Jing, but Mi Fu *had* seen writing that pre-dated the Two Wangs, and it confirmed his belief that older was better. That calligraphy belonged to the third-century emperor Jin Wudi and to Wang Rong, two Jin dynasty writers showcased in the celebrated scroll owned by Li Wei. As Mi Fu's "Grand Preceptor Li" demonstrates, the distinctively archaic quality of Wudi's and Wang Rong's calligraphy had already made a strong impression on Mi Fu when he first became acquainted with Li Wei's prize in about 1086 (see fig. 29). The scroll again attracted Mi Fu's interest while he was in Lianshui, inspiring his poem to Xue Shaopeng, and it became the subject of an important piece of writing Mi Fu wrote titled "The Collector." I suspect that "The Collector" was also written for Xue Shaopeng:

There is a tie in the possession of a collector which is like the *zhuan* and *zhou* archaic seal scripts. Looking back at the Two Wangs, suddenly they are tainted with dust. I am speaking of Emperor Wudi's tie. . . . The scroll has jade rollers and old silk brocade mounting. Every part of it is antique. It is a rare treasure of this world, no description of which will serve it justice. My regret is that you are unable to appreciate it together with me. Upon returning, I chased after its forms, scribbling away on dozens of pieces of paper, but it was as if I had suddenly forgotten how to walk. What a laugh! . . . When Tuizhi [Han Yu] said, "[Wang Xizhi's] vulgar writing avails itself of pretty graces," it was not only the Stone Drums that had inspired him to such thoughts; he had also seen writing like this! Jin Wudi's writing—the paper is wasted and torn but the ink's color is like new. In the places where there is ink it is not damaged. Ah! How could one ever come to write like this through studying and copying? It is enough to make one throw away brush and inkstone. With writing like this to learn from how could calligraphers of the past not reach the realm of the marvelous? If one studies only Tang calligraphy, then one's ideas and manner will be sickly and weak. How then could one's writing triumph? His [Jin Wudi's] writing is like the image of primitive man. It has the substance of natural, rustic simplicity. Aide Zhang [Zhang Xu] and Huaisu could never even reach his outer fence. . . . I want to empty my whole treasure box of calligraphy and trade it for one or two tie from this scroll, but I fear [the owner] will not agree. These days I am too lazy even to open my trunk, but I grind the ink all day long and chase after one or two characters as a means of solace.[32]

In the middle of this lengthy note Mi Fu refers to a famous line from Han Yu's "Song of the Stone Drums," in which the seductive charm of Wang Xizhi is unfavorably compared to the forthright power of writing found engraved on five ancient and celebrated stones of pre-Qin dynasty date discovered in a Shaanxi field early in the Tang dynasty. It is a contrast that would be long-lived in the history of Chinese calligraphy, though the emphasis would shift from the antiqueness of the Stone Drums to simply the strength of the style they presented. This transformation is reflected in the gradual replacement of Yan Zhenqing for the Stone Drums as the antithesis to the Wang Xizhi style, a process that was already under way in Mi Fu's time.[33] The antipodal qualities that Mi Fu establishes in contrast to Wang Xizhi, however, are clearly something different from Tang dynasty "muscles and bone." More to the point, Mi Fu saw the qualities of strength and integrity that cluster opposite the Wang Xizhi style as inextricably rooted in deepest antiquity.

Mi Fu's rejection of the Two Wangs in "The Collector" has its roots in an ancient debate that took place well before Han Yu's "Song of the Stone Drums" and reflects on an important paradigm in Chinese criticism that cuts across the arts to establish two camps: the progressive and the revisionary. In calligraphy the debate appears to have arisen out of a mania for self-evaluation and comparison during the Wei-Jin period. By late in the fifth century the emphasis shifted from personal abilities to grander historical, even metaphysical, schemes, as the participants reflected on the great developments over the preceding three to four hundred years and argued which was better, the new or the old. The argument centered on Wang Xizhi, Wang Xianzhi, and their two famous predecessors, Zhang Zhi (?–AD 190) and Zhong You. In his *Memorial Discussing Calligraphy* (*Lunshu biao*) of 470, Yu He states the position of the progressives:

> What is ancient is artless and substantial and what is modern is graceful and beautiful. This is the natural law of things. The beautiful is loved and the artless is disregarded. These are the natural inclinations of human feelings. Zhong [You] and Zhang [Zhi], compared to the Two Wangs, can be called ancient. How could the difference not exist here as well between the artless and the beautiful? Moreover, the works of the Two Wangs' late years are entirely superior to those of their youths. Between father and son there is also the distinction of the old and the new. Zijing [Wang Xianzhi] exhausted the subtleties of the beautiful and this is only appropriate.[34]

Yu He would not have gone to the trouble of promoting the "modern" style of Wang Xianzhi over the antiquated and artless Zhang Zhi and Zhong You had there not been active support for Zhang and Zhong. Two generations later such support is recorded in a short note on calligraphy by Emperor Wudi of Liang (r. 502–49), titled *Examining the Calligraphy of Zhong You: Twelve Concepts*. Zhang Zhi's and Zhong You's calligraphy, he writes, is so full of skill and intrinsic flavor that it is as if it belonged to Creation itself. Wang Xizhi, in contrast, is a Johnny-come-lately, a dedicated follower of Zhong You whose original ideas fell short of expectations. "Just as Yishao [Wang Xizhi] was unable to attain the level of Yuanchang [Zhong You], so, too, was Zijing [Wang Xianzhi] unable to match the abilities of Yishao."[35] The basic question underlying this debate can be stated thus: Does an artist's work improve on that of its predecessors, or does it fall away from its original power and substance, complicate it with empty adornments and mannerisms? Almost two hundred years later Sun Guoting summarized the arguments and provided a Confucian compromise:

Although writing was first created for the purpose of recording words, as civilization transformed over time, so, too, did its substance and patterns. It is an eternal law of the phenomenal world that changes occur with the relentless turning of the wheel of time. What is essential is to be able to be ancient without forsaking one's own time, and to be modern without sharing in the common faults [of one's own day]. As it has been said, "When [outer] pattern and [inner] substance are in equal harmony, then there is a gentleman." Why trade an adorned palace to live in a cave or a jade carriage to ride in a menial pushcart?[36]

Sun Guoting lived amid the great confidence of the early Tang, a time when the exalted orthodoxy of calligraphy's past was matched by the abilities of the present, and there was little to question of the patterns of his own day. Four hundred years later, however, the great house of Tang was long finished, and nothing but questions remained for this fundamental issue of style. Mi Fu takes the position that the adorned palace and jade carriage had obscured the inner substance of their prototypes. Like Liang Wudi, he believed it was a natural law for the past to be superior to the present. For Mi Fu, however, it was not enough to return to the antiquity of Zhang Zhi and Zhong You, these men who, in the historiography of Chinese calligraphy, represented the beginnings of writing as a high art. Jin Wudi's *tie* was a window to the predecessors' predecessors, and together with the early calligraphy Mi Fu knew from outside the epistle tradition it led to the culmination of his historical view in *Famous Words:* "With the rise of the clerical script the ancient methods of the great seal were destroyed. In the zhuan and zhou seal scripts the size of a character was determined by its form. Thus, one knows from them the myriad manners of nature. Alive and full of motion, round and complete, each is a self-contained image. With the clerical script the forces of stretching and compressing began, and the methods of the three ancient dynasties [Xia, Shang, and Zhou] were lost."[37]

According to tradition, development of the clerical script, *li shu*, took place during the reign of Shihuangdi of Qin (r. 246–210 B.C.), the first emperor of China.[38] The clerical script represented the codification of writing in a period of oppressive standardization, simplifying the forms of the characters to suit the needs of a unified and efficient empire. Qin was a great watershed in the early history of China. It marked the end of great antiquity and the advent of the imperial civilization that would lead eventually to Mi Fu's era. Perhaps it was inevitable that Mi Fu would ultimately apply this turning point in the historical evolution of the Chinese scripts to his theories on calligraphy. For the revisionary, the transformation of the seal scripts into a more serviceable form of writing represented a fall from the grace of early civilization.

Mi Fu's infatuation with the methods of antiquity could be understood as a natural, if extreme, extension of his early interest in rare works of calligraphy as a connoisseur. It also, however, belongs to the much broader recurring cultural pattern generally referred to as *fugu,* "returning to antiquity." Ever since Confucius proclaimed his allegiance to the early Zhou dynasty and its presumed utopian society overseen by sage rulers, the revisionary's prospect was established on the bedrock of orthodoxy. As a result, Mi Fu's promotion of the salient features of ancient writing cannot simply be considered the amusement of someone indulging in the novelties of primitivism. He was engaged, rather, in a noble pursuit whose presumptions would not have been questioned by Northern Song society. In fact, Mi Fu's exploration of early calligraphy is but one example of a strong manifestation of fugu sentiment that permeated the later eleventh century. Such prominent and disparate phenomena as the "ancient prose" movement promoted by Ouyang Xiu and Wang Anshi's "New Law" policies of the 1070s were founded on the basic premises that the ancient was superior to the modern and that the policies and cultural patterns of recent history reflected an alarming distance from the presumed perfection of early civilization. Fugu values underlie the burgeoning interest in ancient bronzes and *jinshi** "metal and stone" epigraphy studies. They play a prominent role in the development of literati painting. From this perspective, Mi Fu's comments on calligraphy, especially in the years immediately following his assignment to Lianshui, are well within the mainstream of Northern Song society. What makes them stand out is the fact that so few contemporaries shared Mi Fu's grasp of the history of calligraphy that his pronounced judgments on such sacred figures as Yan Zhenqing and even the Two Wangs seemed anything but rational. In China, paradoxically, it is during the most modern of times that fugu movements emerge with the greatest intensity. Similarly, sometimes those who pursue orthodoxy with the most concentrated energy achieve the most original and creative results.

There is, however, more to fugu than the orthodoxy of the good Confucian. The point is best illustrated with a fanciful story of a meeting between Confucius and Laozi recorded in the Daoist classic *Zhuangzi.* Laozi had just finished washing his hair and had let it down to dry, sitting so still that he appeared other than human. Confucius bided in wait, watching him sit in this trance. Afterward he approached and asked what had happened: "A moment ago, Sir, your body was as still as withered wood. It seemed as if you had left behind material things, distanced yourself from humankind to stand in something apart." Laozi replied, "I was roaming my heart to the beginnings of things." Confucius questioned Laozi further about this mystical journey but ultimately admitted to his disciple Yan Hui the limits of his understanding, like a small gnat trapped in a pickle

barrel.[39] The key word in this charming story is "roam," *you*. It connotes freedom unrestricted by social ties and the vagaries of human emotion. To roam to the beginnings of things means to witness the elemental mystery of creation. It is the ultimate fugu, and one of which Confucius and the society spawned by his philosophy will never partake.

"Returning to antiquity" is the concern of both Confucians and Daoists, but whereas the Confucians' "return" is to some earlier, utopian model of civilization, there are no limits to the Daoists' sojourn; Daoists return to a state of un-civilization. A parallel might be drawn with calligraphy. To the average Song bureaucrat, the choice of calligraphic models is part of a broader concern with establishing oneself in a network of social relationships and public values. He reacts to what is current—models commonly promoted by the leaders of society and often belonging to earlier masters whose images somehow coincide with the values of the ruling order. Calligraphy styles that emanate strength and durability, such as those of Ouyang Xun, Yan Zhenqing, and Liu Gongquan, have a natural appeal in this service to the state, though grace and beauty, as exemplified by Wang Xizhi, have also proven equally important at other times and to other people. The important point is that each style represents a terminus in the return, a goal. The pattern that Mi Fu presents essentially denies the validity of goals. If there is one, it resides in the dynamic process of returning itself and in the process of self-discovery that naturally occurs in this roaming to the beginnings of things.[40]

> At first I studied Yan Zhenqing. I was seven or eight at the time. My characters were as large as the paper itself, and I was incapable of writing notes. Then I saw Liu [Gongquan] and yearned after his tight structures; so I studied Liu—his "Diamond Sutra." After a while I realized that Liu came out of Ou [-yang Xun], so I studied Ou. With the passage of time my calligraphy resembled counting slats, so I looked with longing toward Chu [Suiliang]. I studied him the longest. I also was attracted to Duan Ji and his calligraphy's twists and turns and plenteous beauty. The eight sides were complete. After a while I realized that Duan had developed completely from the Lanting, and thus I began to look at rubbing compendia of model writings and entered the pingdan of Jin and Wei. I rejected the squareness of Zhong [You] and studied Shi Yiguan—his stele for Liu Kuan. For seal script I love "Cursing Chu" and the stone drum inscriptions. I also awakened to the calligraphy of lacquer written with a bamboo stylus on bamboo slips and the wonders of antiquity in the writing found in archaic bronze vessels.[41]

This celebrated self-account of Mi Fu's study of calligraphy is structured after the Daoist paradigm of the mystical sojourn to the undifferentiated beginnings of the precosmic condition of chaos, the Great Unity. Its contents have been taken literally by most who have studied Mi Fu, and there is no reason to question their basic validity. Nevertheless, Mi Fu's account should also be recognized as an attempt to fashion of his life a Daoist myth of return. It is remarkable how persistently Mi Fu presents the Daoist persona, from the free-spirit immortal of Chu who prefers "tower-living" to the sage ruler of Yongqiu who rules with inaction, and to the degree that such labels have any significance, Mi Fu was decidedly a Daoist calligrapher. His call for a return to the methods of antiquity mirrors the Daoist's return to the fundamental roots of precivilization. His insistence on writing unhewn by the axes of both personal and societal intent parallels the Daoist's value of the plain and pristine form of the "uncarved block." His advocacy of allowing the characters to realize their own callings in size subtly recalls Zhuangzi's relativism and the equality of all things. Conversely, his unmitigated criticism of the stretching and contracting of writing so that the characters lifelessly fit into boxes of uniformity suggests the Daoist's disdain for the "progress" of civilization. Even Mi Fu's most technical advice for the writing of calligraphy has a decidedly Daoist touch: "In the study of calligraphy what is to be valued is the handling of the brush. That is to say, the brush must be held lightly, with the hand naturally forming a void in the center. Swiftly, rapidly, naturalness [*tianzhen*] then emerges from beyond conscious intent."[42]

The light grasp ensures that the brush's movements are not forced by ideas but are the products of a natural process that somehow emanates from an empty center, presumably a metaphor for the Daoist's nonbeing from which all phenomena are born. This advice, which begins Mi Fu's self-account of his study of calligraphy, continues by emphasizing how diversity and individuality are natural to the way things are. The character *san*, "three," is composed of three horizontal strokes, but each is written differently, he writes. "Variation results from the fact that the process of 'self-so naturalness' [*ziran tianzhen*] makes them different. This was the way it was with the men of antiquity." If it were otherwise, he remarks, their calligraphy would be "slave writing."

"Slave writing" is the term Ouyang Xiu used in his championing of individuality in calligraphy. A generation later, Mi Fu provided a philosophical and technical rationale for the individual style based on the discourse of naturalness. We are again reminded that much of what Mi Fu advocated was in one form or another also embraced by his peers. But what for Ouyang Xiu was a brief reflection on a favorite hobby became an elaborate and coherent argument. No one else assembled elements of history, philosophy, aesthetics, and practice to fashion a

systematic ideology of calligraphy. That it accords not only with the persona of the free-spirit immortal Mi Fu presents so effectively and consistently over the years but also with his late-period writing makes this ideology all the more compelling.

Great Synthesis

"In my early years I was unable to establish a personal style. People said my writing was a compendium of ancient characters, for I chose the strengths of the various early masters, combined and synthesized them. As I grew old I finally established my own style, and when people now look at my calligraphy they have no idea from what sources it developed."[1] Mi Fu's comment on the emergence of his personal style is found at the beginning of *Famous Words from the Studio of Oceans and Mountains* and as such sounds an important theme in his theoretical structure for calligraphy: *dacheng,* "the great synthesis." In the study of Chinese art history the theory of dacheng is best known through the critical writings of Dong Qichang and the paintings of the early Qing orthodox masters who followed.[2] There is little doubt, however, that Dong Qichang was heavily influenced by Mi Fu, and never more so than in this fundamental approach to the development of a mature personal style. The theory of the great synthesis has its roots in early Chinese philosophy, where dacheng commonly refers to the realization of a paramount goal—a "great completion" in a social or personal enterprise. The means to this realization are found in *Mencius* and in the analogy of the great synthesis to Confucius, who is likened to the ultimate symphony of perfect music, melded from the harmonious assemblage of myriad sounds.[3]

Dacheng assumes great importance in the formulation of a Chinese model for style. It dovetails with preconceived ideas of old age to suggest a final plateau of wisdom and experience. Like Buddhist enlightenment, it presumes the attainment of universal knowledge, drawn from all corners and harmoniously blended, and like enlightenment, it suggests personal transcendence. Dacheng is the realm of absolute naturalness, where actions are spontaneous and unpremeditated, yet mature in a particular form of perfection that bears witness to the individual's apotheosis. Here, however, there is a divergence between theory and practice, for in its practical application as a model for style, the idea of the great synthesis, like naturalness, presents a considerable problem: it is something better recognized in others than pursued on one's own. One may read a thousand books and travel ten thousand miles, as Dong Qichang urged, but such preparation does not guarantee a crossing of the threshold, just as years of meditation do not guarantee enlightenment.

The calligraphy from the last six or seven years of Mi Fu's life has a maturity and consistency that seem to corroborate his claim of having achieved a great synthesis. "Ideas" appear to recede, accompanied by a diminished sense of self-consciousness. The writing presents the very image of naturalness. But there is something disturbing about the artist who advertises his own enlightenment. The action seems self-contradictory, reflecting consciousness of that which should happen unconsciously, concern by one who should be without concern. The very fact that Mi Fu tried to replace those early, pretty writings that people collected with his old-age calligraphy indicates continued insecurities about who he was and how he was perceived. One is left with a troubling question: Is Mi Fu's late writing truly what it purports to be, or is it simply a culminating stage of Song ideas—the presentation of the idea of naturalness? The question carries a certain urgency from a traditional perspective, for it raises the issue of calligraphy's ability to reflect honestly the character of the writer. Ultimately, however, it cannot be answered. Mi Fu's consciousness of style presents an intrusion that thoroughly complicates what in theory is a simple equation between heart and hand. The final stage of the style-conscious artist is characterized by the effort to appear unconscious of style, and when the artist is as demonstrative as Mi Fu, what becomes most noticeable is the effort itself.

Life and Calligraphy at the Court of Emperor Huizong

From his first post as a collator in the Department of the Palace Library to his service in the military commandery at Lianshui, Mi Fu's official career is noted more for its disruptions and demotions than its successes. Nevertheless, Mi Fu's hopes to succeed in the world of officialdom should not be underestimated. The pride and ambition he exhibited as district magistrate of Yongqiu in 1092 was a clear reflection of a powerful desire to present his virtue to the world. It reveals itself again in the poem he wrote for Lü Dafang on the eve of his departure for Lianshui, and yet again in a ci lyric he wrote for his two sons, Mi Youren and Mi Yinzhi, a few years later:

> To the tune "Dianjiang jun," shown to my sons Yinren [Youren] and Yinzhi
>
> The fields of Xin are vast and lonely,
> The banks of the Wei extensive and silent—these feelings are limitless.
> Great mounds of documents,
> Too lazy to pass them another glance.
> Don't be surprised, children,
> That my head is filled with frost.
> Merit and fame are late in coming.

Waters and clouds are buoyant and expansive,
Casually, I go to the outpost pavilion and watch.[4]

The fields of Xin were tilled by Yi Yin at the end of the Xia dynasty. Discovered by Tang, the founder of Shang, Yi Yin was invited to serve the new dynasty and went on to become a meritorious prime minister. The banks of the Wei were fished by an old hermit named Lü Shang during the reign of Wen Wang of Zhou. Discovered by the king during an imperial hunt, he was brought to the capital and instated as a general.[5] Mi Fu's allusions to these paragons of antiquity are an expression of bravado: like Yi Yin and Lü Shang, Mi Fu would be discovered. The closing image of water and clouds reveals Mi Fu's sense of identity with those elements of nature that move in perfect naturalness. There is no chagrin or anxiousness, only a calm and even harmony as Mi Fu waits his turn. Such nonchalance is in marked contrast to the following letter addressed to some important patron probably written toward the end of Mi Fu's tenure in Lianshui:

> Fu bows his head in greetings and writes once more. As usual, I receive
> your kindness and dare not exclude myself from your grace. With these
> true sentiments I look up to you, Sir. My present duties do not prevent
> my requesting a recommendation for office. If I were to receive a post
> handling documents or working in an accounts office I would drive
> myself hard, sparing not an ounce of energy. As of the sixth month I
> will have been here a full thirty months. Everyone heads west, fearful of
> the fierce summer heat, but I am poor, without a penny to my name. If I
> were to receive your benevolent grace I will serve you with the unfailing
> fortitude of one who bears a mountain on his back. Fu respectfully bows
> his head.[6]

Other letters that survive from this period are equally ingratiating. One celebrated note to an old friend, Jiang Zhiqi (1031–1104), goes so far as to suggest the exact wording by which Mi Fu might be recommended to the court.[7] In another, congratulating the influential Deng Xunwu (1055–1119) on his recent promotion, Mi Fu humbles himself to the role of disciple and retainer (*menren*), even though he was Deng's senior by a few years (fig. 62).[8] Private correspondences have a way of bringing even the most ebullient of individuals down to earth. These are not the kinds of documents Mi Fu would have liked to be preserved in the historical record, but they well illustrate the fact that worldly success, especially for someone with the temperament of Mi Fu, was largely dependent on personal connections, and it came with a price. "Handling documents,"

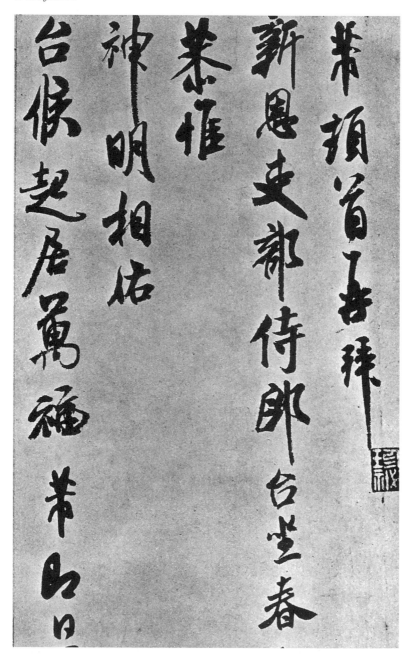

62. *Mi Fu, "Letter to Deng Xunwu." Datable to 1102, Northern Song period. Detail of an album leaf, 33.3 × 48.5 cm. The Palace Museum, Beijing. From* Mi Fu chidu.

from the letter above, translates into the duties of a minor bureaucrat with some skill as a calligrapher. The irony is self-evident.

Mi Fu's request appears to have been answered. In the latter half of 1100 or in early 1101, Mi Fu was reassigned to the Office of the Supply Commission for the Jiangnan, Huainan, Jinghu, and Liangzhe circuits as a manager of documents. According to one source, Mi Fu was stationed in Zhenzhou (modern-day Yizheng, Jiangsu Province), a mere fifteen miles up the Yangtze River from Runzhou, and it is evident from the numerous recorded inscriptions Mi Fu wrote for his prized collection of calligraphy at this time that his official duties were not so pressing that he could not enjoy the "lakes and rivers" of his old home.[9] In fact, Mi Fu probably spent much of his time on a boat coursing those lakes and rivers, if not in the service of his job or commuting between Zhenzhou and Runzhou, then moored in the canal near the family residence appreciating his collection of art. This was the famed "Mi Family Riverboat of Calligraphy and Painting" (he hung this sign atop it), which Huang Tingjian mentions in a short poem of 1101.[10] As of the second month, 1101, the Mi family boat had a new treasure—Xie An's "Fifth Day of the Eighth Month," from the scroll of fourteen Jin dynasty masters previously owned by Li Wei and one of the most respected works of calligraphy Mi Fu had seen. He received it from the minister Cai Jing (1046–1126).[11]

After the trials of Lianshui, Mi Fu was reinvigorated traversing the Yangtze River near his home in Runzhou. This was how Su Shi found him in the sixth lunar month of 1101, returning from his long exile in the southernmost extremity of the empire. The two friends were united in Zhenzhou, but it was not under the happiest of circumstances. Suffering from malaria and bothered by the heat and mosquitoes, Su Shi was unable to eat or sleep comfortably. Mi Fu sent medicine and showed him his latest acquisitions, including the Xie An letter, which he invited Su Shi to inscribe. Su Shi wished to but was inhibited by extreme weakness.[12] The physical and spiritual contrast between the two men emerges poignantly in some of the short letters Su Shi sent to Mi Fu just before and after they met. The rhapsody Su Shi mentions in the first letter had been written by Mi Fu in Lianshui.

> Over the last couple of days my fever has increased rather than subsided. Even though I have been moved outside of the *yamen*, where the wind and air are a bit fresher, I feel empty, unable to eat and barely able to speak. Where did my son ever acquire this poem "Rhapsody on the Tower of the Precious Moon"? He was barely halfway through reciting these clear, jade-like sounds when, listening, I suddenly arose from the bed I was lying upon, much enlivened. My big regret is that in the twenty years we have known each other I have never fully under-

stood you. Like this rhapsody—it is superior to what the men of antiquity wrote, not to mention our own generation. Why is it that the world is always filled with people like myself, utterly confused. It will not be long, Sir, before you are famous. That goes without saying. I would really like to talk with you, but in fact I am unable. Perhaps if we wait a few days.[13]

For eight years in Linghai [Guangdong Province] I was cut off from family and friends, but I did not miss them. I only thought of my [Mi] Yuanzhang's cloud-leaping spirit, his clear and stalwart writings, which exist beyond the pale of the common and vulgar, and his transcendent calligraphy, which partakes of the divine. When would I see him again and wash clean these malarial poisons that have accumulated over the years?! Now, today, I have finally had the opportunity to see you. Nothing more need be said.[14]

Some of Su Shi's praise for Mi Fu can be attributed to the conventions that govern the meeting of old acquaintances, but not all. These late writings have a warmth that is absent in Su Shi's earlier letters to Mi Fu, and they contrast sharply with those early poems Su Shi wrote to poke fun at Mi Fu's infatuation with calligraphy and collecting. Mi Fu's outspokenness and lack of humility may have inhibited Su Shi's appreciation. Following banishment to the bottom of China, however, and now on the eve of his death, Su Shi discovered that Mi Fu's transcendent qualities were in fact rare gifts for mortals. Su Shi left Zhenzhou on the first day of the seventh lunar month. He died twenty-seven days later.

Letters are often responses, containing references to letters or poems received that no longer exist. Su Shi's first letter has the tone of such a response. Its praise for Mi Fu's poem, admittance of not fully understanding Mi Fu, and reassurance of future fame could well have been written in reaction to Mi Fu's expressed dissatisfaction with the way things had turned out for himself. It reminds us that even with his return home, Mi Fu still sought recognition for public service. This desire put him in a subtle predicament, however. His ideal is the sage, like Yi Yin or Lü Shang, who is discovered in the wilds but has no thought of self-promotion. Mi Fu wishes to call attention to his virtue, but in a manner obliquely, even antithetically, related to the obvious requirements of government service. One can put it this way: the curriculum vitae of the Daoist ruler would include experience in such vocations as fishing and gathering wood. The following letter Mi Fu wrote in the summer of 1102, titled "Sweet Dew," reveals this delicate posturing (figs. 63, 64). In it he describes the main family residence located west of Qianqiu (Thousand Autumn) Bridge and facing the canal (see map 2).[15]

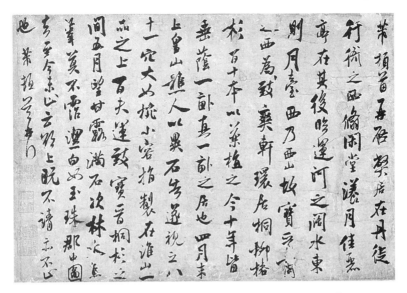

63. *Mi Fu, "Sweet Dew." Datable to 1102, Northern Song period. Album leaf, ink on paper,
35.5 × 50.3 cm. Collection of the National Palace Museum, Taipei, Taiwan, Republic of
China.*

Fu bows his head in greeting and writes again. My lowly abode is west
of the Dantu prefectural offices. Behind it are the Hall of Free Leisure
and the Flooded Moon and Exquisite Pavilions. It faces the broad waters
of the canal. To the east is Moon Terrace, and to the west is West
Mountain. West of where my Precious Jin Study formerly was located is
now the Studio of Full Exhilaration. Surrounding my dwelling are
hundreds of firmianas, willows, cedars, and firs, which I originally
planted for medicine. Now, ten years later, they form an acre of shade.
This is truly a "one-acre dwelling." A woodcutter from Shanghuang
Mountain told me of an unusual rock, so I went to take a look. There
were eighty-one holes, the large ones the size of a bowl, the small ones
just a finger in span. It is better than "top class" rock from the mountains
of Huai. One hundred workmen transported it to a place between
Precious Jin Study's firmianas and firs. On the fifteenth day of the fifth
month sweet dew covered the rock. All of the trees and plants, even the
withered grasses, were wet with this dew. It was bright white, like
strings of pearls. The prefectural authorities have been planning to take
it away, but to date nothing has been done. I tell them that I wish to
present it, but they neither invite this offer nor tell me to desist. Fu bows
his head and writes again.[16]

The letter's laconic description belies a subtle bid at self-promotion. The term "one-acre dwelling" that Mi Fu uses to describe the Mi family residence is a slight variation of the humble "one-acre palace" of the poor scholar, and it signifies Mi Fu's desire to depict himself as a virtuous man living harmoniously with nature.[17] Nature responds with news of this magic rock auspiciously endowed with eighty-one holes (a significant number in the Daoist scheme), communicated to Mi Fu by another Daoist model of natural rusticity, the woodcutter. Mi Fu recognizes the rock's virtue, has it brought to his home, and is immediately blessed with a *ruiying*, or "auspicious response," from heaven: sweet dew, white, and thick like honey. Mi Fu emerges as the perspicacious sage who discerns the subtle mysteries of nature and is consequently rewarded. Could a parallel be intended between this rock, which Mi Fu offers to the court, and the slightly less subtle mystery of Mi Fu himself? And what is one to make of the lucky coincidence of this rock being found by a woodcutter from a mountain called Shanghuang, which could alternatively be translated as "august imperial" or "presenting-to-the-emperor"?

One must dig a shade deeper to understand the full subtext of "Sweet Dew." Two years earlier the eleventh son of Shenzong ascended the throne to become Emperor Huizong (Zhao Ji, 1082–1135, r. 1100–1125). Predisposed toward the time-honored tradition of reading auguries and omens as a means for measuring the tenor of his rule, one of Huizong's earliest decrees requested that all prefectures and commanderies present their auspicious discoveries to the court; if the actual ruiying could not be submitted, then a painting should be made describing its appearance.[18] Mi Fu's acquisition of the auspicious rock and his offer to present it to the court must be understood in this context. He paints himself as the undiscovered sage enjoying his humble one-acre dwelling, but in fact he is soliciting an invitation to be brought in from the wilds.

"Sweet Dew" certainly does not look like a letter advertising credentials for office. Its loose manner, for example, is markedly more casual than the graceful but restricted style seen in the letter to Deng Xunwu of only a couple of months earlier (compare with fig. 62). Heavy pools of ink in places barely pass as linear movements of the brush (fig. 64). Characters such as *bai* (one hundred) and *da* (large) are frankly gross, with little sense of brush control. Even if not readily apparent, however, skill is most certainly present. Mi Fu purposely lades the brush with such heavy charges of ink that his writing appears dripping wet, like the viscous dew itself. Under this moistly rich exterior Mi Fu's brush gently conducts the black liquid into dots and dashes that come together as legible graphs. The sparse spacing of the strokes, exemplified by the characters *fu* (workmen) and *wan* (bowl), gives the writing a faintly antique aura: "distant and sparse" are two of the adjectives commonly used in the Northern Song to describe pre-Tang

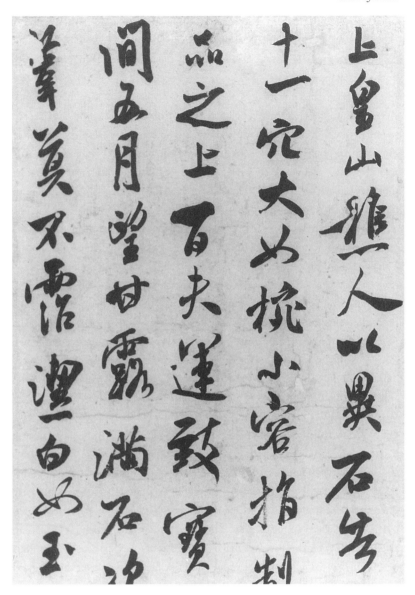

64. *Detail of Mi Fu's "Sweet Dew."* Da *is the fourth character of the second column from the right;* wan *is the sixth in the same column.* Bai *and* fu *are the fourth and fifth characters of the third column.*

calligraphy. But the real attraction of the writing is the manner in which it almost appears to write itself, particularly in the seemingly chance assemblage of ink configurations toward its end. Mi Fu is simply the mediator, the message-bearer of this auspicious response.

In his poem for Lü Dafang of six years earlier, Mi Fu remarked that the times were not for him. That situation changes with Huizong's ascension, and it leads to one of the more colorful partnerships in Chinese history. Huizong inclined toward Daoist beliefs, and he sought esoteric knowledge to help define his rule with a splendor that would rival the great former dynasties of Han and Tang. At times he looked for that knowledge in "extraordinary men" (*yiren*), unusual figures whose training and achievements lay outside conventional means. Throughout China's history it is often the charlatan and master of the sleight-of-hand who fits into this category, but it could also include the talented eccentric. Evidence of Mi Fu's eagerness to satisfy Huizong's interest in the recondite appears in his *History of Painting,* where he claims to have made a thorough study of the solar and lunar phases that will rebuke the "nonsense theories of the hundred scholars, past and present."[19] He also wrote a work on tides, which he plans to present to the court, as well as a study of the musical tones based on the five directions and five phases (*wuxing*) that will clarify the mysteries of the cosmos: "My book is titled *The True Tones of the Five Sounds of the Great Song Dynasty.* Used to regulate the pitches and generate music, it will call forth the Great Harmony and allow realization of the Great Peace. I will bury it at a famous mountain where it will wait one hundred generations for one with like aspirations. This was not written in vain for the ignorant and lowly."[20]

The last two sentences possibly reflect Mi Fu's bitterness of not seeing this magnum opus put to good use. In fact, early in his reign Huizong was intensely interested in rectifying the tones and creating proper music worthy of his court, but he opted instead for the theories of another "extraordinary man," Wei Hanjin, pupil of the reputed immortal Li Babai (Li Eight-Hundred). However ingenious Mi Fu's idea of using the five directions and five phases to recover the standard pitches established by the sages of antiquity and presumed long lost, it could not compete in attraction with Wei Hanjin's approach, which used the lengths of Huizong's fingers to establish the orthodox standards. This was the so-called body-as-measurement method attributed to the legendary Yellow Emperor. Nonsensical as it may seem, one can understand its appeal to the youthful Huizong, encouraged to believe that the supreme music ultimately derived from his very person.[21]

Huizong may not have cared for Mi Fu's theories of the tides or music, but this most aesthetic of emperors clearly appreciated Mi Fu's knowledge of the arts. That appreciation explains a remarkable turnaround in Mi Fu's career. Be-

ginning with his assignment to the Office of the Supply Commission, Mi Fu
embarked on a fast-moving path that led him directly to the inner chambers of
the court. In all likelihood, most of this sudden success was owed to the impor-
tant intermediary figure of Cai Jing, a high minister of unenviable historical
reputation who was particularly attuned to Huizong's tastes and an excellent cal-
ligrapher in his own right.[22] From Zhenzhou, Mi Fu was appointed administrator
for supervising the distribution and transportation to the capital of tax grain and
other commodities in the Cai River section, a position that brought him back to
the environs of Kaifeng. This post from the beginning may well have been in-
tended as nothing more than a temporary convenience to show off Mi Fu's yiren
qualities, for early in 1103, Mi Fu had already assumed the new post of erudite of
the Court of Imperial Sacrifices.[23] This was an esteemed if ceremonial position
charged with the handling of the detailed preparations of court rituals. There is
evidence to suggest that among Mi Fu's duties was preparation of the "roster of
names," a task that would have showcased his writing abilities.[24] In any case, Mi
Fu's presence at the Ministry of Rites must have added considerably to the color
and pageantry of Huizong's court.

Considering both Huizong's notoriety as an emperor more interested in the
visual and occult arts than in matters of practical governance and Mi Fu's reputa-
tion as an eccentric whose very sanity was a matter of debate, it is not surprising
that the association between these two spawned some curious stories. Such ac-
counts naturally helped to define Mi Fu's image for later generations, but how
truthful a picture they paint of Mi Fu's relationship with Huizong is question-
able. The information found in Cai Zhao's funerary inscription for Mi Fu is more
reliable, if less colorful, and here is confirmation that it was primarily Mi Fu's
ability as a calligrapher that attracted the attention of the emperor. Huizong or-
dered Mi Fu to write the "Thousand Character Essay" in the small standard script
style of Wang Xizhi's rendering of the Daoist medical text, *Classic of the Yellow
Court*—a test, perhaps, of Mi Fu's control of this most fundamental of scripts as
exemplified by one of the legendary works of calligraphy lore.[25] We have no
knowledge of how Huizong responded to Mi Fu's efforts, but he certainly must
have been pleased with what followed. According to Cai Zhao, Mi Fu offered the
emperor choice works of calligraphy and painting from his famed collection.
Huizong answered with a gift of one hundred strings of gold. This, we are told,
was the beginning of Huizong's famed Xuanhe collection, perhaps the finest as-
semblage of art ever amassed by a Chinese emperor. When Huizong invited Cai
Jing to inscribe the new holdings, Mi Fu was allowed to attend as an observer.
Cai Zhao writes that Mi Fu's peers all considered this to be a moment of crown-
ing success. Recognition had finally arrived.

The chronology of the events that follow is a little uncertain. According to Cai Zhao, Mi Fu was soon assigned the post of prefect of Changzhou, on the Grand Canal near Runzhou, but never went. He was then made keeper of the Daoist temple Dongxiaogong (Palace of the Cavern to the Empyrean) in Yuhang Prefecture, near Hangzhou. Although this was a major institution, the posting was nominal and signaled a sudden loss of favor. In all likelihood Mi Fu bided his time back in Runzhou.[26] After a year, Mi Fu was reassigned, this time as prefect of the commandery at Wuwei, up the Yangtze River in modern-day Anhui Province. It was at Wuwei that Mi Fu reportedly bowed to an extraordinary rock and saluted it as elder brother. He was there for only a year before being recalled to the capital to serve in what must be considered a most appropriate post for Mi Fu: erudite of calligraphy and painting.[27] Mi Fu's return to the capital in late 1105 marks the apex of his official career. He was honored with a private audience with Huizong, at which time Mi Fu presented to the emperor a landscape titled "Pure Dawn in the Mountains of Chu," painted by his son, Mi Youren. The emperor in return gave to Mi Fu two fans each of his own painting and calligraphy. An uncharacteristic humility colors a poem that Mi Fu wrote for Cai Jing on the occasion of assuming his post as erudite of calligraphy. The last lines read:

From my humble place among the hundred officials I gaze at the cinnabar steps.

Amid the dazzle of variegated colors I peer up at His jade countenance.

Some foolishly say my "calligraphy name" has fallen to the world of men.

Only you, my lord, understand that it has penetrated the gates of Heaven.[28]

Within months Mi Fu was promoted to vice-director in the Ministry of Rites. This was the highest ranking position Mi Fu would ever attain in government service, though his success would prove short-lived.

Huizong's reign marks an important moment for Northern Song politics and the arts. In the second half of 1102, prompted by Cai Jing, the Yuanyou Party and its policies were officially disgraced. Those associated with Sima Guang, Lü Dafang, Su Shi, and other prominent conservatives were demoted, dismissed, or barred from office. Two years later Huizong reestablished the Imperial Institutes of Calligraphy and Painting with an aim toward standardizing and professionalizing the practice of these arts at the court.[29] The immediate effect of these developments on calligraphy is not easy to gauge because of the relative paucity of writings extant from the early twelfth century, but a few observations can be offered.

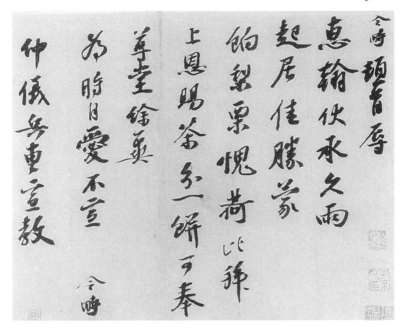

65. *Zhao Lingzhi (d. 1134), "Letter to Zhongyi." Northern Song period. Detail of an album leaf, ink on paper, 29.1 × 44.4 cm. Collection of the National Palace Museum, Taipei, Taiwan, Republic of China.*

Many writers were influenced by Su Shi's style of calligraphy even after the Yuanyou Party was discredited. For some of Su's generation, resemblances may owe more to shared training and models than to direct influence: the plumpness of his brushwork and squat proportioning of his characters derives partly from lingering influences of the early Northern Song, to which the writing of such senior figures as Han Yi and Lü Dafang attests. Others junior to Su Shi, such as Zeng Zhao (1047–1107), Zhao Lingzhi (d. 1134), and Zhai Ruwen (1076–1141), reveal a distinct and purposeful allegiance to Su Shi's style (fig. 65), as do many who followed later in the Southern Song.[30] But graphic resemblance should not be the only measure of Su Shi's influence. It is also apparent in a general approach favored by many at the end of the Northern Song that emphasized individualism and personal flavor, even if the results were unorthodox. This trend was prominent into the twelfth century, and it may have contributed to Huizong's decision to revitalize the study of calligraphy at the court.

In contrast, there were those whose handwriting was founded on a more careful study of the great tradition. Mi Fu and Xue Shaopeng are paramount examples. Another is Shao Chi (1073 jinshi), a generally ignored contemporary

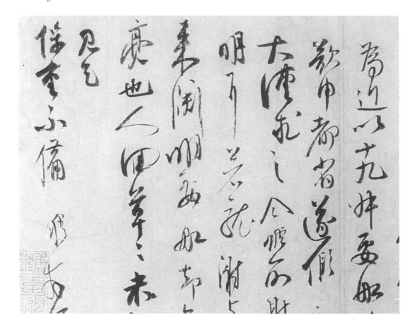

66. Shao Chi, *"Letter."* Ca. 1085–1100, Northern Song period. Detail of an album leaf, ink on paper, 31.8 × 49 cm. Collection of the National Palace Museum, Taipei, Taiwan, Republic of China.

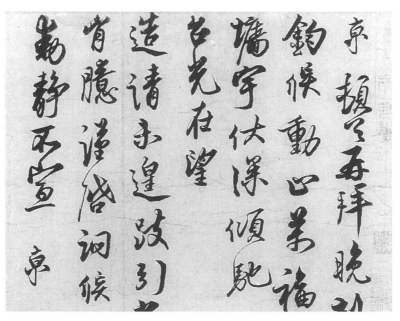

67. Cai Jing (1047–1126), *"Letter."* Northern Song period. Detail of an album leaf, ink on paper, 31.4 × 41.3 cm. Collection of the National Palace Museum, Taipei, Taiwan, Republic of China.

68. *Emperor Huizong (Zhao Ji, 1082–1135, r. 1101–25), "Five-Colored Parakeet on Blossoming Apricot Tree." Circa 1110–20, Northern Song period. Detail of a handscroll, ink and color on silk, 53.3 × 125.1 cm. Museum of Fine Arts, Boston. Maria Antoinette Evans Fund. Courtesy Museum of Fine Arts, Boston.*

from the Runzhou area whose calligraphy is exceptionally skilled and attractive (fig. 66).[31] Also belonging to this category is Shao Chi's teacher and Mi Fu's patron, Cai Jing (fig. 67). Cai Jing's development as a calligrapher is described by his son, Cai Tao, who writes that his father learned first from his paternal uncle, the great calligrapher of midcentury, Cai Xiang (see fig. 16). While serving in Hangzhou in the early 1070s, Cai Jing studied the mid-Tang calligrapher Xu Hao only to turn soon to another Tang writer, Shen Chuanshi (it was at this time that Shao Chi studied with Cai Jing). In the early 1090s Cai Jing switched again, this time to Ouyang Xun (see figs. 4, 23). According to his son, Cai Jing's calligraphy gained in such force and strength that none could match his skills during the Shaosheng reign (1094–97). But Cai Jing was not finished with his studies: he made one last transition, this time to the Two Wangs. "Accordingly, he established his own style, which all in the realm honored."[32] Cai Tao adds that, in response to Cai Jing's question about capable calligraphers of their time, an obsequious Mi Fu answers, "Since the time of Liu [Gongquan] of the late Tang, you, Sir, and your brother [Cai Bian, 1058–1117] are it." Pushed by Cai Jing to come up with another name, Mi Fu admits that he is number three.[33]

因賦是詩焉 種態度縱目觀之宛勝圖畫 翔翥其上雅託容與自有一 於苑囿間方中春繁杏遍開 篡馴服可愛飛鳴自適往來 五色鸚鵡來自嶺表養之禁

69. Detail of Emperor Huizong's inscription to "Five-Colored Parakeet on Blossoming Apricot Tree."

Ignoring the obvious bias and probable embellishments, Cai Tao's account of his father's calligraphy should be considered accurate, and what he reveals is a striking similarity between Cai Jing's and Mi Fu's practice of the art. The two may differ in the particulars of their models, but both share a catholic approach that finally dwells on the Two Wangs and Jin calligraphy. Equally important, in the end both Cai Jing and Mi Fu had the confidence to press beyond their models and create calligraphy that was not merely skillful but also independently assertive—a point of difference with Shao Chi's writing, which never loses its sense of graceful balance and beauty. Cai Jing and Mi Fu brought to Huizong's court a unique combination: a proven foundation in the fundamentals of the tradition, a profound study of the rarefied beginnings of that tradition, and the individualism that remains the hallmark of Northern Song writing.

The court was the pinnacle of the public domain and as such provided an entirely different arena and function for calligraphy. Together with the other ritual apparatuses of the court, including music and the rites, calligraphy offered an immediate, tangible representation of imperial rule. The graphic traces left by the imperial hand, and by extension those of his ministers, were a significant symbol of dynastic legitimacy (or lack thereof) and thus merited profound consideration. In conventional times such imperial insignia were predictably decorous—the most direct expression of orthodoxy is through custom and tradition. Huizong, however, was not a conventional ruler, and his calligraphy was absolutely beyond prediction (figs. 68, 69). This is not the calligraphy of the hallowed Wang Xizhi tradition, model for both the early Tang and Song courts. Nor does it suggest Yan Zhenqing, the only other viable model for calligraphy that claims the voice of moral authority. This is Huizong's very own "slender gold" (*shoujin*).[34]

Although Cai Tao remarks that Huizong studied Huang Tingjian, most sources state that Huizong developed his style of calligraphy from the wiry and graceful writing of the Tang dynasty courtier Xue Ji (649–713).[35] More recently this theory has been modified slightly and attention has been drawn to a cliff inscription by Xue Ji's cousin, Xue Yao, that looks remarkably like Huizong's writing.[36] In any case, placing too much emphasis on the precise sources of Huizong's style of writing misses the point, for there was no imperial intention to suggest historical precedent. To the contrary, this is writing whose purpose is to appear unprecedented and unique. One knows this by the writer's decision to ignore many fundamental rules of good calligraphy. Hooking strokes curl rather than snap. The ends of Huizong's *shu* and *heng* strokes often have a pronounced hitch. One can hardly speak of brushwork when the strokes are pencil-thin, but if one does there is no way of avoiding the fact that Huizong's writing often flirts

with such defects of writing as the knobby "crane's leg." Huizong's writing establishes its own rules. He purposely fashioned a style of calligraphy that was at once different and dazzling. Xue Ji and Xue Yao may have provided the basic forms, but in some ways Huizong's true models were the various ornamental scripts of earlier times. Commonly employed for decorative purposes, these unusual, barely legible scripts whose names reflect the real and imagined phenomena their forms imitate—"Immortal" (*xianren*), "Phoenix" (*luan*), "Unicorn" (*qilin*), and so on—were auspicious in nature and semimagical in function.[37] It has even been suggested that Huizong specifically had the crane's leg in mind when he fashioned his distinctive style of calligraphy, the crane being an auspicious bird and a favorite of this emperor.

Whatever the source of Huizong's inspiration, his calligraphy style was certainly designed to convey an impression of rarity and auspiciousness. The point is best illustrated by its particular function in the example provided: a "slender gold" textual accompaniment to a painting of a colorful parakeet purportedly from Huizong's hand. The bird is an auspicious object, one of thousands presented to the court during the first two decades of the twelfth century and depicted in such paintings as this, each one paired with Huizong's description and poem. According to Huizong's inscription, the parakeet has come to the imperial precincts from Lingbiao, far to the south. It was tame, of noble bearing, and "capable of uttering many a fine speech." The supremely detailed, naturalistic style of the painting presents the talking bird, and the auspicious response it represents, as fact. Huizong's calligraphy, by the grace of its otherness, complements the image with an inscription that also appears heaven-sent.

It is tempting to dismiss Huizong's exceptional interest in ruiying as eccentric and nonsensical, but there is an underlying seriousness of purpose that must be acknowledged. Auspicious responses are celestial nods of encouragement—direct confirmation of the legitimacy and propriety that a youthful emperor craved to establish the greatness of his reign. What is significant are what the ruiying were responses to: ceremonial and ritual programs Huizong initiated at the court in a determined effort to hasten and clarify the communication between heaven above and the son of heaven below. Reformation of the court music, employing the theories of Li Eight-Hundred and Wei Hanjin, is but one prominent example. The national odes were rewritten, the Nine Tripods of antiquity were reforged, and, most significant, new ritual vessels were cast for use in Song imperial worship.[39] The value of these projects is well expressed in the following memorial written by a court official:

> If the emperor were to carry out great symbolic acts in order to settle
> the country, heaven and man would be in harmonious communion and

the dark [*yin*] and bright [*yang*] would be stimulated into movement. Establish the Nine Tripods and create glorious music; receive the dark *gui* jade and perform the rite of the cap; pray to heaven at the rounded hill and make offerings to earth at the square altar. Then the confluence of yin and yang pneumas will flow laterally, and the rare and auspicious will come one after another. The heavenly gods will descend and the earthly deities will appear. All will be magnificent acts of supreme virtue, something unheard of since ancient days.[40]

The last sentence rings most loudly, echoed by a comment made by Cai Tao: "[Huizong] wished to establish and codify the ways of the beginnings of antiquity. Distantly he chased after the thoughts of [the ancient sage kings] Yao and Shun."[41] The greatness of Huizong's reign would be represented by a ritual apparatus unsullied by the false habits of recent generations. He shared the perception, already noted for calligraphy, that the received tradition had gone hopelessly astray. The correct musical tones of antiquity had been long lost, and ritual bronzes were made increasingly inaccurate in both form and function. Dramatic proof for the the decline in bronzework appeared as archaic bronzes of Shang and Zhou dynasty date were excavated from ancient tombs and presented to the court. These exciting discoveries—tangible remains from what was believed to be the time of sage kings and utopian rule—provided the single most powerful impetus for restructuring ritual worship at Huizong's court. The orthodox patterns of antiquity could be copied directly.

Conceivably, Huizong could have developed a style of calligraphy that, like his new ritual bronzes, was overtly archaic. He did not because the ancient seal-script writing found in the early bronzes did not present a formal, unified image and because it was too far removed from the kai standard script that had long been used in court and public. It is more difficult to determine why Huizong did not return to the early forms of the kai and xing scripts for the fashioning of his handwriting—perhaps because it had been done before, in the early Tang and early Song, and perhaps because Wei-Jin calligraphy was too closely associated with the received tradition. A return to such overworked standards as the Lanting Preface, in any case, would not have accomplished Huizong's goal of setting his writing and his reign apart from all others. Yet to overemphasize the differentness of Huizong's calligraphy and its distance from the received tradition is to obscure a vital point: fundamentally, Huizong's writing presents itself as an image of orthodoxy. Moreover, it does so largely by adopting the order and regularity of early Tang methods. True, Huizong's writing ignores some common rules, but the tight compositional structuring of his characters and the methodical constancy with which the writing maintains its image of decorum owes much to

70. *Mi Fu, "Presentation of Duties." Datable to ca. 1105. Detail of a rubbing from*
Qunyutang tie. *The Palace Museum, Beijing. From* Qunyutang Mi tie.

early Tang calligraphy. What it scrupulously avoids is any resemblance to the corpulent style of calligraphy that had formed the mainstream of the received tradition since Tang Xuanzong's reign in the mid-eighth century and had, by the late eleventh century, become commonly perceived as "vulgar."

Recognizing the dual character of Huizong's calligraphy as being at once eccentric and orthodox helps explain both Mi Fu's acceptance at the court and, ultimately, his inability to remain there long. Huizong undoubtedly found Mi Fu's exceptional talent with the brush and yiren qualities intriguing. Moreover, Mi Fu's knowledge of his art, especially its early history, made him an invaluable resource. Conforming to the strict regimen of the court, however, must have been difficult for Mi Fu. As erudite of calligraphy in charge of thirty students at the newly established Imperial Institute for Calligraphy (with another thirty at the Imperial Institute for Painting), Mi Fu presumably had to teach all manners of scripts and subtleties of connoisseurship.[42] The eccentric free spirit was now a technical expert. Documents related to Mi Fu's tenure as erudite of calligraphy are extremely few, but what exists shows a constrained formality to Mi Fu's hand that contrasts markedly with his letters and poems (fig. 70).[43]

In the fourth-century compilation *Tales of Immortals* a charming story is told of the extraordinary man Wei Shuqing, who in 109 B.C. descended from the sky in a "cloud chariot" yoked with white deer and landed at the palace of Emperor Han Wudi only to disappear abruptly after discovering his host's imperial presumption that Wei was still the emperor's subject.[44] Genuine immortals did not conform; would-be immortals like Mi Fu had little choice but to try and fail. In this regard, the final lines of Mi Fu's poem presented to Cai Jing on assuming his duties as erudite of calligraphy prove wrong: Mi Fu's "calligraphy name" had indeed fallen to the world of mortal men. Too brash, too outspoken, too unpolitic, Mi Fu was fundamentally out of step with the decorum and orthodoxy of the court. He had lost his position in the Court of Imperial Sacrifices because of unspecified indiscretions. It happened again after his return to the capital as erudite of calligraphy and painting and eventual rise to vice-director in the Ministry of Rites. Cai Zhao merely remarks that there was "talk." Wu Zeng's unofficial history *Nenggaizhai manlu* provides a more detailed description of what was being said:

> In the fourth year of the Chongning reign [1105], Mi Yuanzhang served as vice-director in the Ministry of Rites. A petition for impeachment was submitted. It read, "Mi Fu is improper, erratic, and strange. He is crafty, deceitful, and without emotions. He dares to say strange things and act eccentrically, all in an effort to cheat and confuse the common people. News of his bizarre and absurd affairs is passed around for laughs.

When people look at him they presume he is crazy. Officials in the Ministry of Rites are looked upon by scholars to serve as models of exemplary behavior. Mi Fu's origins are lowly and muddled. He besmears his office and fails to promote decorous behavior to the four quarters." The order was issued for his dismissal, and Mi Fu was reassigned as prefect of the commandery at Huaiyang. The petition's charge that Mi Fu's origins are lowly and muddled is a reference to his ancestors.[45]

Prefect of Huaiyang commandery, situated up the Si River from Lianshui in the northern-most reaches of Jiangsu Province, was Mi Fu's final post. He served for one year before suddenly developing a brain tumor. His petition to retire from office was denied, and Mi Fu died in his prefectural quarters in late 1107 or early 1108 at the age of no more than fifty-six years.

Roots and Branches

"Those who evaluated calligraphy in ancient times also evaluated the life of the calligrapher. If the man was not praiseworthy, then even if his calligraphy was skillful, it was not valued."[46] Su Shi's words reflect an attitude that pervades the appreciation of the arts in China. They imply the ephemerality of skill, its deceptiveness and illusion. Skill is surface and appearance. In contrast, one's virtue (*de*), reflected in words and actions, is deep and long-lasting. In its ideal form, literati theory of the arts might posit a smooth continuum from virtue to skill, from inner substance to outer form, but in reality the skilled calligrapher was not necessarily praiseworthy, just as the worthy person was not necessarily talented as a calligrapher, poet, or painter. The permutations that delineate this complex relation between skill and virtue all derive from recognition of self-expression as a determining factor in the patterns (*wen*) formed by human voices and hands. Understood as a product of individual character, the writing of the praiseworthy person is valued because his or her virtue is revealed in the brushstrokes. Unfortunately, the technical dimension that skill occupies does not map neatly with the moral dimension of virtue. When skill is found in the writing of the respected individual the tendency is to regard it as a reflection of inner substance. When the character of that person is found wanting, however, there is an inherent mistrust of skill, and it is regarded with the same distaste reserved for the false charms and words of an abject flatterer. Though the eye objects, self-expression relegates skill to a position of secondary consideration. The great individual could be a skilled calligrapher, but the skill of the calligrapher should never define a person's greatness.

Mi Fu knew this. By traditional standards, to be known only as a calligrapher and connoisseur was not to be known in any meaningful manner at all. Historical precedents of high officials who were rudely treated for their "artisan" skills were well known, as were admonitions against relying on such skills for establishing one's reputation.[47] Without independent confirmation of his worthiness, the beauty of Mi Fu's *wen* would not necessarily be recognized as reflecting the quality of his virtue. Worse, its very skillfulness could elicit a detrimental response, feeding off the unique mistrust the Chinese held for obvious dexterity. Some of these thoughts may have influenced the transformation of his style after Lianshui and his efforts to replace his early "pretty" writing with examples of his late calligraphy. They may also help to explain Mi Fu's promotion of his studies on musical tones, the tides, and celestial bodies—proof not only for Huizong but for later generations that Mi Fu's skills were not limited to calligraphy and connoisseurship.

Ultimately, however, whatever success Mi Fu enjoyed during the early years of Huizong's reign was entirely dependent on his skills with the brush, and as this recognition took hold, Mi Fu began to promote the idea that the arts were not as secondary as conventional wisdom insisted. Evidence for this is found in an official memorial Mi Fu submitted to Huizong on assuming his duties as erudite of calligraphy and painting (see fig. 70). Training for these arts needs to be upgraded, he argues, with a program of examination based on the classics and an association with the national university. Moreover, the emperor should play a more active role in judging the quality and accuracy of copies made of famous works of painting and calligraphy. After flattering the emperor's artistic abilities, Mi Fu uses the opportunity to suggest a more direct administrative channel from his personal bailiwick to the top. Interestingly, some of these recommendations may have been adopted: Huizong is known to have raised the standards of education among his academy painters, and at least one high-quality copy of an earlier painting still with us is ostensibly from Huizong's own hand.[48]

More commonly, Mi Fu's rhetoric appears outside the sphere of court and office. Calligraphy and collecting were a key source of consolation during such periods of difficulty as the aftermath of the Yongqiu affair and Mi Fu's service in Lianshui. They play this role again during a period of personal tragedy about 1103–4, after Mi Fu lost four of his children,[49] and again, most important, during the repeated incidents of demotion from Huizong's court during the last five years of his life. Art for Mi Fu had always been most closely associated with life out of office, naturalness, and self-cultivation. In the aftermath of his children's death and faced with his own mortality, it assumed life-affirming properties.

Our attention is drawn to three late works of calligraphy that comment on

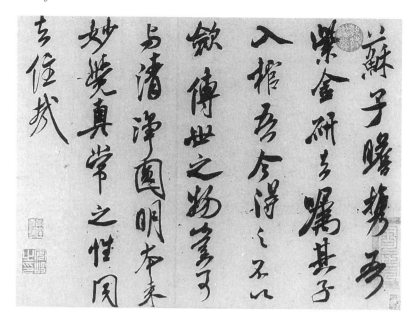

71. Mi Fu, "Purple-Gold Inkstone." Refer to figure 57.

the central position of art in Mi Fu's life. Their messages differ in tone and emphasis, but they are similar in the self-reflective manner in which they reveal Mi Fu's thoughts on the nature of his accomplishments. The first, "Purple-Gold Inkstone" (fig. 71; see also fig. 57), was examined earlier for its presentation of Mi Fu's emphasis on naturalness in his late writing. At first reading, its contents seem as misshapen as some of Mi Fu's characters: "Su Shi carried off my purple-gold inkstone and ordered his son to put it in his coffin. Today I got it back. It was not placed in the coffin. How could an object that is passed down from generation to generation be dispatched to coexist with the purely pristine, wholly luminous, original, subtly perceiving, true and eternal nature [that is, Su Shi's soul]?"

Inkstones were important collectibles in Northern Song China, and they played a particularly colorful role in Mi Fu's life. Two in the shape of mountains have already been mentioned: one that served as the purchasing price for the land under Beigushan upon which Mi Fu first built his Studio of Oceans and Mountains, and another that was apparently the key element in the failed deal to land Liu Jisun's scroll of two letters attributed to Wang Xianzhi. What has not been mentioned is Su Shi's particular attachment to inkstones. In fact, according to Mi Fu, Su Shi coveted the mountain inkstone that was to be traded for the Wang Xianzhi calligraphy. Liu Jisun's insistence on its inclusion in the deal stemmed

from his desire to present it to Su, who had sponsored Liu in the past. Mi Fu pointedly remarks that he initially refused to give the inkstone to Su Shi. Presumably it was simply too valuable, but one wonders if Mi Fu's ungenerosity may also have been prompted by Su Shi's public criticism of Mi Fu's excessive collecting. If so, this particular note on an inkstone that Su Shi had borrowed from Mi Fu and was nearly sent to the scholar's studio in the great beyond may represent a last laugh on Su Shi's hypocrisy.[50]

Mi Fu's point in writing "Purple-Gold Inkstone" could not have been simply to settle a long-standing debt with his recently deceased friend. His intent, rather, was to promote a controversial theme that established itself most succinctly through opposition. "Purple-Gold Inkstone" argues for the lastingness of objects, especially objects of art. The conventional view, well known through the writings of Ouyang Xiu and Su Shi, emphasized the ephemerality of material things and warned against relying on them as the means to gaining a long-lasting name.[51] Mi Fu challenges this idea with a very plain, and for many, unpalatable observation: objects of beauty and utility are valued and preserved. The inkstone may be mundane, but it is intended to endure in the human realm, to be passed down from generation to generation. This is the same theme that Mi Fu takes to an iconoclastic extreme in the preface to his *Hua shi* (cited in the Introduction), where great achievements, the most certain of the "non-decays," compare unfavorably with such ordinary objects of pleasure as hair ornaments and brocades.

Inkstones, however, do not belong in the same category as hair ornaments and silk fabrics, and Mi Fu's message here is decidedly more subtle. Beyond the beauty of the stone or the wonder of its configurations, an inkstone is fundamentally a tool for writing. The devoted calligrapher handles the inkstone—washes it, grinds the ink in it—and is rewarded with an awakening of the senses in preparation to writing. Mi Fu recounts in one note that his writing does not succeed if he does not wash the inkstone and cut the paper himself.[52] Inkstones, moreover, were not neutral in their affect. In a companion note to "Purple-Gold Inkstone," possibly speaking of the same object, Mi Fu writes: "Recently I acquired a purple-gold inkstone from Wang Xizhi's native land [Langye, Shandong Province]. I immediately set to work, using it to write calligraphy over a number of days, but I just couldn't make it happen. As a consequence, I have not used this stone again."[53]

Perhaps the calligraphy that presents both of these notes is the result of Mi Fu's engagement with this valuable but problematic rock. This might explain the roughness of the writing and the little splatters of ink that pepper the paper of "Purple-Gold Inkstone" in particular. Whatever the case, the results are vivid and immediate. Few pieces of writing by Mi Fu or any other calligrapher preserve such a powerful sense of the spontaneity of a moment. Working our way

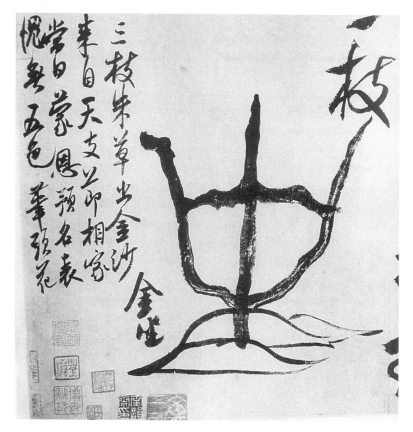

72. *Mi Fu, "Coral." Datable to ca. 1104. Album leaf, ink on paper, 26.6 × 47.1 cm. The Palace Museum, Beijing. From* Gugong bowuyuan cang lidai fashu xuanji, *vol. 2.*

through the content of "Purple-Gold Inkstone" and regarding the traces of Mi Fu's brush, we are encouraged to recognize that because an inkstone was not dispatched with Su Shi to the afterworld calligraphy continued to be written. With good fortune this writing, too, would be treasured, thus preserving for later generations the moment of an individual's engagement with his art.

The second piece that represents Mi Fu's late calligraphy further develops the theme of spontaneity and naturalness, though with a design so well wrought as to leave little doubt of Mi Fu's premeditation (fig. 72). "Coral" consists of two short texts and an unusual sketch that Mi Fu plants directly in between. There is no symmetry to the arrangement: the calligraphy to the right is generously spaced and large-sized; the writing to the left is smaller and cramped. The texts differ in format as well: one is a prose account, the other a poem:

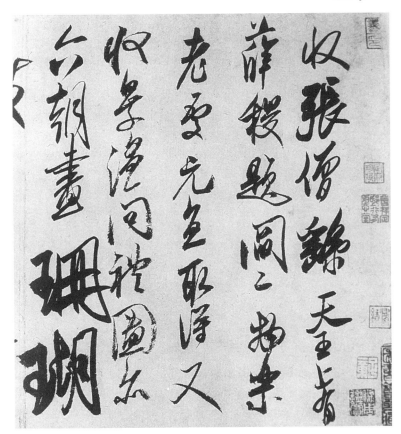

I have collected Zhang Sengyou's "Heavenly King." Above is an inscription by Xue Ji. The painting once belonged to Yan the Second. Yuanzhi obtained it from Old Le's place. I have also collected Jingwen's "Inquiring about the Rites," which is also a Six Dynasties painting, and a branch of coral.

Three branches of crimson grass emerge from golden sand;
It has come from the house of the commissioner, himself a heavenly branch.
That day imperial grace received, I prepared the roster of names;
I fear, however, no flowers sprouted from the head of a rainbow brush.

The roster of names mentioned in Mi Fu's poem refers to official duties associated with the Ministry of Rites, most likely his position of 1103 as erudite of

the Court of Imperial Sacrifices. The poem alludes to the loss of that position and thus allows a provisional dating of 1104, during Mi Fu's forced sabbatical in Runzhou.[54] The situation parallels Mi Fu's dismissal from Yongqiu ten years earlier, and "Coral" is just as biting in its commentary on his failure as an official as his earlier poems "Upon Receiving Orders for the Zhongyue Post" (chapter 3).

The intended sequence is from right to left, beginning with the inventory of objects that opens "Coral" in a vigorous display of semicursive writing. Under Mi Fu's prosaic tone lies the pride of a successful collector. Six Dynasties period paintings were as rare and almost as valued as Jin calligraphy, especially those of the early sixth-century painter Zhang Sengyou, one of the "three masters of antiquity." How much more to be prized is a Zhang Sengyou painting once owned by the Tang painter and devoted Zhang admirer Yan Liben (d. 673), younger brother of Yan Lide (d. 656), hence Yan the Second.[55] This, Mi Fu reveals, is known from an inscription by the Tang dynasty courtier and artist-connoisseur Xue Ji (649–713), who in turn is said to have modeled his style of painting after Yan Liben. Mi Fu now affixes his name to this impressive pedigree, as well as to those of the unidentified Old Le and Teng Zhongfu (style name Yuanzhi, born after 1020).[56] The second painting Mi Fu mentions was presumably an anonymous work depicting the story of Confucius inquiring of the rites from Laozi. Xie Jingwen (1049 jinshi), under whom Mi Fu had briefly served thirty years earlier in Changsha, would have been a former owner.

Seemingly as an afterthought, Mi Fu adds a branch of coral to his list, which in turn inspires the poem that follows. The commissioner and former owner of the coral, or "crimson grass," probably refers to either Zhao Zhongyuan (1054–1123) or the painter Zhao Lingrang, both of whom were close friends of Mi Fu as well as notable collectors and scions of the royal family—or "branches of heaven." Like many members of the imperial house, Zhao Zhongyuan and Zhao Lingrang served as military commissioners. The last line of Mi Fu's poem combines two allusions, one to the Tang poet Li Bo (701–62), who after dreaming as a youth that flowers blossomed from his brushtip began to exhibit exceptional literary talent, and one to the Liang dynasty poet Jiang Yan (444–505), who in similar fashion showed magnificent skill as a poet after dreaming that a man presented him with a five-hued brush, only to lose that talent later in life when in another dream the same man came for its return.[57] These function as a tactful reference to Mi Fu's recent dismissal from the court, assuming responsibility by deflecting the issue away from his eccentric behavior to a lack of talent. Needless to say, Mi Fu's words are disingenuous. The demonstration of talent is precisely what "Coral" is all about.

The sketch has been called by some Mi Fu's sole extant painting, but it clearly

is not a painting in the literal sense. Attempting to establish a context for the drawing, Xu Bangda rightfully refers to a twelfth-century description of a late letter Mi Fu wrote to Cai Jing, in which Mi Fu added a sketch of a small boat swimming among the columns of characters to illustrate the tiny size of his family transport on the way to Huaiyang from the capital.[58] But whereas that floating skiff seems truly to have been a playful afterthought, Mi Fu's coral is anything but impromptu. The three-pronged coral was carefully drawn, with outlines sketched and the interior brushed over and over with small strokes designed to produce a feibai "flying white" effect for a weathered, hoary texture. A closer look at how the sketch of coral functions in relation to the two texts confirms the thought that went into its fashioning. Just between the first line of the poem and the lower left-hand portion of the sketch Mi Fu wrote the two extra characters *jinzuo*, "gold base," which must refer to the basin in which his tree of coral sits. Aligned slightly to the bottom right of that line's last two characters, *jinsha*, "golden sand," a visual correspondence appears between the last downward-slanting pie stroke of the poem's final character *sha* and the parallel stroke on the roof of *jin* of *jinzuo* just below it. Similarly, the final horizontal stroke of *zuo* has just enough lilt to create a visual link with the sloping hill of the "base" in the sketch. This is a pun—a playful way of announcing that the golden sand is in the gold basin. Looking anew at the first line of Mi Fu's poem, it becomes clear that the pun blossoms into a remarkably clever parallel between text and image: just as the sketch of coral rises from the hills, so does the text quite literally reverse itself and grow upward, nouns and verb stacked in logical sequence: gold basin, golden sand, rises, crimson grass, three branches.

 The other side of the sketch reveals a comparable pun. The short list of acquisitions ends with the final two characters *yizhi*, "one branch." Extending into a cavity of that last character "branch" is the right-hand branch of the ideographic coral. Just as the hills exhale the cloudlike characters "gold basin" to link picture with poem, this crusty branch of coral rises from its trunk to merge with the written "branch" of Mi Fu's prose. Far from being a corollary to the texts, Mi Fu's sketch of coral thus proves to be the note's generating force: viewed in its entirety the whole thing develops upward and outward from the golden base of the sketch, represented by three schematic hills. In spite of the simplicity of their presentation, these are recognizable through the tenth-century landscape painting of Dong Yuan as a shorthand representation of the landscape of Jiangnan, the region south of the Yangtze River and Mi Fu's adopted home. If a direct allusion to Dong Yuan's painting was intended, "Coral" provides an ingenious comment on the interrelations among the various arts of the versatile Northern Song scholar—prose writing, poetry, calligraphy, and painting—and all composed

within a structure dictated by the paramount realities of a life in and out of office.

The cleverness of "Coral" is highlighted by Su Shi's earlier lament for Wen Tong, whose virtue went unappreciated even though it was the source for all that followed: prose writing, poetry, calligraphy, and, last, painting. "Coral," too, is about unappreciated virtue. We are reminded of Mi Fu's use of the mythical coral-like langgan tree in his poem for Lü Dafang to symbolize virtue unseen, submerged beneath the briny depths. Suddenly this symbol has emerged, but from the hills of Jiangnan rather than the ocean's waters. Rooted in the southern landscape, the coral tree of Mi Fu's virtue branches off into opposite directions, conflicting fates. Whereas the right-hand branch leads organically into the written character for branch, that on the left side is suddenly stunted, affecting little more than a suggestion of the direction in which it was meant to grow. Mi Fu's virtue blossoms in that world represented by his list of acquistions, a lifetime of involvement with the arts, but it remains unfulfilled in the public world of government service—no flowers blooming from a rainbow brush. Mi Fu's calligraphy reflects the contrast, abandoned and open to the right, cramped and restricted to the left. A life involved with painting and calligraphy allows Mi Fu to vent the full measure of his energetic nature. Life in the capital, preparing the roster of names, confines the characters to equally sized little boxes. The style of the calligraphy is essentially the same, derived from a single personality, a single tree of virtue, but the external circumstances prose and poem represent are vastly different. This is Mi Fu's personal adaptation of the paradigm of Wang Xizhi's calligraphy: in office it is constrained, tainted with vulgar, dusty airs, but when it accords with his period among mountains and forest, it becomes something truly marvelous.

The calligraphy of "Coral" is one of the finest examples of Mi Fu's late style and a textbook illustration of the theories espoused in *Famous Words from the Studio of Oceans and Mountains*. As is often the case, the initial characters set the tone, and the first two columns in particular display an extraordinary combination of sinewy strength, pliancy, and movement. The characters seem to stretch and contract according to their own requirements and consequently seem alive and natural. Yet to accept the calligraphy at face value is to turn a blind eye to the extraordinary thought demonstrated in every other aspect of "Coral." Mi Fu, in fact, *is* writing with intent: the intent to be as natural as possible. That intention suddenly reveals itself with the last two characters of the fifth column, *shanhu* (coral), written with such size and force as to suggest something other than the natural course of things. Wen Fong was the first to draw a connection between "Coral" and Mi Fu's acclamatory description of the great seal script of high antiquity in *Famous Words*. He observes that the varying forms and sizes of the

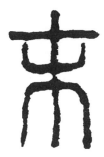

73. The character mo *(branch) as written in the archaic da𝑧huan, or large seal, script.*

characters seem to correspond with Mi Fu's aesthetic understanding of the archaic writing, "alive and full of motion, round and complete, each a self-contained image."[59] Especially noteworthy is Fong's suggestion that the sketch of coral rising from its landscape base was intended to recall the emblematic pictographs of China's earliest writing known from bronze ritual vessels of the Shang dynasty. The fact that it is the characters *shanhu yizhi*, "one branch of coral," that Mi Fu most strongly accents in his prose account supports this suggestion.

Wen Fong's proposition can be taken a step further. The coral not only resembles a pictograph, it seems to be one. The seal script writing of the character *mo* 末 , meaning the furthest reaches of a tree, or in other words the tips of its branches, is close in appearance to Mi Fu's coral (fig. 73). The roots of Mi Fu's mo are not visible, buried in the Jiangnan hills, and the horizontal bar has been lowered, but these are relatively minor adjustments. There is a particular appropriateness to this character, extending well beyond mo's basic meaning of branch tips. *Mo* is commonly used in the sense of the very end, the insignificant, the hair's tip—as in Su Shi's description of Wen Tong's poetry: "the hair's tip [*haomo*] of his prose." Earlier the Tang critic Li Sizhen (active ca. 649) made the vital connection between the arts and mo in a preface to his collected comments on calligraphy, *Shu hou pin*. Citing the *Book of Rites*, he announces that when de, virtue, was established, the qualities of human behavior it represents—humaneness, righteousness, propriety, wisdom, and honesty—were elevated to the supreme position. When the arts were established, their manifestations—rites, music, archery, charioteering, calligraphy, and mathematics—were considered secondary. Noting how few calligraphers rank in his highest class, he remarks, "Thus we know that the arts are indeed mo."[60]

"Coral" is Mi Fu's wry comment on a life devoted to that which was always destined to be insignificant. He reveals to us the tip of a branch of his coral, his virtue. Most lies hidden, buried in the mountains and forests of Jiangnan, but

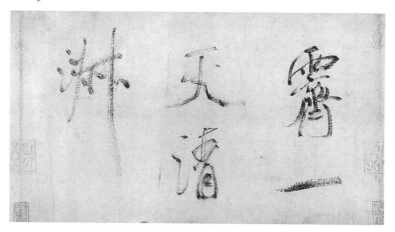

74a. Mi Fu, "Poems Written at Hongxian." Datable to 1106. Handscroll, ink on paper, 31.2 × 487.7 cm. Tokyo National Museum. First section, beginning at the right.

what is revealed shows to those who know how to play this game that what is left unseen is a generating force of profound, primordial mystery. We read back from the calligraphy, with its references to the pristine and natural qualities of China's beginnings, and the message is that Mi Fu's virtue is untainted and genuine.

The final scroll considered here is no less magnificent than "Coral." "Poems Written at Hongxian," scholars seem to agree, was written in 1106–7 (fig. 74). There are different theories, however, concerning Mi Fu's situation at the time. Cao Baolin proposes that Mi Fu was still serving as erudite of calligraphy and painting and that the calligraphy was written during a trip along the Grand Canal between Runzhou and the capital.[61] Others, including myself, associate "Poems Written at Hongxian" with the period following Mi Fu's last expulsion from Huizong's court and his service in Huaiyang, forty miles due north of Hongxian.[62] The tone is introspective, the calligraphy heroic; these are the characteristics of Mi Fu's life out of office. Traveling along the Bian River, Mi Fu discovers a poem he had written a number of years earlier, probably dating from his service in nearby Lianshui. Mi Fu copies out his old poem and adds a new one, as if to lay bare two periods of his life. The poems offer a poignant contrast: while the younger man wholeheartedly loses himself in a world of eremetic ideals, the older Mi Fu realizes that this alter life immersed in art and landscape, what was always expected to be a corollary to greater things, has in the end become his whole existence.

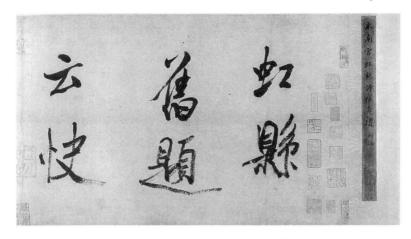

My old poem inscribed at Hongxian:

One day a sudden clearing—pure and chaste airs;
Stalwart sail for one thousand miles in the green elm wind.
Filling my skiff: calligraphy and painting together with a brilliant moon;
Ten days of following flowers into the distant depths.

I inscribe again:

Blue elm, green willow—partaking again of a past journey;
White hair and ashen face: the old man who has yet to retire.
Heaven assigns these remaining years to the handling of brush and inkstone;
Wise men know this minor art defines my family style.
Once more I made it to the capital, but the man had aged,
When will my path allow me to settle again in the east?
Leaf-boat by inscribed pillar—I really have grown old!
And in the end, no career or commission with which to report greatmerit.

The calligraphy begins modestly, almost timidly, the character *hong* small in relation to the great space of paper it opens. But confidence builds quickly, and by the third character the writing settles into a stately, majestic rhythm, two characters filling each line until the ink runs out. So it continues through the first poem. Mi Fu writes with measured control, imparting a noble monumentality to

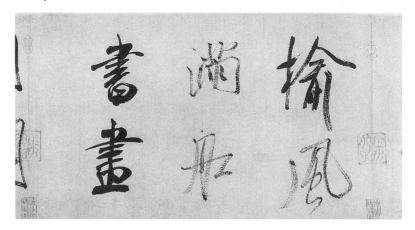

74b. "Poems Written at Hongxian." Second section, beginning at the right.

his old verse, as if to etch it in stone. Yet the calligraphy never loses Mi Fu's characteristic buoyancy. This combination of strength and lightness has the uncanny effect of somehow making the last ghostlike characters of each charge of ink the most indelible. By the end of the first poem the pace quickens slightly and the brush is charged with ink more frequently. The characters tighten, deliberation fades. The brush turns constantly, pivoting spiritedly as Mi Fu's suspended wrist twists and revolves. By the end of the second poem the intervals between characters widen, and the writing slowly comes to a halt. The final character, *gong*, sits like a small mountain with two clouds lazily rising up. The sudden calm with which this one character closes the calligraphy subtly recalls its beginning. The energies pass no further, and the scroll reverberates with life.

"Poems Written at Hongxian" is extraordinary writing, and the subtle relation between the calligraphy and the content of the two poems makes it all the more impressive. Intentions color its beginning only to disperse as the calligraphy seems to enter into a rhythm of self-generation. The transition occurs as one moves from poem to poem, thus reinforcing their differences. Mi Fu contemplates his memory of an earlier time with obvious fondness. Each character in that first poem stands like a monument to the past and to the cavalier energies the poem describes. In contrast, Mi Fu's second poem is resigned, slightly melancholy in tone. Old age, possibly encroaching death, occupies his thoughts. "East" refers to Runzhou, to home. The old man who has yet to retire remains mired in the insignificance of a provincial post. Only calligraphy remains—that, he now admits, is all that represents the family style. The term Mi Fu uses here is "wind,"

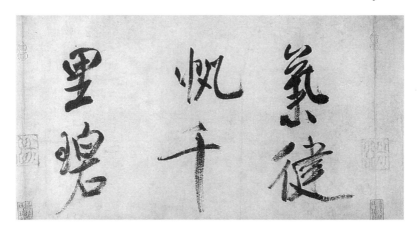

the airs that traverse time and space to teach and transform. Such self-reflective words might make us pause to reevaluate the calligraphy that writes them, but in contrast to the first half of the scroll, there is no hint of self-consciousness. The writing does not strive to be impressive; it simply is. The open and mortal honesty of this second poem is unusual for Mi Fu. Candidness produces a sense of intimacy that is strangely affecting within this structure of monumentality. Mi Fu reveals himself in his simplest, most elemental form. It proves to be his most powerful. In these final columns the calligraphy climaxes, each character becoming an exclamation of grace and power. The writing forms a stark and vivid contrast to what the last line of his poem pronounces—a final irony that Mi Fu, no doubt, could not resist laying bare.

"Poems Written at Hongxian" reveals Mi Fu's recognition that the accomplishments of his life were to be limited to his artistic achievements. Like a recurring malady, the chimera of fame haunts Mi Fu to his final days, and he dwells on it, even while his calligraphy presents a hand seemingly unencumbered by mundane concerns. It is a disjuncture that reveals the fallacy of the assumption that a simple correlation exists between mind and hand, like the faulty presumption that skill and virtue inhabit a single dimension of measurable coordinates. Mi Fu presumed that in the absence of great deeds his calligraphy might yet preserve a record of his virtue for later generations. It has preserved, rather, a record of Mi Fu's greatness as a calligrapher and his interest as an individual. Nevertheless, of one thing he was certainly correct: this art possessed the means to carry his winds far.

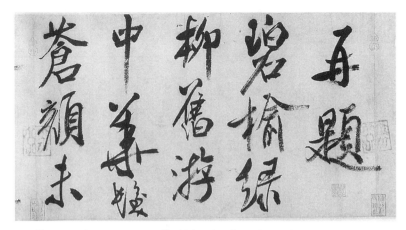

74c. "Poems Written at Hongxian." Third section, beginning at the right.

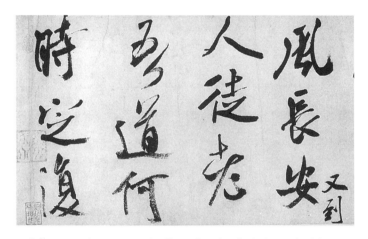

74d. "Poems Written at Hongxian." Fourth section, beginning at the right.

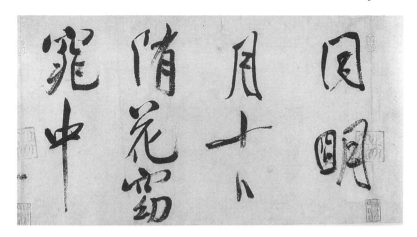

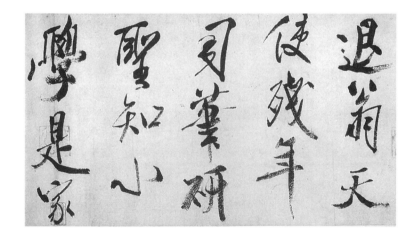

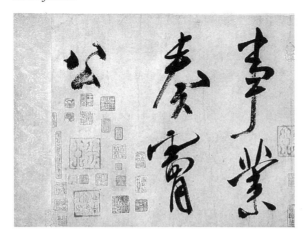

74e. "Poems Written at Hongxian." Fifth section, beginning at the right.

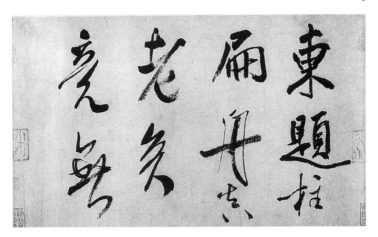

Lingering Winds—The Legacy of Mad Mi

The longevity of an artist's style depends on how strongly it affects those it encounters and their willingness to act as regenerating sources of energy. Although there are various possible reasons for the attraction, sheer skill and beauty are rarely the most important. One looks, rather, at the significance of the style, the purport of its form and manners. In Mi Fu's case, this was interpreted in a curiously schizophrenic way. His style was recognized as an assertive statement of orthodoxy born of a penetrating study of the classical tradition, but it was also seen as the embodiment of originality born of personal eccentricity. Both qualities were discerned early in the historical evaluation of Mi Fu's calligraphy, and both were instrumental in inspiring the perpetuity of his style.

Orthodoxy has never been the most immediate association with Mi Fu's name, but there is no doubt that this aspect of his practice of calligraphy ultimately allowed Mi Fu's writings, both in handwritten and engraved form, to outnumber by far those of any other Song calligrapher. When the Song dynasty fell victim to the Jurchen invasions of 1127, much of the cultural and material wealth of the dynasty was lost, along with the capital Bianjing and the north of China. Sorely pressed to recapture some of the grandeur of Huizong's reign to bolster its claim of legitimacy, the Southern Song court under the stewardship of Huizong's ninth son, Zhao Gou (Song Gaozong, r. 1127–62), began the arduous task of rebuilding the imperial collections of art. Gaozong was especially fond of calligraphy, and he was particularly attracted to Mi Fu. But it was less the untrammeled nature of Mi Fu's writing that earned the emperor's acclaim than its reflection of diligent study and its ties to the classical tradition of Jin dynasty calligraphy. In Gaozong's eyes, Mi Fu represented a worthy model for his own subjects—the free-spirit whose natural tendencies toward excess could be tempered by respect for and understanding of the orthodoxy represented by the Two Wangs. It is noteworthy that Mi Fu's freehand copies of Jin dynasty tie, especially those by Wang Xizhi, were singled out as a unique group of valued writings on entering the Southern Song imperial collection. Given the straitened circumstances of the collection at this time, these may well have been the most accurate reflections of Jin calligraphy available to Gaozong and an inspiration, if not a direct model,

for the emperor's own developing style of writing. In 1140, after having been assiduously collected, collated, and authenticated (under the supervision of Mi Fu's son Mi Youren, who had been serving as calligraphy adviser and official connoisseur to Gaozong), Mi Fu's extant calligraphy was arranged in fascicles and engraved in stone on imperial orders, with copies distributed to the high officials of the inner court. It was an honor no other Song dynasty calligrapher enjoyed and a guarantee of the preservation and transmission of Mi Fu's art.[1]

Although by necessity the spokesman for the propriety of orthodoxy, Song Gaozong was not impervious to the more carefree charms of Mi Fu's calligraphy. In one memorable critique, the emperor likens himself to Zhidun (314–66), the Jin dynasty monk criticized for his excessive love of horses. Just as it was inappropriate for Zhidun, a devout Buddhist, to become attracted to something as mundane as a fine steed, so, Gaozong suggests, was it unseemly for an emperor to be drawn to the unfettered style of a confirmed eccentric. He excuses himself, as Zhidun did, by claiming it was simply this divine swiftness that so attracted him, Mi Fu's poetry and calligraphy "possessing the spirit of soaring among the clouds."[2]

Lesser individuals, of course, need not excuse their attraction to Mi Fu's unbridledness. Indeed, throughout history it has been the stories of Mi Fu's eccentricity that have most readily been recalled to accompany the enjoyment of his writing. This is the other side of Mi Fu, and it is just as important for defining his image and style for later generations. The anecdotes are generally ignored in the serious study of Mi Fu, but they have always had their place in traditional Chinese historiography. The original sources are mostly Southern Song and Yuan dynasty collections of miscellany—the *yishi,* or "leftover affairs." Many were later collected, along with biographical information and various pieces of Mi Fu's and others' writings, and published as specialized unofficial histories. One of the better known is *Mi Xiangyang zhilin* (*A Grove of Records of Mi Fu of Xiangyang*) in sixteen fascicles, compiled in 1604 by Fan Mingtai. Fan cites a lost work, *Nangong yishi* (*Leftover Affairs of Nangong* [Mi Fu]), collected by the fourteenth-century connoisseur Lu You, as one of his sources.[3] Closer to Fan Mingtai's own time, however, was a very similar compilation in eight fascicles dated 1492 edited by the prominent scholar and calligrapher Zhu Yunming (1460–1526). This was titled *Mi dian xiaoshi* (*Minor [Unofficial] History of Mad Mi*). Zhu Yunming's collection of Mi Fu memorabilia is especially notable because the original manuscript recently resurfaced.[4]

These are informal works, and in the spirit of their casualness I offer a small sampling of what I consider to be a few of the more interesting stories told of Mi Fu. Some, of course, are apocryphal, and many provide a distorted view. Yet

some of Mi Fu's own writings substantiate the spirit, if not fact, of their content. The categories are roughly modeled after some of those found in Zhu Yunming's and Fan Mingtai's unofficial histories, though some of the stories could be included under more than one heading.

Madness

Mi Yuanzhang acquired a reputation as a calligrapher. His literary writings, too, are unbridled and uncommonplace. [Su] Dongpo once said that while in a boat, returning from across the southern sea, he heard his son reciting an old-style verse by Mi, and he began to regret that he had only come to know Mi Fu late in life. At Huizong's court some officials discussed recommending him for service. Mi Fu was appointed erudite at the Court of Imperial Sacrifices. At the time, Wu Shi [1073 jinshi], a drafter in the Secretariat, circulated his own verses, enjoying the praise of many. Yuanzhang liked them, and he wrote his own poem to express his thanks. The last stanza went:

In our midst, an elder of solitude,
Learning the Way, an ascending immortal who begins to make the grade.
Dawn court, under the bright sun I pay respect to the multihued brilliance,
The Jade Emperor should find strange the white of my beard and eyebrows.

Mi Fu was referring to himself in the poem and failed to convey any sense of thanks [to Wu Shi]. People at the time said that Mi Fu tended toward the unorthodox and strange. Crafty and deceitful, he was detached from the feelings of others. Labeled mad, some objected to his inclusion in the register of court officials. The order [of promotion] was consequently rescinded. [Mi] Yuanzhang was extremely unhappy, and he submitted a memorial appealing this matter. In it he argued that he had served as an official some fifteen times, with forty-five people offering recommendations. How could this be the accomplishment of someone who was mad? In the end he did not report. Four years would pass before he was called back to the court. Yuanzhang liked to dress in the clothing of the Tang dynasty, with wide sleeves and a broad belt. People found this very strange. He also had a mania for cleanliness, not allowing others to touch the implements he used himself. Once he had dressed up to pay his respects to another official, but the top of his hat was too tall to allow him into the sedan chair. Consequently, it poked through the cover of the chair. All who saw this were overcome with laughter. There are many stories of this kind.

—Zeng Minxing, *Duxing zazhi*, juan 6, 2a–b

This anecdote appears to confuse the events surrounding Mi Fu's dismissal from the Court of Imperial Sacrifices with his impeachment, a few years later, from the Ministry of Rites.

Mi Fu, style name Yuanzhang, was a broadly learned connoisseur fond of antiquities. Because of his unwillingness to be constrained by the conventions of society, scholars regarded him as mad. Lord Lu [Cai Jing] was deeply fond of him. In the past Mi Fu served as erudite of calligraphy. Later he was promoted to vice-director in the Ministry of Rites. A number of times he encountered memorials of impeachment and was expelled. On one occasion he sent a letter to Lord Lu informing him of his misfortune. He told of how his entire family, consisting of some ten people, traveling at Chenliu [Henan Province], were limited to a single boat just "so big." He then sketched a small skiff between the columns of his letter. Lord Lu got a laugh out of that. The letter is now in my collection. Sometimes the impeachment documents actually referred to him as mad. Mi Fu, in consequence, informed Lord Lu and all of the other heads of government that for many years he had served both in and out of the capital, and he had become familiar with many important officials. In all of the thousands of times these gentlemen had recommended him at the court, it had always been his administrative abilities they had emphasized. None had recommended him because he was mad. Afterward people began to talk about Old Mi's "Letter on Determining Insanity" ["Biandian tie"].
—Cai Tao, *Tieweishan congtan,* juan 4, 61

Note the impeachment memorial translated in chapter 6.

There is a note by Mi Yuanzhang that reads, "Your younger brother's [my] collected writings, *Shanlin ji,* is larger than that of Meiyang [Su Shi], and yet there is not a single line lifted from the ancients." When Zizhan [Su Shi] returned from the deep south he spoke with Mi Fu, sighing at great lengths. It is almost as if he was sighing over his "thievery." I playfully inscribe two verses [only one is included here]:

Two tomes: one transmitted, the other not,
Can it be Precious Jin bested Slope Immortal?
Su Shi wasn't drunk, but always appeared that way;
Old Mi was truly mad, yet tried to debate insanity!

[Original note:] It is said that Old Mi wrote a "Letter on Determining Insanity."

—Liu Kezhuang, *Houcun ji,* juan 10, 7b–8a

Su Dongpo [Su Shi] was in Weiyang [Yangzhou, Jiangsu Province]. One day he hosted a party, with more than ten guests. All were famous scholars of the time. Mi Yuanzhang was also there. Halfway through their cups, Mi Fu suddenly got up and bragged about himself, "People all think that Fu is crazy. I would like to ask Zizhan [Su Shi] what he thinks." Changgong [Su Shi] laughed and replied, "I'll go along with the crowd."

—Zhao Lingzhi, *Houqing lu,* juan 7, 10b

My regulated verse has already been engraved on the pillar of the Haidai Tower, opposite that of Mad Liu [on the flanking pillar]. Fu bows his head [in greeting]. If not two madmen [*erdianzhe*], I would not have had it engraved.

—Mi Fu, letter from *Yingguangtang tie,* reproduced in *Zhongguo shufa quanji,* 38:349

Mad Liu should be Liu Jing. The Haidai Tower was in Lianshui.

Cleanliness

Mi Fu had a mania for cleanliness. When he served as erudite of the Court for Imperial Sacrifices, in preparation for the ceremony at the Imperial Ancestral Temple, Mi Fu scrubbed his official gowns so vigorously that the fire-and-watergrass patterned embroidery came undone. He was demoted in punishment for this transgression. Mi Fu's compulsion, however, was partly feigned. When Mi Fu was serving at the commandery at Lianshui, my father [Zhuang Gongyue, 1059 jinshi] served as transport intendant. He always told me that he never saw Mi Fu wash his hands when preparing official documents. My brother visited him once, however, and when he presented his name card Mi Fu suddenly had to wash his hands. From this one knows that he was faking. At the house of Zhongyu, prince of Huayuan [Zhao Zhongyu, 1052–1122], there were many women singers. One time he wanted to test Mi Fu, so a large banquet was arranged with Mi Fu set by himself on a single dais where he was served wine and food by a number of servants wearing brightly colored clothes with their arms exposed. The song girls made a ring around the other guests. Goblets and platters were messily scattered everywhere. After a while, Mi Fu also joined in, relocating to sit among the crowd. From this one knows that his mania for cleanliness was not a natural trait.

—Zhuang Chuo, *Jile bian,* juan 1, 10a–b

My great-grandfather, the principal graduate [Zhou Tong, 1076 jinshi], was very close friends with Yuanzhang [Mi Fu]. Whatever pieces of calligraphy and painting they had collected, if one liked what the other had it would immediately be given as a gift. One day Yuanzhang said that he had acquired an extraordinary, otherworldly inkstone. "Heaven must have kept it hidden, waiting for me to recognize it," he said. My great-grandfather responded, "Though you are quite knowledgeable, Sir, your collection is half filled with fakes. You are particularly good at exaggerating, so let me have a look." Yuanzhang got up to take the inkstone out of its box. My great-grandfather also got up and sought a towel with which to wash his hands, as if to prepare for a respectful viewing. When Yuanzhang saw this he was very happy. The inkstone emerged and great-grandfather praised it unstintingly. Then he said, "Truly this is an extraordinary object, but I wonder how it is at making ink." He ordered some water to be brought forward, but before the water arrived he suddenly spit into the inkstone and started grinding ink. Yuanzhang's face turned color. He then said to my great-grandfather, "How can you at first be so respectful and then turn so inconsiderate? You've dirtied my inkstone. As I can no longer use it, I am giving it to you." My great-grandfather was simply playing a joke on Mi Fu, knowing his compulsion for cleanliness. Afterward, he tried to give the inkstone back, but in the end Mi Fu would not accept it. At the time, my great-grandfather was serving as prefect of Jingkou [Runzhou].

—Zhou Hui, *Qingbo zazhi*, juan 5, 13b–14a

Mi Fu's friendship to Zhou Tong is documented in ci poems collected in Bao-Jinzhai fatie, *juan 10. The incident, if true, would probably have taken place circa 1095–96, during Mi Fu's second period in Runzhou.*

People have said that Mi Fu had a mania for cleanliness, but at first I had no idea why they thought this. Then I acquired a note written by Mi Fu that spoke of how his court boots had been carried by someone else. Thoroughly disgusted, he washed them so many times that they were damaged and could not be worn. From this I understood his reputation for cleanliness: if he would wash something like boots so thoroughly, one can imagine what he was like when it came to other things. Another time Fu was choosing a son-in-law. When he came across Duan Fu [style name Quchen] of Jiankang, Fu said, "This fellow's name is Fu ["to brush away"], and also Quchen ["to expel dust"]—truly a son-in-law for me." Mi Fu married his daughter to him.

—Chen Gu, *Qijiu xuwen*, juan 3, 6a–b

Official Career

When Mi Yuanzhang was young he served as a prefect. There was a great drought and he sent underlings out to exterminate the locusts in all haste. A neighboring prefect sent a letter upbraiding him, informing Mi that his workers had chased the locusts into his own district. Yuanzhang then wrote out a short poem in large characters on the back of that official note. It read,

Locusts, from the beginning, are a natural disaster;
They are not dispatched through human effort.
If they were chased over from our humble city,
Then bother your honored district to send them back!
All who saw this laughed.

—Zhou Cizhi, *Zhupo laoren shihua*, 3b—4a

In another version of this story found in He Yuan's Chunzhu jiwen *it is specified that this took place when Mi Fu was serving at Yongqiu in the early 1090s. However, Mi Fu's problems in Yongqiu stemmed not from a drought but from too much rain. It is much more probable that this story is derived from Mi Fu's encounter with locusts while serving in Lianshui circa 1098.*

Mi Fu once wrote a letter to Jiang Yishu [Jiang Zhiqi] of the West Administration that went: "Fu is old! Do not, Sir, show mercy with baseless arguments at the court. You can recommend me by saying, 'Mi Fu of Xiangyang is between Su Shi and Huang Tingjian. He relies on his own talents and has nothing to do with party cliques. He is old now, and hampered by his qualifications. If it were his misfortune to die one day without having the opportunity to enrich His Majesty's enterprise and thus embellish His Majesty's magnanimity, this official would consider it a pity. I hope that the illustrious emperor will depart from the standard procedures and look into the matter.' What does the gentleman think? Fu humbly writes." People have called this Old Mi's "Letter of Self-Recommendation."

—Zhou Hui, *Qingbo biezhi*, juan 1, 20b—21a

This same letter cited by Zhou Hui, with only one or two minor differences, is preserved as a rubbing in Bao-Jinzhai fatie, *juan 10. In the rubbing version, however, the addressee is not specified.*

Imperial Patronage

Emperor Huizong had heard of Mi Fu's reputation as an accomplished calligrapher. One day in the Yaolin [Jasper Grove] Palace he had a large piece of silk spread out, two yards square. An agate inkstone and Li Tinggui ink were prepared, as well as an ivory-handled brush, a gold ink box, a jade paper weight, and a water dropper. Mi Fu was summoned to write. The emperor concealed himself behind a curtain and watched. Liang Shoudao [Liang Shicheng, ca. 1063–1126] was ordered to accompany Mi and provide him with refreshments of wine and fruit. Gathering back his robes and sleeves, Mi Fu leapt forward, nimble as can be. His brush descended like swirling clouds, dragons and serpents flying about. Hearing that the emperor was watching from behind the curtain, Mi Fu turned that way and said in a loud voice, "The rarest of the rare, Your Majesty." Huizong was greatly pleased and presented Mi Fu with an imperial banquet and a gift of the various writing implements. Soon afterward Mi Fu was promoted erudite of calligraphy.

—Qian Shizhao, *Qianshi sizhi*, 8b

Fu was serving as erudite of calligraphy. One day the emperor and Cai Jing were discussing calligraphy in the Genyue Park. They summoned Fu and ordered him to write upon a large screen. It was indicated that he could use an imperial writing stand and inkstone, which he did, and the calligraphy was completed. Mi Fu then held up the inkstone while kneeling in front of the emperor and said, "This inkstone has now been stained by your servant and cannot be returned to imperial use. I thus desist from presenting it to Your Highness." The emperor laughed loudly and gave it to Mi Fu as a gift. Fu danced a jig of thanks, clasping the inkstone as he hurried out. The remaining ink spilled onto his clothes, soiling his robe and sleeve, yet there was only a look of utter glee on his face. The emperor looked at Jing and said, "This reputation of being mad is not empty after all." Jing answered, "Fu's personal character is truly lofty. As they say, there should be one of his type, but god forbid there be two."

—He Yuan, *Chunzhu jiwen*, juan 7, 9a–b

Haiyue [Mi Fu], as erudite of calligraphy, was summoned for an audience with the emperor. The emperor asked him about a number of

writers of the present dynasty who had achieved reputations as
calligraphers. Haiyue then characterized each of them, saying, "Cai Jing
lacks brush. Cai Bian [1058–1117] has brush but lacks untrammeled
spirit. Cai Xiang labored his characters. Shen Liao [1032–85] arranged
his characters. Huang Tingjian sketches his characters. Su Shi drew his
characters." The emperor then asked Mi Fu of his own calligraphy. He
answered, "Your servant brushes his characters."

—Zhang Bangji, *Mozhuang manlu*, juan 6, 6a–b

These tie were copied by the former official Fu in his middle years.
Today they are collected in the Imperial Treasure of the Successor of
Sagacity of the Shaoxing reign [Gaozong], and indeed they will be
transmitted for ten thousand generations in perfect condition. This
study of calligraphy is truly extraordinary. There must be some divine
spirit protecting it. One could also say that it has met with imperial
favor. Today I have had the chance to catch a glimpse of it and respect-
fully add an inscription at its end. I have also received a copy from the
hand of the emperor [Gaozong]. I reverently witness the quick and
untrammeled quality of the emperor's brushwork—conceptions ready
before the brush moves. Character after character follow from his heart,
one connected to the other in a continuous stream. Dragons and
phoenixes flying and wheeling, dazzling the eyes of those who look. The
emperor has deeply attained the methods of Wang Xizhi. Such subtleties
are not something this stupid servant would dare lightly glance at and
praise. Having received it I will treasure it ten thousand-fold and hand it
down to be shown to the hundreds who will throng like clouds. My
family's meeting with imperial honor, father and son, is indeed such
good fortune that is not easily encountered in a thousand years. [Dated]
the twelfth day, [intercalary] tenth month, Shaoxing 7 (1137).

—From an inscription by Mi Youren written for Mi Fu's copies of Wang
Xizhi calligraphy. Yue Ke, *Baozhenzhai fashu zan*, juan 20, 300–301

Collecting and Connoisseurship

In the past I suspected that although Mi Yuanzhang is peerless in our
time at handling the brush, only half of the calligraphy he has collected
is genuine; the other half is spurious. On the twelfth day of the sixth
lunar month, Yuanyou 4 [1089], Zhang Zhiping and I together passed by

Yuanzhang's place. [During the visit] Zhiping turned to me and said, "Have you ever noticed how when showing calligraphy Mi Fu personally locks his treasure box and uses both hands to hold the scroll, maintaining a distance of more than a yard from his guest viewers? If they move closer, he immediately pulls it away." Yuanzhang laughed. He then proceeded to take out ten or so scrolls of the writing of the Two Wangs, Zhang Xu, Huaisu, and others of that caliber. After this I knew that what Mi Fu normally pulls out to show others is limited to that which will please the average eye.

—Su Shi, "Shu Mi Yuanzhang cangtie," *Su Shi wenji*, addendum, juan 6, 2570

In the Xiangxi district of Changsha are the two famous temples Daolin and Yuelu. The Tang dynasty calligrapher Shen Chuanshi wrote his Daolin poems here. The large-style writing, characters as big as fists, was written on a plaque that had always been kept in a small gateway in the temple. Old Mi Yuanzhang, during the period in his life when he was serving in minor offices, traveled through this region, mooring his boat along the Xiang River. He approached the head abbot of the temple with the request to borrow the calligraphy for study. One night, however, Mi Fu spread his sails and took off with it. The temple monks urgently made a formal complaint to the local authority, who dispatched a speedy courier to bring back the plaque. People consider this a great subject of gossip. During the Zhenghe reign [1111–18] the emperor [Huizong] ordered that the plaque with Shen Chuanshi's poems be taken from the temple and stored in the palace. He also had the Daolin poems copied and carved into stone. Rubbings were widely disseminated to the many officials, but they just weren't like the Daolin plaque, whose essential character was its naturalness.

—Cai Tao, *Tieweishan congtan*, juan 4, 76

Mi Fu speaks of studying Shen Chuanshi's "Daolin Poems" in Shu shi, *18b–19a, but there is no mention of the controversy suggested here.*

Mi Fu was a joking, deceitful prankster, fond of the unusual. When he was at Zhenzhou he went to pay his respects to Cai You [1077–1126] of the Large Security Group. You pulled out his collected masterpiece, the general of the right's [Wang Xizhi] "National Territory," and showed it

to Fu. Fu was overcome with admiration and begged to trade it for some paintings, but You appeared unwilling. Fu thereupon said, "If you, Sir, do not agree to follow my wish, there will be no reason for me to go on living. I'll throw myself into this river and drown. He then let out a loud shout and grabbed the hull of the boat as if to go over. You quickly gave him the calligraphy.

—Ye Mengde, *Shilin yanyu*, juan 10, 15a–b

If this unlikely story is true, it probably would have taken place when Mi Fu was serving as a manager of documents for the Office of the Supply Commission around 1101–2. The remainder of Ye Mengde's anecdote is found in the section "Rocks and Inkstones."

Old Mi had a mighty appetite for calligraphy and painting. One time he borrowed an ancient painting and made an exact copy. When the copy was finished he returned the genuine along with the fake to the owner so that he would have to choose between them. The owner couldn't tell which was the original. Mi Fu was clever and bold at stealing and thus acquired a large collection. Thus, Dongpo [Su Shi] once inscribed the following on a scroll of the Two Wangs' calligraphy in order to mock him: "Embroidered bag and ivory rollers come without feet, Brilliantly swiping the genuine, you must have the knowledge of a sage."

—Zhou Hui, *Qingbo zazhi*, juan 5, 13a–b

These two lines come from the second of Su Shi's two poems written after Mi Fu's verses added to the Tang tracing copy of Wang Xianzhi's "New Bride Fan" (see chapter 1).[5] Zhou Hui's anecdote continues with another version of the story of Mi Fu acquiring the Wang Xizhi calligraphy by threatening to jump off a boat.

When Mi Fu was serving in Lianshui a guest wanted to sell him a Dai Song painting of a water buffalo. Yuanzhang borrowed it for a few days, copied it, and sent the copy back to the owner, who couldn't tell the difference. Later the guest brought the copy to Mi Fu and demanded that he return the genuine painting. Yuanzhang found this strange and asked him how he knew. The guest replied, "There should be a reflection of the herdboy visible in the eye of the buffalo. That's missing in this painting."

—Zhou Hui, *Qingbo zazhi*, juan 5, 12b–13a

Some versions of this story erroneously use Mi Youren's sobriquet, Yuanhui, rather than that of Mi Fu, Yuanzhang.

When Yang Ciweng [Yang Jie, 1059 jinshi] was serving as prefect of Danyang [Runzhou], Mi Yuanzhang once passed through the prefecture and stayed for a few days. Yuanzhang liked to trade for other people's calligraphy and painting. Ciweng made a stew to serve Mi Fu, saying to him, "Today I'm cooking blowfish for you." In fact, he was using another kind of fish. Yuanzhang would not eat it. Ciweng laughed, saying, "You don't have to be so suspicious. It's a fake."

—Zhou Cizhi, *Zhupo laoren shihua*, 17a–b

The notorious hetun *(river pig), or blowfish, possesses a poison that can be deadly if the fish is incorrectly prepared.*

Rocks and Inkstones

The former ruler of Jiangnan [Southern Tang], Li Houzhu [Li Yu, r. 961–75] owned a precious inkstone in the form of a mountain, barely a foot in length. Thirty-six peaks rose straight up in the front, each about the size of a finger. To the sides it led to two slopes, and in the center was a cavity for grinding the ink. When the Jiangnan kingdom was destroyed, the inkstone mountain passed into the hands of a number of private families. Finally Mi Yuanzhang managed to acquire it. Later, Old Mi moved to Danyang. He wished to establish a studio but for a long time was unsuccessful. At the time, the brother of Su Zhongrong, who was also the grandson of Caiweng [Su Shunyuan, 1006–54], owned a thickly wooded piece of property with some old graves just underneath the Ganlu Temple adjacent to the river. People had lived here during the Jin and Tang dynasties. Old Mi wanted his studio, and Su coveted the inkstone mountain. Vice-director Wang Yanzhao [Wang Hanzhi, 1054–1123] and his brother [Wang Huanzhi, 1060–1124] climbed Beigushan and together acted as intermediaries, allowing Su and Mi to make the trade. What Mi later called Haiyuean, Studio of Oceans and Mountains, was built on this site. The inkstone mountain was with the Su family but not long after was acquired for the imperial collection.[6]

—Cai Tao, *Tieweishan congtan*, juan 5, 96

Mi Fu served as the prefect of the commandery at Wuwei. When he first entered the prefectural administrative office he saw a standing rock whose appearance was quite extraordinary. Happily, Mi Fu exclaimed, "This fellow is worthy of my bow." Whereupon he ordered his assistants to bring him his official gown and tablet and made his obeisance. Afterward Mi Fu always addressed it as Brother Rock. Critics who hear this story always discuss it. At the court as well it has been passed down as an amusing matter.

—Ye Mengde, *Shilin yanyu,* juan 15b

Abbreviations

BJZFT	*Bao-Jinzhai fatie*
BJYGJ	Mi Fu, *Bao-Jin yingguang ji*
BZDFL	Mi Fu, *Baozhang daifang lu*
BZZFSZ	Yue Ke, *Baozhenzhai fashu zan*
CST	*Chūgoku shoron taikei*
FSYL	*Fashu yaolu*
GGLDFSQJ	*Gugong lidai fashu quanji*
GSHGYYL	Xu Bangda, *Gu shuhua guoyan yaolu*
HYMY	Mi Fu, *Haiyue mingyan*
JS	*Jin shu*
JTS	*Jiu Tang shu*
OYXQJ	Ouyang Xiu, *Ouyang Xiu quanji*
SDGJ	*Shodō geijutsu*
SDZS	*Shodō zenshū*
SS	*Song shi*
SSSJ	Su Shi, *Su Shi shiji*
SSWJ	Su Shi, *Su Shi wenji*
TS	*Tang shu*
XHSP	*Xuanhe shupu*
XSD	Zhu Changwen, *Xu shu duan*
XTS	*Xin Tang shu*
ZGSFQJ	*Zhongguo shufa quanji*

Notes

Introduction

1. Cai Tao, *Tieweishan congtan* (hereafter cited as Cai Tao), juan 5, 96. A translation is included in the Epilogue.

2. The precise location of the second Haiyue Studio has not been determined. Mi Fu moved his studio after fire destroyed the Ganlu Temple in 1100.

3. *Helinsi zhi,* 5a, 6a, 7a, 18a–19b, 20a–23b, 27a, 30a, 32b, 35a, 38b–39b, 41a–b, 81a–b. The engraved self-portrait was probably a recension from the same composition known today by a stone engraving at Fubo Mountain in Guilin, Guangxi Province (see fig. 33).

4. Mi Fu's collected works in their present form are known by the title *Bao-Jin yingguang ji* (hereafter *BJYGJ*), named after Mi Fu's Studio of Precious Jin Treasures located at the main Mi family dwelling in Runzhou. Consisting of eight fascicles and an addendum, this work is but a small fraction of Mi Fu's original one-hundred fascicle collection, titled *Shanlin ji,* which was lost during the fall of the Northern Song in the late 1120s. Credit for putting together *BJYGJ* is often given to Yue Ke, whose preface of 1232 is found at its beginning, but the primary figure was Mi Fu's third-generation descendant Mi Xian. His postscript, dated 1201, is still seen in certain editions. A Southern Song edition of Mi Xian's edited version, titled *Bao-Jin shanlin ji shiyi* and including Mi Fu's other writings, *Baozhang daifang lu, Shu shi, Hua shi,* and *Yan shi,* is in the Beijing Library. See Xu Bangda, "Liangzhong youguan shuhua shulu kaobian," 63–66. Throughout this book, citations to *BJYGJ* are from the readily available edition published by Xuesheng shuju, which reproduces a Qing dynasty manuscript copy kept in the National Central Library in Taiwan and, according to Ruan Yuan's inscription of 1816, originally descended from the collection of Liu Kezhuang (1187–1269). This consists of Mi Xian's edited volume (including Mi Fu's four additional histories), Yue Ke's additions, and others postdating Yue Ke's efforts. I have collated it with the earlier version housed in Beijing, as well as with another manuscript copy written by Wu Yifeng (Qing dynasty) kept in the National Palace Museum, Taipei (hence occasional discrepancies between my translations with the texts found in Xuesheng shuju's published edition). Yue Ke's additions amount to seventeen poems and a handful of other writings, all labeled as "new additions from the Yingguangtang Compendium of Model Writings," which refers to the engraved set of Mi Fu's calligraphy edited by Yue Ke. For more on this important source for Mi Fu's calligraphy, see Nakata Yūjirō, *Bei Futsu* (hereafter *Bei Futsu*), 1:167–182.

5. *Beigushan zhi,* juan 2, 10b–11a, 20b–21b; juan 4, 8b, 9a–10a; juan 5, 5a–6b. Some of this is summarized in Gao Huiyang, "Mi Fu jiashi nianli kao."

6. *Xiangyang xianzhi,* juan 2, 51ff.

7. Weng Fanggang, "Jiuyaoshi kao," in *Yuedong jinshi lue,* addendum, 7b. Fang Xinru, "Bao-Jin Mi gong huaxiang ji," in Xie Qikun, *Yuexi jinshi lue,* juan 11, 21b–23b. *Hunan tongzhi,* juan 269, 5489; juan 275, 5605. For a summary of such references, see Gao Huiyang, "Mi Fu qi ren ji qi shufa," 51–88.

8. *Andong xianzhi,* juan 2, 7a; juan 15, 1b–2a. *Huaian fuzhi* (edited by Ye Changyang), juan 28, 16a. *Huaian fuzhi* (edited by Chen Genshan), juan 14, 5b.

9. Ye Mengde, *Shilin yanyu,* juan 10, 15b. A translation is included in the Epilogue. For other materials on Mi Fu at Wuwei, see *Wuwei zhouzhi,* juan 4, 2a–3a; juan 14, 3b–4a;

juan 28, 1a–3a.

10. Legge, *Chinese Classics,* 5:505–7 (the twenty-fourth year of Duke Xiang).

11. Mi Fu, *Hua shi,* 187. Mi Fu cites Du Fu's "Guan Xue Ji shaobao shuhua bi," in Du Fu, *Du Shaoling ji xiangzhu,* juan 11, 816–17. The five Kings are the Tang dynasty figures Huan Yanfan, Jing Hui, Cui Yuanwei, Zhang Jianzhi, and Yuan Shuji, all contemporaries of Xue Ji active in the late seventh century. With the exception of Cui, all have official biographies in *Jiu Tang shu* (hereafter *JTS*), juan 91, and *Xin Tang shu* (hereafter *XTS*), juan 120.

12. *Siku quanshu zongmu,* 957–58.

13. Within the vast body of critical writings on style, the following relatively recent studies proved particularly useful: Ackerman, "Theory of Style"; Gombrich, "Style"; Goodman, "Status of Style"; Hirsch, "Stylistics and Synonymity"; Kubler, "Towards a Reductive Theory of Visual Style"; Lang, "Style as Instrument, Style as Person"; Meyer, "Toward a Theory of Style"; Schapiro, "Style."

14. Lang, "Style as Instrument, Style as Person," 715.

15. Ibid., 716.

16. Ibid., 730.

17. Liu Xie, *Wenxin diaolong jiaoshi* (XXVIII), 105–9. Shih, trans., *Literary Mind and Carving of Dragons,* 162–63. Gibbs, "Notes on the Wind," 285–93. Hay, "Values and History," esp. 86–87. Kuriyama, "Imagination of Winds."

18. Hay, "Human Body."

19. The term is derived from the story of the skilled musician Bo Ya and his friend Zhong Ziqi of the Warring States period. When Zhong Ziqi died, Bo Ya refused to play his zither again, because the one person who understood his sounds was gone. *Liezi jishi,* juan 5, 178–79. Graham, trans., *Book of Lieh-tzu,* 109–10. "Zhiyin," translated as "An Understanding Critic" by Vincent Yu-chung Shih, is a section in Liu Xie's *Wenxin diaolong* (XLVIII); Shih, trans., *Literary Mind and Carving of Dragons,* 258–63. For a thoughtful discussion on the role of the zhiyinzhe, see Owen, *Traditional Chinese Poetry and Poetics,* 54–77.

20. Su Shi, "Jingyinyuan hua ji," in *Su Shi wenji* (hereafter *SSWJ*), juan 11, 367. Bush, *Chinese Literati on Painting,* 42.

21. The phrase is derived from a passage in Yang Xiong's *Fayan* of the Han dynasty. *Yangzi Fayan,* juan 5, 14. Among those who quote it are Guo Ruoxu and Mi Youren, both of whom extend writing's capacity for self-expression to painting. Guo Ruoxu, *Tuhua jianwen zhi,* juan 1, 9; Alexander Soper, *Kuo Jo-hsü's Experiences in Painting,* 15. Mi Youren's citation is in an inscription to a documented painting titled "Landscape for Jiang Zhongyou." Bian Yongyu, *Shigutang shuhua huikao,* juan 13, 22.

22. The phrase *zicheng yijia* is derived from a related passage found in a famous letter written by the Han dynasty historian Sima Qian (145–ca. 90 B.C.) to his friend Ren An. Describing his grand historical project, *Shi ji,* he wrote (in James Hightower's translation), "It was also my hope that through a thorough examination of all things human and divine, and through comprehension of the historical changes, from antiquity to the present, I would be able to establish a school of my own" (*cheng yijia zhi yan,* literally, "establish the words of one school"). Sima Qian then expresses his hope for a future zhiyinzhe who will come along and understand his work, "stored away in a famous mountain." Hightower's translation is found in Birch, ed., *Anthology of Chinese Literature,* 101.

23. A more detailed introduction can be provided by one of the growing number of excellent general books on the art of calligraphy, including Fu, *Traces of the Brush;* Nakata, *Chinese Calligraphy;* Chang and Miller, *Four Thousand Years of Chinese Calligraphy;* and Tseng, *History of Chinese Calligraphy.*

24. From "Bi zhen tu" ("The Battle Formation of the Brush"), attributed to Lady Wei (272–349) but believed to date from the early Tang dynasty. *Fashu yaolu* (hereafter *FSYL*), juan 1, 6. Translation by Barnhart, "Wei Fu-jen's *Pi Chen T'u*," 16.
25. Cai Xiang, as quoted by Chen Tong, *Neige mizhuan zi fu*, in *Cai Xiang shufa shiliao ji*, 11.

Chapter 1 *"Ideas" and Northern Song Calligraphy*

1. Dong Qichang, *Rongtai ji*, juan 4, 23b.
2. Goldberg, "Court Calligraphy."
3. "Shu Wu Daozi hua hou," *SSWJ*, juan 70, 2210–11.
4. By his own admission Ouyang was not a notable calligrapher in his own right, but as an avid collector of inscriptions and rubbings he had seen much and considered himself broadly knowledgeable of the art. "Tang Xuanjing xiansheng bei," in "Jigu lu" (2), *Ouyang Xiu quanji* (hereafter *OYXQJ*), juan 6, 36. A fine survey and analysis of Ouyang Xiu's attitudes toward calligraphy is Egan, "Ou-yang Hsiu and Su Shih." See also Nakata Yūjirō, "Ōyō Shū no Hissetsu, Shihitsu."
5. "Tang Angong meizheng song," in "Jigu lu" (2), *OYXQJ*, juan 6, 21–22. Egan, "Ou-yang Hsiu and Su Shih," 375.
6. "Guo Zhongshu xiaozi shuowen ziyuan," in "Jigu lu" (2), *OYXQJ*, juan 6, 70.
7. "Shiren zuo feizi shuo," in "Bishuo," *OYXQJ*, juan 5, 114. The "three," as Ouyang suggests in another inscription, are Cai Xiang (1012–67) and the brothers Su Shunqin (1008–48) and Su Shunyuan (1006–54). "Ba Yongcheng xianxue ji," in "Jushi waiji" (2), *OYXQJ*, juan 3, 138.
8. "Shiren zuo feizi shuo." The account of Yang Ningshi criticizing his father, Yang She, for turning over the Tang dynasty's seals of state to Zhu Quanzhong is cited from *Wudai shi bu*, in *Jiu Wudai shi*, juan 128, 1685.
9. "Li Zhen bi shuo," in "Bishuo," *OYXQJ*, juan 5, 115.
10. "Xueshu zichengjia shuo," in "Bishuo," *OYXQJ*, juan 5, 113.
11. There have been various reprints of *Model Writings from the Chunhua Pavilion*. For information on its contents and a historical critique, see Rong Geng, *Congtie mu*, 1–28; Nakata Yūjirō, "Junkakaku cho"; and Fu, "Huang T'ing-chien's Calligraphy," 199–203.
12. Su Shi, "Bian guanben fatie" and "Bian fatie," *SSWJ*, juan 69, 2172. Mi Fu's colophon, titled "Ba mige fatie," is found in Huang Bosi, *Dongguan yulun*, juan 1, 46a–b.
13. Ouyang Xiu comments on the prevalency of Ouyang Xun's calligraphy in "Ba Chalu," in "Jushi waiji" (2), *OYXQJ*, juan 3, 139. Mi Fu describes how Ouyang Xun's style was widely practiced at the end of the Tang. *Shu shi*, 19a–b.
14. For a detailed introduction to the "Orchid Pavilion Preface," its influence at the Tang court, and references to the vast corpus of literature devoted to the famous preface, see Ledderose, *Mi Fu and Classical Tradition*, 19–28.
15. "Ba Yongcheng xianxue ji."
16. Su Shi, "Ba Hu Peiran shuxia hou," *SSWJ*, juan 69, 2179.
17. Ouyang Xiu, "Tang Zheng Huan yinfu jing xu," "Tang Li Shi shendao bei," and "Tang Gao Zhong bei," in "Jigu lu" (2), *OYXQJ*, juan 6, 54, 55.
18. Dong Shi, *Shu lu*, juan 2, 6b.
19. *XTS*, juan 153, 4854–61; Aoki Seiji, "Gen Shinkyō no shogaku"; McNair, "Su Shih's Copy."
20. "Tang Yan Zhenqing xiaozi Magu tan ji," in "Jigu lu" (2), *OYXQJ*, juan 6, 27.
21. "Ba Yongcheng xianxue ji." Ouyang Xiu emphasizes in particular Wang Wenbing's lesser seal script, Li E's and Guo Zhongshu's standard, and Yang Ningshi's semicursive and cursive. Qian Shu was known for skill in wild cursive.
22. "Ping Yang shi suocang Ou Cai shu," *SSWJ*, juan 69, 2187.

23. Ouyang Xiu strongly criticized Feng Dao because of this issue. See Wang, "Feng Tao."

24. Zheng Minzhong, "Ji Wudai Yang Ningshi fashu"; Fu, "Huang T'ing-chien's Calligraphy," 214–22; Xu Bangda, "Yang Ningshi moji zhenwei geben de kaobian" and *Gu shuhua guoyan yaolu* (hereafter *GSHGYYL*), 99–104.

25. Huang Tingjian, "Ba Xiangtie chungong shu," *Shangu ji*, juan 29, 14b. *Xuanhe shupu* (hereafter *XHSP*), juan 12, 2b–3a.

26. See note 22. The late Northern Song catalogue of the imperial collection of calligraphy, *Xuanhe shupu*, suggests that Su Shi was reacting to the sincere, slightly plodding character of Li Jianzhong's calligraphy. *XHSP*, juan 12, 3a.

27. "Ti Yan Lugong tie," *Shangu ji*, juan 28, 16a.

28. For the guwen movement, see Chaves, *Mei Yao-ch'en*, chaps. 2, 3; Egan, *Literary Works*, esp. 12–29, 78–84; and Bol, *"This Culture of Ours,"* esp. 131–40, 160–66, 177–88. Egan broaches the influence of guwen values on calligraphy in "Ou-yang Hsiu and Su Shih," 379–85.

29. Chaves, *Mei Yao-ch'en*, 64–68; Egan, *Literary Works*, 78–81; Bol, *"This Culture of Ours,"* 161–62.

30. "Shihua," *OYXQJ*, juan 5, 109–10. Translated by Chaves, *Mei Yao-ch'en*, 75–76.

31. Chaves, *Mei Yao-ch'en*, 76.

32. Shi Jie, "Guaishuo" (*xia*), *Zulai Shi xiansheng wenji*, juan 5, 4b; cited from Chaves, *Mei Yao-ch'en*, 72.

33. Ibid.

34. There is a brief notice of Yang Yi's skill in the small-sized standard script in Tao Zongyi's *Shushi huiyao*, juan 6, 16b.

35. Dong Shi, *Shu lu*, juan 2, 6a–b.

36. "Shiren zuo feizi shuo." We must qualify Dong Shi's suggestion that Li Zonge was the specific subject of Ouyang Xiu's criticism of "mantou calligraphy" by noting the presence of one inscription Ouyang wrote in which Li Zonge's writing is described as rugged and full of individual spirit. "Ba Li Hanlin Changwu shu," in "Jushi waiji" (2), *OYXQJ*, juan 3, 136. Nonetheless, the mannered tendencies apparent in Li Zonge's writing demonstrate how much the received tradition had departed from Tang standards of order and beauty.

37. *Shu shi*, 38b–39a.

38. See note 27.

39. Fu, "Huang T'ing-chien's Calligraphy," 224–33, 293–94, note 107. Wen Fong, *Images of the Mind*, 76–82.

40. Cai Xiang, "Shu ping," *Duanming ji*, juan 34, 17b. Cai Xiang thought that "Eulogy for a Dead Crane" dated to the Sui dynasty (589–618). The prevailing opinion is that it was written by Tao Hongjing in ca. 512–14. For Ouyang Xiu's inscription, see "Jigu lu" (2), *OYXQJ*, juan 6, 63.

41. "Ba Chalu"; "Su Zimei Cai Junmo shu" in "Shibi," *OYXQJ*, juan 5, 118.

42. Cai Xiang, "Shu ping," 17a.

43. Amy McNair discusses this letter in her short article "The Sung Calligrapher Ts'ai Hsiang," 67.

44. Mei Yaochen, "Yiyun he Yongshu Chengxintang zhi da Liu Yuanfu," *Wanling ji*, juan 35, 6b–7a. Chaves, *Mei Yao-ch'en*, 82.

45. Already in the early Ming dynasty it was suggested that Cai, the fourth of the surnames, refers not to Cai Xiang but to the late Northern Song calligrapher Cai Jing (1046–1126). This theory, however, does little more than accommodate the question of the surname's placement on the list. Cai Jing's reputation as a calligrapher never approached that of Cai Xiang. For a summary of the arguments, see *Cai Xiang*, 1–4.

46. Yu Ji, "Ti Wu Fupeng shu bing Li Tang shanshui ba," *Daoyuan xuegu lu*, juan 11, 13a. "Slope" and "Valley" are abbreviations of Su Shi's and Huang Tingjian's sobriquets: the Layman of East Slope (Dongpo) and Mountain Valley (Shangu).

47. "Ba Junmo shu fu" and "Ba Cai Junmo shu" (among others), *SSWJ*, juan 69, 2182, 2192. The latter is dated 1085, indicating that by this time Cai Xiang's reputation had already faltered.

48. "Shu," *BJYGJ*, addendum, 5a.

49. *Shu shi*, 23b.

50. Dong Shi, *Shu lu*, juan 2, 31b–32a. An example of Li Peng's writing is seen in *Gugong lidai fashu quanji* (hereafter *GGLDFSQJ*), 13:10–11.

51. Dong Shi, *Shu lu*, juan 2, 13b.

52. Huang Tingjian, "Ba Dongpo moji," *Shangu ji*, juan 29, 4a. Su Shi, "Zi ping zi," *SSWJ*, juan 69, 2196–97. For a well-known piece attributed to Xu Hao, see *GGLDFSQJ*, 2:23–33. Cai Tao mentions that Xu Hao became a popular model during the reign of Shenzong (r. 1067–85) because of the emperor's taste. Specifically, he suggests that Su Shi and his father, Cai Jing, studied Xu Hao's style while in Hangzhou in the early 1070s. Cai Tao, juan 4, 76. Su Shi's calligraphy from the 1060s and 1070s, however, does not reveal any obvious stylistic shift.

53. "Ji yu Junmo lun shu," *SSWJ*, juan 69, 2193. Ouyang Xiu also claims to have used this metaphor. "Su Zimei Cai Junmo shu," in "Shibi," *OYXQJ*, juan 5, 118.

54. "Ba Dongpo moji," *Shangu ji*, juan 29, 4a.

55. "Ba Dongpo xu Yinghuang shi tie," *Shangu ji*, juan 29, 2b–3a.

56. "Shi Cangshu Zuimotang," *Su Shi shiji* (hereafter *SSSJ*), juan 6, 235. Fuller, *Road to East Slope*, 122–24.

57. "Zi ping wen," *SSWJ*, juan 66, 2069.

58. From a note recorded in Zhang Chou, *Zhenji rilu*, juan 4, 2b.

59. "Xueshu zishu tie," in *Qunyutang tie. Bei Futsu*, 2:161–71.

60. Zhu Changwen, *Xu shu duan* (hereafter *XSD*), juan 2, in *Chūgoku shoron taikei* (hereafter *CST*), 4:515.

61. Ouyang Xiu, "Su shi wenji xu," in "Jushi ji" (2), *OYXQJ*, juan 2, 122. *XSD*, juan 1, in *CST*, 4:437.

62. "Li Yong shu," in "Shi bi," *OYXQJ*, juan 5, 118–19.

63. Su Shi, "Zi ping zi," 2196–97.

64. "Shu," *BJYGJ*, addendum, 5a.

65. *XSD*, juan 1, in *CST*, 4:429. *JTS*, juan 149, 4034–38. A lone example of Shen Chuanshi's calligraphy, "Stele of the Temple at Luochi in Liuzhou," is reproduced in *Shodō zenshū* (hereafter *SDZS*), 10:plates 104–5.

66. See note 10.

67. Mi Fu, *Haiyue mingyan* (hereafter *HYMY*), in *CST*, 4:356.

68. "Jin Wang Xianzhi fatie," in "Jigu lu" (1), *OYXQJ*, juan 5, 208. Egan, "Ou-yang Hsiu and Su Shih," 377.

69. "Ba mige fatie." See note 12.

70. "Baohuitang ji," *SSWJ*, juan 11, 356–57.

71. Zeng Minxing, *Duxing zazhi*, juan 3, 4a.

72. "Ba Wang Jinqing shu," *Shangu ji*, juan 29, 19a–b.

73. "Wen Yuke hua mozhu pingfeng zan," *SSWJ*, juan 21, 614. Bush, *Chinese Literati on Painting*, 12.

Chapter 2 *The Style of a Connoisseur*

1. Tao Zongyi, *Shushi huiyao*, juan 6, 6b.

2. For examples of Su Mai's calligraphy, see *GGLDFSQJ*, 10:16–17. Su Chi's sole extant writing is an inscription of 1133 added to Huaisu's "Self Statement" in the National Palace Museum, Taipei.

3. Gao Huiyang, "Mi Fu qi ren ji qi shufa," 13–49, citing "Xingshi jijiu pian" from *Yu hai*, vol. 8.

4. Chen Zhensun, *Zhizhai shulu jieti*, juan 8, 5a. Gao Huiyang, "Mi Fu qi ren ji qi shufa," 20–21. The details of the genealogy are missing, but it can be partially reconstructed as follows: Mi Xin (ca. 927–ca. 993), Mi Jifeng (ca. 950–ca. 1020), ?, ?, Mi Zuo (ca. 1025–ca. 1100?), Mi Fu (1052–1107/8), Mi Youren (1074–1151), ?, Mi Xian (ca. 1125–after 1201).

5. *Song shi* (hereafter *SS*), juan 260, 9022–24. Wang Cheng, *Dongdu shilue*, juan 28, 6a–b. Xi Qiu, *Song chu fengyun renwu*, 251–55.

6. Li Han and Shen Xueming, "Lue lun Xizu zai Liao dai de fazhan."

7. *SS*, juan 260, 9023.

8. Ibid., 9023–24, supplemented with information from He Chengju's biography in juan 273, 9328.

9. Cai Zhao, "Gu Song libu yuanwailang Mi Haiyue xiansheng muzhi ming" (hereafter Cai Zhao), in *Helinsi zhi*, 20a–23b.

10. A shrine to Mi Fu in Xiangyang, established on the old family property, survived through the Qing dynasty replete with the customary strata of engraved encomia written by later admirers. *Xiangyang xianzhi*, juan 2, 51ff. There is little here relevant to Mi Fu's own time, but one stelae in particular, Zheng Jizhi's "Record of the Mi Family Genealogy," of 1619, provides some detailed information on the comings and goings of later members of the family.

11. Ibid., juan 1, 28a–b. The association of Mi Fu's early calligraphy with Luo Rang's stele appears as early as the twelfth century in Ge Lifang's *Yunyu yangqiu*, juan 14, 1a. Luo Rang's short biography is found in *XTS*, juan 197, 5628–29.

12. Mi Fu indicates the month and year of his birth in a colophon to Xie An's "Bari tie," *BJYGJ*, juan 7, 8a–b. As Susan Bush has pointed out, the *xinchou* month that Mi Fu mentions was the twelfth month of the lunar calendar, which corresponds to early in 1052. Bush, *Chinese Literati on Painting*, 4, n. 6. Discussions of Mi Fu's dates are found in Gao Huiyang, "Mi Fu qi ren ji qi shufa," 51ff.; Xu Bangda, *Lidai shuhuajia chuanji kaobian*, 10–15. See also Cao Baolin's chronology in *Zhongguo shufa quanji* (hereafter *ZGSFQJ*), 38:549–58.

13. The sources that reveal the role of Mi Fu's mother as a nursemaid are Yang Wanli's *Chengzhai shihua*, 14b, and Zhuang Chuo, *Jile bian*, juan 1, 10a. See also Empress Gao's biography in *SS*, juan 242, 8625–27. Yingzong and Empress Gao had at least six children, four sons—Zhao Xu (1048–85), who later became Emperor Shenzong (r. 1067–85), Zhao Hao, Zhao Yan, and Zhao Jun (1056–88), and at least two daughters—the princess of Wei (1051–80) and her twin sister, the princess of Han-Wei (1051–1123). Yingzong had two other daughters—the princess of Shu, who died young, and the eldest, the princess of Wei-Chu, but their mother(s) is not specified.

14. *SS*, juan 248, 8778–80. The princess's biography notes that she lived near Wang Shen and his mother.

15. Mi Youren recounts in his inscription to a painting titled "Mountains and Lakes in Mist and Rain" that his father's only sibling was an older sister. Bian Yongyu, *Shigutang shuhua huikao*, juan 13, 24.

16. Cai Zhao, 21a.

17. Biographical information on Guan Ji (style name Weizong), son of Guan Lu (?–1052), is

found in *Hunan tongzhi*, juan 275, 5603–4. For source materials on Mi Fu's travels at this time see Introduction, note 7.

18. Mi Fu, *Baozhang daifang lu*, 15; *Shu shi*, 15b–16a.

19. Information on Mi Fu's petition is found after his poem, "Ti Wuxi shi," which was engraved at the Wu Stream in Qiyang, Hunan Province, on the fifteenth day of the tenth lunar month, 1075, as Mi Fu traveled to Changsha from Lingui. *Hunan tongzhi*, juan 275, 5605. A rubbing of the calligraphy, with only a few characters barely discernible, is reproduced in *Beijing tushuguan cang Zhongguo lidai shike taben huibian*, 39:84. This is the earliest known calligraphy by Mi Fu, written when he was twenty-three.

20. "Poem Sending Off the Supervisor" is datable by its reference to the Xiang River and by the style of the writing, which accords perfectly with the short inscription Mi Fu added to Yan Liben's "Palanquin Bearers" (Palace Museum, Beijing), dated the twenty-sixth day of the eighth lunar month, 1080. Zheng Jinfa, "Mi Fu Shu su tie," 79–80. *GSHGYYL*, 331.

21. Zeng Minxing, *Duxing zazhi*, juan 5, 9b–10a.

22. The calligraphy that Mi Fu owned was "Du Shang." Three years later he purchased another of the series, "Yu Liang." "Ouyang Xun Du Shang Yu Liang tie zan," *BJYGJ*, juan 6, 7b–8a. A questionable version of "Du Shang" appears in Dong Qichang's compilation of model writings, *Xihongtang fatie*, juan 5. Tracing copies of two other works from "Historical Matters" are in the Palace Museum, Beijing: "Pu Shang" and "Zhang Han." *GSHGYYL*, 52–58; Yang Renkai, "Ouyang Xun 'Mengdian tie' kaobian," and "'Zhongni mengdian tie' de liuchuan zhenyan niandai kao," in his *Muyulou shuhua lungao*, 297–305.

23. "Xueshu zishu tie," in *Qunyutang tie*; *Bei Futsu*, 2:161–71. In his commentary to this rubbing, Weng Fanggang (1733–1818) identifies Duan Ji as Duan Wenchang, a scholar of the Yuanhe period (806–20) of the Tang dynasty. I am following Nakata Yūjirō's suggestion that the person in question is the little-known Duan Jizhan (ibid., 1:138). A short description of Duan Jizhan's calligraphy is found in *XSD*, juan 2, in *CST*, 4:492.

24. *SDZS*, 10:plates 82–83.

25. This comment is found in Mi Fu's criticisms of a copy of Shen Chuanshi's calligraphy made by a local monk named Xibai. *Shu shi*, 19a. Ouyang Xiu also mentions this poem by Shen Chuanshi, the calligraphy of which he describes as "especially untrammeled." "Tang Shen Chuanshi you Daolin Yuelusi shi," in "Jigu lu" (2), *OYXQJ*, juan 6, 51.

26. "Record of the Fangyuan Studio at Longjing" is a text composed earlier by the monk Shouyi for the residence of Master Biancai at the Shousheng Temple in the environs of Hangzhou. Mi Fu's calligraphy was engraved in stone, an early rubbing of which was collected by the Ming dynasty artist Shen Zhou (1427–1509) before passing through the hands of a number of Ming and Qing dynasty connoisseurs. The critique cited presently is from Zhou Eryan's inscription of 1800. Mi Fu, *Song ta Fangyuanan ji*; *Bei Futsu*, 1:193.

27. Hibino Takeo, "Shū Ō Seikyōjo no ishibumi ni tsuite"; Nakata Yūjirō, "Tōdai no ishibumi."

28. There is a long-standing counterargument that the good connoisseur does not practice calligraphy and the good calligrapher is not a connoisseur. The argument is attributed to none other than Wang Xizhi in a text titled "Shu lun." *Quan shanggu sandai Qin Han Sanguo Liuchao wen*, juan 26, 11a–b. Mi Fu repeats it in his criticism of the Tang calligrapher Liu Gongquan (*Shu shi*, 6a–7a), and ironically, it is mentioned in an alluded slight against Mi Fu's connoisseurship by his contemporary Huang Bosi. *Dongguan yulun*, juan 1, 1b. Nevertheless, this counterargument seems to have had little effect on hundreds of years of the practice of art and connoisseurship in China.

29. Ledderose, *Mi Fu and Classical Tradition*, 83–85.

30. According to Su Shi, Liu Jisun was penniless at the time of his death, but he had amassed a collection of thirty thousand scrolls of calligraphy and hundreds of paintings. "Ji Liu Jingwen shi," *SSWJ*, juan 68, 2153. Cao Baolin, "Mi Fu Qiezhong tie kao."

31. *Shu shi*, 6a–7a.

32. Ibid., 24b–25a. Yu Zhang is unidentified.

33. "Smudging" is a convenient if not entirely accurate translation of what literally reads "sprouting hair." Mi Fu is referring to the fuzz that appears on the surface of paper that is badly remounted or subject to excessive wear. Certain kinds of paper were more prone to "sprouting hair" than others. See *Shu shi*, 27b–29a, for Mi Fu's detailed discussion of remounting old works of calligraphy, and esp. 27b–28a on old papers. This citation is also relevant to the first line of the third poem.

34. The Wei River meets the Jing River in Gaoling Prefecture, Shaanxi Province. The Wei is known for its clear waters, the Jing for its muddy waters. In "Gu feng" from the *Book of Songs* it is written, "The muddiness of the King [Jing] appears from the Wei" (Legge, trans., *Chinese Classics*, 4:56). Mi Fu is alluding to his own clarity of vision, which reveals in contrast the poor connoisseurship of Liu Gongquan.

35. Wang Sengqian, *Lun shu*, in *FSYL*, juan 1, 18; *CST*, 1:206. In some versions of the text "wild pheasant" is omitted.

36. *Shu shi*, 6a–b. See also "Liu Jisun bati," in *BJYGJ*, juan 8, 5a–b, and Mi Fu's extant letter written to Liu Jisun on the eve of Liu's departure for Xianzhou, "Qiezhong tie" (National Palace Museum, Taipei), *GGLDFSQJ*, 11:54–55. The letter dates to about 1092–93 and was probably written when Mi Fu was serving in Yongqiu, not far from the capital. Because Mi Fu's poems seem to allude to a deal in the making, it is possible that the exchange of poems with Su Shi took place ca. 1092, and not in 1087, as the editors of Su Shi's poetry suggest.

37. "Ci yun Mi Fu er Wang shu bawei ershou," *SSSJ*, juan 29, 1536–37. Mi Fu cites another poem that Su Shi wrote on Liu Jisun's scroll in *Shu shi*, 6a. This poem, a regulated verse titled "Shu Liu Jingwen Zuozang suocang Wang Zijing tie," is also found in Su Shi's collected poems, *SSSJ*, juan 32, 1685. Su's commentators date it to 1090.

38. "Lai qin tie," of "Seventeen Missives." *SDZS*, 4:plate 57.

39. "He has not the atmosphere of a gentleman. Line for line his calligraphy creeps along like spring earthworms; character for character it is entangled like autumn snakes." See *Jin shu* (hereafter *JS*), juan 80, 2107–8; translation by Ledderose, *Mi Fu and Classical Tradition*, 107, n. 119.

40. *JS*, juan 92, 44b–45a.

41. *XTS*, juan 179, 14a–b. Su Shi also used this allusion in his record of Wang Shen's Hall of Precious Paintings, "Wang jun Baohuitang ji." See chapter 1, note 70.

42. This meeting is described in Mi Fu's *Hua shi*, 200.

43. *SSWJ*, juan 60, 1819, cited from Egan, "Su Shih's 'Notes,'" 571.

44. Wen Ge (1115 jinshi), cited by Li Zonghan in his 1825 inscription to Mi Fu's "Record of the Fangyuan Studio." See Mi Fu, *Song ta Fangyuanan ji*.

45. "Tang Yan Lugong shu Cao bei," in "Jigu lu" (2), *OYXQJ*, juan 6, 31. Translation by Egan, "Ou-yang Hsiu and Su Shih," 372.

46. This association is best known through the famous Han Yu poem "Song of the Stone Drums," in which Wang Xizhi's calligraphy, "availing itself of pretty graces," is unfavorably compared with the hoary strength of the ancient writing found on a famous set of stones discovered in Shaanxi. Han Yu, *Wubaijia zhu Changli wenji*, juan 5, 13a–17a. Owen, *Poetry of Meng Chiao and Han Yu*, 247–56.

47. *BZDFL*, 14–16; *Shu shi*, 37a; *BJYGJ*, juan 6, 8a; juan 7, 7a–b, 9b–10a; juan 8, 2b; Ledderose, *Mi Fu and Classical Tradition*, 47–48. Mi Fu claims to have spent much of his time copying ancient works of calligraphy while living in Suzhou. His neighbor Ge Zao collected these copies and then as a joke mounted them together, doctored the scroll, and added old seals recorded in Zhang Yanyuan's *Lidai minghua ji*. Later a man by the name of Chen Yu collected the scroll as a set of genuine works. *Shu shi*, 27a–b.

48. *Bei Futsu*, 2:3–31; *GGLDFSQJ*, 2:122–32. Zheng Jinfa, "Mi Fu Shu su tie."

49. Anecdotes told of Xie An, Dai Kui, and the various other fourth-century figures are largely found in Liu Yiqing's *Shishuo xinyu* (translated by Mather, *New Account*). One *Shishuo* passage Mi Fu may have had in mind when he wrote his poem concerns a meeting between Dai Kui and Xie An in which the two speak of nothing but the subtleties of the *qin* zither and calligraphy. *Shishuo xinyu jiaojian*, 209; Mather, *New Account*, 192.

50. "Presenting Oranges," known today from a Tang dynasty tracing copy in the National Palace Museum, Taipei (*GGLDFSQJ*, 1:6–7), and familiar to Mi Fu. *Shu shi*, 3a; Ledderose, *Mi Fu and Classical Tradition*, 101. In this *Shu shi* passage Mi Fu connects a later verse by the Tang poet Wei Yingwu (737–?) with Wang Xizhi's note. Mi Fu uses the allusion to the frost-filled oranges of Lake Dongting (Hunan Province) again in the second poem of the "Sichuan Silk Poems," titled "Composed at the Hanging Rainbow Pavilion on the Wu River."

51. A reference to the wine brewed with the water from a famous stream at Hui Mountain, just west of Wuxi.

52. The identities of Liu, Li, and Zhou remain uncertain, as does the exact content of the "worm-eaten epistles." Mi Fu may have had in mind something like Wang Xizhi's "National Territory" ("Wanglue tie"), a short letter in which Wang expresses joy on hearing the news that the old capital Luoyang had been recaptured by Jin troops. Ledderose, *Mi Fu and Classical Tradition*, 81–82.

53. "Jiuri xianju," *Tao Yuanming ji*, juan 2, 2b–3a. Davis, "Double Ninth Festival."

54. "When Wang Xizhi saw Du Yi, he sighed in admiration, saying, 'His face is like congealed ointment and his eyes like dotted lacquer; this is a man from among the gods and immortals.'" Liu Yiqing, *Shishuo xinyu jiaojian*, 340; translation by Mather, *New Account*, 314. See also Du Yi's biography in *JS*, juan 93, 2414.

55. Mi Fu's extensive dealings with various versions of the Orchid Pavilion Preface are recounted in Ledderose, *Mi Fu and Classical Tradition*, 76–80, 102–103. See also *Bei Futsu*, 1:42–47. The key description of the Su family preface that Mi Fu acquired is found in *Shu shi*, 11a–b. Ledderose, *Mi Fu and Classical Tradition*, 103, n. 69 and plate 48.

56. Another follower of Wang Xizhi and the "Orchid Pavilion Preface," the Tang dynasty calligrapher Lu Jianzhi, also made note of the original preface's mistakes. In Lu's transcription of Lu Ji's "Rhapsody on Literature" (National Palace Museum, Taipei), the character *wen* is repeatedly written with a double charge of ink, demonstrating Lu Jianzhi's slavish devotion to his model. *GGLDFSQJ*, 1:64–79.

57. Cai Zhao, 23b.

58. Li Wei was related to the imperial family through his marriage to Emperor Renzong's eldest daughter and was thus a slightly older member of the circle in which Mi Fu and Wang Shen grew up. The scroll of calligraphy by various Jin masters is well described in Ledderose, *Mi Fu and Classical Tradition*, 89–91, 111, and *Bei Futsu*, 1:69ff. *BZDFL*, 20–21; *Shu shi*, 1a–b. Note also Mi Fu's "Collector," discussed in chapter 5.

59. Yu He, *Lunshu biao*, in *FSYL*, juan 2, 44; *CST*, 1:192.

60. *BZDFL*, 15–16; *Shu shi*, 15b–16b.

61. *Shu shi*, 4a; translated by Ledderose, with modifications, in *Mi Fu and Classical Tradition*, 86–88, 109; *Bei Futsu*, 1:64–65, 212. Yue Ke's *Baozhenzhai fashu zan* (hereafter *BZZFSZ*), juan 4, 46–47, includes Li Wei's inscription of 1087 and information on the later history of the scroll.

62. Zhang Chou, *Zhenji rilu*, juan 4, 2b. From the same passage cited in chapter 1, note 58.

Chapter 3 *Styles In and Out of Office*

1. James Cahill and Wen Fong have introduced and discussed Ni Zan's portrait in, respectively, *Hills beyond a River*, 114, 116, and *Images of the Mind*, 105ff.

2. The portrait was committed to stone by Fang Xinru (1177–1222) in 1215 on a cliff by the Huanzhu Cave at Fubo Mountain in Guilin, Guangxi Province, inspired by a short inscription written there by Mi Fu in the fifth month, 1074. Mi's original inscription is a single line of graffiti commemorating an outing to the area with Pan Jingzhuo. According to Fang Xinru's long accompanying inscription (partially lost due to the weathering of the stone) the portrait was in the possession of a descendant of Mi Fu named Guoxiu who was serving in the area. On it was a short inscription by Mi Youren, noting that the painting had entered the imperial collection of Song Gaozong (r. 1127–62), and a poetic encomium by the emperor. The engraving is still visible at Fubo Mountain. The portrait and Fang's inscription are recorded in various gazetteers and epigraphy collections, including Xie Qikun's *Yuexi jinshi lue*, juan 11, 21b–23b. For a detailed description, including references to other versions of Mi Fu's self-portrait noted in the seventeenth century, see *Bei Futsu*, 1:244–45.

3. "Ba Mi Yuanzhang shu," *Shangu ji*, juan 29, 19a.

4. Sima Qian, *Shi ji*, juan 67, 2191. This Zhong You* is not to be confused with the Three Kingdoms period minister and calligrapher of similar sounding name (same romanization, different characters).

5. From Mi Youren's inscription to "Rare Views of Xiao-Xiang" (Introduction). Zhai Ruwen's poem was written ca. 1101.

6. Sima Qian, *Shi ji*, juan 28, 1400. Watson, *Records of the Grand Historian*, 1:63.

7. Sima Qian, *Shi ji*, juan 40, 1689–92.

8. Wu Zeng, *Nenggaizhai manlu*, juan 12, 42a. Translated in chapter 6.

9. Weng Fanggang, *Mi Fu nianpu*, 7b–8a.

10. *BJYGJ*, juan 8, 5a. The original note is found in *Shaoxing Mi tie*, reproduced in *ZGSFQJ*, 38:plate 140. There are some minor textual corruptions in the *Bao-Jin yingguang ji* version. Mi Fu continues by citing a precedent of two characters being combined into a single graph in seals of the Three Kingdoms period.

11. From the entry on the surname Mi found in "Shizu dian," *Gujin tushu jicheng*, juan 419, 44,645, citing Huang Tingjian's literary works, *Yuzhang Huang xiansheng wenji*. Gao Huiyang, "Mi Fu qi ren ji qi shufa," 22.

12. "Shu zeng Yu Qinglao," *Shangu ji*, juan 25, 19a–b.

13. *Liezi jishi*, juan 3, 90–91, in Graham, *Book of Lieh-tzu*, 61–62.

14. Hawkes, trans., *Ch'u Tz'u*.

15. *BZZFSZ*, juan 20, 300–301.

16. Liu Yiqing, *Shishuo xinyu jiaojian*, 496–97, in Mather, *New Account*, 492–94. *JS*, juan 80, 2100–2101.

17. *BJYGJ*, addendum, 6a. Wang Xizhi's official biography confirms that his calligraphy became truly great only in his last years. *JS*, juan 80, 2100.

18. Translation by Lau, *Lao Tzu, Tao Te Ching*, 58, 59.

19. Translation partially based on that of Wen Fong, *Images of the Mind*, 87.

20. In the collection of the National Palace Museum, Taipei. *GGLDFSQJ*, 11:58–59. The "river problem" emerges as a frequent topic of concern in governmental discussions in the first and eighth lunar months of 1093 and the first two months of 1094. Li Dao, *Xu zizhi tongjian changbian*, juan 480, 13b–17a; juan 481, 8a–11b, 14b–15a; addendum juan 8, 15a–16a, and juan 9, 1b–13b.

21. Chief Zhang would appear to be the same person to whom "River Problem" is addressed. The Construction Foreman's Office was possibly with the Directorate of

Waterways. Xu Bangda also dates these two letters to Mi Fu's tenure at Yongqiu. *GSHGYYL*, 342–43. For an alternative dating see Cao Baolin, *ZGSFQJ*, 38:517–18.

22. See Mi Fu's poem "Hastening the Taxes" ("Tsuizu shi") in *BZZFSZ*, juan 20, 290. A key document related to Mi Fu's problems at Yongqiu that establishes the dating of events is found in Li Dao, *Xu zizhi tongjian changbian*, juan 483, 8b.

23. "Escaping Summer Heat" is undated and undatable from its content. Wen Fong's dating of "Escaping Summer Heat" to this time can be supported by two recorded letters. In one, Mi Fu requests an extension for the paying of crop taxes (hence datable to the summer of 1093) and complains about extreme heat. In the other, Mi Fu apprehensively awaits an official investigator while trying to cope with the hot weather. *BZZFSZ*, juan 19, 267–68 (letters no. 5, 7). For an alternative dating, see Cao Baolin, *ZGSFQJ*, 38:491.

24. Mi Fu narrates the events in a letter to someone addressed as Brother Le ("Le xiong tie," in a private collection in Japan; *SDZS*, 15:105–6). Wen Fong discusses this letter in *Images of the Mind*, 86–88. See also Xu Bangda, *GSHGYYL*, 345–46, where it is determined that this letter should be dated 1096, and Cao Baolin, "Mi Fu 'Lexiong tie' kao." In *Song shi* (juan 170, 4081–82) it is explicitly stated that superintendant of Zhongyue Temple was not a position that could be requested, contrary to the title of Mi Fu's poem "Seeking the Position of Keeper of the Temple" ("Qiu jianmiao zuo"), *BJYGJ*, juan 5, 1a. Mi Fu had assumed his new duties by the tenth lunar month, 1094. "Lu Zhu zhi bei," *BJYGJ*, juan 7, 3b–4a.

25. "Jin Wang Xianzhi zhi fatie," in "Jigu lu" (1), *OYXQJ*, juan 5, 208. Translation by Egan, "Ou-yang Hsiu and Su Shih," 377.

26. "Ziti Jinshan huaxiang," *SSSJ*, juan 48, 2641–42. Fuller, *Road to East Slope*, 4.

27. *Zhuangzi jishi*, juan 1, 43; juan 10, 1040.

28. "Shu Wang Dingguo suocang yanjiang diezhang tu," *SSSJ*, juan 30, 1607–9. Egan, "Poems on Paintings: Su Shih and Huang T'ing-chien," 428–29. A well-known painting of the same title by Wang Shen is in the Shanghai Museum.

29. Han Yu, "Song Meng Dongye xu," *Wubaijia zhu Changli wenji*, juan 19, 12a–14b. Hartman, *Han Yu*, 230ff.

30. This issue is discussed in my article "Donkey Rider as Icon."

31. Fuller, *Road to East Slope*, 251ff.

32. Included in Su Shi's collected works under the title "Hanshi yu," *SSSJ*, juan 21, 1112–13. A translation of the first poem is found in Egan, *Word, Image and Deed*, 254.

33. Liu Yiqing, *Shishuo xinyu jiaojian*, 393, in Mather, *New Account*, 331–32.

34. Fu, "Huang T'ing-chien's Calligraphy." Wen, *Images of the Mind*, 82–84.

35. Fu, "Huang T'ing-chien's Calligraphy," 20, 21.

36. Ibid., 74–77.

37. Wang Fu, *Qianfu lun. Hou Han shu*, juan 49, 1630.

38. Zhao Lingzhi, *Houqing lu*, juan 6, 2b–3a.

39. Jin Xueshi, *Muzhu xianhua*, 17b–18a.

40. The likely source for Mi Fu's allusion is a passage from *Liezi* (juan 7, 221, in Graham, *Book of Lieh-tzu*, 141), where Boyi and Liuxia Hui are criticized for possessing, respectively, excessive pride in purity and correctness. Mi Fu seems to have identified with their uncompromising nature, regardless of the criticism leveled at them in *Liezi*.

41. Besides "Watching the Tidal Bore," dated calligraphy in the unbridled style in *Bao-Jinzhai fatie* (hereafter *BJZFT*) are a ci song written on the occasion of drinking tea with the prefect Zhou Tong (1076 jinshi) in the spring of 1096, and two congratulatory ci songs written for the minister Lü Dafang (1027–97) on the occasion of his seventieth *sui* birthday in the fifth lunar month, 1096. Two more excellent examples of this style of calligraphy are a "longevity" poem on plum blossoms and another birthday poem, both

of which may also have been written for Lü Dafang in the spring of 1096. All of these poems and songs are found in juan 10. One song in the group, to the tune "Manting fang," presents particular problems: Mi Fu used an incorrect cyclical date (there was no *bingshu* year during the Shaosheng reign; *bingzi* [1096] was intended). Moreover, this same ci is also found in the literary works of Mi Fu's contemporary, Qin Guan (1049–1100). *Huaihai ji*, "Changduan ju" (2), 8b–9a. How this information is to be interpreted remains debatable. One person who has questioned the reliability of these writings is Zhang Boying, whose assessment is included in Rong Geng's entry on the fatie compendium in *Cong tie mu*, 1:147–63. Rong Geng does not consider Zhang's opinion to be necessarily correct. Ye Gongchuo in *Mi Nangong shu Wujiang zhou zhong shi zhenji* and Nakata Yūjirō in "Calligraphic Style and Poetry Handscrolls" also place "Sailing on the Wu River" in the mid-1090s.

42. When Wu Yuan was forced to commit suicide in Wu, he ordered his followers to gouge out his eyes after his death and nail them to the east gate of the city so that he could see Yue come and destroy Wu as he had prophesied. Sima Qian, *Shi ji*, juan 66, 2171–83.

43. *Zhuangzi jishi*, juan 26, 924.

44. Han Yu, "Song Gaoxian shangren xu," *Wubaijia zhu Changli wenji*, juan 21, 3b–5a; Hartman, *Han Yu*, 222–23; Egan, "Ou-yang Hsiu and Su Shih," 406–08.

45. "Song Canliao shi," *SSSJ*, juan 17, 905–07. Egan, "Ou-yang Hsiu and Su Shih," 407–8. It may be significant in this context that the most notable practitioners of kuangcao after Zhang Xu were all Buddhist monks, including Huaisu, Bianguang, Gaoxian, Guangxiu, and Yaxi, who were coined the Five Calligrapher Monks of the Tang by Mi Fu's friend Liu Jing. All have entries in Huizong's *Xuanhe shupu*, juan 19. The kuangcao of another monk of the Tang–Five Dynasties period named Yanxiu (otherwise unknown), is preserved in a stele at Xi'an. *Xi'an beilin shufa yishu*, 202–3.

46. "Inscription for a Mountain-Inkstone" (Fujii Yurinkan, Kyoto) and "Poem Written for the Duojing Tower" (Shanghai Museum) are reproduced in *ZGSFQJ*, 38:297–99, 412–19. "Self-Statement," reproduced in *Bei Futsu*, 2:161–71, and "Poems Written at Hongxian" are discussed later.

47. From Mi Fu's brief inscription accompanying "Poem Written for the Duojing Tower" it is apparent that Mi Fu wrote this sometime after the conflagration that destroyed the Ganlu Temple in 1100. It is, in any case, a foregone conclusion that Mi Fu wrote it while in Runzhou.

48. Mather, "Controversy over Conformity."

49. "Shu zizuo caoshu," *Shangu ji*, juan 10, 9a–b. Cited from Fu, "Huang Ting-chien's Calligraphy," 19.

50. "Ba Luzhi wei Wang Jinqing xiao shu erya," *SSWJ*, juan 69, 2195. The third contradiction concerns the manner in which Huang loses himself in the writing of matters of "hair-splitting" detail despite his lofty aspirations and magnanimous personality.

Chapter 4 *The Pingdan Aesthetic*

1. See chapter 3, note 24.

2. *SS*, juan 18, 342; juan 340, 10844.

3. "Fu dunshou jinri quguo . . . ," *BJYGJ*, juan 2, 3b–4b.

4. A letter addressed to Lü Dafang, written while Mi Fu was still serving in Yongqiu in early 1094, is noted in an inscription by Zhou Bida. Zhou Bida, *Wenzhong ji*, juan 51, 4b–5a.

5. *Shanhai jing jiaozhu*, 302–3.

6. *Zhuangzi jishi*, juan 31, 1031–32.

7. "Letter to Dechen" (National Palace Museum, Taipei), one of the "Nine Works of

Cursive Calligraphy" discussed in more detail presently. *GGLDFSQJ*, 3:42–45. Dechen is likely to have been the brother of Ge Yun (style name Shuchen, 1063 jinshi), who is mentioned in Mi Fu's "Family Planning," one of the now missing tie from "Nine Cursive Works." The Ge family resided in Dantu (Runzhou area). *Jingkou qijiu zhuan*, juan 1, 13a–14a; *Zhishun Zhenjiang zhi*, juan 18, 22a. Lin may be Lin Xi. Cao Baolin correctly identifies Mi Fu's line, "The realm is lacking," as a citation from *Liezi*, where it refers to a famine in the ancient state of Zheng. *ZGSFQJ*, 38:497. Mi Fu's "departure of a sage" cleverly alludes to Liezi's subsequent exit from Zheng. *Liezi jishi*, juan 1, 1; Graham, trans., *Book of Lieh-tzu*, 17.

8. The *Andong xianzhi* gazetteer (juan 8, 2b–3a) records that Mi Fu served in Lianshui for more than two years during the Yuanyou reign (1086–93), but this is clearly mistaken. A note in a Southern Song gazetteer for Zhenjiang mentions that Mi Fu was still in Lianshui in 1100. *Jiading Zhenjiang zhi*, juan 10, 7a.

9. *BZZFSZ*, juan 20, 292–93. *Andong xianzhi*, juan 15, 1b–2a. The ninth of Mi Fu's letters in the early compendium *Yingguangtang tie* describes his Tower of the Precious Moon. Reproduced in *ZGSFQJ*, 37:221.

10. *SS*, juan 443, 13104–5. Deng Chun, *Hua ji*, juan 3, 16. Among the numerous references to Liu Jing in Mi Fu's writings, the most extensive and telling is found in *Shu shi*, 25b–27a. At the end of this extended passage are some jocular verses that celebrate Mi Fu's, Xue Shaopeng's, and Liu Jing's common mission as collectors and connoisseurs.

11. Xue Shaopeng was the son of Xue Xiang (*SS*, juan 328, 10585–88) and the great-grandson of Xue Yan (953–1025, *SS*, juan 299, 9943–44). According to Tao Zongyi, he called himself a descendant of the "three phoenixes of Hedong"—Xue Yuanjing, Xue Shou, and Xue Deyin, well-known figures of the early Tang. *Shushi huiyao*, juan 6, 18a.

12. *Shu shi*, 33a–b. The Dragon Palace of Kunming Lake and its mythical medicines are described in Duan Chengshi, *Youyang zazu*, juan 2, 12a–13a. "Jug of soup" is an allusion from *Mengzi*, in which the local populace welcomes the troops with rice and soup. Legge, *Chinese Classics*, 2:170. The celestial Weaving Maiden, separated by the Milky Way from her lover, the Cowherd, for all but one day of the year, calls attention to Mi Fu's isolation at Lianshui. Jade unicorn probably refers to a paperweight. Yew table (*feiji*) is borrowed from Wang Xizhi's biography in *JS*, juan 80, 2100. Wisps of mist, dragons, and snakes are all metaphors for Chinese calligraphy.

13. *JS*, juan 80, 2100. Regional inspector, *cishi*, was an anachronistic title by the Northern Song. For more on these official positions see Hucker, *Dictionary of Official Titles*, 504, 558.

14. *Shu shi*, 33b–34a. Regarding the reference to Zhiyong in lines 9 and 10, Mi Fu claimed to own an inkstone of Zhiyong's that was worn through from the monk's incessant grinding of ink, proof of Zhiyong's renowned diligence at practicing calligraphy. *Shu shi*, 29b; *HYMY* in *CST*, 4:368. Fatie should refer to *Model Writings from the Chunhua Tower*, but it is unclear exactly what Mi Fu means here. The only Zhiyong calligraphy included is a letter ("Daishen tie," also called "Huanlai tie," in juan 7) that seems to have been mistaken for Wang Xizhi's; this is considered spurious, and some have read the signature not as Zhiyong but as Zhiguo. *Shodō geijutsu* (hereafter *SDGJ*), 2:189. Mi Fu's criticism of this compendium includes a specific barb aimed at a "follower of Zhiyong" taken to be Wang Xizhi (chapter 1, note 12). This is probably the tie he had in mind, and possibly what he refers to here. The question posed by Mi Fu in line 13 of his poem refers to Liu Gongquan, who says something like this in response to a question from Emperor Muzong (r. 820–24): "If the heart is proper [zheng], the brush will be proper." *XHSP*, juan 3, in *CST*, 5:92.

15. Du Fu, "Yinzhong baxian ge," *Du shi xiangzhu*, juan 2, 80–85. *XSD*, juan 1, in *CST*, 4:403–4. *XHSP*, juan 18, in *CST*, 6:147.

16. Nakata Yūjirō, "Tōdai no kakushinha no sho."
17. Xu Bangda, *Gu shuhua weie kaobian*, 94–98. Qi Gong, "Jiu ti Zhang Xu caoshu gushi tie bian." Because "Poems" is recorded in Huizong's *Xuanhe shupu* under Xie Lingyun's name, the calligraphy could date no later than early in the twelfth century; a much more likely date is the first half of the eleventh century. *XHSP*, juan 16, in *CST*, 6:99.
18. *Langguan* is a general term for the official positions of *langzhong* (director) and *yuanwailang* (vice-director). The original stele commemorated the names of those who filled the sixty-one langguan positions at this time. *SDZS*, 8:100–103.
19. Su Shi, "Shu Tang shi liujia shu hou," *SSWJ*, juan 69, 2206. Huang Tingjian, "Ti Jiangben fatie," *Shangu ji*, juan 28, 10b–11a.
20. Huang Tingjian, "Ba Zhai Gongzhuan suocang shike," *Shangu ji*, juan 28, 20a; "Ba Zhou Zifa tie," juan 29, 17a–b. Su Shi, "Shu Tang shi liujia shu hou." A poem by Su Shi dated to 1085 written for some Wang Xizhi calligraphy adumbrates the attitude Mi Fu expresses in "The Sage of Cursive Calligraphy." It begins, "Crazy Zhang and Drunken Su [Huaisu], those two hairless fellows, chased shamelessly after the public fancy and called their calligraphy skillful. Even in their dreams they couldn't have laid eyes on Wang [Xizhi] and Zhong [You], foolishly adorning themselves with powder and jewels to cheat the deaf and blind." "Ti Wang Yishao tie," *SSSJ*, juan 25, 1342–43. Generally speaking, however, Su Shi had positive things to say about Zhang Xu's wild cursive. Huang Tingjian was unstinting in his praise. He regarded Zhang as one of only three men in recent centuries to penetrate the secrets of cursive calligraphy; the other two were Huaisu and himself. "Ba Cijunxuan shi," *Shangu ji* ("Bieji"), juan 11, 10b–11a. See also Fu, "Huang T'ing-chien's Cursive Script."
21. Yu Xin, *Yu Zishan ji*, juan 5, 5a. East Radiant Lord is Xia Qi, one of four such mythical rulers of the four quadrants of the heavens. Bei Zhu is an immortal figure of ancient times. Topsy-Turvy Land is the realm above the moon and sun, four thousand *li* away, where everything is illuminated from below and hence upside down. The jasper bird is the harbinger of the Queen Mother of the West, who arrives to the court of the Han emperor Wudi. Wudi is also alluded to in the next line—the recipient of four magic peaches from the Queen Mother and the would-be gardener of the pits until informed that it takes three thousand years for the fruit to appear. The Marquis of Qi inquires of Yanzi [Yan Ying] concerning the jujube that flowers in the Eastern Sea but never bears fruit. Cai Jing* is a commoner destined to become an immortal and so recognized by another Daoist figure, Wang Yuan, who resides at Cai's house for a week.
22. *Ōbei shūzō Chūgoku hōsho meiseki shū*, ed. Fu Shen and Nakata Yūjirō, 1:140.
23. The title is taken from Mi Youren's authentication which originally followed at the end of the scroll. Two letters from the original set of nine tie are now missing. Nevertheless, because the entire scroll was included in the Wen family's sixteenth century compendium "Model Writings from the Halting Clouds Villa" (*Tingyunguan tie*), its entire original appearance is still visible. The calligraphy is now divided between the National Palace Museum, Taipei, and the Osaka Municipal Museum, which also owns Mi Youren's authentication. *Bei Futsu*, 1:212–15, 2:44–57. For more on the Southern Song collecting and editing of Mi Fu's calligraphy, see my article "Kejin xiaodao de Mi Youren." Almost all of the "Nine Cursive Works" can be dated by their content to Mi Fu's period in Lianshui. Nakata Yūjirō first raised the possibility that all of these writings belong to Lianshui, basing his theory in part on recognition of a general uniformity of style (*Bei Futsu*, 1:215). I have seconded this proposal in my article. For another opinion see Cao Baolin, *ZGSFQJ*, 38:471 (under the title "Zhang dian tie").
24. For pingdan and its place in Song dynasty poetry, see Yokoyama Iseo, "Sō shiron ni miru 'heitan no tai' ni tsuite," and Chaves, *Mei Yaochen*, 85ff. I am especially indebted to Chaves's study.

25. *Daode jing* LXIII: "Do that which consists in taking no action; pursue that which is not meddlesome; savour that which has no flavor." Translation by Lau, *Tao Te Ching*, 124. *Zhuangzi jishi*, juan 5, 457: "Emptiness, stillness, limpidity [*tiandan:* 'calm and bland'], silence, inaction are the root of the ten thousand things." Translation by Chaves, *Mei Yaochen*, 117.

26. Liu Shao, *Renwu zhi*, juan 1, 1b. Chaves, *Mei Yaochen*, 118.

27. Cited by Su Shi's brother, Su Che, in "Zizhan he Tao Yuanming shiji yin," *Luancheng houji*, juan 21, in *Su Che ji*, 1110. Su Che's preface is dated 1097.

28. "Ping Han Liu shi," *SSWJ*, juan 67, 2109–10.

29. Zhong Rong, *Shi pin*, juan 1, 1b. Translation by Chaves, *Mei Yaochen*, 116, slightly modified.

30. Mei Yaochen characterizes a poem written by a friend as "even and light," "like ancient music." Su Shunqin, too, associated pingdan with ancient music, or at least the music played on an ancient zither. Han Yu and Wang Yucheng (954–1001), preceding Ouyang Xiu and Mei Yaochen, were both fond of using the descriptive term "ancient and light." Pingdan was also associated with the ancient anthology of poems *Shijing* by Mei Yaochen. Chaves, *Mei Yaochen*, 114–23.

31. Su Shi, "Shu Tang shi liujia shu hou."

32. "Shu Huang Zisi shiji hou," *SSWJ*, juan 67, 2124.

33. Qi Gong, *Lunshu jueju*, 72.

34. Later rubbings of "Yue yi," attributed to Suo Jing, are found in various fatie collections.

35. *Shu shi*, 10b.

36. *HYMY*, in *CST*, 4:368. *BZDFL*, 27. *Shu shi*, 7b. *BJYGJ*, juan 6, 7a–b; juan 7, 9a–b. The last two references are, respectively, an encomium and inscription. The former is in the Palace Museum collection, Beijing, reproduced in *ZGSFQJ*, 38:325–27, and a rubbing of the latter is included in *Qunyutang tie*, reproduced in *ZGSFQJ*, 38:322–24. Mi Fu's experiences with this scroll are well described in Ledderose, *Mi Fu and Classical Tradition*, 81–83.

37. Notably, Wang Xizhi's "Seventeen Missives," reproduced in *SDZS*, 4:plates 46–57.

38. Mi Fu's inscription for "National Territory" is dated 1103 (see note 36). In it he describes how the calligraphy was long promised to him by the Su family but then was sold to Zhao Zhongyuan. Mi Fu had to purchase it from Zhao at an inflated price and with the original inscriptions already removed. An extant letter by Mi Fu titled "Suiting One's Conception," datable to ca. 1103–4, also mentions the scroll (National Palace Museum, Taipei, *GGLDSFQJ*, 2:154–55). In it Mi Fu remarks that it took fifteen years for the scroll to enter his hands; a timeframe of 1088–1103 would more or less circumscribe Mi Fu's experiences with the calligraphy. A last piece of evidence confirming a date of 1103 for Mi Fu's purchase of the scroll is Huang Bosi's inscription in *Dongguan yulun*, juan 2, 1b–2a, where it is directly stated that Mi Fu bought the calligraphy that spring. In "Suiting One's Conception," Mi Fu mentions that Huang was familiar with the calligraphy.

39. *HYMY*, in *CST*, 4:368.

40. Mei Yaochen, "Da Zhongdao xiaoji jianji," *Wanling ji*, juan 24, 15b–16a. Chaves, *Mei Yaochen*, 124.

41. *BZZFSZ*, juan 20, 292–93.

Chapter 5 *Naturalness*

1. Xu Wei, "Ping zi," *Xu Wenchang yigao*, juan 24, 1b.

2. This is a continuation of the tie seen and recorded by Zhang Chou in the seventeenth century in which Mi Fu narrates the development of his early calligraphy and its perceived resemblance to Li Yong. See chapter 1, note 58. A short passage between the two quotations is omitted.

3. Dong Qichang, *Rongtai bieji*, juan 5, 8b–9a. Xu Fuguan, *Zhongguo yishu jingshen*, 413.

4. Mei Yaochen, "Lin Hejing xiansheng shiji xu," *Wanling ji*, juan 60, 1b–2b. Chaves, *Mei Yaochen*, 58, 117.

5. *Zhuangzi jishi*, juan 3, 292–94. Translation by Watson, *Complete Works of Chuang-tzu*, 90–91. Chaves, *Mei Yaochen*, 117.

6. "Yu Wang Guanfu shu," *Shangu ji*, juan 19, 17b–18a. Du Fu was in Kuizhou (Sichuan Province) from 765 to 768. The time Du Fu spent in this forbidding and removed place among the Yangtze River gorges is generally considered to be Du Fu's most productive and creative.

7. Mei Yaochen, "Yiyun He Xianggong," *Wanling ji*, juan 28, 10b. Translation by Chaves, *Mei Yaochen*, 114.

8. Han Yu, "Song Wuben shi gui Fanyang," *Wubaijia zhu Changli wenji*, juan 5, 12a. Cited from Chaves, *Mei Yaochen*, 120. See also Charles Hartman, *Han Yu and the Tang Search for Unity*, 271, and Owen, *Poetry of Meng Chiao and Han Yu*, 224–25.

9. "Yu erlang zhi shu," SSWJ, addendum, juan 4, 2523.

10. See chapter 4, note 14. Some texts record the character *gong*⸳ "lord" in place of *gong*⸳⸳ "skill," which produces a very different reading of this line. My choice is based on the relative reliability of the *Shu shi* text and the Beijing Library's Southern Song edition of Mi Fu's *Bao-Jin yingguang ji*, both of which print *gong*⸳⸳ "skill."

11. Mi Fu's *Famous Words* has not always been praised as a source of wisdom. The Qing dynasty editors of *Siku quanshu* in particular consider Mi Fu's candid opinions about earlier calligraphers to be slanderous and self-promoting. *Siku quanshu zongmu*, 958. The most common edition of *Haiyue mingyan* is that found in Huang Binhong's and Deng Shi's *Meishu congshu*. There are, however, at least two annotated editions: one by Nakata Yūjirō, included in the useful series *Chūgoku shoron taikei*, and one by Sha Menghai, with additional notes by Cao Baolin, reprinted in the second volume on Mi Fu (vol. 38) of the *Zhongguo shufa quanji* series. Citations here are to Nakata's *Chūgoku shoron taikei* edition.

12. Zhang Bangji, *Mozhuang manlu*, juan 6, 1a.

13. This is on the basis of references to Mi Fu's youngest son, Mi Yinzhi, who was born ca. 1084 and died around 1103, and to Xu Jiang (1037–1111). The high praise Mi Fu bestows on his talented son and the fact that he mentions how little Yinzhi occasionally acted as his substitute writer for stele calligraphy suggest that Mi Yinzhi was at least fifteen or sixteen when *Haiyue mingyan* was written. Mi Fu's manner of reference also suggests that Mi Yinzhi had not yet died. Xu Jiang is addressed as vice-director of the Chancellery, a position that he assumed in the fifth lunar month, 1102. One last piece of evidence is provided by the reference to Wang Xizhi's "National Territory," which appears to have remained in the hands of others when Mi Fu wrote *Haiyue mingyan*. Mi Fu's inscription to "National Territory" establishes that he owned it by the third lunar month, 1103, which in turn suggests that *Haiyue mingyan* was written sometime before this date.

14. *Shu shi*, 19a.

15. Yanwen, "Yan Zhenqing de 'Zheng zuowei tie.'" Amy McNair, "Su Shih's Copy of the *Letter on the Controversy over Seating Protocol*."

16. "Shu," *BJYGJ*, addendum, 5a. Mi Fu prefaces this description with the metaphor of the two legendary warriors Xiang Yu and Fan Kuai locked in hand-to-hand battle.

17. *HYMY*, in *CST*, 4:361.

18. Ouyang Xiu, "Tang Zheng Huan Yinfu jing xu," in "Jigu lu" (2), *OYXQJ*, juan 6, 54.

19. "Ba Yan shu," *BJYGJ*, addendum, 5b–6a. Mi Fu's inscription, dated the sixth day, sixth

lunar month, 1106, is also included in the later compilation *Haiyue tiba* under the title "Pingyuan tie." Yan Zhenqing served in Liquan Prefecture, outside the capital at Chang'an in 742. "Record of the Immortal Magu" exists in three different versions (large, medium and small characters), all dated to the fourth lunar month, 771. Which version Mi Fu refers to is difficult to say, though the large character version carries the same mannerisms that Mi Fu criticizes here. See *SDGJ,* 4:194–96.

20. Described in Yan Zhenqing's "Zhang Changshi shier yi bifa ji," in *CST,* 2:243. Although there is suspicion concerning Yan's authorship of this text, it was nonetheless associated with him in the late eleventh century. See Sugimura Kunihiko's introduction in *CST,* 2:238–42.

21. *Hua shi,* 191.

22. *HYMY,* in *CST,* 4:362.

23. Note the following comment from the entry on Yan Zhenqing in *Xuanhe shupu* (*CST,* 5:84): "Later vulgar followers of Yan only sought the outward appearance of his calligraphy, stopping with what they called his 'silkworm heads' and 'swallow tails' and not understanding the marvels of the awl writing in the sand." "Awl writing in sand" is a metaphorical reference to the concealed brush technique, with it denotation of internal strength.

24. *HYMY,* in *CST,* 4:360. For more on Zhong You see Zhu Huiliang, "The Chung Yu (A.D. 151–230) Tradition: A Pivotal Development in Sung Calligraphy," and "The Calligraphy of Li Kung-lin," in Barnhart et al., *Li Kung-lin's Classic of Filial Piety,* 53–71.

25. *HYMY,* in *CST,* 4:363.

26. Mi Fu remarks how Zhang Dun (1035–1105) would acknowledge Mi's ability only in the semicursive and cursive scripts. For standard script, Zhang considered his own writing superior. Mi Fu continues, "Zhang wants my writing to look like counting slats, but standard script calligraphy must have *tishi* ['body force,' or 'configurative energy']." *HYMY,* in *CST,* 4:366.

27. Ibid., 358.

28. Ibid., 359. Mi Fu is probably referring specifically to Zhiyong's "Thousand Character Essay" in Tang Jiong's collection, more of which is written about in another passage of *Famous Words* (ibid., 365). Ding refers to Ding Daohuo (active late sixth, early seventh centuries). For a rubbing of his text written for the Qifasi Temple, dated A.D. 602, see *SDZS,* 7:plates 14–17.

29. *HYMY,* in *CST,* 4:360.

30. Ibid., 365. Huang Tingjian makes a similar comment in "Ba Dongpo tie hou," where he writes that the untrammeled spirit of the Two Wangs was destroyed by "Ou, Yu, Chu, and Xue" (Xue Ji, 649–713) and then completely swept away by Xu Hao and Shen Chuanshi, only to be partly recovered by Yan Zhenqing and Yang Ningshi. *Shangu ji,* juan 29, 5b. This accords with Mi Fu's account except concerning Yan Zhenqing and Shen Chuanshi. Mi Fu disliked Yan but praised Shen, whom he saw as "transforming the period style and possessing a transcendant, genuine flavor." Ibid.

31. Ibid., 368.

32. *Qunyutang tie,* juan 8; *Bei Futsu,* 2:153–59. "Forgetting how to walk" refers to the story in *Zhuangzi* of the young men from Shouling who went to Handan to learn their particular way of walking and ended up forgetting how to walk altogether. For the Han Yu citation, see chapter 2, note 46. "The Collector" is written in the same pingdan cursive mode as found in "The Sage of Cursive Calligraphy" (fig. 48) and other tie dating from Mi Fu's period in Lianshui. For another opinion of the dating of "The Collector," see Cao Baolin, *ZGSFQJ,* 38:477. Li Wei died sometime before 1098. Cai Jing acquired one of the tie from this scroll, Xie An's "Fifth Day of the Eighth Month," between 1098 and 1100, suggesting that the scroll was broken up to be resold at greater

profit after Li's death. *BJYGJ*, juan 7, 8a–b. Mi Fu may well have seen the scroll again at this time.

33. This is evident in the comments on Yan Zhenqing's calligraphy in Zhu Changwen's *Xu shu duan*, where Han Yu's poem is cited to turn Yan's perceived lack of grace into an asset. Though Zhu never cites the Stone Drums as an influence, Yan Zhenqing is credited with combining principles of the archaic *zhuan* and *zhou* scripts into his writing. *CST*, 4:399–400.

34. Yu He, *Lunshu biao*, *FSYL*, juan 2, 36.

35. Liang Wudi, *Guan Zhong You shufa shier yi*, *FSYL*, juan 2, 45.

36. Sun Guoting, *Shu pu*, in *CST*, 2:100. Confucius' comment comes from the *Analects:* "The Master said, 'Where the solid qualities are in excess of accomplishments, we have rusticity; where the accomplishments are in excess of the solid qualities, we have the manners of a clerk. When the accomplishments and solid qualities are equally blended, we then have a man of virtue." Translation by Legge, *Chinese Classics*, 1:190. Legge's "accomplishments" are literally *wen*, "outward appearance"; "solid qualities" are *zhi*, "inner substance."

37. *HYMY*, in *CST*, 4:364.

38. Xu Shen, *Shuowen jiezi*, juan 15, 3b. Mi Fu probably had in mind Xu Shen's passage, which mentions that after the li shu developed, the ancient scripts were abandoned.

39. *Zhuangzi jishi*, 711–17.

40. The Daoist's return to the chaos condition is well discussed in Girardot, *Myth and Meaning in Early Taoism*, especially chapter 2, "'Beginning and Return' in the Tao Te Ching," 47–76.

41. "Xueshu zishu tie," from *Qunyutang tie*, juan 8; *Bei Futsu*, 2:161–71. Shi Yiguan was famous for his clerical script during the Eastern Han. Liu Kuan was active during the reigns of Han Huandi and Han Lingdi (A.D. 146–89). A "Liu Kuan bei" is recorded in Zhao Mingcheng's *Jinshi lu*, juan 18, 331–32, though the author of the calligraphy is not mentioned. "Cursing Chu," one of the eight wonders of Fengxiang described in a poem by Su Shi ("Fengxiang baguan," *SSSJ*, juan 3, 99–119), was written in 313 B.C. *SDZS*, 1:plate 48.

42. Also from "Xueshu zishu tie"; *Bei Futsu*, 2:161–171.

Chapter 6 *Great Synthesis*

1. *HYMY*, in *CST*, 4:356.

2. Wen Fong, *Images of the Mind*, 164ff. Cahill, *Distant Mountains*, 118–19.

3. *Mengzi*, juan 5, 13b–14a.

4. *BJYGJ*, juan 5, 7b–8a.

5. Sima Qian, *Shi ji*, juan 3, 94; juan 32, 1477–79.

6. *BZZFSZ*, juan 19, 271.

7. Recorded in Zhou Hui's *Qingbo biezhi*, juan 1, 20b–21a. A rubbing of the letter is seen in *BZZFT*, juan 10, though it is not specifically addressed to Jiang Zhiqi. A translation is included in the Epilogue.

8. See Cao Baolin's analysis of this letter in *ZGSFQJ*, 38:505–6.

9. Cai Zhao, 22a–b. Wang Mingqing, *Huizhu houlu*, juan 7, 12a–13a. Mi Fu signed his full official designation, Office of the Supply Commission for the Jiangnan, Huainan, Jinghu, and Liangzhe Circuits, Commandant of the Military Cavalry, and Recipient of the Crimson Fish Sash, on his eulogy poems "Daxing Huang Taihou mianci" of 1101 (Palace Museum, Beijing). *Bei Futsu*, 2:134–35. He used it again on a funerary inscription dated the seventeenth day, third lunar month, 1102. *BZZFSZ*, juan 20, 295.

10. "Xi zeng Mi Yuanzhang er shou," *Shangu shiji zhu*, juan 15, 11b–12a.

11. "Ba Xie Anshi tie," *BJYGJ*, juan 7, 8a–b. Ledderose, *Mi Fu and Classical Tradition*, 90–91, 111–12.

12. The twenty-eight known letters Su Shi wrote to Mi Fu are recorded in *SSWJ*, juan 58, 1777–84. The last nine were written on Su Shi's return from the south. The ones cited here are the twenty-third and twenty-fourth, juan 58, 1782.

13. Ibid., 1781 (twenty-first letter).

14. Ibid., 1783 (twenty-fifth letter).

15. *Zhishun Zhenjiang zhi*, juan 12, 3a. There were two studios here: Zhishuangzhai and Bao-Jinzhai (Precious Jin Study); Bao-Jinzhai was named after Mi Fu's treasured paintings and calligraphy of Jin dynasty date.

16. More on this rock and the auspicious sweet dew is found in Mi Fu's colophon of 1102 to Wang Xianzhi's "Shieryue tie," *BJYGJ*, juan 6, 8a; his "Shu yishi," *BJYGJ*, addendum, 9b; and his inscription to an engraving of the Lanting Preface that he sponsored with his two sons, "San Mi Lanting ba," included in *Shaoxing Mi tie* (*ZGSFQJ*, 38:302–4). A rubbing of "Shu yishi" is included in Dong Qichang's *Xihongtang tie* (*Bei Futsu*, 2:200). Mount Shanghuang is unidentified. Mi Fu's "Shu yishi" clarifies the provenance of "top class" (*yipin*) rock(s) as being the mountains of Si and Huai (northern Jiangsu, near Lianshui).

17. *Liji zhengyi*, juan 59, 4a.

18. Xu Song, *Song huiyao jigao*, juan 52, 2073. Sturman, "Cranes above Kaifeng," 34–35.

19. *Hua shi*, 214.

20. Ibid. Mi Fu's last two sentences echo a famous passage from Sima Qian's letter to Ren An. See Introduction, note 22.

21. Wei Hanjin's musical theories were presented to the throne in February 1104. Li You, *Song chao shishi*, juan 14, 220–21; Sturman, "Cranes above Kaifeng," 37–40. For information on Li Babai, see *Taiping guangji*, juan 7, 49–50.

22. Cai Jing's rise to prominence began in 1102, after a period of disfavor. Mi Fu's letter to Deng Xunwu of the third month, 1102 ("Xin'en tie," see fig. 62) alludes to Cai Jing's return to favor: "The preeminent sage has returned to court to open the era of great peace. I share in this happiness." Wang Mingqing's *Huizhu hou lu* recounts an instance of Cai Jing coming to Mi Fu's assistance while Mi was associated with the Supply Commision in Zhenzhou (see note 9). This supports the argument that Cai was the key patron directing Mi Fu's rise from the obscurity of Lianshui. Cai Tao, Cai Jing's son, also comments on his father's friendship with Mi Fu in *Tieweishan congtan*, juan 4, 61, 77–78. Mi Fu knew Cai Jing at least as early as 1096, when Cai Jing imprinted Mi Fu's Wang Xizhi "Kuai xue qing tie" with a seal of the Hanlin Academy. *BJYGJ*, juan 7, 7a–b.

23. Cai Zhao, 20a. Mi Fu had already begun to serve as erudite when he remounted and inscribed Wang Xizhi's "National Territory" at the Bamboo Studio of the Jade Hall on the ninth day of the third lunar month, 1103. *BJYGJ*, juan 7, 9a–b.

24. Mi Fu mentions the roster of names (*mingbiao*) in "Coral," which is discussed later in this chapter, and the apparently related Clerk's Office (Shubiaosi) in a recorded letter (*BZZFSZ*, juan 19, 275). The connection with the Court of Imperial Sacrifices (Taichangsi) is found in *Song shi*, juan 164, 3884. It is unclear to what precisely the roster of names refers. Charles Hucker suggests a connection with the posted rosters of successful examinees of the civil service recruitment examinations. Hucker, *Dictionary of Official Titles*, 334.

25. Cai Zhao, 20a–b. Ledderose discusses this famous work and Mi Fu's knowledge of various versions in *Mi Fu and Classical Tradition*, 70–71.

26. A description of the Dongxiaogong is found in "Cheng neiwai zhu gongguan" of Wu Zimu's *Mengliang lu*, juan 15. Meng Yuanlao et al., *Dongjing menghua lu wai sizhong*, 257. Cao Baolin presumes that Mi Fu remained in Runzhou while serving as titular head of

the Dongxiaogong. This would follow the pattern of Mi Fu's service as superintendant of the Middle Yue Temple during the mid-1090s. Cao also places an extant letter titled "Returning to Office" ("Fuguan tie," Beijing Palace Museum; *Bei Futsu*, 2:124–25) in this context. In the letter, written in the seventh month, Mi Fu professes ignorance of the transgressions that resulted in his demotion one year earlier. If Cao Baolin is correct in his dating of the letter, Mi Fu would have lost his position at the court around the seventh lunar month, 1103, returned to Runzhou and remained there for a year. *ZGSFQJ*, 38:516–17.

27. Cai Zhao, 20b. According to Cai Tao (juan 4, 78), the first person in charge of the Imperial Institutes for Calligraphy and Painting was Song Qiaonian (1047–1113), followed by Mi Fu. Cai Jing may have had the deciding voice in staffing this position, as Song Qiaonian was related to him by marriage (Song's daughter was married to one of Cai Jing's sons). Tao Zongyi's *Shushi huiyao* (juan 6, 17a) records that Mi Fu's duties as erudite of calligraphy were shared with Li Shiyong, a popular calligrapher and recognized painter in the early twelfth century whose work appears to be no longer extant. See also *Xuanhe huapu*, juan 12, 133.

28. *BJYGJ*, juan 4, 4a.

29. *Xu zizhi tongjian changbian*, juan 24, 6a–7a.

30. For Han Yi's, Lü Dafang's, Zeng Chao's, and Zhai Ruwen's calligraphy, see *GGLDFSQJ*, 12:104–5, 108–9, 174–75, and 13:70–71.

31. *Jingkou qijiu zhuan*, juan 3, 15b–16b. Dong Shi, *Shu lu*, juan 2, 22b–23a.

32. Cai Tao, juan 4, 76.

33. Ibid., 77–78.

34. This was Huizong's own label for his writing according to Tao Zongyi, *Shushi huiyao*, juan 6, 1b. Some have assumed that originally a different character was used for *jin* for a more somatic descriptive label of Huizong's writing: "slender tendons."

35. Cai Tao, juan 1, 6. Dong Shi, juan 1, 7b; Tao Zongyi, juan 6, 1b. A good example of Xue Ji's calligraphy is "Stele Inscription for the Chan Master Xinxing," *SDZS*, 8:plates 70–73.

36. "Poems and Preface on a Summer Outing," dated A.D. 700, ibid.:plates 74, 75.

37. These and dozens of other unorthodox scripts are found in Yu Yuanwei's *Lun shu* of the sixth century, *FSYL*, juan 2, 54–61. An English translation is provided in Tseng Yuho, *History of Chinese Calligraphy*, 373–74. See also the author's introduction to the ornamental and magic scripts, ibid., 64–96.

38. Huizong's "Xuanhe ruilan ce" program, which consisted of recording through hundreds of volumes of paintings all of the auspicious objects that flooded the realm during Huizong's reign, is described in my article "Cranes above Kaifeng," esp. 34–37.

39. Li You, *Songchao shishi*, juan 14, 222; Cai Tao, juan 1, 11–12; Yang Zhongliang, *Zizhi tongjian changbian jishi benmo*, juan 134, 1a ff. The Nine Tripods were forged with the metals from the nine provinces in the time of the legendary emperor Yu and were considered the glory of the nation—powerful symbols of China's sovereignty over its far-flung territories. Huizong reforged the Nine Tripods in 1104, shortly before the completion of the new court music in 1105. The larger project of recasting the imperial ritual vessels was completed ca. 1113–15.

40. From the tomb inscription to Zhai Ruwen, *Zhonghui ji*, addendum, 4b. The dark, or black, primal gui jade was given by Yao to Yu, who had drained the floodwaters of China, as a sign of the completion of his labors. See Cai Tao, juan 1, 9–11, for an extensive description of its discovery in the twelfth century. Antiquity's rite of the cap marked a young man's entrance into manhood, performed when he reached age twenty.

41. Cai Tao, juan 4, 79.

42. Cao Baolin cites *Xu zizhi tongjian changbian shibu* for information on the imperial institutes. *ZGSFQJ*, 38:519. Two rare rubbings of Mi Fu's essays in the clerical and seal

scripts possibly date to his tenure as erudite of calligraphy. Ibid., 407–11. Twenty years later (1124), Mi Youren followed his father's path by becoming one of three managers in Huizong's Calligrapher Service, the duties of which included teaching five hundred bureaucratic scribes everything from archaic bronze inscription calligraphy to the styles of the prominent Tang masters. *Xu zizhi tongjian changbian shibu*, juan 48, 1b–2a. Mi Fu's duties in the Imperial Institute of Calligraphy, though undoubtedly less exacting and bureaucratic, were probably similar.

43. See also Mi Fu's short inscription to Cai Xiang's "Xie si yushu shi" (Tokyo Calligraphy Museum), reproduced in *ZGSFQJ*, 38:382.

44. Ge Hong, *Shenxian zhuan*, juan 2, 5a–6b.

45. Wu Zeng, *Nenggaizhai manlu*, juan 12, 42a.

46. Su Shi, "Shu Tang shi liujia shu hou," *SSWJ*, juan 69, 2206. Translation by Egan, "Ouyang Hsiu and Su Shih," 398.

47. Wei Dan (179–253), known for his ability as a calligrapher, was hoisted 180 feet off the ground to write the tablet for the Lingyun Terrace when the tablet was mistakenly first put in place. Frightened and upset, Wei threw away his brush and warned his sons never to become famous as practitioners of the kai standard script. Yang Xin, *Gulai nengshu renming*, in *FSYL*, juan 1, 12. Yan Zhitui alludes to this story, warning his own sons, in *Yanshi jiaxun*, juan 2, 40b. Yan Liben (d. 673), even after attaining high office, was called to paint when the emperor so desired, leaving Yan regretful for having attained skill in this art. Zhang Yanyuan, *Lidai minghua ji*, juan 9, 103–6. This issue is briefly discussed by Ledderose in *Mi Fu and Classical Tradition*, 31–33.

48. Li Huishu, "Songdai huafeng zhuanbian ji qiji—Huizong meishu jiaoyu chenggong zhi shili." The painting is "Ladies Preparing Newly Woven Silk," in the Museum of Fine Arts, Boston. This purports to be a copy of an original by the Tang painter Zhang Xuan.

49. This included the most talented of his children, Mi Yinzhi, who died at age twenty. "How can one bear this in old age?" he asks in one letter. *BZZFSZ*, juan 19, 270. "I feel solitary, lonely, suddenly weakened. . . . Amusing myself with painting and calligraphy, I yearn for nothing outside," he writes in another called "Jin zhi," one of nine letters mounted in a scroll titled "Handu jiutie" in the National Palace Museum, Taipei. *GGLDFSQJ*, 2:152–53.

50. Mi Fu's comment on Su Shi's interest in his inkstone in the shape of a mountain is found in *BJYGJ*, juan 8, 5a. There is ample evidence of Su Shi's love of inkstones in the many inscriptions he wrote for them included in his literary works. Some later painters, such as the Yangzhou "eccentric" Huang Shen (1687–1768), were fond of portraying Su Shi playing with an inkstone.

51. This included personal writings for Ouyang Xiu, who warned Xu Wudang away from the idea of using literature as a vehicle for immortality. "Song Xu Wudang nan gui xu," in "Jushi ji," *OYXQJ*, juan 2, 131–32. For Su Shi's views on the subject one need look no further than the poem he wrote following the rhymes of Mi Fu, translated in chapter 2.

52. Zhang Chou, *Zhenji rilu*, juan 4, 2b.

53. "Inkstone from the Land [of Wang Xizhi]," in the collection of the National Palace Museum, Taipei. *GGLDFSQJ*, 12:34–35.

54. This amends my earlier suggestion that "Coral" was written in the last year of Mi Fu's life. "Kejin xiaodao de Mi Youren," 104–5. Since the Southern Song, when "Coral" was collected by the imperial court, this note has been paired with Mi Fu's "Returning to Office" (see note 26). I argue in my article that one criterion for the groupings of such letters is date. Cao Baolin has presented a convincing argument for "Returning to Office" to date from 1104, on the eve of Mi Fu's return to service after a year's forced sabbatical. This corroborates a date of 1104 for "Coral."

55. Canonization of Zhang Sengyou, along with Gu Kaizhi and Lu Tanwei, is found in Zhang Yanyuan, *Lidai minghua ji*, juan 2, 25; juan 7, 90–91. See ibid., juan 9, 105, for Yan

Liben's relationship with Zhang Sengyou. In *Hua shi* (188), Mi Fu mentions a "Heavenly King" painted by Zhang Sengyou in the collection of Su Bi. Whether this is the same painting remains undetermined.

56. Old Le is possibly Zhu Changwen (1039–98, sobriquet Lepu), author of the important calligraphy text *Xu shu duan*. Teng Zhongfu is mentioned in Mi Fu's *Hua shi*, 202.

57. Wang Renyu, *Kaiyuan Tianbao yishi*, 8b. *Nan shi*, juan 59, 6b–7a.

58. Cai Tao, juan 4, 61. *GSHGYYL*, 358–59.

59. Wen Fong, *Images of the Mind*, 91.

60. *FSYL*, juan 3, 100. Some versions of Li Sizhen's text replace *mo* with the visually similar character *wei*. Both characters make sense grammatically, though the context of the passage favors *mo*. See Nakata Yūjirō's commentary in *CST*, 2:75, n. 9.

61. *ZGSFQJ*, 38:518.

62. Nishikawa Yasushi, "Bei Genshō no Kokenshi," 10.

Epilogue

1. Li Xinchuan, *Jianyan yilai xinian yaolu*, juan 147, 12a. Zhai Qinian, *Zhou shi*, 26a. The rubbings are known today as the *Shaoxing Mi tie*. *Bei Futsu*, 1:202–6. For information on the Southern Song imperial collection see Zhou Mi, "Shaoxing yufu shuhua shi," in *Qidong yeyu*, juan 6, 1a–10b. Gulik, *Chinese Pictorial Art*, 205–8. Sturman, "Kejin xiaodao de Mi Youren."

2. Song Gaozong, *Hanmo zhi*, in *CST*, 6:246–47. The Story of Zhidun and his love of horses is found in Liu Yiqing, 68, in Mather, *New Account*, 61.

3. Nakata Yūjirō introduces Fan's compilation in *Bei Futsu*, 1:136–37. According to Zhu Yunming's *Mi dian xiaoshi* (juan 7, 8a), Lu You's compilation (here called *Mi Haiyue yishi*) consisted of twenty-seven entries and was put together during the Yuantong reing (1332–34).

4. Zhu Yunming's manuscript was auctioned at Sotheby's, New York, November 25, 1991. An 1863 handwritten transcription of Zhu's text is in the National Central Library, Taipei. Though not as detailed as *Mi Xiangyang zhilin*, the two texts largely duplicate each other, with many identicial headings. Another source for compiled anecdotes of Mi Fu is Ding Chuanjing's *Songren yishi huibian (Left-over Affairs of Song Personalities)*, published in 1935. The Mi Fu anecdotes are found in juan 13. A partial translation Ding's compilation, including a number of the Mi Fu stories, is Djang and Djang, *Compilation of Anecdotes of Sung Personalities*. Nakata Yūjirō also includes a number of the anecdotes in *Bei Futsu*, 1:249–57.

5. Su Shi, "Ciyun Mi Fu er Wang shu bawei ershou," *SSSJ*, juan 29, 1538.

6. This grandson of Su Shunyuan is unidentified, as is Su Zhongrong (Zhongrong is a style name). Presumably they were the sons of Su Ji, whom Mi Fu knew when he lived in Suzhou during the mid-1080's. Mi Fu's friendship with the two Wang brothers is also documented. See his "Song Wang Huanzhi Yanzhou" on the "Sichuan Poems" scroll and "Taishi xing ji Wang Taishi Yanzhou," *BJYGJ*, juan 3, 4a. Furong may have been named after a mountain peak; there were two—one at Yandangshan in Leqing, Zhejiang Province, and one at Hengshan in Hunan Province.

Glossary

ao 鼇

bafen 八分
Bao-Jin 寶晉
bei 碑
*bei** 北
Bei Zhu 北燭
benmo 本末
Biancai 辨才
Bianguang 晉光
bo 波
Boyi 伯夷
buping er ming 不平而鳴

Cai Bian 蔡卞
Cai Jing 蔡京
Cai Jing* 蔡經
Cai Tao 蔡條
Cai Xiang 蔡襄
Cai You 蔡攸
Cai Zhao 蔡肇
cangfeng 藏鋒
cao shu 草書
ce 側
Chen Yu 陳史
cheng yijia zhi yan 成一家之言
chu 出
Chu 楚
Chu Suiliang 褚遂良
ci 詞
cishi 刺史
Cui Yuanwei 崔元暐

dacheng 大成
Dai Kui 戴逵
dan 淡
Daoqian 道潛
daxiao yilun 大小一倫

de 德
Deng Xunwu 鄧洵武
dian 點
Ding Daohuo 丁道護
Ding Jing 丁倩
dong 東
Dong Qichang 董其昌
Dong Shi 董史
Dong Yuan 董源
Du Fu 杜甫
Du Yi 杜乂
Duan Fu 段拂
Duan Jizhan 段季展
Duan Wenchang 段文昌

er dianzhe 二顛者

fa 法
Fan Kuai 樊噲
Fan Mingtai 范明泰
Fan Zhongyan 范仲淹
Fang Xinru 方信孺
fatie 法帖
feibai 飛白
feiji 棐几
feng 風
Feng Dao 馮道
fengdiao 風調
fengdu 風度
fengge 風格
fengliu 風流
Foyin 佛印
fugu 復古

Gao Huanghou 高皇后
Gao Yang 高陽
Gaoxian 高閒
Ge Liangsi 葛良嗣

Ge Yun　葛蘊
Ge Zao　葛藻
gong　功
*gong**　公
*gong***　工
Gongsun daniang　公孫大娘
gu　骨
Gu Kaizhi　顧愷之
Guan Ji　關杞
Guan Jingren　關景仁
Guan Lu　關魯
Guanxiu　貫休
gui　圭
guiju　規矩
Guo Yingyi　郭英乂
Guo Zhongshu　郭忠恕
Guoxiu　國秀
guwen　古文

Han Huandi　漢桓帝
Han Lingdi　漢靈帝
Han Qi　韓琦
Han Wudi　漢武帝
Han Yi　韓繹
Han Yu　韓愈
Han Zhangdi　漢章帝
haofang　豪放
haomo　毫末
He Chengju　何承矩
heng　衡
Hu　胡
Huairen　懷仁
Huaisu　懷素
Huan Wen　桓溫
Huan Xuan　桓玄
Huan Yanfan　桓彥範
Huang Bosi　黃伯思
Huang Shen　黃愼
Huang Tingjian　黃庭堅
huozheng　火正

jia　家
Jia Dao　賈島
Jiang Yan　江淹
Jiang Zhiqi　蔣之奇
jie　磔
Jin Wudi　晉武帝
jincao　今草
Jing Hui　敬暉
jingcheng　精誠
jinshi　進士
*jinshi**　金石
Juran　巨然

kai shu　楷書
Kangxi　康熙
kuangcao　狂草

langzhong　郎中
Laozi　老子
le　勒
Li Babai　李八百
Li Bo　李白
Li Cheng　李成
Li E　李鄂
Li Gonglin　李公麟
Li Jianzhong　李建中
Li Peng　李彭
Li Shangyin　李商隱
Li Shiyong　李時雍
li shu　隸書
Li Sizhen　李嗣眞
Li Tinggui　李廷珪
Li Wei　李瑋
Li Yong　李邕
Li Yu　李煜
Li Zonge　李宗諤
Liang Shicheng　梁師成
Liang Wudi　梁武帝
lin　臨
Lin Bu　林逋

Lin Xi 林希
lingbi 靈礕
Liu Gongquan 柳公權
Liu Jing 劉涇
Liu Jisun 劉季孫
Liu Kai 柳開
Liu Kuan 劉寬
Liu Shao 劉韶
Liu Zongyuan 柳宗元
Liuxia Hui 柳下惠
loufeng 露鋒
lü 律
Lü Dafang 呂大防
Lu Daxing 陸大姓
Lu Jianzhi 陸柬之
Lü Shang 呂尙
Lü Shengqing 呂升卿
Lu Tanwei 陸探微
Lu Tong 盧仝
Lu You 陸友
luan 鸞
lue 掠
Luo Rang 羅讓
Luo Shaowei 羅紹威

Mei Yaochen 梅堯臣
Meng Haoran 孟浩然
Meng Jiao 孟郊
menren 門人
Mi Fu 米芾
Mi Jifeng 米繼豐
Mi Quan 米全
Mi Xian 米憲
Mi Xin 米信
Mi Yinren 米尹仁
Mi Yinzhi 米尹知
Mi Youren 米友仁
Mi Zuo 米佐
mingbiao 名表
mo 末

*mo** 沒

na 捺
nan 南
Ni Zan 倪瓚
nu 努
nushu 奴書

Ouyang Xiu 歐陽修
Ouyang Xun 歐陽詢

Pan Jingzhuo 潘景純
pie 撇
pingdan 平淡

Qian Shu 錢俶
qilin 麒麟
Qin Guan 秦觀
Qin Shihuangdi 秦始皇帝
qiyun 氣韻
quchen 去塵

Ruan Ji 阮籍
ruiying 瑞應

san 三
san buxiu 三不朽
shang 上
Shao Chi 邵鬶
Shen Chuanshi 沈傳師
Shen Gou 沈遘
Shen Liao 沈遼
Shen Su 沈遬
Shen Yansi 沈延嗣
Shen Zhou 沈周
shi 勢
Shi Jie 石介
Shi Manqing 石曼卿
Shi Yannian 石延年
Shi Yiguan 師宜官
shoujin 瘦金
Shouyi 守一

shu 豎

shuanggou 雙鉤

shubiaosi 書表司

Shun 舜

shunwu ziran 順物自然

Shuqi 叔齊

Shusun Bao 叔孫豹

Sima Guang 司馬光

Sima Qian 司馬遷

Song Gaozong 宋高宗

Song Huizong 宋徽宗

Song Qiaonian 宋喬年

Song Renzong 宋仁宗

Song Shenzong 宋神宗

Song Shou 宋綬

Song Taizong 宋太宗

Song Taizu 宋太祖

Song Yingzong 宋英宗

Song Zhezong 宋哲宗

Su Bi 蘇泌

Su Che 蘇轍

Su Chi 蘇遲

Su Guo 蘇過

Su Ji 蘇激

Su Mai 蘇邁

Su Shi 蘇軾

Su Shunqin 蘇舜欽

Su Shunyuan 蘇舜元

Su Xun 蘇洵

Su Zhichun 蘇之純

Su Zhongrong 蘇仲容

Sun Guoting 孫過庭

Suo Jing 索靖

Taichangsi 太常寺

Taizu 太祖

Tang Jiong 唐冏

Tang Muzong 唐穆宗

Tang Taizong 唐太宗

Tang Xuanzong 唐玄宗

Tang Xun 唐詢

Tang Zhaozong 唐昭宗

Tao Yuanming 陶淵明

Tao Zongyi 陶宗儀

Teng Zhongfu 滕中孚

ti 體

tian 天

Tian Gen 天根

tiandan 天淡

tiangu 天骨

tiankai haiyue 天開海岳

tianzhen 天眞

tie 帖

tishi 體勢

Wang Anshi 王安石

Wang Fan 王蕃

Wang Fu 王符

Wang Hanzhi 王漢之

Wang Huanzhi 王渙之

Wang Quanbin 王全斌

Wang Rong 王戎

Wang Sengqian 王僧虔

Wang Shen 王詵

Wang Shu 王述

Wang Wei 王維

Wang Wenbing 王文秉

Wang Xianzhi 王獻之

Wang Xizhi 王羲之

Wang Ya 王涯

Wang Yuan 王遠

Wang Yucheng 王禹偁

Wang Zhu 王著

wei 爲

*wei** 未

Wei Dan 韋誕

Wei Hanjin 魏漢津

Wei Shuqing 衞叔卿

Wei Tai 魏泰

Wei Yingwu 韋應物

wen 文
Wen Ge 溫革
Wen Tong 文同
Weng Fanggang 翁方綱
Wu Daozi 吳道子
Wu Shi 吳栻
Wu Yuan 伍員
Wu Zeng 吳曾
wuxing 五行

Xi 奚
xia 下
Xia Qi 夏啓
xian 仙
Xianbei 鮮卑
Xiang Yu 項羽
xianglong 祥龍
xianren 仙人
Xiao Ziyun 蕭子雲
xiaozhuan 小篆
Xibai 希白
Xie An 謝安
Xie Jingwen 謝景溫
Xie Lingyun 謝靈運
Xie Shang 謝尙
Xikun 西崑
xing 性
xing shu 行書
Xiong Yi 熊繹
Xu Hao 徐浩
Xu Wei 徐渭
Xu Wudang 徐無黨
Xue Deyin 薛德音
Xue Ji 薛稷
Xue Shaopeng 薛紹彭
Xue Shou 薛收
Xue Xiang 薛向
Xue Yan 薛顏
Xue Yao 薛曜
Xue Yuanjing 薛元敬

yan 言
Yan Hui 顏回
Yan Liben 閻立本
Yan Lide 閻立德
Yan Shu 晏殊
Yan Ying 晏嬰
Yan Zhenqing 顏眞卿
Yan Zhitui 顏之推
yang 陽
Yang Jie 楊傑
Yang Ningshi 楊凝式
Yang She 楊涉
Yang Xin 羊欣
Yang Yi 楊億
Yanxiu 彥修
Yanzi 晏子
Yao 堯
Yaxi 亞栖
Ye Mengde 葉夢得
yi 意
Yi Yin 伊尹
yin 陰
yiren 異人
yishi 遺事
you 游
Yu 虞
Yu He 虞龢
Yu Ji 虞集
Yu Shinan 虞世南
Yu Xin 庾信
Yu Xiong 鬻熊
Yu Yi 余翼
Yu Zhang 余章
Yuan Ang 袁昂
Yuan Shuji 袁恕己
yuanwailang 員外郎
Yue Ke 岳珂
yun 韻

Zeng Zhao 曾肇

Zhai Ruwen 翟汝文

zhan 戰

Zhan Qin 展禽

Zhang Bangji 張邦基

Zhang Chou 張丑

Zhang Daheng 張大亨

Zhang Datong 張大同

Zhang Dun 章惇

Zhang Hua 張華

Zhang Ji 張籍

Zhang Jianzhi 張柬之

Zhang Sengyou 張僧繇

Zhang Xu 張旭

Zhang Xuan 張萱

Zhang Yu 張羽

Zhang Zhi 張芝

zhangcao 章草

Zhao Danian 趙大年

Zhao Hao 趙顥

Zhao Ji 趙佶

Zhao Jun 趙頵

Zhao Lingran 趙令穰

Zhao Lingzhi 趙令時

Zhao Shu 趙曙

Zhao Xu 趙頊

Zhao Yan 趙顏

Zhao Yunrang 趙允讓

Zhao Zhongyu 趙仲御

Zhao Zhongyuan 趙仲爰

zhen 眞

zheng 正

zhi 質

Zhidun 支遁

Zhiguo 智果

zhiyinzhe 知音者

Zhiyong 智永

Zhong Li 重黎

Zhong Rong 鍾嶸

Zhong Shaojing 鍾紹京

Zhong You 鍾繇

Zhong You* 仲由

Zhou Bida 周必大

Zhou Eryan 周而衍

Zhou Muwang 周穆王

Zhou Tong 周穜

Zhou Xingsi 周興嗣

Zhou Yue 周越

zhou shu 籀書

Zhu Changwen 朱長文

Zhu Quanzhong 朱全忠

Zhu Yunming 祝允明

Zhuang Gongyue 莊公岳

Zhuang Zhou 壯周

zhuangguan 莊觀

zhuan shu 篆書

zicheng yijia 自成一家

ziran tianzhen 自然天眞

Zixu 子胥

Bibliography

Classical Chinese Sources

An Shifeng (b. 1557/8). *Molin kuaishi*. Seventeenth century. Taipei: Zhongyang tushuguan, reprinted., 1970.

Andong xianzhi. 1875. Edited by Jin Yuanlang et al. National Palace Museum, Taiwan.

Bao-Jinzhai fatie. 1268. Edited by Cao Zhige. Photo-reprint of a Song dynasty edition. Beijing: Zhonghua shuju, 1962.

Beigushan zhi. Compiled by Zhou Boyi. Zhenjiang: n.p., 1904.

Bian Yongyu (1645–1712). *Shigutang shuhua huikao*. 1682. Taipei: Zhengzhong shuju, 1958.

Cai Tao (?–after 1147). *Tieweishan congtan*. Circa 1130. Beijing: Zhonghua shuju, 1983.

Cai Xiang (1012–67). *Duanming ji*. Eleventh century. *Siku quanshu* edition.

Cai Zhao. "Mi Yuanzhang muzhi ming" (Grave inscription for Mi Fu). Circa 1108. In *Helinsi zhi*, 20a-23b.

Chao Buzhi (1053–1110). *Qibei xiansheng jile ji*. 1094. *Siku quanshu* edition.

Chen Gu (fl. 1216). *Qijiu xuwen*. *Siku quanshu* edition.

Chen Shidao (1053–1101). *Houshan tancong*. Circa 1100. *Congshu jicheng jianben* edition.

Chen Zhensun (ca. 1190–after 1249). *Zhizhai shulu jieti*. Thirteenth century. *Siku quanshu* edition.

Cheng Ju (1078–1144). *Beishan ji*. Twelfth century. *Siku quanshu* edition.

Chongxiu Wuwei zhou zhi. 1520. Compiled by Wu Zhen et al. Tokyo: Tōyō bunko.

Chunhuage tie. 992. Edited by Wang Zhu et al. Photo-reprint of a Song dynasty edition. Taipei: Da Zhongguo tushu gongsi, 1972.

Congshu jicheng jianben. Reprint ed., Taipei: Shangwu yinshuguan, 1965.

Dantu xian zhi. 1521. Compiled by Yang Wan et al. National Palace Museum, Taipei.

Danyang xian zhi. 1569. Compiled by Ding Huayang et al. National Palace Museum, Taipei.

Deng Chun (fl. 1127–67). *Hua ji*. 1167. *Huashi congshu* edition.

Deng Su (1091–1132). *Binglu ji*. Twelfth century. *Siku quanshu* edition.

Ding Chuanjing (1870–1930). *Songren dieshi huibian*. Reprint ed., Taipei: Shangwu yinshuguan, 1982.

Dong Qichang (1555–1636). *Rongtai ji*. Seventeenth century. Reprint ed., Taipei: Zhongyang tushuguan, 1968.

Dong Shi. *Shu lu* (also titled *Huang Song shu lu*). Thirteenth century. *Siku quanshu* edition.

Dong You (fl. 1126). *Guangchuan shuba*. Twelfth century. *Siku quanshu* edition.

Du Fu (712–70). *Du Shaoling ji xiangzhu*. Edited by Qiu Zhaoao. Reprint ed., Beijing: Zhonghua shuju, 1979.

Duan Chengshi (d. 863). *Youyang zazu*. Ninth century. *Siku quanshu* edition.

Fang Xinru (1177–1222). "Bao-Jin Mi gong huaxiang ji." 1215. In *Yuexi jinshi lue*.

Feng Wu (b. 1627). *Shufa zheng zhuan*. Reprint ed., Beijing: Zhongguo shudian, 1983.

Ge Lifang (d. 1164). *Yunyu yangqiu*. Twelfth century. Reprint ed., Shanghai: Shanghai guji chubanshe, 1979.

Gujin tushu jicheng. Eighteenth century. Compiled by Chen Menglei et al. Reprint ed., Shanghai: Zhonghua shuju, 1934.

Guo Ruoxu (fl. 1075). *Tuhua jianwen zhi*. Circa 1075. *Huashi congshu* edition.

Han Yu (768–824). *Wubaijia zhu Changli wenji*. *Siku quanshu* edition.

He Wei. *Chunzhu jiwen*. Eleventh century. *Siku quanshu* edition.

He Zhu (1052–1125). *Qinghu yilao shiji*. Twelfth century. *Siku quanshu* edition.

Helinsi zhi. Wanli reign (1573–1607). Edited by Mingxian. National Palace Museum, Taipei.

Hou Han shu. Edited by Fan Ye (d. 445) and Sima Biao (240–305). Reprint ed., Beijing: Zhonghua shuju, 1982.

Huaian fu zhi. 1518. Compiled by Chen Genshan et al. National Palace Museum, Taipei.

———. 1748. Compiled by Ye Changyang et al. National Palace Museum, Taipei.

Huang Bosi (1079–1118). *Dongguan yulun*. Twelfth century. Reprint ed., Taipei: Guoli zhongyang tushuguan, 1974.

Huang Tingjian (1045–1105). *Shangu shiji zhu*. Twelfth century. *Sibu beiyao* edition.

———. *Shangu ji*. Twelfth century. *Siku quanshu* edition.

Huashi congshu. Edited by An Yulan. Shanghai: Renmin meishu chubanshe, 1982.

Huihong (1071–1128). *Shimen wenzi chan*. Twelfth century. *Siku quanshu* edition.

Hunan tongzhi. 1885. Compiled by Zeng Guoquan et al. Shanghai: Shangwu yinshuguan, 1934.

Jiading Zhenjiang zhi. Compiled by Lu Xian et al. Thirteenth century. Reprint ed., Taipei: Chengwen chubanshe, 1983.

Jin shu. Seventh century. Edited by Fang Xuanling (578–648). Reprint ed., Beijing: Zhonghua shuju, 1982.

Jin Xueshi. *Muzhu xianhua*. In *Congshu jicheng xubian*, vol. 102. Taipei: Xinwenfeng chuban gongsi, 1989.

Jingkou qijiu zhuan. Ca. thirteenth century. *Siku quanshu* edition.

Jingkou sanshan zhi. 1512. Compiled by Zhang Lai et al. National Palace Museum, Taipei.

Jingkou shanshui zhi. 1844. Edited by Yang Qi. Taipei: Chengwen chubanshe, 1970.

Jiu Tang shu. Edited by Liu Xu (886–946). Reprint ed., Beijing: Zhonghua shuju, 1982.

Laozi Daodejing zhu. Reprint ed., Taipei: Shijie shuju, 1967.

Li E (1692–1752). *Songshi jishi*. Eighteenth century. Reprint ed., Taipei: Zhonghua shuju, 1971.

Li Peng (fl. 1100). *Risheyuan ji*. Twelfth century. *Siku quanshu* edition.

Liezi jishi. Edited by Yang Bojun. Beijing: Zhonghua shuju, 1979.

Li Sizhen. *Shu hou pin*. Eighth century. In *Chūgoku shoron taikei*, vol. 2.

Li Xinchuan (1166–1243). *Jianyan yilai chaoye zazhi*. Thirteenth century. Reprint ed., Taipei: Wenhai chubanshe, 1967.

————. *Jianyan yilai xinian yaolu*. Thirteenth century. Reprint ed., Taipei: Zhongwen chubanshe, 1983.

Liyang xianzhi. 1498. Compiled by Fu Guan et al. National Palace Museum, Taipei.

————. 1813. Compiled by Bailing et al., 1896. Reprint ed., Tokyo: Tōyō bunko.

————. 1899. Compiled by Yang Jing et al. Tokyo: Tōyō bunko.

Li You (fl. 1134). *Songchao shishi*. Twelfth century, with later additions. Reprint ed., Taipei: Wenhai chubanshe, 1967.

Li Zhiyi (?–after 1108). *Guxi jushi ji*. Twelfth century. *Siku quanshu* edition.

Liji zhengyi. *Sibu beiyao* edition.

Lin Xiyi (ca. 1210–ca. 1273). *Zhuxianzhai shiyi gao xuji*. Thirteenth century. *Siku quanshu* edition.

Liu Chang (1019–68). *Gongshi ji*. Eleventh century. *Siku quanshu* edition.

Liu Kezhuang (1187–1269). *Houcun ji*. Thirteenth century. *Siku quanshu* edition.

Liu Shao. *Renwu zhi*. Third century. *Sibu beiyao* edition.

Liu Xie (ca. 465–ca. 522). *Wenxin diaolong jiaoshi*. Edited by Liu Yongqi. Reprint ed., Hong Kong: Zhonghua shuju, 1980.

Liu Yiqing (403–44). *Shishuo xinyu jiaojian*. Edited by Xu Zhen'e. Beijing: Zhonghua shuju, 1984.

Liu Yizhi (1079–1160). *Tiaoxi ji*. Twelfth century. *Siku quanshu* edition.

Lou Yue (1137–1213). *Gongkui ji*. Thirteenth century. *Siku quanshu* edition.

Lu You (1125–1210). *Laoxuean biji*. Ca. 1200. In Mao Jin, comp., *Jindai bishu*. Reprint ed., Shanghai: Boguzhai, 1922.

————. *Weinan wenji*. Thirteenth century. *Sibu congkan chubian* edition.

Lu You. *Mo shi*. Fourteenth century. *Congshu jicheng jianben* edition.

————. *Yanbei zazhi*. Fourteenth century. In *Gujin shuobu congshu*. Shanghai: Zhongguo tushu gongsi, 1915.

Ma Duanlin (1254–1325). *Wenxian tongkao*. Fourteenth century. *Siku quanshu* edition.

Mai Yaochen (1002–60). *Wanling ji*. Eleventh century. *Siku quanshu* edition.

Meishu congshu. Edited by Huang Binhong and Deng Shi. Reprint ed., Shanghai: Jiangsu guji chubanshe, 1986.

Mengzi. In *Sishu jizhu*. *Sibu beiyao* edition.

Mi dian xiaoshi. 1492. Compiled by Zhu Yunming (1460–1526). 1863 MS edition transcribed by Jin Erzhen. Central Library, Taipei.

Mi Fu (1052–1107/8). *Bao-Jin yingguang ji*. Edited by Mi Xian and Yue Ke (1183–1240). Taipei: Xuesheng shuju (reprint of Qing dynasty MS copy of the Taiwan Central Library), 1971. Collated with various versions, including the Southern Song printed edition of the Yunyangjunzhai of 1201 housed in the Beijing Library.

————. *Baozhang daifang lu*. 1086. *Meishu congshu* edition.

————. *Haiyue mingyan*. In *Chūgoku shoron taikei*, vol. 4.

————. *Haiyue tiba*. In Mao Jin, ed., *Jindai bishu*. Reprint ed., Shanghai: Boguzhai, 1922.

————. *Hua shi*. Circa 1104. In Yu Anlan, ed., *Huapin congshu*. Shanghai: Renmin meishu chubanshe, 1982.

————. *Shu shi*. In Wang Shizhen, ed., *Wang shi shuhuayuan*. Central Library, Taipei.

————. *Song ta Fangyuanan ji*. 1083. Photo-reprint of a Song dynasty rubbing. Shanghai: Zhonghua shuju, 1934.

————. *Yan shi*. *Meishu congshu* edition.

Nan shi. Edited by Li Yanshou (?–after 675). Seventh century. Reprint ed., Beijing: Zhonghua shuju, 1982.

Ouyang Xiu (1007–72). *Ouyang Xiu quanji*. Eleventh century. Reprint ed., Hong Kong: Guanzhi shuju, n.d.

Peiwenzhai shuhuapu. 1708. Compiled by Wang Yuanqi (1642–1715) et al. Reprint ed., Taipei: Hanhua wenhua shiye, 1972.

Qin Guan (1049–1100). *Huaihai ji*. Eleventh century. *Siku quanshu* edition.

Quan shanggu sandai Qin Han Sanguo Liuchao wen. Compiled by Yan Kejun. Reprint ed., Taipei: Shijie shuju, 1963.

Quan Song ci. Edited by Tang Guizhan. Reprint ed., Taipei: Wenguang chubanshe, 1973.

Sanxitang shiqu baoji fatie. 1750. Compiled by Liang Shizheng et al. Reprint ed., Hong Kong: Xingfu chubanshe, n.d.

Shanhaijing jiaozhu. Edited by Yuan Ke. Shanghai: Guji chubanshe, 1980.

Shao Bo (?–1158). *Henan Shao shi wenjian houlu*. Twelfth century. In Zhang Haipeng, ed., *Xuejin taoyuan*. Reprint ed., Shanghai: Shangwu yinshuguan, n.d.

Shen Gua (1031–95). *Mengqi bitan*. Circa 1093. *Siku quanshu* edition.

Shiqu baoji. 1745. Edited by Zhang Zhao (1691–1745) et al. Reprint ed., Taipei: Guoli gugong bowuyuan, 1971.

Shiqu baoji sanbian. 1816. Edited by Hu Jing (1769–1845) et al. Reprint ed., Taipei: Guoli gugong bowuyuan, 1971.

Shiqu baoji xubian. 1793. Edited by Wang Jie (1725–1805) et al. Reprint ed., Taipei: Guoli gugong bowuyuan, 1971.

Sibu beiyao. Reprint ed., Taipei: Zhonghua shuju, 1981.

Sibu congkan chubian. Taipei: Shangwu yinshuguan, 1967.

Siku quanshu. Shanghai: Shanghai guji chubanshe, 1987.

Siku quanshu zongmu. Eighteenth century. Edited by Yong Rong (1744–90) et al. Reprint ed., Beijing: Zhonghua shuju, 1983.

Song Gaozong (Zhao Gou, 1107–87). *Hanmo zhi*. In *Chūgoku shoron taikei*, vol. 6.

Song huiyao jigao. Edited by Xu Song (1781–1848). 1809. Beijing: Zhonghua shuju, 1957.

Song shi. Edited by Tuotuo (1313–55). Beijing: Zhonghua shuju, reprint ed., 1977.

Su Che (1039–1112). *Su Che ji*. Beijing: Zhonghua shuju, 1990.

Su Shi lun shuhua shiliao. Edited by Li Fushun. Shanghai: Shanghai renmin meishu chubanshe, 1988.

Su Shi (1037–1101). *Su Shi shiji*. Edited by Wang Wengao, Kong Fanli. Reprint ed., Beijing: Zhonghua shuju, 1987.

————. *Su Shi wenji*. Edited by Kong Fanli. Reprint ed., Beijing: Zhonghua shuju, 1986.

Sun Guoting (648–703). *Shu pu*, 687. In *Chūgoku shoron taikei*, vol. 2.

Suzhou fuzhi. Hongwu reign edition (1368–98). Compiled by Lu Xiong et al. National Palace Museum, Taipei.

Taiping guangji. Compiled by Li Fang (925–96). Reprint ed., Beijing: Zhonghua shuju, 1981.

Tao Yuanming (365–427). *Tao Yuanming ji*. *Siku quanshu* edition.

Tao Zongyi (fl. 1360–76). *Shu shi huiyao*. 1376. Reprint ed., Shanghai: Shanghai shudian, 1984.

Wang Cheng. *Dongdu shilue*. 1186. Reprint ed., Taipei: Wenhai chubanshe, 1971.

Wang Fu (fl. 115). *Qianfu lun*. Second century. Shanghai: Guji shuju, 1978.

Wang Mingqing (1127–after 1214). *Huizhu houlu*. 1194. *Siku quanshu* edition.

Wang Renyu (880–942). *Kaiyuan Tianbao yishi*. In *Gushi wenfang xiaoshuo*. Reprint ed., Shanghai: Shangwu yinshuguan, 1934.

Wang Sengqian (426–85). *Lun shu*. In *Chūgoku shoron taikei*, vol. 1.

Wang Yinglin (1223–96). *Xiaoxue ganzhu*. *Siku quanshu* edition.

———. *Yu hai*. Thirteenth century. Zhejiang shuju, 1883.

Wang Yun (1227–1304). *Qiujian xiansheng daquan wenji*. Fourteenth century. *Siku quanshu* edition.

———. *Yutang jiahua*. 1288. In Qian Xizu, ed., *Shoushange congshu*. Shanghai: Boguzhai, 1862.

Wei Heng (252–91). *Siti shushi*. In *Chūgoku shoron taikei*, vol. 1.

Wei Liaoweng (1178–1237). *Chongjiao Heshan xiansheng da quanji*. Thirteenth century. *Sibu congkan chubian* edition.

Wei Tai (ca. 1050–1110). *Dongxuan bilu*. Circa 1090. *Siku quanshu* edition.

———. *Lin Han yinju shihua*. Circa 1090. *Siku quanshu* edition.

Weng Fanggang (1733–1818). *Mi Fu nianpu*. In Wu Chongyao (1810–63), comp., *Yueyatang congshu*. *Baibu congshu jicheng* reprint edition. Taipei: Yiwen yinshuguan, 1965.

Wu jun zhi. 1192, addenda 1229. Compiled by Fan Chengda (1120–93). Jiguge reprint edition (ca. 1640), National Palace Museum, Taipei.

Wu Zeli (d. 1121). *Beihu ji*. Twelfth century. *Siku quanshu* edition.

Wu Zeng (?–after 1170). *Nenggaizhai manlu*. 1157. *Siku quanshu* edition.

Wuwei zhouzhi. 1520. Compiled by Wu Zhen et al. National Palace Museum, Taipei.

———. 1803. Compiled by Zhang Xiangyun et al. Tokyo: Tōyō bunko.

Xiangyang xianzhi. 1874. Edited by Cui Quan et al. Cambridge: Harvard-Yenching Library.

Xianyu Shu (ca. 1257–1302). *Kunxuezhai zalu*. Fourteenth century. *Congshu jicheng jianben* edition.

Xin Tang shu. 1060. Edited by Song Qi (998–1061), Ouyang Xiu (1007–72), et al. Reprint ed., Beijing: Zhonghua shuju, 1975.

Xiong Ke (1111–90). *Zhongxing xiaoji*. Circa 1185. *Congshu jicheng* edition. Shanghai: Shangwu yinshuguan, 1936.

Xu Shen (30–124). *Shuowen jiezi zhenben*. *Sibu beiyao* edition.

Xu Wei (1521–93). *Xu Wenchang yigao*. Reprint ed., Taipei: Weiwen tushu chubanshe, 1977.

Xu zizhi tongjian changbian shibu. Twelfth century. Compiled by Li Tao (1115–84); revised by Huang Yizhao et al. Reprint ed., Shanghai: Shanghai guji chubanshe, 1986.

Xuanhe huapu. 1120. *Huashi congshu* edition.

Xuanhe shupu. 1120. In *Chūgoku shoron taikei*, vols. 5–6.

Xuanhe yishi. Ca. 1300. *Sibu beiyao* edition.

Yang Wanli (1127–1206). *Chengzhai ji*. *Siku quanshu* edition.

———. *Chengzhai shihua*. *Siku quanshu* edition.

Yang Xin (370–442). *Gulai nengshu renming*. Fifth century. In *Chūgoku shoron taikei*, vol. 1.

Yang Xiong (53 B.C.–A.D.18). *Yangzi fayan*. *Sibu congkan* edition. Reprint ed., Taipei: Shangwu yinshuguan, 1965.

Yang Zhongliang (1241–71). *Zizhi tongjian changbian jishi benmo*. Thirteenth century. Reprint ed., Taipei: Wenhai chubanshe, 1968.

Ye Mengde (1077–1148). *Bishu luhua*. Twelfth century. Edited by Ye Tingguan. N.p., 1845.

———. *Shilin yanyu*. Twelfth century. *Siku quanshu* edition.

Yu He. *Lunshu biao*. 470. In *Chūgoku shoron taikei*, vol. 1.

Yu Ji (1272–1348). *Daoyuan xuegu lu*. Fourteenth century.

Yu Xin (513–81). *Yu Zishan ji*. Sixth century. *Siku quanshu* edition.

Yuan Ang (461–540). *Gujin shuping*. Sixth century. In *Chūgoku shoron taikei*, vol. 1.

Yuan Jue (1266–1327). *Qingrong jushi ji*. Fourteenth century. *Siku quanshu* edition.

Yuan Haowen (1190–1257). *Yuan Yishan shi jianzhu*. *Sibu beiyao* edition.

Yuan Yueyou (1140–1204). *Dongtang ji*. Twelfth century. *Siku quanshu* edition.

Yue Ke (1183–1240). *Baozhenzhai fashu zan*. Thirteenth century. In *Yishu congbian*. Taipei: Shijie shuju, 1962.

Yuedong jinshi lue. Compiled by Weng Fanggang (1733–1818). In *Shike shiliao xianbian*, vol. 17. Reprint ed., Taipei: Xinwenfeng chuban gongsi, 1986.

Yuexi jinshi lue. Compiled by Xie Qikun (1737–1802). In *Shike shiliao xianbian*, vol. 17. Reprint ed., Taipei: Xinwenfeng chuban gongsi, 1986.

Zeng Minxing (1118–75). *Duxing zazhi*. *Siku quanshu* edition.

Zhai Qinian. *Zhou shi*. 1142. In Qian Xizuo, ed., *Shoushange congshu*. Shanghai: Boguzhai, 1862.

Zhai Ruwen (1076–1141). *Zhonghui ji*. Twelfth century. *Siku quanshu* edition.

Zhang Bangji (?–after 1150). *Mozhuang manlu*. 1144. *Siku quanshu* edition.

Zhang Chou (1577–1643). *Qinghe shuhua fang*. 1616. Reprint ed., Taipei: Xuehai chubanshe, 1975.

———. *Zhenji rilu*. *Siku quanshu* edition.

Zhang Gang (1083–1166). *Huayang ji*. Twelfth century. *Siku quanshu* edition.

Zhang Yanyuan. *Lidai minghua ji*. Ninth century. In *Huashi congshu*.

Zhang Zhifu. *Ke shu*. Twelfth century. *Congshu jicheng jianben* edition.

Zhao Bingwen (1159–1232). *Xianxian laoren fushui wenji.* Thirteenth century. *Sibu congkan* edition. Reprint ed., Taipei: Shangwu yinshuguan, 1965.

Zhao Lingzhi (ca. 1051–1134). *Houqing lu.* Twelfth century. *Siku quanshu* edition.

Zhao Mingcheng (1081–1129). *Jinshi lu.* Twelfth century. In *Shike shiliao congshu.* Taipei: Yiwen yinshuguan, 1967.

Zhao Xigu (ca. 1170–after 1242). *Dongtian qinglu ji.* In *Meishu congshu.*

Zhenjiang fuzhi. 1597. Compiled by Wang Jiao et al. National Palace Museum, Taipei.

Zhishun Zhenjiang zhi. 1332–33. Compiled by Yu Xilu (ca. 1279–1368) et al. Reprint ed., Nanjing: Jiangsu guji chubanshe, 1990.

Zhong Rong (fl. 502–19). *Shi pin.* Sixth century. *Sibu beiyao* edition.

Zhou Bida (1126–1204). *Wenzhong ji. Siku quanshu* edition.

Zhou Hui (1126–after 1198). *Qingbo biezhi.* Twelfth century. *Siku quanshu* edition.

———. *Qingbo zazhi.* Twelfth century. *Siku quanshu* edition.

Zhou Mi (1232–1308). *Guixin zazhi.* Ca. 1298. In Mao Jin, ed., *Jindai bishu.* Reprint ed., Shanghai: Boguzhai, 1922.

———. *Qidong yeyu. Siku quanshu* edition.

———. *Yunyan guoyan lu.* In An Yulan, ed., *Huapin congshu.* Shanghai: Renmin meishu chubanshe, 1982.

———. *Zhiyatang zachao.* In Cao Qiuyue, ed., *Xuehai leibian.* Taipei: Wenyuan shuju, 1964.

Zhou Zizhi (1082–after 1151). *Zhupo laoren shihua.* Twelfth century. *Siku quanshu* edition.

Zhu Changwen (1039–98). *Xu shu duan.* In *Chūgoku shoron taikei,* vol. 4.

Zhuang Chuo (ca. 1090–ca. 1150). *Jile bian* (1133). *Siku quanshu* edition.

Zhuangzi jishi. Edited by Guo Qingfan. Reprint ed., Beijing: Zhonghua shuju, 1989.

Modern Chinese and Japanese Sources

Adachi Toyomi. "Bei Futsu no shokai senbun to shogagaku hakushi to" (Mi Fu's "Thousand Character Essay" in the small-standard script and his role as erudite of calligraphy and painting). *Shoron* 11 (1977): 85–88.

Aoki Seiji. "Gen Shinkyō no shogaku" (Yan Zhenqing's study of calligraphy). In *Shodō zenshū,* 10:10–13.

Bei Futsu shu. Chūgoku hōsho gaido series, no. 48. Tokyo: Nigensha shuppansha, 1988.

Beijing tushuguan cang Zhongguo lidai shike taben huibian. 101 vols. Zhengzhou: Zhongzhou guji chubanshe, 1989–91.

Cai Xiang. Moji daguan series. Shanghai: Shanghai renmin meishu chubanshe, 1990.

Cai Xiang shufa shiliao ji. Edited by Shui Saiyou. Shanghai: Shanghai shuhua chubanshe, 1983.

Cao Baolin. "Mi Fu 'Lexiong tie' kao" (Study of Mi Fu's "Lexiong tie"). *Shu pu,* 1989, no. 5, 53–55.

———. "Mi Fu 'Qiezhong tie' kao" (Study of Mi Fu's "Qiezhong tie"). *Zhongguo shufa quanji,* 37:32–34.

———. "Mi Fu 'Taishi xing ji Wang Taishi Yanzhou' benshi suoyin" (Close reading

of Mi Fu's poem for Wang Huanzhi). *Shu pu*, 1986, no. 1, 48–51.

———. "Mi Fu yu Su Huang Cai sanjia jiaoyou kaolue" (Study of Mi Fu and his relationships with Su Shi, Huang Tingjian and Cai Jing). *Zhongguo shufa*, 1990, no. 2, 39–44.

———. "Mi Fu 'Zhuqian huaihou shi tie' kao" (Study of Mi Fu's handwritten poem "Zhuqian huaihou"). *Shu pu*, 1986, no. 6.

Chen Gaohua. *Song Liao Jin huajia shiliao*. Beijing: Wenwu chubanshe, 1984.

Chūgoku shoron taikei. 18 vols. Edited by Nakata Yūjirō. Tokyo: Nigensha shuppansha, 1977–92.

Chūgoku shodo zenshū. 8 vols. Edited by Nakata Yūjirō. Tokyo: Heibonsha shuppansha, 1986–89.

Da Tang sancang shengjiaoxu. Photo reprint of a Song dynasty rubbing formerly in the Luo Zhenyu collection. Shangyu: n.p., 1923.

Ding Wenjun. *Shufa jinglun*. Beijing: Zhongguo shudian, reprint ed., 1983.

Gao Huiyang. "Mi Fu jiashi nianli kao" (A study of the genealogy and dates of Mi Fu). *Tenri daigaku gakuhō* 121 (September 1979): 1–16.

———. "Mi Fu qi ren ji qi shufa" (Mi Fu, the man and his calligraphy). M.A. thesis, Chinese Cultural University, 1973.

Gugong bowuyuan cang lidai fashu xuanji. Beijing: Wenwu chubanshe, 1982.

Gugong lidai fashu quanji. 30 vols. Taipei: Guoli gugong bowuyuan, 1984.

Hibino Takeo. "Shū Ō Seikyōjo no ishibumi ni tsuite" (On "Preface to the Sacred Teachings"). In *Shodō zenshū*, 8:33–40.

Huang Qifang. "Mi Fu de shengping yu wenxue" (Biography and writings of Mi Fu). In *Liang Song wenshi luncong*, 495–521. Taipei: Xuehai chubanshe, 1985.

Huang Tingjian. *Moji daguan* series. Shanghai: Shanghai renmin meishu chubanshe, 1991.

Ikeda Tetsuya. "So Tōba no sho no seiseitei ni tsuite" (On the development of Su Shi's calligraphy). *Shoron* 20 (1983): 276–84.

Isshida Hajime. "Sōdai shitaifu to sho—Ōyō Shū rei to shite" (Song literati and calligraphy—Ouyang Xiu as an example). *Shoron* 4 (1974): 35–43.

———. "So Tōba to Bei Genshō" (Su Shi and Mi Fu). *Shoron* 11 (1977): 89–96.

Kakui Hiroshi. "Hokusō yōshiki no tenkei—So Shoku o chūshin to suru bunjin shohō no tokushitsu" (The model of Northern Song style—characteristics of literati calligraphy with a focus on Su Shi). *Tōkyō kokuritsu hakubutsukan kiyō* 20 (1985): 69–180.

Kishida Tomoko. "Ōyō Shū to sho" (Ouyang Xiu and calligraphy). In *Tōyō geirin ronsō—Nakata Yūjirō sensei shoju kinen ronshū*, 153–63. Tokyo: Heibonsha, 1985.

Kō Teiken shu. Chūgoku hōsho gaido series, no. 47. Tokyo: Nigensha shuppansha, 1989.

Lanting moji huibian. Beijing: Beijing chubanshe, 1985.

Li Gonglin shengxian tu shike. Edited by Huang Yongquan. Beijing: Renmin meishu chubanshe, 1963.

Li Han and Shen Xueming. "Lue lun Xi zu zai Liaodai de fazhan" (Discussion of the development of the Xi tribe under the Liao). In Cui Wenyin, ed., *Song Liao Jin shi*

luncong, 277–94. Beijing: Zhonghua shuju, 1985.

Li Huishu, "Songdai huafeng zhuanbian ji qiji—Huizong meishu jiaoyu chenggong zhi shili" (Huizong and the education of the Painting Academy—a stylistic turning point in Song dynasty painting). *Gugong xueshu jikan* 1, no. 4 (Summer 1984): 71–94; 2, no. 1 (Autumn 1984): 9–36.

Liang Guangze. "Huang Shangu yu 'Yiheming' ji qita" (Huang Tingjian and the "Yiheming"). *Shu pu*, 1982, no. 2, 64–65.

Liu Gongquan. Beijing: Wenwu chubanshe, 1980.

Liu Jiuan. "Shitan Mi Fu zishu tie yu lin gutie de jige wenti" (Comments on Mi Fu's calligraphy and his copies of ancient *tie*). *Wenwu*, 1962, no. 6, 50–57.

Luo Suizu. "Shi lun Mi Fu de shuhua yong yin" (Preliminary discussion of Mi Fu's use of seals on his calligraphy and painting). *Shufa congkan* 15 (1988): 92–96.

Luo Tai (Lothar Ledderose). "Mi Fu yu Wang Xianzhi de guanxi" (Mi Fu and Wang Xianzhi). *Gugong jikan* 7, no. 2 (Winter 1972): 71–84.

Ma Zonghuo. *Shulin caojian*. 2 vols. Taipei: Taiwan shangwu yinshuguan, 1965.

Mi Fu. *Moji daguan* series. Shanghai: Shanghai renmin meishu chubanshe, 1989.

Mi Fu. 2 vols. Edited by Cao Baolin. *Zhongguo shufa quanji* series, vols. 37–38.

Mi Fu chidu. Beijing: Guoli Beiping Gugong bowuyuan, 1947.

Mi Fu fuzi shiliao. Compilation of articles and essays, no author or publisher. Hong Kong: n.d. [1976?].

Nagata Toshio. "Ō Kenshi—sono hito sono sho ni tsuite" (Wang Xianzhi—the person and his calligraphy). *Hokkaido Kyōiku daigaku kiyō* 30, no. 2 (1980): 1–20.

Naito Kankichi. "Bei Futsu ni tsuite" (Mi Fu). In *Shodō zenshū*, 15:26–36.

Nakata Yūjirō. *Bei Futsu*. 2 vols. Tokyo: Nigensha shuppansha, 1982.

———. "Bei Futsu chosho shoken hōsho kō" (Study of calligraphy as seen through Mi Fu's writings). In *Nakata Yūjirō chosakushu*, 3:415–35.

———. "Bei Futsu no Eikōdōchō ni tsuite" (Mi Fu and the *Yingguangtang tie*). *Shoron* 11 (1977): 100–116.

———. "Bei Futsu no shoron" (Mi Fu's comments on calligraphy). *Shoron* 15 (1979): 112–27.

———. "Bei Futsu Shoshi shosei Tō kakushinha sho kō" (Study of the calligraphy of the Tang "revolutionary" school as recorded in Mi Fu's *Shu shi*). *Otemae joshi daigaku ronshū* 11 (1977): 1–22.

———. "Junkakakuchō" (*Model Writings from the Chunhuage*). *Nakata Yūjirō chosakushu*, 3:215–75.

———. "Kō Sankoku no sho to shoron" (Huang Tingjian's calligraphy and comments on calligraphy). *Nakata Yūjirō chosakushū*, 3:373–77.

———. *Nakata Yūjirō chosakushū*. 10 vols. Tokyo: Nigensha shuppansha, 1984.

———. *Ō Gishi o chūshin to suru hōjō no kenkyū*. Reprint ed., Tokyo: Nigensha shuppansha, 1979.

———. "Ōyō Shū no Hissetsu, Shihitsu" (Ouyang Xiu's "Bishuo" and "Shibi"). *Nakata Yūjirō chosakushū*, 3:326–39.

———. "Ri Yō no sho" (The calligraphy of Li Yong). *Nakata Yūjirō chosakushū*,

3:188–91.

———. "So Tōba no sho to shoron." *Nakata Yūjirō chosakushū*, 3:352–72.

———. "Tōdai no ishibumi." *Nakata Yūjirō chosakushū*, 3:14–124.

———. "Tōdai no kakushinha no sho" (The calligraphy of the Tang "revolutionary" school). *Nakata Yūjirō chosakushū*, 3:193–211.

Nanba Masahisa. "Sō dai no sho to Bei Futsu" (Song dynasty calligraphy and Mi Fu). *Nisho Gakusha soritsu hyakujushunen kinen ronbunshū*, 695–709. Tokyo: Nisho Gakusha, 1987.

Nishikawa Yasushi. *Nishikawa Yasushi chosakushū*. 10 vols. Tokyo: Nigensha shuppansha, 1991–93.

———. "Bei Genshō no Kokenshi" (Mi Fu's "Hongxian Poems"). *Shohin* 153 (August 1964): 2–68.

———. "Bei Genshō no sanchō ni tsuite" (Concerning three handwritten works by Mi Fu). *Nishikawa Fujino chosakushū*, 2:138–44.

Ōbei shūzō Chūgoku hōsho meiseki shū. Vol. 1. Edited by Nakata Yūjirō and Fu Shen. Tokyo: Chūō koronsha, 1981.

Ōno Shusaku. "Bei Futsu shū" (Mi Fu). In *Bei Futsu shū*, 8–17. Tokyo: Nigensha shuppansha, 1988.

———. "Ko Teiken no shoron" (Huang Tingjian's comments on calligraphy). *Shoron* 15 (1980): 79–111.

Qi Gong. "'Ji Wang Xizhi shu Shengjiao xu' Song ta zhengfu de faxian jian tan ci bei de yixie wenti" (Discovery of a complete Song rubbing of the "Preface to the Sacred Teachings" composed of Wang Xizhi's characters and some related questions). In *Qi Gong conggao*, 256–62.

———. "Jiu ti Zhang Xu caoshu gushi tie bian" (Study of "Poems" in cursive calligraphy formerly attributed to Zhang Xu). In *Qi Gong conggao*, 90–100.

———. *Lunshu jueju*. Hong Kong: Shangwu yinshuguan, 1985.

———. "Mi Fu hua" (Painting by Mi Fu). In *Qi Gong conggao*, 288–90.

———. "Mi Yuanzhang tie" (Calligraphy by Mi Fu). In *Qi Gong conggao*, 287–88.

———. *Qi Gong conggao*. Beijing: Zhonghua shuju, 1981.

Qunyutang Mi tie. Shanghai: Shanghai shuhua chubanshe, 1982.

Rong Geng. *Cong tie mu*. 3 vols. Reprint ed., Taipei: Huazheng shuju youxian gongsi, 1984.

She Cheng, "Tang dai shutan qijie Li Yong he take shufa" (The outstanding calligrapher of the Tang dynasty Li Yong and his calligraphy). *Gugong xueshu jikan* 2, no. 2 (1984): 81–131.

Shi Man (Peter Sturman). "Kejin xiaodao de Mi Youren—lun qi dui fuqin Mi Fu shu ji de souji ji Mi Fu shuji dui Gaozong chaoting de yingxiang" (Mi Youren as filial son—notes on the collecting of Mi Fu's calligraphy and its influence at Song Gaozong's court). *Gugong xueshu jikan* 9, no. 4 (July 1992): 89–126.

Shodō geijutsu. 24 vols. Edited by Nakata Yūjirō. Tokyo: Chūō koronsha, 1971–73.

Shodō zenshū. 26 vols. Edited by Kanda Kiichirō. Tokyo: Heibonsha, 1954–61.

Shoseki meihin sōkan. 208 vols. Tokyo: Nigensha shuppansha, 1958–90.

Song ta Bao-Jinzhai fatie. Shanghai: Zhonghua shuju, 1962.

Song ta Jiuchenggong liquan ming. Beijing: Wenwu chubanshe, 1962.

Sotoyama Gunji. "Tō Taisō to Shōryō no ishibumi" (Tang Taizong and the stelae of Shaoling). In *Shodō zenshū* 7:21–26.

Su Shi. 2 vols. Edited by Liu Zhengcheng. *Zhongguo shufa quanji,* vols. 33–34.

Sugimura Kunihiko. "Bei Kaigaku sensei boshimei yakuchu" (Annotated version of Mi Fu's grave inscription). *Shoron* 11 (1977): 117–27.

———. "Bei Futsu to Kō Teiken" (Mi Fu and Huang Tingjian). *Shoron* 11 (1977): 97–99.

———. "So Tōba no Gen Shinkyō kan" (Su Shi's view of Yan Zhenqing). *Shoron* 20 (1983): 268–75.

Sun Zubai. *Mi Fu yu Mi Youren. Zhonghua huajia congshu* series. Reprint ed., Shanghai: Shanghai renmin meishu chubanshe, 1982.

Tang Lan. "Bao-Jinzhai fatie duhou ji" (Notes on the *Bao-Jin fatie*). *Wenwu,* 1963, no. 3, 30–33.

Tang Li Sixun bei. Shanghai: Yiyuanzhenshangshe, n.d.

Tang Ouyang Xun Mengdian tie. Beijing: Wenwu chubanshe, 1961.

Tang Yan Zhenqing shu Zheng zuowei tie. Beijing: Wenwu chubanshe, 1982.

Tang Zhang Xu caoshu gushi sitie. Beijing: Wenwu chubanshe, 1962.

Tō Gan Shinkei, Saitetsu bunkō, Koku hakufu bunkō, Sō za'i bunkō. Chūgoku hōshu sen series, vol. 41. Tokyo: Nigensha shuppansha, 1994.

Tō Ōyo Jun, Kyūseikyū reisen mei. Chūgoku hōsho sen series, vol. 31. Tokyo: Nigensha shuppansha, 1994.

Tō Riyō, Ri Shikun hi. Chūgoku hōsho sen series, vol. 39. Tokyo: Nigensha shuppansha, 1994.

Tsutsumi Koji. "Futari no shūzōka—Bei Futsu to Ō Sen" (Two collectors: Mi Fu and Wang Shen). In *Bei Futsu shu,* 18–22.

———. "Kō Sankoku no shoron" (Huang Tingjian's comments on calligraphy). *Aiwa Kyōiku Daigaku kenkyū hakuhō* 28 (March 1979): 17–26.

Xi Qiu. *Song chu fengyun renwu.* Taipei: Sanmin shuju, 1986.

Xi'an beilin shufa yishu. Xi'an: Shaanxi renmin meishu chubanshe, 1988.

Xiong Bingming. "Yi Zhang Xu caoshu sitie shi yi lin ben" (Suspicion concerning Zhang Xu's "Poems" in cursive script). *Shu pu,* 1982, no. 2, 18–24.

Xu Bangda. "Gugong bowuyuan cang Mi Fu zhongyao moji kao" (Study of important handwritten works by Mi Fu in the Palace Museum). *Shufa congkan* 15 (1988): 4–13.

———. *Gu shuhua guoyan yaolu.* Changsha: Hunan meishu chubanshe, 1987.

———. "Liangzhong youguan shuhua shulu kaobian." *Wenwu,* 1985, no. 5, 63–66.

———. *Lidai shuhuajia zhuanji kaobian.* Shanghai: Shanghai renmin meishu chubanshe, 1983.

———. "Su Shi he Mi Fu de xingshu" (Semi-cursive calligraphy of Su Shi and Mi Fu). *Shufa congkan* 1 (1981): 82–87.

———. "Yang Ningshi moji zhenwei ge ben de kaozheng" (Examination of the authenticity of the various handwritten examples attributed to Yang Ningshi). *Shu*

pu 36 (1980): 46–49.

Xu Senyu. "Bao-Jinzhai tie kao" (Examination of the *Bao-Jinzhai fatie*). *Wenwu*, 1962 no. 12, 9–19.

Yan Zhenqing. 2 vols. Beijing: Wenwu chubanshe, 1985.

Yanwen. "Yan Zhenqing de 'Zheng zuowei tie'" (Yan Zhenqing's 'Zheng zuowei tie'). *Shu pu*, 1977, no. 8, 34–46.

Yang Renkai. *Muyulou shuhua lungao*. Shanghai: Shanghai renmin meishu chubanshe, 1988.

———. "Ouyang Xun 'Mengdian tie' kaobian" (Study of Ouyang Xun's "Mengdian tie"). *Yiyuan duoying*, 1978, no. 3, 28–29.

———. "Song Huizong Zhao Ji shufa yishu suotan" (Comments on the art of Song Huizong's calligraphy). *Shufa congkan* 14 (1988): 4–10.

Yokoyama Iseo. "Sō shiron ni miru 'heitan no tai' ni tsuite" (Concerning the pingdan style as seen in the work of the Song dynasty poets). *Kambun gakkai kaiho* 20 (1961): 33–40.

Zhang Guangbin. *Zhongguo shufa shi*. Reprint ed., Taipei: Shangwu yinshuguan, 1984.

Zhang Jian. *Song Jin sijia wenxue piping yanjiu*. Reprint ed., Taipei: Lianjing chuban shiye, 1983.

Zheng Jinfa. "Mi Fu Shu su tie" (Mi Fu's "Poems on Sichuan Silk"). M.A. thesis, National Taiwan University, 1975.

Zheng Minzhong. "Ji Wudai Yang Ningshi fashu" (On Yang Ningshi's calligraphy). *Wenwu*, 1962, no. 6, 59–62.

———. "Mi Fu de shufa yishu" (The art of Mi Fu's calligraphy). *Shufa congkan* 15 (1988): 70–75.

Zhongguo lidai huihua (*Gugong bowuyuan cang hua ji*), vol. 3. Beijing: Renmin meishu chubanshe, 1982.

Zhongguo meishu quanji. 50 vols. Beijing: Renmin meishu chubanshe, 1985–89.

Zhongguo shufa quanji. 100 vols. (proposed). Edited by Liu Zhengcheng et al. Beijing: Rongbaozhai, 1991– .

Zhu Huiliang. "Nan Song huangshi shufa" (Imperial calligraphy of the Southern Song). *Gugong xueshu jikan* 2, no. 4 (Summer 1985): 17–52.

Zhu Huiliang and Yang Meili, ed. *Fashu pian*. Vol. 2. Taipei: Guoli gugong bowuyuan, 1985.

Zui Chi'ei, Shinssenjumon. Shoseki meihin sōkan series, vol. 72. Tokyo: Nigensha shuppansha, 1989.

Western Sources

Ackerman, James. "A Theory of Style." *Journal of Aesthetics and Art Criticism* 20 (1962): 227–37.

Barnhart, Richard M., with Robert E. Harrist, Jr., and Hui-liang Chu (Zhu Huiliang). *Li Kung-lin's Classic of Filial Piety*. New York: Metropolitan Museum of Art.

———. "Li Kung-lin's Hsiao-ching t'u, Illustrations of the Classic of Filial Piety." Ph.D. diss., Princeton University, 1967.

————. *"Marriage of the Lord of the River": A Lost Landscape by Tung Yuan*. Ascona: Artibus Asiae, 1970.

————. "Wei Fu-jen's *Pi Chen T'u* and the Early Texts on Calligraphy." *Archives of the Chinese Art Society of America* 18 (1964): 13–25.

Birch, Cyril, ed. *Anthology of Chinese Literature*. New York: Grove Press, 1965.

Bol, Peter. *"This Culture of Ours": Intellectual Transitions in T'ang and Sung China*. Stanford: Stanford University Press, 1992.

Bush, Susan. *The Chinese Literati on Painting from Su Shih (1037–1101) to Tung Ch'i-ch'ang (1555–1636)*. Cambridge: Harvard University Press, 1971.

Cahill, James. *The Distant Mountains*. New York: Weatherhill, 1982.

————. *Hills beyond a River: Chinese Painting of the Yüan Dynasty*. New York: Weatherhill, 1976.

Chang, Leon Long-yien, and Peter Miller. *Four Thousand Years of Chinese Calligraphy*. Chicago: University of Chicago Press, 1989.

Chaves, Jonathan. *Mei Yao-ch'en and the Development of Early Sung Poetry*. New York: Columbia University Press, 1976.

Chiang Yee. *Chinese Calligraphy*. Reprint ed., Cambridge: Harvard University Press, 1973.

Chinese and Japanese Calligraphy Spanning Two Thousand Years—The Heinẓ Gotẓe Collection, Heidelberg. Edited by Komatsu Shigemi and Wang Kwan-shut, with contributions by Lothar Ledderose and others. Munich: Prestel-Verlag, 1989.

Chu Hui-liang [Zhu Huiliang]. "The Chung Yu (AD151–230) Tradition: A Pivotal Development in Sung Calligraphy." Ph.D. diss., Princeton University, 1990.

Davis, A. R. "The Double Ninth Festival in Chinese Poetry: A Study of Variations upon a Theme." In Chow Tse-tsung, ed., *Wenlin: Studies in the Chinese Humanities*, 45–64. Madison: University of Wisconsin, 1968.

Egan, Ronald C. *The Literary Works of Ou-yang Hsiu (1007–72)*. Cambridge: Cambridge University Press, 1984.

————. "Ou-yang Hsiu and Su Shih on Calligraphy." *Harvard Journal of Asiatic Studies*, 49, no. 2 (December 1989): 365–419.

————. "Poems on Paintings: Su Shih and Huang T'ing-ch'ien." *Harvard Journal of Asiatic Studies*, vol. 43, no. 2 (December 1983): 413–51.

————. "Su Shih's 'Notes' as a Historical and Literary Source." *Harvard Journal of Asiatic Studies* 50, no. 2 (December 1990): 561–88.

————. *Word, Image and Deed in the Life of Su Shi*. Cambridge: Council on East Asian Studies, Harvard University, 1994.

Ferguson, John C. "Mi Fu on Ink-Stones. By R. H. van Gulik." Review in *T'ien Hsia Monthly* 7, no. 2 (September 1938): 217–20.

Fong, Wen C. *Beyond Representation: Chinese Painting and Calligraphy, Eighth–Fourteenth Century*. New York: Metropolitan Museum of Art, 1992.

————. *Images of the Mind: Selections from the Edward L. Elliott Family and John B. Elliott Collections of Chinese Calligraphy and Painting*. Princeton: Princeton University Press, 1984.

Fu, Shen C. Y. "Huang T'ing-chien's Calligraphy and His *Scroll for Chang Ta-t'ung:* A Masterpiece Written in Exile." Ph.D. diss., Princeton University, 1976.

—————. "Huang T'ing-chien's Cursive Script and Its Influence." In Alfreda Murck and Wen Fong, ed., *Words and Images,* 107–22.

—————. *Traces of the Brush: Studies in Chinese Calligraphy.* New Haven and London: Yale University Press, 1980.

Fuller, Michael A. *The Road to East Slope: The Development of Su Shih's Poetic Voice.* Stanford: Stanford University Press, 1990.

Gibbs, Donald A. "Notes on the Wind: The Term 'Feng' in Chinese Literary Criticism." David C. Buxbaum and Frederck W. Mote, ed., *Transition and Permanence: Chinese History and Culture,* 285–93. Hong Kong: Cathay Press, 1972.

Girardot, N. J. *Myth and Meaning in Early Taoism.* Berkeley: University of California Press, 1983.

Goldberg, Stephen J. "Court Calligraphy of the Early T'ang Dynasty." *Artibus Asiae* 49 (1988–89): 189–237.

Gombrich, E. H. "Style." *International Encyclopedia of the Social Sciences.* New York: Macmillan, 1968.

Goodman, Nelson. "The Status of Style." *Critical Inquiry* 1 (1975): 799–811.

Graham, A. C., trans. *The Book of Lieh-tzu.* London: J. Murray, 1960.

Gulik, Robert H. van. *Chinese Pictorial Art as Viewed by the Connoisseur.* Rome: Istituto Italiano per il Medio ed Estremo Oriente, 1958. Reprint ed., Taipei: Southern Materials Center, 1981.

—————. *Mi Fu on Inkstones.* Beijing: Henri Vetch, 1938.

Hartman, Charles. *Han Yü and the Search for T'ang Unity.* Princeton: Princeton University Press, 1986.

Hawkes, David, trans. *Ch'u T'zu: Songs of the South.* Oxford: Clarendon, 1959.

Hay, John. "The Human Body as a Microcosmic Source of Macrocosmic Values in Calligraphy." In Susan Bush and Christian Murck, ed., *Theories of the Arts in China,* 74–102. Princeton: Princeton University Press, 1981.

—————. "Values and History in Chinese Painting, I: Hsieh Ho Revisited." *RES* 6 (Fall 1983): 72–111.

Hervouet, Yves, ed. *A Sung Bibliography.* Hong Kong: Chinese University Press, 1978.

Hirsch, E. D., Jr. "Stylistics and Synonymity." *Critical Inquiry* 1 (1975): 559–79.

Ho Wai-kam. "Mi Fei." *Encyclopedia of World Art,* 10:84–90. New York: McGraw-Hill, 1965.

Hucker, Charles O. *A Dictionary of Official Titles in Imperial China.* Stanford: Stanford University Press, 1985.

Kuriyama Shigehisa. "The Imagination of Winds and the Development of the Chinese Conception of the Body." In Angela Zito and Tani E. Barlow, ed., *Body, Subject, and Power in China,* 23–41. Chicago: University of Chicago Press, 1994.

Kubler, George. "Towards a Reductive Theory of Visual Style." In Lang, ed., *Concept of Style,* 119–27.

Lang, Berel, ed. *The Concept of Style.* Philadelphia: University of Pennsylvania Press,

1979.

———. "Style as Instrument, Style as Person." *Critical Inquiry* 4 (1979): 715–39.

Lau, D. C., trans. *Lao Tzu, Tao Te Ching*. Baltimore: Penguin Books, 1963.

Ledderose, Lothar. "Mi Fu." In Herbert Franke, ed., *Sung Biographies*, 116–27. Wiesbaden: Franz Steiner, 1976.

———. *Mi Fu and the Classical Tradition of Chinese Calligraphy*. Princeton: Princeton University Press, 1979.

Legge, James. *The Chinese Classics*. 5 vols. Oxford: Oxford University Press, 1935. Reprint ed., Taipei: Southern Materials Center, 1983.

Liu, James J. Y. *Major Lyricists of the Northern Song*. Princeton: Princeton University Press, 1974.

Liu, James T. C. *Ou-yang Hsiu, an Eleventh-Century Neo-Confucianist*. Stanford: Stanford University Press, 1967.

Mather, Richard, trans. *A New Account of Tales of the World*. Minneapolis: University of Minnesota Press, 1976.

———. "The Controversy over Conformity and Naturalness during the Six Dynasties." *History of Religions* 9, nos. 2–3 (1969–70), 160–80.

McNair, Amy. "*Fa shu yao lu*, a Ninth-Century Compendium of Texts on Calligraphy." *T'ang Studies* 5 (1987): 69–86.

———. "Su Shih's Copy of the *Letter on the Controversy over Seating Protocol*." *Archives of Asian Art* 43 (1990): 38–48.

———. "The Sung Calligrapher Ts'ai Hsiang." *Bulletin of Sung-Yuan Studies* 18 (1986): 61–75.

Meskill, John. *Wang An-shih: Practical Reformer? Problems in Asian Civilizations Series*. Boston: D. C. Heath, 1963.

Meyer, Leonard B. "Toward a Theory of Style." In Lang, ed., *Concept of Style*, 3–44.

Murck, Alfreda, and Wen Fong, eds. *Words and Images*. Princeton: Princeton University Press, 1991.

Nakata Yūjirō. "Calligraphic Style and Poetry Handscrolls: On Mi Fu's *Sailing on the Wu River*." In Murck and Fong, eds., *Words and Images*, 91–106.

Nakata Yūjirō, general editor. *Chinese Calligraphy*. Translated and adapted by Jeffrey Hunter. New York: Weatherhill, 1983.

Owen, Stephen. *The Poetry of Meng Chiao and Han Yu*. New Haven and London: Yale University Press, 1975.

———. *Traditional Chinese Poetry and Poetics: Omens of the World*. Madison: University of Wisconsin Press, 1985.

Palumbo-Liu, David. *The Poetics of Appropriation: The Literary Theory and Practice of Huang Tingjian*. Stanford: Stanford University Press, 1993.

Rickett, Adele Austin, ed. *Chinese Approaches to Literature from Confucius to Liang Ch'i-ch'ao*. Princeton: Princeton University Press, 1978.

Schapiro, Meyer. "Style." In A. L. Kroeber, ed., *Anthropology Today: An Encyclopedic Inventory*, 287–312. Chicago: University of Chicago Press, 1953.

Shih, Hsio-yen. "Mi Yu-jen." In Herbert Franke, ed., *Sung Biographies*, 127–34.

Wiesbaden: Franz Steiner, 1976.

Shih, Vincent Yu-chung, trans. *The Literary Mind and the Carving of Dragons*. New York: Columbia University Press, 1959.

Smith, Kidder, Jr., Peter Bol, et al. *Sung Dynasty Uses of the I-ching*. Princeton: Princeton University Press, 1990.

Soper, Alexander, trans. *Kuo Jo-hsü's Experiences in Painting*. Washington, D.C.: American Council of Learned Societies, 1951.

Sturman, Peter C. "Cranes above Kaifeng: The Auspicious Image at the Court of Huizong." *Ars Orientalis* 20 (1990): 33–68.

———. "The Donkey Rider as Icon: Li Cheng and Early Chinese Landscape Painting." *Artibus Asiae* 55, nos. 1–2 (1995): 43–97.

———. "Mi Youren and the Inherited Literati Tradition: Dimensions of Ink-play." Ph.D. diss., Yale University, 1989.

Teng Ssu-yu, trans. *Family Instructions for the Yen Clan*. Leiden: E. J. Brill, 1968.

Tseng, Yuho [Betty Ecke]. *A History of Chinese Calligraphy*. Hong Kong: Chinese University Press, 1993.

Vandier-Nicolas, Nicole. *Art et sagesses en Chine: Mi Fou (1051–1107)—peintre et connaisseur d'art dans la perspective de l'esthétique des lettres*. Paris: Presses Universitaires de France, 1964.

Wang, Gung-wu. "Feng Tao: An Essay on Confucian Loyalty." In Arthur F. Wright and Denis Twitchett, eds., *Confucian Personalities*, 123–45. Stanford: Stanford University Press, 1962.

Watson, Burton, trans. *The Complete Works of Chuang-tzu*. New York: Columbia University Press, 1968.

———. *Records of the Grand Historian: Translated from the Shi-chi of Ssu-ma Ch'ien*. 2 vols. New York: Columbia University Press, 1961.

Wong, Kwan-shut. *Masterpieces of Sung and Yuan Dynasty Calligraphy from the John M. Crawford Collection*. New York: China Institute in America, 1981.

Index